This has proved to be a valuable, insig[...] [...]ery
fine "gateway" into a growing field.

[...] E

Author of Voicing C[...] [...] Arts

It Was Good is one of the best examples I know of the new day that is dawning in Christian conversation on the arts. What we have needed is a thick description both of Christianity and of art making. And both are here in abundance, along with generous displays of great art motivated by faith both from the present and the past. This will definitely be a part of my course syllabus.

—*william* DYRNESS
Professor of Theology and Culture, Fuller Theological Seminary

Neglect of the arts in faith communities has resulted in a diminished language to speak about the arts. *It Was Good* is a valuable resource to help us to renew our language about the arts. But more than this it provides insights into the meaning of the divine call to art making in our contemporary world. Rich with visual images these reflective essays will be of great value both for those just discovering the world of the arts and the more experienced. The range of topics provides an excellent introduction to key themes in the arts. This is a book that is engaging and will inspire fresh appreciation for the God-given gifts of creativity and imagination.

—*john* FRANKLIN
Executive Director of Imago, Toronto, Canada

Wrought from years of reflection and practice this is a wonderful book whose pages are graced with an ancient wisdom. We are invited in to ponder the deepest and richest truths from a remarkably gifted faculty of visionaries whose vocations range across the *divers arts*, each one offering a window into what the arts mean and why they matter. For anyone anywhere who cares about beauty and truth and goodness, but who also feels the aches and sorrows and pains in contemporary culture, *It Was Good* is very good.

—*steve* GARBER
Author of Weaving Together Belief and Behavior

One of my spiritual Fathers, Saint John Chrysostom (c. 347–407), ascetic, preacher and finally Bishop of Constantinople, Doctor of the Church and ultimately martyred at the hand of his own bishops (something many an artist is familiar with) said: "God created the arts in order that life might be held together by them, so that we should not separate ourselves from spiritual things." (Homily

to the Philippians, 10.5) Art is liturgy, the holding of the world together, a glimpse of the presence seen. *It Was Good: Making Art to the Glory of God* signals the Second Renaissance, the second birth of all that is best in the Christian tradition's vocabulary illuminating the human nature. For this we give thanks and praise.

—*david j.* GOA
Director of the Chester Ronning Centre for the Study
of Religion and Public Life, University of Alberta, Canada,
and, Chief Curator of the international exhibition,
Incarnation: A Recovery of Meaning.

How we think about art is related to how we think about God. To confess we "believe in God, the Father Almighty, the Creator of heaven and earth" is to acknowledge that the One we worship has revealed himself to be both truth and beauty, both life and light. His glory, expressed in his riotous creativity when he called all things into being, is essential to the gospel we are called to demonstrate and share in a world where glimpses of beauty are at best fragmented. *It Was Good,* like the comforting statement of the Creator who said it first, is like a prism that works in reverse, taking the fragmented glimpses and refracting them into biblical wholeness. The authors help us think clearly, creatively, about art and Christian faith, so that we can embrace the breath-taking wonder of living as if we actually believed we are created in the image of the One who declared beauty, creativity, and art to be "very good!" Read this book and love God and life more deeply. Then give a copy to all your friends.

—*denis* HAACK
Co-director of Ransom Fellowship

This anthology's contributors unabashedly but thoughtfully love the symbiotic good gifts of Creation and creativity. As artists and friends of art, they know that the physical world is too good a gift to allow it to be reduced to an object lesson about "spiritual things," and that the making and perceiving of art is too valuable to allow it to be reduced to politics or theology. They know as well that God is good but not safe, and that the urge for safe art is often a worldly temptation away from goodness.

—*ken* MYERS
Executive Director at Mars Hill Audio

If believing Christians thought about it carefully, we would realize that there is a conversation we desperately need to have. When it comes to art, it appears we have limited ourselves to two unfortunate choices—pious schlock or impious relevance. *It Was Good: Making Art to the Glory of God* is an important book that I hope will help initiate the discussion that should have begun decades ago.

—*douglas* WILSON
Pastor of Christ Church in Moscow, Idaho

IT was GOOD

MAKING ART

to the GLORY of

GOD

IT was GOOD

MAKING ART

to the
GLORY of
GOD

Revised and
Expanded

EDITED BY *ned* BUSTARD

In Christian art, the square halo identified a living person
presumed to be a saint. Square Halo Books is devoted to
publishing works that present contextually sensitive biblical studies,
and practical instruction consistent with the Doctrines of the Reformation.
The goal of Square Halo Books is to provide materials
useful for encouraging and equipping the saints.

Second Edition 2006

Copyright ©2006 Square Halo Books
P.O. Box 18954, Baltimore, MD 21206

ISBN 0-9785097-1-4

Library of Congress Control Number: 2006931257

Printed in Korea

*This book is dedicated to
Alan and Diana—
who are responsible
for this, and so many other
good things in my life.*

*With thanks to
my dear wife Leslie,
through whom God shows
His goodness to me.*

FOREWORD

Early in my artistic career I was encouraged to read *The Christian Mind* by Harry Blamires. The book challenged Christians to "think Christianly," to grapple with our faith in relation to every area of life from a Christian perspective, and to struggle with issues that touch on our work and world. The book did not deal in any way with art, but it set in motion the principles that would help me question from a Christian perspective how and why I worked as an artist.

Thirty years ago there were only a limited number of books addressing art and faith and even fewer written by Christian artists about their art-making. How did we exist? How did we grow? In what context did we create?

Even though artists essentially work alone in the studio, there is a deep need for community. The local church is supposed to be a place for personal and spiritual development, but most Christian artists find themselves lonely with few to help them work through theological or practical issues of concern to them. At the same time Christian artists experience a sense of alienation from the arts community.

To help fill this void CIVA, Christians in the Visual Arts was founded in the late 70's. Over the years hundreds of artists, theologians, and art historians have come together to help work through some of the issues, to challenge one another to excellence, and to create an environment in which relationships could develop that would nurture and build Christian community among artists. The fruits of some of those relationships have begun to surface as is evidenced in this collection of essays, *It Was Good: Making Art to the Glory of God.*

Much has changed in these years. There is a quiet renaissance in the church

with renewed interest in the arts surfacing at many levels. At the same time a cry for the 'spiritual' comes from all corners of our culture. The time is ripe for the Christian artist to be a presence seen.

However, some questions beg our attention. Are we ready for the next century? Do we as artists know how to "think Christianly" in matters of art-making? Is our work grounded in good theology? Are we prepared to create work that is so compelling it will leave its mark on the next generation? Are we engaged in the culture enough to offer anything of significance?

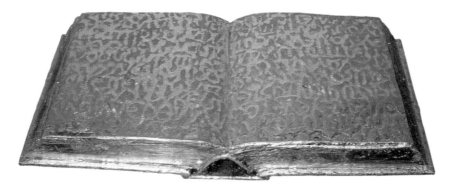

SANDRA BOWDEN. *Resurrection Book.* 2004. Mixed media, 5 1/4 x 11 inches.

This book is a valuable gift to the next generation of Christian artists who must grapple with these questions. It offers voices of experience and insight from godly artists who have dedicated their lives and talents to the arts. Their commitment to being artists of integrity as well as thoughtful Christians has laid a foundation for the next generation.

—Sandra Bowden
President of CIVA

AN ARCHITECTURE
of Living Stones

Whensoever you make good use of my labors, commend me in prayer to the mercy of Almighty God, who knows that I have not written these things for love of praise nor for covetousness of worldly reward, nor enviously or jealously reserving any precious or rare knowledge for myself alone—nay, rather, for the increase of God's honor and the glory of God's name have I succored the needs of others, and taken thought for their advancement.[1]

In 1122, a Benedictine monk identified only by the pseudonym Theophilus—lover of God—compiled the first known European manual on the arts written by an artist, rather than a scholar or theologian. "Whosoever you may be," his prologue in *Diversarum artium schedula* urges, "into whose heart God set the yearning to explore fully that great and wide field of *diverse arts*...now, greedily behold and covet this little scrip of *Divers Arts*. Read it through, hold it fast in memory."[2] Theophilus promised that diligent study would inspire mastery in Byzantine color formulas, Russian enamelwork, Arabian hammered reliefs, Tuscan ornament, costly church window technique pioneered by the French, and German excellence in precious metals, wood, stone, and iron.

If, as some scholars dream, Theophilus was actually Roger of Helmarhausen, his authority as the first arts treatise writer was virtually unsurpassed, since Roger was widely considered the finest metalworker in the entire Holy Roman Empire. Vaporizing chronological distinctions, Theophilus' humbly offered 'little scroll' not only parallels the job description in Exodus for Bezalel's fitness as

building chief, designer, and decorator of the first Tabernacle, but re-emerges as an authoritative source for more than eight centuries. For example, in 1959, Russian-born constructivist Naum Gabo credited Theophilus as the *'one voice* in particular' who directly influenced his work during a series of prestigious Princeton lectures titled "Of Divers Arts." As Gabo plainly stated, *"That* artist knew exactly what he was working for and what he had to do," ruefully adding, "And here *I* am, at the other end of a millennium."[3] Amazingly, this child of Lenin's atheist Russia, artistically shaped by Europe's atheistic avant-garde groups, and speaking into the relatively atheistic milieu of the modern art world, chooses to invoke the wisdom of an anonymous Benedictine monk.

THEODORE PRESCOTT. *Annunciation,* 1978–79. Mixed media including cast hydrocal, wood, neon, and found objects. 48 x 144 inches.

If you are reading this sentence, you already demonstrate a stellar motivation to parley with the *divers* arts. Most of us can draw distinctions between "art-as-such" and our expectations of what art *should* be. Christians ostensibly freight this expectation with the responsible burdens of intelligibility, propriety, the seven gifts of the spirit, the six-no-seven things that are abominations to the Lord, scriptural accuracy, and exegetical vigor. Fundamentally, each contributor in *It Was Good: Making Art to the Glory of God* ascribes to the breathtaking promise of infinite creativity, transmitted through our admittedly finite vessels but

reflective of our genesis in the image of the Infinite Creator. These artists, educators and pastors model a particular form of *Self*-expression, as individuals made in the image of the intelligible Ultimate Self—the "I AM THAT I AM."[4] Each one operates independently, yet simultaneously participates in a community of believers. Each shares a sense of anticipation for completion and redemption in the fullness of eternal time. We will truly understand the meaning of 'perfection in Christ,' which (as Madeleine L'Engle loved to explain) referred to 'perfect' knowledge as the most thorough and complete knowledge possible. The culminating event of a heavenly finale may not only involve the greatest, most perfect art exhibition of all time, but may *finally* answer that pressing eternal question: "What art hangs on God's refrigerator door?"[5]

Several triads provide inherent structure for *It Was Good,* which primarily hinges on the traditional classical triad of beauty, goodness and truth. Additionally, the successive trajectory of Creation, Fall and Redemption weighs into the discussion, coupled with a sense of *past* perfection, *present* cultural alienation, and *future* restoration. The flawless creation that we long for in the *past,* the *present* situation marked by a general fall from grace, and the *future* promise of complete redemption inflect all artistic endeavor, whether acknowledged or not.[6] Finally, the overarching triad that provides the key organizing framework for the book pivots on a trinitarian consideration of the *Creator* as the primary source of creativity, *creating* as a transformative process that emulates a Christ-like model, and all that is *created* as a sector of reality that requires maintenance and renewal, under the guidance of the Spirit.

The entire endeavor reinforces a conviction that the implicit classical trinity of truth, beauty and goodness—values that are sometimes expressed by their absence or opposites in art—operates continuously under God's fiat. Despite the fact that truth, beauty and goodness appear relativized, marginalized, fragmented, eroded or otherwise compromised in *this* world, they exist in their fullness as God intended them to be in the eternal, redeemed realm—currently beyond the reach of our senses. The reasons for these corruptions and indignities are succinctly stated in Genesis. After merely two chapters of frolic in the spanking new creation of Paradise (Eden), the protagonists (all humankind) become plunged into the consequences of separation from God. A perfect, pristine beginning is all too quickly marred by a willfullness to operate outside God's scheme, resulting in rupture, dissolution, and alienation. Canadian literary critic Michael Edwards suggested in *Towards a Christian Poetics* that the modern and contemporary arts seem endlessly occupied with this fallen moment. Hard as they might try, no one escapes the twentieth century's fatal flirtations with gratuitous violence, fragmentation, annihilation, and despair. The effect is compounded by the fact that artists in general cannot resist incessantly reproducing either the vestigial beauties or looming flaws of this world—as Edwards concluded, "A space

traveler arriving on the earth and discovering so many millions of paintings might be surprised at our valuing our world so highly that we should be endlessly reproducing it, and might also wonder what it is that we find wrong with our world, that in our paintings we should be endlessly changing it."[7]

Consequently, the third moment—broadly marginalized by the world as a cosmic pipe dream, but essential to the completed Christian vision—involves transformation, restitution, or in other words, Paradise. One of the few artworks that considers all three moments at once is Don Forsythe's twelve-box series, *Long Night's Journey*. Forsythe's shadow boxes move from blackened frames to bare wood, chronicling the disintegration of a meticulously constructed façade faintly faced in bible verses. In the last box, an ostensibly invisible force unaccountably—or miraculously—reassembles an entirely new facade. A small piece of scorched detritus serves as a reminder, in this metaphorical reconstruction, of the past destruction—like Christ's stigmata. This is the Word, brutally dismantled by the world's evil and rebuilt by the grace of God; this is the temple Christ promised to rebuild in three days. Even the cantankerous, phenomenally contrary art critic Robert Hughes could not fail to compliment the sweeping fullness of Forsythe's assemblage, exhibited at the 1993 CIVA biennial exhibit.

In the sense of completed and resolved reality, Paradise rarely, fleetingly or unconvincingly occupies the labors of artists, particularly in recent centuries. While Naum Gabo concurred with Theophilus that Satan absconded with Paradise, he also concluded that God allowed our "inborn capacity for the diverse arts"[8] to remain behind as its reminder. But face it—Paradise is just too difficult to specify in visual form with any sense of authenticity or authority. Paradise even manages to stifle Dante Alighieri's formidable giftedness. In his iconic *Divina Comedia*, published after 1305, the scintillating tortures of *Inferno* and the wholly understandable travails of *Purgatorio* segue into *Paradiso*, a perfected realm of light populated by holy figures that beatifically hover around in holy conversation for eternity. Does this truly engage a full-blooded human being? Human imagination gustily cheers the villains in the *Inferno* and

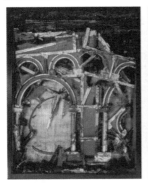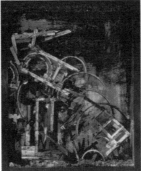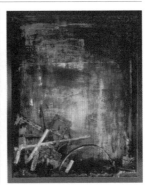

empathizes with *Purgatorio's* labors, but in fact, we can only long for the veiled mysteries of Paradise.

Another triadic organizing logic for this revised edition of *It Was Good* involves the broad categories of *Creator, creating,* and *created.* Considerations of goodness, beauty, substance, presence, creativity and glory speak to the overarching logic of a *Creator* God. The second section explores the processes that drive the act of *creating*—thoughts, theories or practices that occupy artists as they work with visual language, color, light, and shadow, or scriptural operatives that enrich artistic endeavor, such as excellence, incarnation, and mission or purpose. The final chapters reflect on the existing, *created* realm that requires unceasing mediation by the Spirit. Community, collaboration, cultural engagement, synergistic energy, interactive essence, and the formation of identity all equate to sites for demonstrations of the Spirit's indwelling and outworking through art.

Graphic artist Ned Bustard jumpstarted this vision for *It Was Good* with his overriding curiosity and profound appreciation for the arts, extending an invitation to various contributors. Fittingly, he provides a fundamental beginning for this discussion by reviewing different incidents of goodness, illustrated by artistic examples. This reiteration includes scriptural premises for goodness as a moral imperative, a divine gift that remains viable even in the midst of evil, and a natural byproduct of redeeming grace. In the following chapter on beauty, Adrienne Chaplin, who succeeded Calvin Seerveld in aesthetics at Toronto's Institute of Christian Studies, extends a veritable pocket encyclopedia of historical as well as recent discourses on aesthetics. In the process, her articulate analysis reveals the philosophical shifts that muddle the current perception of classical artistic values in the present culture. As Chaplin confirms, if we do not acknowledge this shift, our dialogue regarding beauty will be stilted and irrelevant to the world at large.

Dictionaries, as well as aesthetically conservative Christians, tend to rely with prim insistence upon a traditional *beaux arts* definition for art, which in actuality is more or less in a shambles since Romanticism and its predecessors began percolating.[9] For centuries, art was unquestioningly considered a *deliberate and con-*

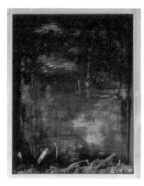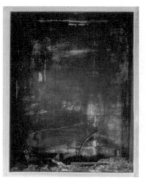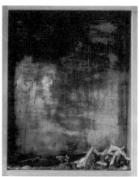

scious arrangement or production of various materials—*i.e.* movement (in dance), sound (in music), gesticulated word (in drama or poetry), fabric, paint, stone, clay, found objects, *etcetera*—intended to engage one's sense of *beauty*. Clearly, many contemporary works are often only *deliberate* in their effort to reject *conscious* arrangement, preferring spontaneous expression to intentional approaches. *Beauty* might be idolized as a vestige of the past, or entirely jettisoned. Etymologically, the meaning of beauty is rooted in the *satisfaction* of the senses, which opens a proverbial Pandora's box of subjective response. Subjective response can be inflected by cultivation or conoisseurship or studied analysis, but equally validates the simplest gut sense of 'liking' what one sees—from the Altamira cave paintings to Ossip Zadkhine, from Ellsworth Kelly to Kinkade. In any event, much contemporary art trumps satisfaction with self-expression. Endlessly reiterated self-expression unmediated by artistic discipline eventually manages to make itself deeply unsatisfying. "Is the Self automatically interesting in art?" Robert Hughes asked, answering himself in the negative with the observation that twentieth-century culture is obsessively preoccupied with the "merely personal," which smothers the conceptual dignity of art with "every kind of petty documentation, psychic laundry list, and autistic gesture."[10] In the end, Christians must be conversant on both sides of the issue—traditional as well as contemporary—to make a difference in the practice of art, which mandates various levels of engagement. As Calvin Seerveld sagely warned, *any* arena from which Christians withdraw simply goes to hell.

Following Ned Bustard and Adrienne Chaplin under the *"Creator"* rubric, perceptual artist/educator Roger Feldman acknowledges God's embodiment of "real" substance as a parallel to the artistic property of mass. He marvels that the choices and controls of art making emulate the pro-activity of the divine Creator, reveling that God allows artists to interact with divinely mandated creativity. Painter Ed Knippers, who has long and steadfastly stood in the breach between the Church and the world, repeatedly celebrates the immanent presence of Jesus Christ through history in his life's work. For decades, Knippers' chosen approach

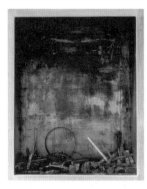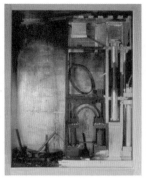

DONALD J. FORSYTHE. *The Long Night,* 1989–91. Mixed media including wood, gold leaf, acrylic mediums, lampblack, ashes, photoserigraph on silk tissue over Bible pages. Each box 21 x 17 x 5 inches, overall length 24 feet.

made him the ultimate artistic misfit: ostensibly rejected by the secular gallery and art world for his insistence on biblical subject matter, but simultaneously rejected by aesthetically conservative Christians, who bridle over his [un]apologetic use of monumental nudes. Despite this, Knippers' career and spirited crash courses in apologetics flourish—as he would be the first to acknowledge—thanks to the sustaining grace of God. Art historian James Romaine, who initiated a visionary academic program with artist John Silvis that enables Christian art majors to partake of New York City's overflowing artistic riches (NY-CAMS), ruminates about the overriding source of creativity as a divine emanation from God, providing historical and recent evidence of its outworking in art. Pastor Tim Keller provides a coda for this section with his meditation about how essential artists can be in Christian community, because art so eloquently enhances our ability to 'see' the glory of God.

Mary McCleary jumpstarts the second section, on *creating,* with another fabulous pocket guide of scriptural references directed to the artist. A sprightly, contemporary counterpart for a medieval Byzantine mosaic artist—with a gentle S'uthern lilt—McCleary builds her scriptural reflections and practical conclusions as meticulously as she constructs breathtaking photorealistic assemblages from tiny bits and pieces of material that most folks would relegate to the dustbin. Artist/housebuilder Gaylen Stewart shares his personal response to the question of locating convincing visual vocabularies, with a vivacity and fearlessness that extend, in part, from a miraculous healing experience. In effect, his body provides a walking reminder to him, emulating the restored body of Christ directly. Cross-cultural observer and inveterate bibliophiliac, Steve Scott, initially set out to be a "rock star," as he admits (in quotes), after conversations with Hans Rookmaaker in Birmingham, England. While that dream abruptly evaporated, Steve's engagement with various creative art projects through Sacramento's Warehouse Ministries led

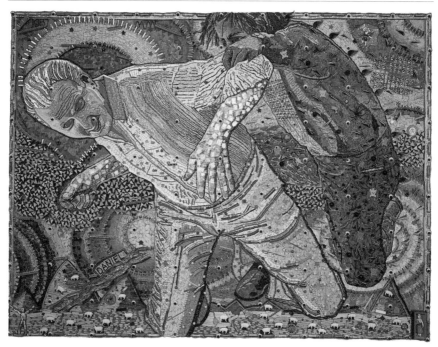

MARY McCLEARY. *Gabriel Being Detained by the Prince of Persia,* 1987. Mixed media collage on paper, 45 x 59.5 inches. *Collection of Edwina Hawley Milner & Charles Porter Milner, Santa Fe, New Mexico.*

to his leadership of international Bali conferences on the arts. Scott synergistically blends discourses from his extensive arts library and life experiences as a poet, musician, and collaborator (*i.e.,* with Gaylen Stewart). His examples make us mindful of the reality that making as well as receiving art with an open heart ultimately enhances our understanding of essential truths like nothing else can. Dale Savidge, experienced in stagecraft as director, agent, educator, and leader of Christians in the Theatre Arts, emphasizes the parallels between actors, who literally 'flesh out' the word, and Jesus Christ's incarnation as *Logos.*[11]

Artist Kim Garza's exploration of color, added to the revised edition because color is so integral to art, noodles over agreements about color in theory, practice and faith and the connections between color and life as God meant us to live it. Theatre designers combine multiple colored gels to attain a white light—a metaphor for divine knowledge composed of many parts. Similarly, painters have told me that when certain pigments are combined in a carefully pre-ordained way, the result inexplicably becomes a muddy looking white. On a scientific level, color only exists as reflected light. The visible world is actually colorless unless light is reflecting on it, which provides a trope for the notion that we are essentially colorless until we reflect the light of God. Scripturally, we are told that our 'inner' lamp must be lit to 'see' properly, implying that sight and reflected light

link with understanding. For photographer Krystyna Sanderson, spectral as well as metaphysical light provides an essential tool. Sanderson observes that light not only serves as a foil for darkness, adding richness and visual texture to photography, but also betrays a sense that a divine presence is intimately involved with her work. Peering out of her lower Manhattan studio windows as the horrific events of 9/11 began to unfold, she instinctively grabbed her gear and went up the street to Ground Zero, acclimatized to crisis situations after years of working as a police photographer. Only after she developed her film did she discover that her images matched those appearing in national news forums—some by photographers who perished when the towers collapsed. Her subsequent volunteer work at St. Paul's Chapel, a colonial-era church that miraculously survived 9/11 in a lot adjacent to Liberty Plaza, led to the photographic essay, *Light at Ground Zero,* which celebrates the selfless (light-shedding) devotion of hundreds of volunteer rescue workers who sought sleep, consolation and sustenance at St. Paul's.[12]

Conversely, Westminster Theological Seminary professor and jazz/blues *aficionado* Bill Edgar describes the choreography between tragedy and joy, or light and shadow, in musical composition. He explores why artists feel impelled to 'light' the miserable, and why shadows are essential to the most authentic depictions of this world in art. Divisions between opposite categories, such as light and shadow, beauty and ugliness, or good and evil, pose an ever-present paradox sanctioned by God. Try as we might, such oppositions can only ultimately be resolved by redemption, requiring some degree of intellectual or artistic surrender to God's greater wisdom in the matter. Edgar implies that the safety net of this resolution allows artists of faith to plumb the world's vice and *misére* as much as its *grandeur,* if the artist is authentically and fearlessly engaged in expressing truth. Closing the creating section, Charlie Peacock reflects on the motivations that drive Christians to sacrifice for a vocation in the arts. His own experience as a successful pop musician and gifted lyric writer guides his advice to go into the arts knowing with certainty: what makes a good story; which direction we want to go in before we even start making art; when being opportunistic is wise and appropriate; and, above all, how to imitate the example of Jesus Christ in all endeavors.

The third section, organized under the general category of all that exists in a *created* state and is subject to the ministrations of the Spirit, begins with Gregory Wolfe's reflections on the dire necessity of cultural stewardship, demonstrated by the progress of contemporary literature. Wolfe's persevering roles as the co-founding publisher of the widely influential *Image* journal since 1989, and as organizer of the enriching multidisciplinary Glen Workshops, clearly model the benefits of a witting, fearless exchange between Christian faith and the culture at large. Shifting to our interactions within the camp, David Giardinere compares the ancient understanding of *koinonia,* or community, with singing in unison. Of course, the beauty of the choir involves a simultaneous celebration of unified

sound made with the fullest diversity of many voices and parts. Reflecting on col-
laboration as an extension of community, a collaboratively-written chapter on
the possibilities of working alongside each other presents numerous examples of
successful collaborative artworks, across all the artistic disciplines, and high-
lights the fact that collaboration is key to certain arts, such as theatre or dance.
The time-tested adage that the 'whole' is greater than the sum of its parts essen-
tially parallels our working relationship with God, whether or not we choose to
acknowledge the transaction, and the pressures of submitting to teamwork pro-
vides a crash course in humility. Cultural standardbearer Mako Fujimura speaks
about the essence of God when art collaborates with scriptural vision. He elo-
quently describes artistic expression as the ultimate dance between God and con-
tent, perfectly fused in the entity of Jesus Christ. Sculptor/educator Ted Prescott
weaves a dialogue between ideas, materials and God over time in his studied con-
sideration of identity within the dual, sometimesantagonistic spheres of art and
Christian faith. As longstanding chair of Messiah College's art department,
Prescott has fielded questions that bedevil younger generations for decades.
Coming out of the sixties and the smothering hegemony of modernism, Prescott
presents a compassionate response to the overriding issue of self-identity: *Who
am I in this world? Who am I as a Christian and/or as an artist? What do I matter,
either way, in the scheme of things?* By discarding 'safe' or conventional categories
for self-identity, usually excerpted from from typical church, societal, or psycho-
logical models, Prescott sculpts a template for real identity, founded on the real-
ity of the most authentic Self, the I AM WHO I AM. As he concludes, no other
identity will suffice if we truly want to succeed as cultural colonizers, rather than
refugees in a cultural ghetto of our own making.

JOHANNES SCHREITER. *Altzentrum*, Betzdorf/Sieg (detail), 1977. 8.7 x 36.1 feet.
From *Die Glasbilder von Johannes Schreiter* (Das Beispiel, 1987), 197.

Astonishingly, after all this is said and done, we must all concede that scriptural references about art making are mostly indirect or inferential. Perhaps this divine lapse constitutes divine wisdom, extending a covenant of potentially infinite creative possibilities to artists on their own recognizance, or giving artists freedom to exercise the gift of their God-given creative impulse. Perhaps this open-endedness preserves any preternaturally pigheaded and maverick artists from God's judgment. Regardless, this brilliantly ambiguous, inherently nonspecific solution never ceases to tantalize the explorations of the Christian imagination. The non-specificity caused the greatest art debate in history, the Iconoclastic Controversy, which lasted over 150 years and led to the violent blinding of uncounted iconographers, and the loss of many precious icons consigned to fire.

CLIFF MCREYNOLDS. *Expanding Creation,* c. 1975. Oil on Panel, 20 x 20 inches.

Nuanced studies concerning the Grail-like search for a unified Christian aesthetic have colored scholarly debates for centuries. Ultimately, perhaps this lack of rules secures the infinite creativity of the infinite Creator God in all its cultural iterations—and will continue to do so, long after the comfortable clichés and commercially viable but flaccid artworks of Christendom revert to dust.

The issue really amounts more to what artists *can do* with such unlimited communicative freedom, rather than what they *should not do.* The penultimate goal of art making under God's dominion is never about being *right,* so much as about being obedient, loving, perfected in Christ, or humble—all those qualities fostered by the will that are not yoked to fluctuations in the art market, or the opinions of ruling vestries, councils, sessions, boards, and so on. God offers no guarantees or contractual stipulations assuring that artists will be helped or hindered, trusted or trussed by their Christian communities in the process. Moreover, there is the annoying fact that nonbelievers may 'speak' more eloquently for God with their art than believers, unwittingly making powerfully conversant art in the tradition of Balaam's ass. After all, with the God Who finds nothing impossible, even an ass can be made to speak truth.[13]

Perhaps divine wisdom also invented the humbling contingency that *everyone* can have opinions about art, regardless of their own ability or training, although some artists bearing the scars of knee jerk responses attribute this condition to the other side. Seriously, though—who among us would attempt to levy medical

diagnoses, assess astrophysical formulas, or propose responsible investment strategies on our brothers and sisters without training or preparation? Because art can convey profound or simple truths to nonthinkers and great intellects with potency (or a dismal lack thereof), art poses a huge target to the very audiences it hopes to engage. Its very existence simultaneously poses a cultural liability, and a magnificent viability.

The most direct allusion to the artist's endeavor—besides the Second Commandment injunction against idolatry, of course—is the laundry list in Exodus concerning Bezalel's qualifications as God's appointed tabernacle designer. Even a superficial reading suggests that all God's people would do well to emulate many of these guidelines, regardless of vocation. As we learn, Bezalel allowed himself to be filled with the Spirit of God, and honed his God-given abilities for work in "all kinds" of *divers arts*. Against stereotype, he was also an adept administrator—*never* a given for an artist, admittedly. He could organize teams of artists; he collaborated with Oholiab; he taught—an endeavor of mixed blessings that occupies many contributors in this book. This acknowledges an inferential mandate to pass on knowledge to subsequent generations. As Chesterton and C. S. Lewis both pointed out, without the transmission of scriptural truth, Christianity is always only a generation away from extinction; imagine how much more tenuous this passage might become for artistic practice and conceptuality. One of Theophilus' categories—glass manufacture and design—even became a lost art in the recent past; forgotten pigmentation formulas and techniques are being rediscovered every year.

Significantly, Bezalel was actually willing to 'do the work' that the Lord commanded, suggesting an attunement to the goals of the ultimate Maker rather than his own. This much is quite clear. Most excitingly, Bezalel's multi-dimensional example migrates, ever so briefly, to the New Testament—tailored for those of us born after the *Anno Domini*. Written during a period that saw the second temple in Jerusalem ransacked by Roman legionnaires in 71 A.D., Peter's epistle infers that God provides an unassailable replacement for a final temple, spectacularly suggesting that the actual *people of God* have become *living stones of the new temple*.[14] Naturally, as an architectural historian, I cannot resist the impulse to consider this the most exciting restoration and conservation campaign in history. Moreover, these living stones rest on an architectural base with an eternal warranty, prefigured in Isaiah 43 centuries before Peter's epistle. Jesus Christ, as Cornerstone, metaphorically supports all other architectural elements, which are in turn subsidiary to His foundation. If they are not subject to this construction, they logically have no place in the building. As Paul reminds us, this Cornerstone is *prominent* enough, *massive* enough, *involved* enough to be a 'stumbling stone' to the unsaved, stiffnecked, goaty, poorly planted, and whitewashed sepulchral types. "Jews demand signs and Greeks desire wisdom," Paul avers, "but we proclaim Christ crucified, a stumbling block to Jews and foolishness to Gentiles, but

to those who are the called, both Jews and Greeks—Christ the power of God and the wisdom of God." The Cornerstone, intentionally laid as a potentially painful, toe-stubbing obstacle that trips up nonbelievers, will not shame those who repent of unbelief, turns out to be an instrument for making distinctions.[15]

Finally, this essential building block did not require status, as the temple's highest, or most lavishly decorated, or most advanced structural feature. This Cornerstone left all that for *us* to enjoy, embellished by *divers arts,* and took on Himself the complete weight of our own existence without being crushed. Consequently, every living stone that rests on the Cornerstone contributes to the temple's soundness, wholeness, and beauty. This is ancient wisdom; the same tenets regulate Vitruvius' seminal treatise, *De Architettura,* from second century Rome. Proper handling of *venustas, firmitas, utilitas,* the Latin equivalents for beauty, strength and functionality, insures lasting construction and aesthetic satisfaction—strange bedfellows in a land of cookie cutter malls, houses and churches that frequently seem constructed overnight.

LUDWIG SCHAFFRATH. *Sketch for Vault Fresco,* 1996. Pencil paper, 8 x 10 inches. *Schaffrath created various fresco designs, stone mosaics, vestments, and windows for the church of Santa Lucia; this sketch took four assistants and nine months to complete, and complements the vaulting structure of the nineteenth century neo-Gothic sanctuary.*

Yet amid the solid walls of living stones, a delicately carved decorative bracket has as much of a role as a sturdy rock that supports a wall, hidden amidst otherstones. The gutter spout or the lowly doorjamb are there to serve, on par with the window aperture and the oculus that allows glorious light to pierce the interior, or the finial that decoratively tops the roofline and leads the eye heavenwards. All contribute to the total effect. As long as we are (unlike Elvis) still in the building, Christ the Cornerstone steadfastly supports our architectonic community.[16]

So now, as Theophilus urged, gather your tools, and "behold this little scrip of diverse arts."

Endnotes

1 Paraphrased from a combination of sources: Theophilus Presbyter, *Diversarum atrium schedula,* quoted in C.G. Coulton, *Art and the Reformation* (Oxford 1928) 97-99, and John G. Hawthorne and Cyril Stanley Smith, Theophilus: *On Divers Arts* (New York: Dover, 1963) 13, as well as Naum Gabo, *Of Divers Arts* (New York: Pantheon Books, 1962), 7-9.

2 Naum Gabo, 1962; Coulton, 1928, 98; Hawthorne and Smith, 1963, 12-13.

3 Gabo, 1962, 8-9. Naum Neemia Pevsner Gabo (1890-1977) co-authored the *Realistic Manifesto* with his brother, Antoine Pevsner (1886-1962), in 1920, providing the theoretical basis for European Constructivism as a lifestyle as well as an art genre. Born in Russia, Gabo circulated through Europe's cultural centers as a young avant-garde artist, relocating after 1922 to Europe and permanently immigrating to the United States in 1946 to avoid the Soviet state's censorship on art.

4 See God's response to Moses in Exodus 3:14, which varies grammatically in different versions of the Bible.

5 L'Engle shared this revelation about perfection at the 1991 C.S. Lewis Summer Institute on the imagination, held at Oxford University.

6 University of Aberdeen professor Michael Edwards unforgettably connected modes of art making with these three seminal moments in time in *Toward a Christian Poetics* (Grand Rapids: Eerdmans, 1984), which is difficult to find, but worth the effort.

7 Edwards, 1984, 201.

8 Gabo, 1962, 8-9.

9 Then again, according to *The Oxford Dictionary of Art,* Romanticism itself "is so varied in its manifestations that a single definition would be impossible"—a condition that ostensibly foreshadows the troublesome qualifier, "postmodern." See Ian Chivers, Harold Osbourne, and Dennis Farr, *The Oxford Dictionary of Art* (Oxford University Press, 1988) 430.

10 Robert Hughes, *The Shock of the New: Art and the Century of Change* (London: BBC, 1980 or Alfred J. Knopf, 1991 edition) 268.

11 St. Paul's choice of the Greek word *hamartia* to signify sin actually reframes a term invented by the ancient Greek playwrights to signify a fatal, inescapable flaw in the hero, whose actions inevitably convert a play into a tragedy. Such tragedies, and the fatal flaws that motivate them, unavoidably tinge our daily experiences.

12 *Light at Ground Zero: St. Paul's Chapel After 9/11* (Square Halo Books, 2004), visually records the activity directly after the World Trade Center calamity, and in particular, St. Paul's ministry to thousands of firefighters and rescue workers.

13 In Numbers 22, Balaam disobeyed God's direct command, riding off on his donkey to capitulate with Moabite officials. God sent a commanding angel, sword in hand, to stop him, but whereas Balaam ignored the angel, his donkey swerved and eventually collapsed under him rather than disobey the angel, inciting Balaam to beat him severely. To get Balaam's attention, God finally resorts to making the donkey launch a verbal protest, which inspires Balaam's subsequent calling as an oracle. See also Luke 1:37. See Matthew 19:26, Mark 10:27, or Luke 18:27 for affirmations that nothing is impossible with God.

14 1 Peter 2: 4-8.

15 For instance, see Jeremiah 6:21; Romans 9:31-33; 1 Corinthians 2:21-25.

16 No slur on Elvis Presley's spiritual status intended!

GOD IS GOOD
like no other[1]

"Why do you call me good?" Jesus answered. "No one is good—except God alone."
　　—Mark 10:18

In a telephone call one day, while *It Was Good: Making Art to the Glory of God* was first coming together, painter Edward Knippers identified a glaring weakness in the project—it was missing a chapter on goodness. And the fact that no one wanted to tackle the topic was no excuse. Since the word was in the book's title and, even more importantly, because the word saturates the account of God's creativity in Creation, the concept *had* to be engaged. So we talked over some of the relevant points, identified potential questions, and then he told me to write it.

A WORLD WITHOUT THE FALL
God's Word is clear that those who are baptized into Christ and clothed in Him are called to be good and beyond that, to take His Kingdom paradigm and apply it to all values and actions. But does it follow that a Christian's handiwork should "do good" as well? For those called to truly be imitators of the Creator, the answer is yes—they need to be good, do good and *make* good. That precedent is clearly set in Genesis 1 in the activity of the Maker of Heaven and Earth. So for believers making art to the glory of God, goodness is not merely something to strive for in their morality, it is also something that should permeate their aesthetic efforts. Certainly not in a garrishly didactic "I've got the joy, joy, joy, joy down in my heart" way, but in such a way that goodness infuses the overall body of their work like rich roots

growing deep and wide. Yet the rub is, if you decide to make art intended to communicate goodness, you'll find the goal is easier to assert than accomplish, because portraying *good* with any precision is excruciatingly difficult.

Inevitably it seems that most attempts to picture good tend to offer the viewer disingenuous, sugary sweet propaganda. Ignoring the implications of the Fall, these artists paint the world as a shiny, happy place. The quintessential example of this in our day is found in Thomas Kinkade's general philosophy. Kinkade professes to be a Christian but has said, "I like to portray a world without the Fall."[2] Yet the opposite extreme is almost easier to fall into: despair—ignoring goodness in favor of pursuing negative themes or motifs. Looking around we have to agree with Stuart McAllister that "much of the energy and effort of our artists and cultural architects has gone into debunking, dismantling, or deconstructing all that is good, beautiful, and respected, to be replaced with the shallow, the ugly, the ephemeral."[3] In contrast, followers of Christ who labor in the arts must oppose this deconstruction by taking up the subject of *good* or *goodness* to the glory of God. They need to struggle to understand it, and to present it, as neither sacchrine nor lost in the mire that surrounds us. Instead it should be conveyed in such a way that a world—forgetful of true goodness since the Fall—can be taught what the word means, and so be led to the only good One. This is a unique opportunity. Christ gives believers the potential to understand good, for if one knows Christ he knows God. Without this basic theological understanding, one's knowledge of God is perverted.

AND GOD SAID IT WAS KALOS

We are confronted with the concept of *good* from the very beginning of Scripture. God made the cosmos to display His goodness. And we are informed by the writer of Genesis that what God made was good. In fact, God said so Himself—the Creator evaluated His own work and pronounced, "It was good." God's goodness moved His wisdom to conceive of creation and His power to make it. This world He created bore no resemblance to the yin-yang pictures of the world presented in other creation stories. What the Almighty made was good in every way for its purpose. It was useful, healthy, and morally perfect.

God's pronouncement on creation transcends mere usefulness because the evaluation of creation's goodness came before anyone could use it. For example, following the creation of light, God said that "it was good." This is not just a pragmatic 'good,' because at that point in the sequence of creation there were no plants existing to conduct photosynthesis using the light, and no humans to work and play in the light. The light merely existed and it was good. "Creation is useful because it is good. It is not good just because it is useful."[4] The universe was made by God, it conformed to His nature, reflected His image and therefore was pronounced 'good.' Though it is drastically altered in the Fall, this goodness of creation has not been obliterated. It can still be seen in the beauty of the earth and in Man the image-bearer of God.

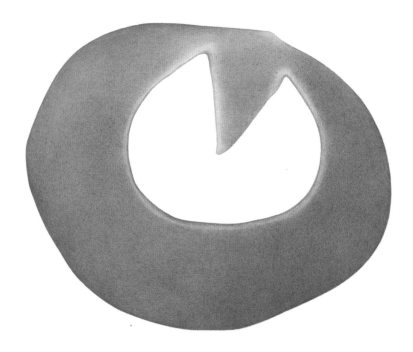

PETER MOLLENKOF. *Largess*, 2001. Colored pencil on paper, 20 x 26 inches.

The word used in Genesis 1 for *good* in the Hebrew is *ṭôḇ* (pronounced "tuv") and conveys the broad meaning of that which is good, useful, and especially good morally—while also conveying the aesthetic moment of beauty. The word for good in Greek is *kalos.* Kalos has the sense of aesthetically beautiful and morally good, and pertains to that good which brings joy to God. So in the first chapter of Genesis, whenever it says that God saw that what He had made was good (or very good), a form of the word kalos is being used. Certainly the unfallen creation was morally good, but it seems that the aspect of good in focus here is what was pleasing to God and beautiful. This understanding of good as both morally right and *beautiful* provides us with a fascinating reread of Scripture. A small sampling yields examples such as Genesis 2 in which we learn that God told Adam that he must not "... eat from the tree of the knowledge of *beautiful* and evil ..." and that "It is not *beautiful* for the man to be alone." In the New Testament we read that "every tree that does not produce *beautiful* fruit will be cut down and thrown into the fire." (Matthew 3:10), that "The kingdom of heaven is like a man who sowed *beautiful* seed in his field" (Matthew 13:24). Jesus says, "I am the *beautiful* shepherd. The *beautiful* shepherd lays down his life for the sheep" (John 10:11). And Paul writes, "Let us not become weary in doing *beautiful,* for at the proper time we will reap a harvest if we do not give up."

(Galatians 6:9). Since the Bible is permeated with this rich, aesthetic, moral, and joy-bringing word, a narrowing of our study is necessary. In this essay we will try to limit our meditation to good as it is used to describe God.

We find this word applied to God in at least three ways. The first application is in *creation* by God making us in His image, giving us souls and placing us in a beautiful garden. Second, in *redemption,* since God was not obligated to show us mercy after we, through Adam, rebelled against the Creator's goodness (as He hadn't shown any to the angels who rebelled). And third, God's *providence* displays His goodness. As J.I. Packer points out in *Knowing God,* God is "good to all in some ways and to some in all ways."

In addition to God's goodness being something He does or pronounces, the Bible also teaches that goodness is an essential part of His being. When Moses asked to see God's glory, we find that His glory *is* His goodness:

> And the LORD said, "I will cause all my goodness to pass in front of you, and I will proclaim my name, the LORD, in your presence. I will have mercy on whom I will have mercy, and I will have compassion on whom I will have compassion."[5]

We also see in God's response that justice is integral to His goodness when God tells of His right to show mercy as He chooses. The act of showing mercy requires the presence of actions that justify punishment. Any permitting of the twisting of good to be evil without consequences issuing from God would impune His goodness. Goodness must hate evil and therefore punish evil. Because sin is evil, God's goodness is shown in His just punishment of evil actions. If God did not show justice and punish evil then He could not be good.

God's goodness isn't restricted to the lofty and heady realms of glory and justice. His goodness is evident in many ordinary ways. His common grace extends to every sphere of life and reaches all of our senses—the crunch of leaves during a walk on a crisp fall day, the tang from the first sip of a robust cabernet, the initial peek at waves through dune grasses, the whiff of chocolate chip cookies cooling in the kitchen, the crush of a black velvet dress on a starlit night, the song of a bird on a winter morning, the warmth of mashed potatoes with gravy, the curve of a new mother's breast, the fragrance from a bank of honeysuckle in bloom, the pudgy cheeks of a toddler—all of these things betray God's righteous hedonism and romp under the umbrella of His ultimate goodness as a covenant-keeping King. This entire book could be devoted to describing His glorious goodness and it would not even begin to scratch the surface.

Our God is perfectly, immutably, essentially, primarily and necessarily good. As the infinite and unchanging initiator of good, goodness is inseparable from His nature. Certainly this divine attribute deserves our attention, reflection, and devotion to understanding it more and our energies spent in portraying it as a theme in our art.

"I'M NOT BAD. I'M JUST DRAWN THAT WAY."[6]

Good is not portrayed well due to a general misunderstanding of what the word really means. We make good the equivalent of "nice try" when we say a child has done good when they have merely put forth effort. And usually "nice" or "sweet" are presented as synonyms of good. This is where we begin to see our collective understanding of the biblical concept of good begin to break down. A nice or sweet God would not destroy every living creature (except those who could fit on one boat), in a worldwide cataclysmic flood. So we find that we all have a misunderstanding of the word, resulting from a distortion of true goodness observable in the world around us.

Perhaps an analogy would help to illustrate the extent to which we don't understand what good means. Imagine a conversation between a fish and a turtle. Both creatures would be able to discuss the idea of *land* but the turtle would have a very different understanding of the concept due to his experience which includes the idea of *dry* dirt, a worldview which would be in contrast to the fish's experience of only *wet* dirt. We use the word *good* and believe that we understand it, but like the fish's understanding of dirt, having only experienced a post-Fall type of goodness in our unregenerate state, our comprehension of good is *bent*.

In C.S. Lewis's *Out of the Silent Planet*, a philologist from Cambridge goes to Mars where he meets creatures who don't have the word *bad* in their vocabulary. So the protagonist uses the word *bent*, a visual term, in order to describe "bad." Then toward the end of the story, Lucifer is referred to as "the Bent One" during a discussion of Lucifer's rebellion against God. Using the word *bent* to describe the situation we experience in the world around us is helpful because we know from Paul's letter to the Romans that creation is groaning under the burden of the Fall, and yet it is not completely perverse because we are still able to see God's goodness as we look into His handiwork. Furthermore, we can still find the image of God in the faces of mankind in spite of the thoroughness of our depravity.

With a restored relationship with the good God, the follower of Christ has the potential of having a greater insight into the true nature of goodness than someone who does not follow Christ. The Christian worldview has the ability to address the issues of a bent world with a message of redemption, hope, and goodness. But the believer's efforts to portray goodness in art can possibly run into problems, even if a truly Christian worldview is utilized, because the Christian cannot control or determine the perception or reception of the art itself. Frequently goodness may be misunderstood or simply not even perceived. This wrong perception is due to living an entire life in a bent world. In other words, when we view and create art we are not able to escape the fallen world we live in. We can neither rise above it, nor go around it. We are bound to it. It pervades everything we think and do. There is a communication problem when trying to portray a proper understanding of good to those whose catalog of images and experiences is thoroughly bent.

The assertion that a believer has the potential for greater insight into the true nature of goodness does not imply a moral or intellectual superiority. As experience shows, believers do not necessarily live out an understanding of goodness better than nonbelievers. No, the good news of Christ boldly asserts that it is the mercy of God and His grace alone that gives followers of Christ new hearts and a sensitivity to the Spirit. And then it is only as we resist conforming to the world's mold and instead are transformed by the renewing of our minds that we are able to *begin* to understand true goodness.

Once *in Christ* the believer is a new creation and God begins the process of remaking so that ultimately the follower of Christ will be in the situations like the turtle with the fish, where true understanding of the former's condition is simply beyond the latter's experience. As believers making art, one part of God's redemptive story we can share with the world is the idea of 'good.' But where do we go for an understanding of 'good' that we can use to begin building bridges across the many chasms of misconception that we must confront?

A GOOD FOUNDATION

The first thing required of Christ's followers when engaging the concept of *good* is that we look to God for insight because goodness is one of His attributes. Of course, because it is a perfect attribute of an infinite Creator and we are only finite creatures, a complete grasp of *good* is beyond our reach, but though we can't know goodness fully, we can know it truly if the Creator reveals it to us.

The almighty, infinite and personal God has revealed Himself through Scripture so it is to Scripture we must turn. If we are to even attempt to communicate good in our art we must push out beyond our bent understanding of it and draw from the depths of God's character. By using the means of grace—those things that God uses to strengthen our faith—made available to us, we can begin building the spiritual and philosophical foundation required for greater insights and discovery about good during the creative process.

To begin "unbending" our understanding of *good* we must read, meditate on, and receive through preaching God's holy Word. It is not the believers' goal to integrate their art with the Faith, rather the art of God's chosen people must spring from faith. And for that real kind of art to bubble forth, the spring of Living Water needs to be cultivated in our lives. We need to soak in its depths, but when we study Scripture, we must approach God's Word mindful that, because of the Fall, we often read the Bible through filters. Max H. Bazerman, a professor of business administration at Harvard Business School has described a phenomenon called "bounded awareness." Bounded awareness is the tendency to fail to see critical information in our environment due to being overly focused on some concept or task.[7] Protestant theologian A.D. Bauer has observed that Christians often experience bounded awareness when they perform their spiritual tasks. He says that this leads to Bible reading where all difficult

elements in the text are filtered out by a reader who is so aware of what he already knows about the text that he is not even aware that he has ignored or altered what he has read. This also occurs when theologians and preachers impose their set of filters that lead to the preaching and teaching of a concept of "good" that is not truly good.

In addition to Scripture study, other means of grace available to us for mining the depths of God are fellowship, prayer, and the sacraments. We learn about God when we spend time with the body of Christ and when we tell others of the amazing grace offered through Jesus. We need to practice *good* to understand more about it. When meditating on the attributes of God such as His goodness during the good work of giving, serving others, and sacrificial fasting, God is often generous in revealing aspects of His person. And when we focus on the person of Christ and His deity during prayer and worship, He helps us understand more adequately the attributes of God, including goodness.

By applying these means of grace in our lives, under the supervision of the Spirit, we can grow in our sanctification, becoming the new creatures that we already are in God's eyes in Christ. Only through "unbending" can we begin to really see things—such as goodness—as they truly are. It is at this point, after the foundation has been laid by the means of grace, that we learn something new of God. We can add the dimension of that insight to our palette, opening up the possibility of discovering much more in the process of creating art that flows from faith. Each of us must

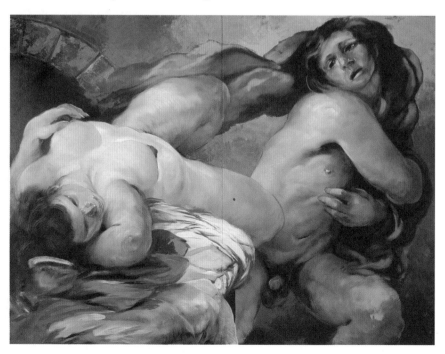

EDWARD KNIPPERS. *Potiphar's Wife*, 1998 Oil on panel, 96 x 144 inches.

wrestle with what scriptural goodness is and expand our knowledge of true goodness when attempting to portray it in art.

MAKING GOOD ART

Speaking to the issue of the portrayal of goodness in art, Knippers insisted, "Goodness needs to be attached to the real world because if you separate it from reality what you are left with is Disney World." The believer's art should be rooted in the rich soil of believing that humanity is far worse off than we think and God's grace extends far beyond what we can imagine. It is in this understanding and not the two-dimensional, sweet, niceness of Snow White that we can produce good fruit that is rich in the fullness of our humanity.

Yet even after all of this reflection on the definition of *good,* the arduous task of crafting good art still remains. So what do we make?

Portraying *good* can be approached from many angles. Moral goodness can be portrayed strikingly as in Knippers' work *Potiphar's Wife.* The painting graphically presents the viewer with a clear moral dilemma. Joseph is tempted by his employer's wife to go to bed with her and it is that moment of temptation that Knippers shows us goodness. We see in Joseph's response to the seductions of Potiphar's wife, good burning through corrupt advances. Knippers says that one man who saw this painting declared that Joseph was crazy—he would have taken her up on the offer. And in this way we see Knippers' painting working, because it shows a goodness that goes beyond conventional wisdom.

As discussed earlier, we see the goodness of God displayed in His creation,

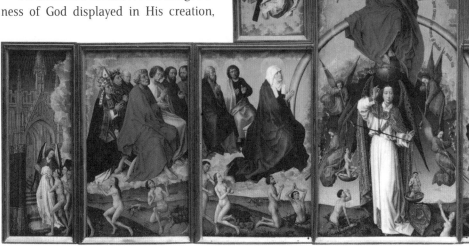

ROGIER VAN DER WEYDEN. *Last Judgement Altarpiece,* (interior), c. 1450.
Oil on panel, partially transferred on canvas. 88 5/8 x 215 inches.

redemption, and providence. For our reflection here on portraying good in art, we will focus on these three aspects. An example of the portrayal of goodness in *creation* can be seen in Peter Mollenkof's drawings. His work straddles abstraction and representation to demonstrate a sense of transcendence in the physical world. In *Largess* we see an organic shape floating on a pure white field, reminiscent of the unseen beauty of God's creation that one might find drifting through a Jacques Cousteau deepsea special or in a series of photos on microscopic pond vegetation in *National Geographic*. The aquatic orb of undulating color is something you have seen before and have never seen before. As you engage with the work there is an intuitive knowing that occurs—a *déjà vu* of goodness. And the title underscores this sensation as it alludes to the bountiful generosity of God in how He bestows good gifts. These biological gifts overlfow from the overabundant goodness of God and are busy bringing glory to God while most people are completely unaware that they even exist.

Goodness in *redemption* can be found in Rogier van der Weyden's *Last Judgment*, designed in the 1450s for the Hôtel-Dieu, a medieval hospital in Beaune, France. In it the artist draws very clear distinctions between the consequences of good and evildoing. One of the best examples in this genre, *The Last Judgment* is a fifteen panel altarpiece (a *polyptych*) that many consider one of the greatest compositional and technical masterpieces from the golden age of Flemish painting. When open, the restrained, monochromatic palette of the exterior panels gives way to a riot of carefully balanced colors. Christ, the Ruler of All, sits on a rainbow throne, symbolizing God's covenant with the world after the Flood. Christ is flanked by the prominent, enlarged figures of the virgin Mary on His right and His cousin John the Baptist, on His left. A lily from the annunciation on the outside of the polyptych now issues from Christ's right hand, the saving hand, in mercy to His

chosen, while a sword of fire hovers over His left hand, the judging hand. A *spruchband,* or scroll of words, springs from Christ, invoking the biblical Word that invites the blessed to inherit the kingdom prepared from the beginning of time for them, and ordering the cursed to enter the everlasting fire prepared for Lucifer and his supporters.

The Apostles, headed by Peter and Paul, flank the central figures, all floating within a nimbus of glorious gilded clouds that seem to explode into the earthly landscape below. A sampling of the Community of Saints,

with Pope Eugene IV and the local civic leaders seated conspicuously in the back row, matches figures representing women on Christ's left side. Below Jesus, four angels sound trumpets, apparently loud enough to wake the dead, while the archangel Michael, set apart by his size and his peacock-feathered wings, holds a scale in which sins (*peccata*) and good deeds (*virtutes*) are weighed.

On Sundays or feast days, the fully opened altarpiece reminded its audience that two eternal options awaited them. The virtuous chosen few are welcomed into a golden gothic Glory, while the sinful despairing damned descend into Hell. Reconciling this inescapable depiction of damnation with the understanding that God is ultimately good seems impossible unless one accepts the fact, discussed earlier, good cannot tolerate evil.

Although this work clearly intends to communicate the idea that the obedient go to heaven and the disobedient go to hell, limiting the composition's meaning to simplistic equations (e.g., 'good=heaven' and 'bad=hell') does the magnificent piece a disservice. Designed for medieval patients and caretaking nuns who face the mystery and fear of death daily, van der Weyden's composition seems to emphasize the restoration of relationships literally under Christ. For instance, the flowing garments of Mary and John point to a couple on either side of the polyptych. On John's side, following those who reject Christ and are bent on their own destruction and eager to drag others down with them, there is a couple striking a pose reminiscent of the Expulsion of Adam and Eve, making one last desperate gesture, belatedly invoking Christ's mercy. On Mary's side, mirroring the fallen couple, rises a renewed Adam and Eve. They look to Christ for their salvation, and experience beneficial reverberations from the goodness of Redemption. Clearly, they model a restored relationship, symbolized by the man's loving attention to his wife, who he helps up. In a heartbeat, this detail displays real intimacy and tenderness—a lovely vignette of the goodness of the good gift of marriage.

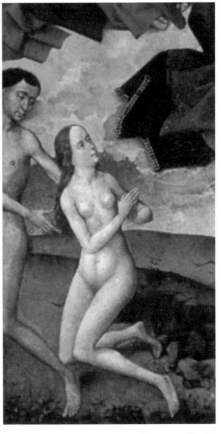

Last Judgement Altarpiece, (detail)

Certainly the altarpiece depicts the dead rising on the Last Day, but seen as a visual essay on the goodness of restored relationships, it extends to a consideration of the Christian life. Under the watchful gaze of a great cloud of witnesses and angels who trust in the work of Christ—symbolized in shorthand by the instruments of the Passion brandished by four angels above Christ's head—people continue to make choices for good and for evil, and reap the consequences. As some enter Heaven on the right of the altarpiece, others are just beginning to get on their way. They anticipate the shining hope of Heaven but also the hope of restoration beginning to operate on this side of Glory. Sadly, the other side of this reality is darkly mirrored under Christ's left hand. These souls are already beyond salvation, and have become virtual islands of isolation and torment, frantically tearing and dragging each other down into Hell in a dark inversion of Christian community. God is gone, God's beautiful creation is gone, and all that is left are pitiful souls doomed to flail and founder in the dark consequences of their own evil choices. Unbelievably, in this realm, all good is gone.

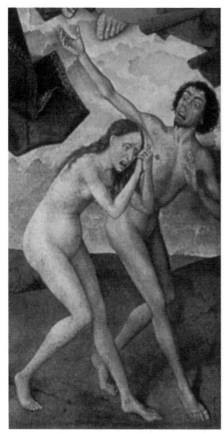

Last Judgement Altarpiece, (detail)

In *Taste and See,* Ted Prescott presents the concept of the *providential* goodness of God. The title springs from Psalm 34:8a: "Taste and see that the Lord is good." This psalm is a record of David praising God irrespective of his circumstances, but Prescott's piece looks as if it could pre-date the psalmist by several hundred years. It has a rough-hewn simplicity that feels like it was crafted by Bezalel during the Exodus wanderings. One can imagine seeing a series of these set up around the camp of the Israelites as reminders to God's chosen people to reflect on His goodness in their everyday lives.

In this sculpture a hand-blown glass bowl filled with honey and nestled in white marble has been placed on a wood frame. When the piece is exhibited in an open setting people stop and taste the honey, giving the piece a sacramental dimension. Though a bit messy, this reminds us that God's goodness is not just abstract, but it is also sensual. *Taste and See* brings God close

to us when we might feel distant from Him.

The use of honey in the piece can also direct the audience to Psalm 19 where we read that God's law is sweeter than honey and more desired than gold and silver. The honey used in this sculpture is Tupelo honey, one of the most expensive honeys to produce. The flavor is delicate and distinctive and it will never crystallize due to its high fructose content. The nature of this particular kind of honey further develops the concept of God's goodness. That the honey remains a liquid gives a timeless sense to the piece.

THEODORE PRESCOTT. *Taste and See.* 1996-97. Colorado Yule marble, butternut wood, hand blown glass, Tupelo honey, 28 x 11 1/2 x 34 3/4 inches.

The three-dimensionality of Prescott's piece brings God's goodness into real space, encouraging the viewers to "see" with all of their senses. This seeing brings to mind the account of Jesus offering to Thomas the opportunity to "see" through touch. Thomas had insisted on placing his fingers in the wounds of Christ before he'd believe in the resurrection. Then when Jesus reappeared to the disciples, Thomas was told by our Lord to "Reach out your hand and put it into my side. Stop doubting and believe." *Taste and See* is not didactic, but evokes the kind of delight we have when we experience something that is good, beautiful and true.

Echoing the psalmist's command to experience God's goodness, Prescott's sculpture teaches us that God's goodness can be experienced and—significantly for the purposes of this essay—that goodness can be *portrayed*. And here is an advantage of portraying good instead of evil. Though difficult, the portrayal of good is a portrayal of *something*. As C.S. Lewis wrote:

> [E]vil is not a real thing at all, like God. It is simply good spoiled. That is why I say there can be good without evil, but no evil without good ... Evil is a parasite. It is there only because good is there for it to spoil and confuse.[8]

This is not to say that evil must be avoided in art but that, unlike goodness, it can not be an artist's steady diet if he is a follower of Christ.

AND YOU WILL SEE MY BACK

Although goodness provides us with a glorious *something* to portray in our art—rather than the parasitic nothingness of evil—this does not make goodness something we can set on a table with a bowl of fruit and paint. Even as a central theme in a work of art, good needs to be something we see out of the corner of our eye. Gregory Wolfe alludes to this idea when discussing the wonderful films of Wim Wenders:

> For someone like Wenders, the frontal approach is doomed to failure: better to refract the ancient story in oblique ways through contemporary narratives that give us situations and characters to which we can relate. The invisible reality of faith is something best made visible when it haunts the edges of our consciousness and memory.[9]

The indirect approach to goodness is even seen in the direct engagement with good that Moses experiences when he sees God's glory. A few verses after God has told Moses that he will cause His goodness to pass in front of the Prophet He says:

> "You cannot see my face, for no one may see me and live." Then the LORD said, "There is a place near me where you may stand on a rock. When my

glory passes by, I will put you in a cleft in the rock and cover you with my hand until I have passed by. Then I will remove my hand and you will see my back; but my face must not be seen."[10]

Moses would have died if he had had a direct experience with the full goodness of God. Even catching a glimpse caused him to glow like Las Vegas.

This is not to suggest that an oblique portrayal of good is the eleventh commandment. Rather, I found while trying to work through the ideas in this chapter in my own work that a peripheral portrayal of good is more manageable. Manageable, that is, but not easy. As asserted at the beginning of this essay, portraying good with any precision is excruciatingly difficult. In fact, so difficult that I knew I should not try it at home by myself. Therefore I enlisted the help of another artist, Matthew Clark, and we collaborated on a series of woodcuts about good.

In one of these woodcuts, *And Such Were You,* we sought to display God's goodness in preservation by depicting Noah's ark in rather dire straits. A sea serpent circles while waves and lightning bear down on the small craft. To portray goodness most clearly required not a shiny happy boat, but a weak, failing vessel plunged in darkness with no hope in sight. For it is in the darkest of times that we see God's hand the clearest. David Wilcox sang about this one evening at the Art House:

If someone wrote a play
Just to glorify what's stronger than hate
Would they not arrange the stage
To look as if the hero came too late
That he's almost in defeat
So it's looking like the evil side will win
So on the edge of every seat
From the moment that the whole thing begins[11]

But even though all looks lost for the wee ark, we know that the vessel and its passengers make it through in the end. In *The City of God,* Augustine describes the ark as a symbol of the Church and the flood as a symbol of this wicked world. Augustine saw the dimensions of the ark as a symbol for the body of Christ and the door as the wound in Christ's side where he was pierced with a spear. From this wound flowed the blood and water—the means of grace for us that are found in the sacraments of Baptism and the Lord's Supper.

A crucial aspect of God's goodness to us in creation, preservation, and redemption is the unworthiness of the object of His benevolence. The animals on the ark in *And Such Were You* are not the cute, innocent animals found in a Noah's Ark playset. According to their traditional symbolic meanings in Christian art, these animals are all evil animals: the bear (evil influence), the cat (laziness),

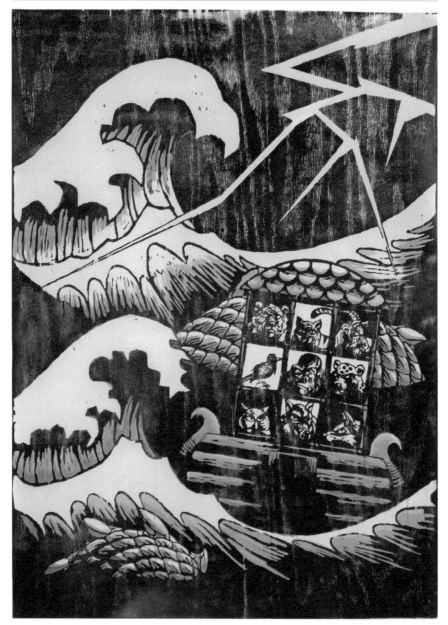

NED BUSTARD and MATTHEW CLARK. *And Such Were You,* 2006. Tinted woodcut, 22 × 30 inches.

the goat (the damned), the blackbird (temptation of the flesh), the ape (malice), the leopard (cruelty), the owl (deception), the hog (gluttony) and the fox (guile). The passengers on the ark that God chooses to save are undeserving. And so are we.

The title for the piece comes from 1 Corinthians 6:9-11:

> Do you not know that the wicked will not inherit the kingdom of God? Do not
> be deceived: Neither the sexually immoral nor idolaters nor adulterers nor
> male prostitutes nor homosexual offenders nor thieves nor the greedy nor
> drunkards nor slanderers nor swindlers will inherit the kingdom of God. And
> that is what some of you were. But you were washed, you were sanctified, you
> were justified in the name of the Lord Jesus Christ and by the Spirit of our God.

Good may be mercurial to represent in regards to the Almighty, but His acts
of goodness in creation, redemption, and providence can be seen as clearly as we
see the path of the wind through the trees. And as close to our experience as our
very souls—God has washed, sanctified and justified *the likes of us.*

LET US NOT BECOME WEARY IN DOING GOOD

The challenge to portray the glory of God's goodness in our art should be
embraced, because it is the philosophical life raft people need; it is the new, unbent
language people must learn to speak. The more we focus on *good*, the more we reveal
who God is—that God *is* good—and provide a vocabulary of grace to those who lack
it. But we should not attempt to portray *good* as a concept or theme in our artwork
merely as a pre-evangelistic tool. Think back to the creation of all that is and remem-
ber that God made light and called it good before it was useful and before it could be
looked to by mankind as a picture of God's invisible attributes. The universe was
brought into being as an act of goodness. "It was good," and therefore it gave glory to
God. As followers of Jesus we also need to focus on bringing glory to God. It is what
we were made for, and it is a pursuit we can enjoy forever. Of course, forever has
already begun. Therefore we should seek to bring glory to God through making
artwork that reflects, alludes to, and glories in the beautiful good.

Endnotes
1 Carey Anne Bustard (age 5), in response to the question, "Tell me something about *good.*"
2 Randall Balmer, "The Kinkade Crusade" *Christianity Today* (2000).
3 Stuart McAllister, "What is Good and Who Says?" Ravi Zacharias International Ministries *Just
 Thinking* newsletter (1998).
4 Charlie Peacock, *At the Crossroads: An Insider's Look at The Past, Present, and Future of
 Contemporary Christian Music* (B&H Publishing Group, March 1999).
5 Exodus 33:19.
6 Jessica Rabbit, "Who Framed Roger Rabbit" (1988).
7 A.D. Bauer.
8 C.S. Lewis, *The Letters of C. S. Lewis to Arthur Greeves*
9 Gregory Wolfe, "Picturing the Passion" *Image: A Journal of Arts and Religion* #41, page 4.
10 Exodus 33:20-23.
11 David Wilcox, "Show the Way," *Live Songs and Stories* (2002).

BEAUTY
Transfigured

Beauty is back. It's official. Ever since art critic Peter Schjeldahl suggested it in the *New York Times* ten years ago, artists, critics and philosophers have embraced the term and fallen in love with it again.[1] The "B-word," as one critic referred to it, can be safely used again without the speaker having to apologize or blush.[2] This, of course, has not always been so. For most of the 20th century, art and beauty had been carefully segregated. Beauty was associated with the sweet and the shallow and the social status quo. It had, by definition, no bite, no critical edge, no "truth." If, as an art student, you were unlucky enough to have your work referred to by your teacher as "beautiful," you had to be careful. This was not to be taken as a compliment. It had as subtext the silent addition: "*but . . .*" Art was supposed to be challenging, authentic, bold, daring, subversive and, if at all possible, shocking. It was to confront the establishment. Art should question prevailing norms and values and, in doing so, suggest new ways of living our lives.

This, of course, put a great burden on art. After all, you can shock only so much and only so often. The effect gradually wears off. People become immune and no longer react with the same vigour as they might have done the first time. Different strategies were needed. After the *"Shock of the New"*—the title of Robert Hughes' book on modern art—we had the "shock of the old"—Charles Jenck's term for the retro- and neo-styles of post-modern art and architecture. However, even that novelty began to wear off.

Whether old or new, however, the pursuit of shock did not include beauty. Beauty continued to be seen as belonging to the 19th century world of such bourgeois values as respectability and decorum. Modern art, from Manet and Picasso

to Duchamps and Barbara Kruger was supposed to challenge all that. As Barnett Newman put it succinctly in 1948: "The impulse of modern art is the desire to destroy beauty."[3]

This has changed. The term "beauty" no longer carries with it an inherently negative connotation. It is again permissible, indeed fashionable, to include it in one's discourse.

The change happened in the early 90's. All of a sudden the academic world buzzed with the "beauty" word and it has not stopped ever since. Art critics David Hickey and Peter Schjeldahl, philosopher Arthur Danto and English professors Elaine Scarry and Wendy Steiner, to name but a few, all wrote significant essays and books addressing the issue.[4]

Curators picked up the trend. At the turn of the millennium, the Hirshhorn Museum and Sculpture Garden in Washington D. C. staged a widely publicized exhibition entitled *Regarding Beauty: A View of the Late 20th Century,* showing eighty-plus works by more than thirty artists since 1950.[5] Its intention was to initiate a discussion about the nature of beauty by displaying works which were either themselves considered to be beautiful or which referred, either positively or critically, to works which were traditionally so regarded. It addressed such issues as body image and the gaze, and the relationship between human and natural beauty.

Most works, such as Italian *Arte Povera* artist Michelangelo Pistoletto's *Venus of the Rags* (1967), would not pretend to promote beauty or be itself beautiful but instead would aim to question and critique traditional notions of (classical) beauty. Consisting of a plaster cast sculpture turning to a huge pile of dirty rags and clothes, Pistoletto's *Venus* is supposed to turn away from her ancient past and face a future in which, as the publicity put it, "conventional standards for making and assessing art are less certain." To the extent that much art in the exhibition was concerned with commenting on its own history and significance, *Regarding Beauty* was still considerably modern and conceptual. However, notwithstanding its somewhat theoretical and didactic tone, the fact that the issue of beauty was again considered a legitimate subject worthy of serious consideration at all was a major breakthrough. After decades of conceptual art and anti-aesthetic theory, the question of aesthetics and beauty was at least back on the table.

To show the shift in focus, it is worth recalling another widely publicized exhibition at the Brooklyn Museum in New York, taking place at exactly the same time. This was the exhibition *Sensation,* showing the Saatchi collection of young Brit' art heralded to be at the cutting edge of the international art scene.[6] Although the works shown in the exhibition were not in fact either more radical or more shocking than might have been seen in any European or North American avant-garde gallery throughout the 20th century, the show was deliberately billed as provocative and "sensational," thereby hoping to attract wide publicity and high attendance figures, something urgently needed by the floundering financial status of the

MICHELANGELO PISTOLETTO. *Venus of the Rags.* 1933. Plaster and fabric, 70 7/8 x 78 3/4 x 47 1/4 inches. *Hirshhorn Museum and Sculpture Garden, Smithsonian Institution, Joseph H. Hirshhorn Bequest Fund, 1999. Lee Stalsworth, photographer.*

museum. The plan worked out as conceived. Senate candidate Mayor Giuliano's well timed protest over the elephant dung, and the almost unnoticeable, minute cutouts from pornographic magazines, employed by Chris Ofili to complete his portrayal of the Virgin Mary, became front page news and were hotly debated for weeks to come. Not since the Dada-movement had there been so much discussion about censorship, human rights and freedom of expression and the role or even the obligaton of art, to shake up the status-quo. As such the show's underlying philosophy followed the classic modernist manifesto to the letter: art should rock the establishment boat. Even if one might have wanted to refer to some of the works as "beautiful"—and, ironically, unlike *Regarding Beauty,* this show did in fact contain some pieces which might be considered serious candidates, this was certainly not part of the intentions of the curators. If there were to be any beauty in any of the works, as there arguably was in an ethnic, folkloric sort of way in Ofili's painting, it was to be in the service of shock, that is in the gradual realisation that what one had initially appreciated for its innocent decorative quality—and would not have minded over one's sofa at home—turned out, on second inspection, to be a vicious and offensive attack on the Catholic church. Or so, at least, it was perceived.

In some ways one might consider these two exhibitions as two symbols of the old and the new: *Sensation* being the last gasp of the modernist belief in art as agent of social confrontation and change, while *Regarding Beauty* heralding the beginning of a renewed focus on beauty and "aesthetic" experience. Beauty lost and beauty re-gained.

CONFUSION

Having said that, if there was one thing clear from *Regarding Beauty* it was this: nobody had a clue anymore what the word exactly meant. While most seem to have agreed that we can safely use the word beauty again, few seem to have any confidence that we know what it means.. As it operates in contemporary discourse, the term is again wide open for discussion. Clearly, no one had in mind a nostalgic return to a pre-modern or classical notion.

In his recent book *History of Beauty* Umberto Eco presents us with an impressive overview of ideals of beauty since ancient Greece. The survey laudably extends beyond beauty in art to cover beauty in nature, in man-made objects and, of course, in the human body. Eco covers Apollonian and Dionysian beauty, beauty as proportion and harmony, Romantic beauty, the beauty of light, monsters, machines, recycled materials and even of consumption and waste. Yet, when he comes to the end of his hefty tome, there is no suggestion that there is anything that might possibly join all these widely differing notions and experiences

REMBRANDT VAN RIJN. *The Return of the Prodigal Son* (detail). 1669. Oil on canvas, 81 x 103 inches.

together. On the contrary, Eco concludes that, when it comes to the 20th century, any objective observer will have "to surrender before the orgy of tolerance, the total syncretism and the absolute and unstoppable polytheism of Beauty."[7] Although this may well be descriptively true, it is hardly a satisfactory situation. When we communicate with each other, we want to be able to know what the words we use mean.

In one of the lectures accompanying the exhibition, well-known art critic, philosopher of art, and author of such seminal books as *The Transfiguration of the Commonplace* and *After the End of Art*, Arthur Danto perfectly illustrated the state of affairs. Unwilling to commit himself to any definition of beauty, he resorted instead to showing pictures and pointing at them saying, "this is beautiful" or "that is lacking in beauty." Needless to say, this led to some heated debate in the discussion time afterwards. By what criteria had he considered that building, body or painting beautiful and the other not? Feminists quickly pointed out that his judgments of female beauty were informed by white male biases. They also raised the fact that, in contrast to the sublime, which is linked to the grand and the impressive, the beautiful has historically been linked to the petite and to other putatively feminine qualities. Others raised similar points regarding class, race and ability/disability. Conceptions and standards of beauty, so we are reminded, are always determined by our social status and cultural values.

At the other end of the debate we find the socio-biologists. Following Edward O. Wilson's seminal *Sociobiology: A New Synthesis*, authors such as Brett Cooke, Frederik Turner and Jan Baptist Bedaux argue that the phenomenon of beauty is a universal feature of life, a genetic and biological given, which plays a significant role not only in natural but also, and predominantly so, in sexual selection.[8] We are told that, throughout evolutionary history, humans tend to be predominantly attracted to those kinds of features in members of the opposite sex, which, in their view, signal vitality and fertility. Conversely, people will go to great lengths to beautify themselves in order to attract suitable partners, guaranteeing, they hope, the necessary offspring for the survival of their species. Likewise, people tend to be more attracted to landscapes scenes, which combine land with lakes, rivers or coastlines than those without. These, arguably, are beneficial for their biological health and well-being and thus for the survival of the species as a whole.

Needless to say, we have entered a complex interdisciplinary web of theories and views. The humanities and social sciences as well as the natural and life sciences all seem to want to enter the conversation as a result of their new discovery of the importance of beauty in nature, animal and human life.

CHRISTIAN RESPONSES

So where in this jungle of views and opinions should Christians position themselves? What kind of contribution might we want to offer to this debate?

Of course, a large proportion of Christians will have been blissfully unaware

of beauty's absence from the art scene over the last century. For them paintings and music have never been anything else than a striving for beauty, whether in terms of the sanguine pictures of Warner Sallman or the sublimity of Bach's *Hohe Messe*. To raise the question of beauty in their company is merely stating the obvious. What else could art be about?

Even so, inviting Christians to define more exactly what the notion of beauty for them means will raise the same type of questions brought to the fore in the wider public debates just reviewed. It will likely also expose some underlying tensions, which have beset Christian thinking about the arts for most of its history.

Christian thinking in general, and about the arts and beauty in particular, has always been ambiguous about the physical, sensuous side of reality. Already in the second and third century Christians were divided about the question whether earthly beauty should be considered a curse or a blessing. Second century church fater Tertullian considered beauty—often linked to female beauty!—to be an evil planted by the devil to seduce and distract us from higher things. Third century neo-platonic philosopher Plotinus, by contrast, saw it as precisely the opposite: a gift of the spirit and a manifestation of divine beauty meant to lead us on to a higher reality.

Of course, Tertullian is right in some respect. One ought not to judge persons by their outward, physical appearance. Personal beauty has an internal quality, related to someone's character and so on. However, Tertullian's stance reflects a deeper unease, which applies to physical appearances in general. This unease is rooted in a denigration of physical reality as such, often referred to as 'the world.' Many Christians believe that there is a biblical injunction for such an other- and anti-worldly stance which is based on John's admonition that "we do not belong to this world" (John 15:19) and therefore ought "not to love the world and anything in it" (1 John 2:15). Prior to John, the Greek philosopher Plato taught what seemed to amount to the same sentiment. Plato is widely known for dividing the world up into a realm of visible, sensuous things and a realm which could only be known by the mind or the intellect. This latter realm, the world of "ideas" or "forms," was considered more "real" than the world of sense-experience, which was seen as only a shadow or faint image of the real thing. In contrast to the world of visible phenomena, which Plato considered to be always changing, flawed and deceptive, this other higher world was perfect, timeless and true. It provided the model for the other world, which was merely an imperfect copy of it. Plato's myth of the cave is about the awakening of people to the fact that the world they live in is in fact a copy world and that there is another, real world somewhere else—a theme echoed in the film *The Matrix*. Because Plato believed that the original forms or "ideas" in the non-physical world really exist and indeed are even more real than the world we live in, he has been called both an "idealist" (because of his emphasis on ideas rather than actual things) and a "realist" (because of his belief that ideas have independent existence and are not just thoughts in someone's mind).

When it comes to images in paintings, therefore, we can now see why Plato is so negative about art. Not only are images deceptive in their illusionary effects—as, for instance, in perspective drawings—they are merely images of images or copies of copies of the real world. Why would anyone want to bother with those?

Yet, although Plato held a low view of art, he nevertheless had a very high view of beauty. Earthly beauty was considered to be both a reminder of and a pointer to spiritual beauty—to heavenly Being. Perhaps it is not difficult to see how the early Christians would take some of these Platonic Greek insights and incorporate these into their own understanding of John's biblical teaching. Both seemed to point to a similar view: that one should look at the transient beauty of this world with a view to rising above it towards a higher, more perfect and more permanent reality.

ONE WORLD

It is at this point that we need to clarify an important point: unlike Plato's dialogues, the Hebrew Scriptures do not teach a doctrine of two worlds. They posit one. We have one Creator and one world created by this one God. Equally important, this world was originally created good. Yet Christians with remarkable persistence speak as if there are two worlds and proceed to describe these in terms of a lower realm of physicality, sensibility, particularity, temporality, imperfection and so on, and a higher realm of immateriality, invisibility, ideality, eternity, perfection, etc. On this model, the lower realm always needs to be transcended in order to reach the higher. This dualism is, at root, a rejection of the true God as He has revealed Himself in Scripture—the Creator of one good, multifaceted world. It denigrates the physical, material, embodied world over against a supposed parallel non-physical, non-sensuous world of perfect ideas and forms.

So when the bible uses the Greek term "kosmos" (as in "cosmetics") for world, this can apply either to its fallen state—as in the "do not love the world" of 1 John 2:15—or to the world as the product of God's handiwork, his "ornament." In Ps. 50:12, for instance, God proclaims that "the world is mine and all that is in it," and in John 3:16 God declares his own deep seated love for this world to the point that he is prepared to give his only Son for it.

If we want to start thinking biblically about the notion of beauty we must therefore abandon this conception of a two-tier world in which earthly beauty is either a mere shadow of or a pointer to another, higher world of capital B Beauty. Beauty, whatever we may eventually decide it means, is an integral feature of the one world created by God and deserves to be honoured exactly as such.

THE BEAUTY OF GOD?

Another deep-seated conviction in the history of Christian thought is the idea that God Himself is beautiful. By the time of Bonaventure, around 1250, God was not only considered to be the source of all beauty, He was considered to be beautiful

Himself. Beauty was considered to be one of the essential attributes or transcendentals of God. For Bonaventure beauty even topped the other three transcendentals—oneness, goodness and truth—so as to unite and reconcile these into a harmonious whole.

But the basis for this thinking was, again, more Greek than Hebrew. The term "beauty" occurs very rarely in Scriptures. More importantly, apart from a very few poetic phrases such as "the beauty of his holiness" (I Chronicles 16:29 and Ps. 29:2) or "the beauty of the Lord," (Ps. 27:4) it never applies to God or Christ himself but only to things, nature and people. In the New Testament the word occurs hardly at all. Indeed, the idea that God would be "beautiful" in any aesthetic sense does not sit easily with the Hebrew sense of God's essentially invisible nature and the fact that we are called to believe that which we have heard but not seen. (John 20:29).

Not only does the Bible itself rarely use the term beauty to describe God, it often warns that beauty can be frivolous, seductive or deceptive. As we saw, this was deeply felt by Tertullian and, in modern times, also by Kierkegaard. We cannot pretend to derive a beauty theology from these few poetic expressions. What seems to have happened is a conflation of the terms "beauty" and "glory," as in the phrase "the glory of the Lord." In contrast to the term beauty, the term "glory" is used repeatedly throughout Scriptures. Significantly, with only one or two' exceptions (when it is applied to the misplaced glory of the nations), the three hundred plus times that the term is used it is always in connection with God or Christ. And, unlike the term "beauty," it is never used in a pejorative sense.

The word "glory" is a translation of the Hebrew *kabod* and the Greek *doxa* (think: "doxology"), which can also be translated as splendour, power and, more generally, worthy of all forms of praise and honour. To talk about God's glory or about giving Him glory is always connected with the way God reveals Himself to us. God manifests Himself in a particular form such as a cloud in His leading of the Israelites through the wilderness (Ex. 16:10; 24:15–18), or in a burning bush in His encounter with Moses (Ex. 33:12–23) or in Jesus' miracle at Cana (John 2:11). Glory often seems associated with a semi-physical display, as in the visions of Ezekiel (Ezek. 1:28) and Isaiah (Is. 6) or in the psalms (Ps. 56:11). Glory can thus be understood as the visible revelation and presence of God on earth. In the New Testament the term similarly refers to the revelation, character and presence of God in the person and work of Christ (Heb.1:3; John 1:14), both at His birth (Luke 2: 9) and His death (1 Cor. 2:9,14), but even more so at his resurrection, ascension, transfiguration and the parousia. Again, it has to do with the Lordship of Christ. This is also reflected in the German and Dutch words for glory—*Herrlichkeit* and *heerlijkheid* respectively, both of which literally mean "lordliness."

In other words, when talking about the glory of the Lord we refer to that aspect of God or Christ which reflects their majesty and lordship over everything that exists. So when Isaiah prophesies that "they shall see the glory of the Lord"

(Is. 35:2) he means that they will see Christ's Lordship displayed. This also explains its use in such verses as "The heavens declare the glory of God" (Ps. 19:1-2) and "Who is this King of glory? The Lord Almighty—he is the King of Glory" (Ps. 24:10).

It seems to me that the conflation of beauty and glory also underlies the work of the German theologian Urs von Balthasar, as can be seen already from the very title of his hefty 7-volume work *Herrlichkeit: Eine Theologische Ästhetik* (translated as "The Glory of the Lord: a Theological Aesthetics"). In other words, he confusingly identifies the biblical term "glory" with an aesthetic category.

Notwithstanding that confusion, von Balthasar nevertheless draws our attention to something important. Observing the arid and unattractive character of most dogmatic theology of his time, he claims that unless we have a deep sense of beauty, not only will dogmatic theology remain bone dry and unconvincing, but we will also lose a proper sense of the good in the world. And, so argues von Balthasar, if the good has lost its attraction, why would man still want to pursue it? Indeed, as he puts it arrestingly: "Why not investigate Satan's depths?"[9] In order to make truth and goodness attractive again, von Balthasar wants to include an "aesthetic" dimension to theology, one which allows for a sensuous, embodied experience of truth and goodness in the visible form of Christ. He deplores the Kantian separation of the true, the good and the beautiful into the three realms of cognition, morality and aesthetics and tries to find ways to re-connect them again. In order to do so, he makes a clear distinction between an aesthetic theology and theological aesthetics. The first version, an aesthetic theology, is linked to a Kantian notion of beauty as an autonomous realm divorced from moral issues and truth. In this "worldly" sense, he claims, the notion of beauty has rightly been rejected both by Protestant and by Catholic thinkers as marginal at best and self-indulgent and deceptive at worst. By contrast, the aesthetic perception and experience as envisaged in a theological aesthetics is a fully integrated experience in which the good and the true are intimately connected. What von Balthasar has in mind here, however, is not primarily beauty in art or nature, but the glory/beauty of God in the form of Christ. This beauty, he argues, is not based on mere outward appearance but on the deeper meaning of the reality of the historical Christ crucified. This also explains the otherwise puzzling prophesy of Isaiah referring to the coming Messiah as "having no beauty to attract us to him" and possessing "nothing in his appearance that we should desire him" (Is. 53:2). Cardinal Joseph Ratzinger (as he then was), comments on this in his message "The Feeling of Things, the Contemplation of Beauty:"

> whoever believes in God, in the God who manifested himself, precisely in the altered appearance of Christ crucified as love "to the end" (John 13:1), knows that beauty is truth and truth is beauty; but in the suffering of

Christ he also learns that the beauty of truth also embraces offence, pain, and even the dark mystery of death, and that this can only be found in accepting the suffering, not in ignoring it.[10]

In other words, the beauty-glory of the resurrected Christ is not rooted in His physical appearance but in His self-sacrificial love, which passes through the ugliness of the cross. It is a beauty which not only embraces the brokenness, and pain of this world but which enables us to see the glory of God through it. For von Balthasar, Christ therefore not only points to the invisible beauty of God, but, as His visible form, is the very apparition and appearance of its mystery.

BEAUTY IN ART AND NATURE

Although this account of the "beauty" of Christ may help us gain a deeper understanding of the meaning of the cross, it does not help us very much with the question of beauty in art or nature. After all, these instances of beauty are essentially rooted in sensuous appearance. Once we have fully accepted the fact that the physicality of the world and of our own bodies is just one among God's many good gifts to us, we can also begin to think more positively about the very notion of appearance, of the way reality impinges on our senses. Contrary to standard opinion, appearances are not by nature deceptive. Instead, they are an indispensable feature of the way things are. They are our first contact with the world. The world reveals itself through the way it can be sensed and felt, by our eyes or ears or by touch or taste. We are not to look for a hidden "essence" behind appearance. At the same time, appearances "appear" differently depending on their context and on our past experiences and future expectations. It is against this larger horizon of lived experience that we will interpret a phenomenon as safe or dangerous, pleasurable or painful, edible or poisonous, attractive or repulsive, large and looming or small and insignificant and so on. There is no neutral perception. The red of a toy fire engine is not the same as that of spilled blood, even if, scientifically, their colors have been given the same name and may seem identical on the lid of a paint can. Outside the world of scientific classification, colors take on a life of their own.

Beauty, likewise, always appears in particular historical and social contexts. It is not the same for everyone at all times. It is always a complex set of factors and considerations which, when seen, evokes from us the exclamation: "How beautiful!"

We cannot point to an objective feature of something beautiful, which can be considered to constitute the kernel of its beauty. As Kant already observed, beauty is indeterminate, yet it expects to receive universal recognition. There are no rules and concepts, which allow us to identify or produce beauty, yet, as Danto also tried to demonstrate, we expect most people to agree with us when we point to something and call it beautiful.

There have, of course, been many attempts throughout history to identify or prescribe certain rules. It was Pythagoras who first discovered that musical intervals and poetic meter could be seen to reflect the mathematically ordered nature of reality as a whole. Thus he asserted that, whether in music or in the cosmos at large, perfect beauty consists of proper measurement, proportion and harmony. Plato and Augustine developed this further, calling beauty and harmony symbols of a universal order. To have no order or form is akin to lacking beauty. Later on, the same principle was articulated in terms of unity in variety: a scene of natural beauty, for instance, contains both rhythmical recurrences of certain shapes and colors—greenish trees, creamy clouds, shady hills, turquoise lakes—but will also have sufficient variation to prevent it being experienced as dull or repetitive. This classical principle still applies to what most people would traditionally describe as a beautiful scene, whether in nature or elsewhere.

With respect to art, however, something else comes into play. Works of art are not the same kind of entity as the things they depict. They are their representations. Unlike mountains, houses or persons, works of art have a symbolic quality: they are created with a view to articulate and convey our understanding of life and the world. Unlike our day-to-day language or science, works of art are

PAUL CÉZANNE. *Le Mont Sainte-Victorie.* 1902–04. Oil on canvas, 27 1/2 x 35 1/4 inches.

uniquely capable of articulating that realm of pre-reflective experience which falls between the cracks of discursive language and abstract thought. It does so primarily by means of sensuous constructs. This also applies to word-based art. Poems and literature draw us into a fictional world of concrete situations, characters and events, which are described in their lively particularity rather than their abstract universality. This creates a world of imagined sensuous, embodied experience.

Beauty, now, is located both in the form and in this symbolic meaning. It does not lie either in an empty formalism, nor in a didactic or moral conceptualism. Instead, it lies in what could arguably be called beauty's most distinctive characterisation: its ability to attract or "be attractive." Beauty, whether in paintings or literature, draws us to itself and invites us to dwell on and behold it. Aquinas already defined beauty as "that which pleases when seen." Elsewhere he claims: "Let that be called beauty, the very perception of which pleases." This pleasure does not have to be "pleasing" in a conventional or confirming way. Something may please because it is striking, or stunning or just plainly intriguing. Beauty invites us to linger on something, to explore the intricacy of its shapes and shades and to ponder its metaphorical associations.

The ugly, by contrast, repels us. More often, unless something is so strikingly ugly that it is labelled "monstrous" or "hideous," it goes unnoticed. We pass by ugly urban scenes—strip malls, highways, subway platforms—without paying attention, keeping our focus on the intended purpose of our trip or merely lost in our own thoughts. Except for the occasional striking billboard with its potentially powerful impact, there is nothing which calls for our more focussed attention. It is clearly this feature of beauty which has also caught von Balthasar's attention. In order for dogmatic theology to come alive again and for the good and the true to play a central role in modern society, they must possess an "attracting" quality. They must display beauty.

Even so, to say that the beauty of art and of nature consists in its capability to attract and hold our attention is not to give those things or the representations thereof our unqualified approbation. Outside the person of Christ, beauty and truth are not identical. Nor can we say, with Plato, that beauty always leads to truth or goodness. There is no causal connection between the two. Aesthetics does not automatically lead to ethics.

In her book *On Beauty and Being Just,* Elaine Scarry tries to argue that there is an intrinsic connection between beauty and justice. The symmetry—read: unity in diversity—in beauty is supposed to be conducive for democratic notions of distributive justice. Historically, however, there seems to be little support for this proposition. The Greeks may have been great sculptors and architects but they were not exemplars of social equality. Likewise, the Weimar Republic produced some great writers, composers and poets, but was not a model for the proper

ordering of a just society. In the same vein there are many examples in history of people passionately devoted both to beauty and to evil—Nero and Hitler, for instance. Surely this lays to rest any illusions we may harbour that the two are necessarily mutually reinforcing.

In our broken world, beauty can be used as a means for flourishing or as an instrument of oppression. In that sense the Hebrew writers had a much more realistic sense of the various roles of beauty in human existence, including the risks it posed: indeed it could be a means of seduction into a world of hedonistic self indulgence or a form of distraction precisely so as not to have to deal with the surrounding injustices.

BEAUTY, TRUTH AND JUSTICE

It seems to me that anyone drawing a close link between beauty on the one hand and truth and goodness on the other, is not so much de-scribing as pre-scribing what they think beauty ought to be. And this, I believe, is something which also ought to inform Christian reflection on beauty. For beauty to be redeemed it should be (re)connected with goodness and truth or, as for Scarry, with justice and peace. Such goodness or justice can be extended to many levels, including the material basis of a work of art or other beautiful object: what materials are involved and what were the conditions in which the work was produced? What health and safety issues were at stake in the making? What ecological implications does the work have for the environment? What level of financial stewardship was attained in the planning of the production, presentation and reception of the work?

One of the problems with understanding the art of our own time is that we often tend to know very little about those aspects. Since the emergence of the art museum there is a serious disconnect between the artist and her audience. Art is no longer produced within and for a community but by one isolated individual for an international global art world. As a consequence the general public no longer tends to know how particular art works originate and in what circumstances. But there are also some signs that this is changing. Postmodern artists are trying to emphasise the local and communal, and are experimenting with neighbourhood-based projects such as murals, linking producers with consumers. In a very different manner, the recent winner of the controversial annual Turner Prize in Britain, Stephen Starling, also emphasised the importance of the process of production in his work *Houseboathouse,* that consists of a shed which was first dismantled and reconstructed as a boat and then, at the location of the museum, rebuilt as a shed. Part of its "meaning" was to focus our attention on the process of handicraft and the potential of recycling and morphing existing objects into very different things. Whatever one may think of the final product, the "beauty" of such an event/work is again its capacity to draw us into its strangeness and

TIM LOWLY. *Carry Me.*
2002. Drawing on
panel, 108 x 48 inches.
Private collection,
Chicago. *The following
North Park University
students provided
collaborative assistance
with this work:
Robin Spencer, Yoonhee
Kim, Amanda Hasse,
Michelle Ness, Heather
Yanul, Krissa Harwood*

seeming absurdity, and its evocative allusions to values long lost in our society. It allows us to discover or re-discover a new dimension about the world, and the world, in turn, reveals itself to us in ways we might not have seen before. As such, we could say with Heidegger that art can reveal some truth about being. Truth or *a-letheia,*—which literally means 'unveiling'—for him is a form of un-covering of previously hidden aspects of the world. Hegel, likewise, spoke of art as the sensuous appearance of the idea of truth. To be clear, this should not be taken to mean that art is expected to carry the responsibility of having to mediate between some human visibility and divine invisibility. Throughout history Christians have struggled sincerely to assign the arts a proper place in life, and ended up oscillating between relegating it to the fringes of society and attributing to it a salvific role. However, art qua art should not be marginalized nor be given a privileged status. It simply has its own creaturely way of being.

True beauty, if you like, is more than skin deep. Taken in its proper context it is a multi-layered affair, which is able to acknowledge and embrace friction, violence, brokenness, pain, suffering and all that a fallen world entails. The best and most enduring works in the history of art, music and literature—Rembrandt's *The Return of the Prodigal Son,* Elgar's *Cello Concerto,* Dostoevsky's *The Brothers Karamazov* and so on—have always been able to visit the darkest places of the human condition and the bleakest moments in human history. Indeed, an important aspect of art's calling is precisely to expose the world's fragmentation and pain as signs of its broken and fallen condition. Such "prophetic" art is not necessarily well proportioned or harmonious in the classical sense but it will be "attractive" or "arresting" in that it captures some of life's most poignant yet elusive experiences. In that sense, art thus helps us make sense of our world and, in doing so, can bring shalom to the world, even as it highlights its brokenness.

In this "deep beauty" of a work of art, formal beauty and metaphoric meaning come together in providing us with a symbolic, suggestive, and sensuously rich structure which appeals not only to the five senses traditionally so called, but also to our sense of justice, peace, equality, safety, belonging and so on. When we feel that these are harmoniously united in the sensuous appearance of a work, we are inclined to refer to such works as "truly beautiful," something not easily uttered in the presence of forms that are just formally pleasing. So why is it then that Isaiah referred to the coming Christ as having "no beauty to attract us to him" and "nothing in his appearance that we should desire him" (Is. 53:2)? This intriguing comment must surely give us pause for thought. Perhaps it is to warn us against the kind of aestheticism which does not probe beyond the pleasing surface. Perhaps it was also to distinguish Christ from the idols of his time or, prophetically, what were to become the idols and male models of Christ's time: the sculpted bodies of the Greek gods. If so, this could be taken as poignant warnings against some of the seductive aestheticism and beauty cult of our own

postmodern consumer culture, whether in advertising, fashion or music. Unless we are able to connect this beauty with values such as justice (proper wages instead of sweatshop slavery); truth (honest marketing instead of hyped up manipulation); financial stewardship (avoidance of excessive luxury); ecological responsibility (use of sustainable resources) and so on, this aesthetic attraction will soon wither and fade. Just like sexual attraction outside the context of a committed relationship needs constant new thrills and excitements to feed ongoing interest, so too will aesthetic attraction outside the context of the good and the true as elaborated above. Perhaps this explains the constant need for shock and sensation in some sectors of modern and postmodern art. "Deep beauty," by contrast, is able to endure the test of time by sustaining our interest not merely within the lifespan of one individual, but throughout generations. This applies not only to the familiar works of the western world of "high" art and music—Handel's *Messiah,* Cézanne's *Mont Sainte-Victoire,* or Picasso's *Guernica*—but also to the delicate decorations on a Haida bracelet, the peaceful simplicity of a Quaker interior, or the energetic rhythms of a Klezmer wedding song. Even though these artistic expressions fall outside the world of "high art" as well as that of the popular culture industry, these are good examples of beauty which can sustain aesthetic interest and "contemplation" for their own sake even as they are fully embedded in the fabric of day-to-day life.

When looking for contemporary examples of such 'deep beauty' in North America we could think of the works in the exhibition *A Broken Beauty,* featuring fifteen artists working in a variety of figurative and narrative modes. As Gordon Fuglie comments in the book accompanying the exhibition:

> The artists in *A Broken Beauty* join the discourse about beauty that broke out in the 1990's and is still seeing resolution. The various notion of beauty encountered in the works here, however, do not betray a yearning for some idealized "golden age," utopia, or return to academic standards of beauty that marked official European and American art at the turn of the century. Rather, they seek a vision grounded in the realities of the present.[11]

The works shown do not avoid the ambiguities and brokenness of this world. On the contrary, they are firmly rooted in the complexity of life's realities, whether private or public, local or global. Even so, they are not overcome by that troubled state of affairs. As a result there is beauty to be found in the midst of struggles, tragedies and confusions, in the forms and shapes which invite us to ponder, enjoy and celebrate the sensuous, embodied nature of God's creation. To mention just one example: Tim Lowly's *Carry Me* is a monochromatic drawing of the artist's severely mentally and physically impaired daughter Temma being lifted upwards by six young women. Whereas all the women have their eyes wide open,

looking at us—at God?—with questioning eyes, Temma has her eyes closed and allows herself to be gently but firmly held and carried. In that gesture of surrender she also transforms the way we see the women: no longer merely questioning but also accepting. They now share in Temma's act of trust and surrender by offering their own broken bodies as 'a living sacrifice, holy and pleasing to God' (Rom. 12:1). By allowing the broken body of Temma to stand for the brokenness of us all, we are encouraged to reflect on our shared humanity. It is through the gestures of the bodies and the structure of the composition—resonating with medieval depictions of the enthroned Mary, carried and surrounded by angels—that one can begin to read these and many more meanings in this moving scene. That is the profound beauty of Lowly's work. As such it embodies what Fuglie describes as characteristic of all the works in the exhibition: "As viewers we are invited to consider the body's capacity for beauty despite its brokenness, in the midst of its brokenness, and, ironically, because of its brokenness."[12]

I believe that Fuglie's comments about the body's capacity for beauty can be legitimately extended to apply to the world in general. As fallen creatures living in a broken world, we cannot ignore, deny or escape its flawed condition. But as renewed and redeemed creatures, living in the expectation of a new heaven and a new earth, we are also capable of seeing traces of the world's original goodness and of tasting the Lord's presence in the midst of it all. To recognize true beauty requires mature, sensitive and spiritually attuned discernment. Long ago the prophet Isaiah warned those who failed to execute such judgment by saying: "Woe to those who call evil good, and good evil; who put darkness for light, and light for darkness; who put bitter for sweet, and sweet for bitter!" (Is. 5:20). Such calling of bitter sweet and sweet bitter is not just a matter of words and verbal rhetoric but also, and often even more so, of images and visuals. When we consider that artists are the creators of the dominant images of our time and the principle shapers of our vision, there is no doubt that they have a crucial role to play in the formation of our culture and our society. To seek and pursue redemptive beauty is therefore not merely a luxury pastime but a call to artists to become agents of restoration and reconciliation. Wise and winsome images—whether in paintings, music or sculptures—can serve as beacons of hope and signs of renewal. And in such creations of redeemed beauty we may be surprised to find that lament and celebration can join hands in unexpected ways.

Endnotes

1 Peter Schjeldahl, "Beauty is Back: A Trampled Esthetic Blooms Again," *The New York Times Magazine,* September 28, 1996. 161.

2 Wendy Steiner, Dove Report, Unilever, 2004

3 Barnett Newman, 'The Sublime is Now,' Tiger's Eye Vol.1, no 6, Dec. 1948, p. 52. It should be noted, however, that abstract expressionist Newman is not advocating a stance against beauty as we understand it as such but against a classical notion of beauty which was tied to concrete sensuous outward forms rather than to the abstract 'exaltation' of our internal emotions. In order to distinguish the latter from the former he referred to these as 'sublime.'

4 Dave Hickey, *The Invisible Dragon / Four Essays on Beauty* (Los Angeles: Art Issues Press, 1993) 64; Arthur Coleman Danto, The Abuse of Beauty: Aesthetics and the Concept of Art (Chicago: Open Court, 2003); Elaine Scarry, On Beauty and Being Just (Princeton, N.J.: Princeton University Press, 1999) 134; Wendy Steiner, Venus in Exile : The Rejection of Beauty in Twentieth-century Art (New York: Free Press, 2001) 280.

5 *Regarding Beauty: A View of the Late 20th Century,* Hirshhorn Museum and Sculpture Garden, 7 October, 1999–17 January, 2000; Catalogue edited by Neal Benezra and Olga Viso.

6 Norman Rosenthal, ed., *Sensation: Young British Artists from the Saatchi Collection,* 2 October, 1999–9 January, 2000. Catalogue. For images of the exhibition see www.artcyclopedia.com/history/sensation.html' www.artcyclopedia.com/history/sensation.html.

7 Umberto Eco and Alastair McEwen, *History of Beauty* (New York: Rizzoli, 2004) 438.

8 Edward Osborne Wilson, *Sociobiology: the New Synthesis,* 25th anniversary ed. (Cambridge, Mass.: Belknap Press of Harvard University Press, 2000); J. B. Bedaux and Brett Cooke, *Sociobiology and the Arts* (Amsterdam ; Atlanta, GA: Editions Rodopi, 1999) 298; Brett Cooke and Frederick Turner, *Biopoetics : Evolutionary Explorations in the Arts* (Lexington, Ky.: Icus, 1999) 466.

9 Hans Urs von Balthasar, *The Glory of the Lord: A Theological Aesthetics,* Vol. 1 (San Francisco; New York: Ignatius Press; Crossroad Publications, 1983) 19.

10 Cardinal Joseph Ratzinger, *The Feeling of Things and the Contemplation of Beauty: Message to the Communion and Liberation* (CL) Meeting, Rimini, Italy, 24–30 August, 2002.

11 Gordon Fuglie, "A Broken Beauty: The Artists and their Art" in Theodore Prescott, *A Broken Beauty* (Grand Rapids, MI: William B. Eerdmans Publishing Company, 2005) 135.

12 Gordon Fuglie, "Beauty Lost, Beauty Found: 100 Years of Attitudes" in Theodore Prescott, *A Broken Beauty* (Grand Rapids, MI: William B. Eerdmans Publishing Company, 2005) 79.

THE POINT
of MASS

A friend of ours flew home to Seattle to attend her father's funeral and to be with her siblings. We had been in a small group with her for several years and had known that her father was an architect. I knew that he was a "pillar" in the church, but to me, he was just our friend's father. He in fact was on a panel that interviewed my wife and I for summer mission trips for our church when we were in college. Our friend relayed more of her father's story after the funeral. Prior to WWII he had gotten his degree in architecture and had fallen in love with her mother. They would take long walks, go to galleries and museums and look at art. Art and beauty were important to them. After they were married, they were optimistic and dreamed of a bright future.

Dreams of making great art are an important starting point and motivation for pursuing art as a vocation. There seems to be a phase in an artist's development which forces a person to evaluate whether they really have what it takes to flourish. When a person is convinced they have the ability (usually in stages), they may choose to pursue what they imagine to be the path. As an artist continues in their career, certain attractions and attitudes toward particular forms, interests, and methodologies emerge. By the time their careers mature, they can look back to what they have produced and recognize their own strategic moments, important works, and, if any, significant contributions to the field.

The creative activity of humans is akin to that of their creator, and the process is an extension of human identity. Dreams, choices, consistencies and maturity gained through trial and error are all part of this creative process. The cognitive understandings of the components utilized in the creative process are governed

by intention. Intention is fueled by dreams and insights which spark imagination, and imagination is a characteristic that traces back to the Creator. The conceptual tools the artist employs in responding to imagination and which lead to the

ROGER FELDMAN. *Inside Outsiders* (detail), 2000. Wood and mixed media. 30 x 14 x 14 feet.

production of art are called the elements and principles of design. The specific elements of line, plane, volume and mass are especially noteworthy in how they parallel with the biblical narrative. Indeed, these elements may extend our understanding of the multidimensional path we walk.

The language of art has a well-proven system of integrating elements and principles to do its work. Elements are the components like ingredients to bake a cake. Principles are like a recipe, which helps to order the elements to make a delicious outcome. It is by understanding the characteristics of elements and principles that one has an expanded sense of what their options are for the purpose of creating. Elements such as line, shape, form, texture, value and color in the two dimensional realm give the artist a palette of alternatives to work with. The principles of organization are applied to the elements and the end result is the work of art. The organizing principles usually include balance, repetition, emphasis, movement, contrast, variety, unity, scale and harmony. While the actual terms and their emphasis may change with different authors, there is agreement that elements and principles are the vocabulary the artist utilizes in order to produce their art.

For most artists the process of creating art is not cognitive but intuitive. The significance of this was brought home to me when I was a panelist at a conference and heard the keynote speaker, James Turrell. Turrell was talking about his own career and how it had grown from working with light and controlling how we perceive light and space to buying a volcano and working with it as a substrate for his thinking. When looking back at his early career, he came to the conclusion that if he had it to do over again, he would have listened less to his head during his creative process and trusted his intuition more. There is a balance and exchange between the rational and the intuitive, and this healthy tension causes productive thinking and work.

Within three-dimensional forms, the vocabulary overlaps the two-dimensional realm, but several elements have additional distinctions due to the third dimension. The two dimensional understanding of line, shape and form, for instance, may overlay the three dimensional terms of, line, plane, volume and mass. Although a painting may utilize the same design elements, a three-dimensional counterpart may have supplementary spatial distinctions. When a viewer looks at a painting on a wall, their position in space may change, but the primary arrangement within the painting does not. However, in three dimensions, when the viewer moves while looking at a three dimensional object, the information changes. The front side is not usually the same as the backside, unless it is a Tony Smith cube, like *Die* of 1968, where all sides of the steel cube are the same dimensions, 6 x 6 x 6 feet! One of the hallmarks of the Minimal Art movement was that extraneous details were excluded. The surfaces of Smith's cube were all the same.

The primary substrate for a painting is plane or surface. The primary substrate or context for a sculpture in the round is form in space. The essence of

the form is comprised of line, plane, volume and mass. As the viewer moves around the structure, the primary information changes and memory of what is on the other side is activated. It is the progressive movement of the viewer which allows the eyes to collect a continuous stream of information as they walk around a sculpture. Our brains make sense of what we are seeing even when the object is out of view. The transitions from one side to another are critical to the ultimate success of the piece. The lack of a logical transition can feel jerky and detract from the cohesive quality of a sculpture in the round. The context for this inter-action between line, plane, volume and mass is space.

Space typically has two general categories in two-dimensional works: actual and implied. Actual space is what we live in physically. Humans and objects exist in this context and nature defines our context. Implied space is that of the two dimensional substrate: paper, canvas, walls, etc. In two-dimensional work, sur-face becomes context and an element simultaneously. The conventions of linear perspective have dominated western notions of space since the early Renaissance, yet challenges to these conventions began in the 1850's and matured by 1913. Space has gone progressively flat in much of twentieth century painting. Despite this, the conventions of illusory space as defined by linear and atmospheric perspective have survived and thrived.

Three dimensional line, plane and volume may either have a geometric or organic orientation or a combination of the two. In either case, elements and principles are simply mental constructs that allow artists to use verbal language to describe what they are seeing or doing with their primary language, in the creation of art. These principle concepts of line, plane and volume act as building blocks that lay a conceptual foundation for how to understand objects in space. The elements and principles expand the palette choices of line, plane and volume.

It is the intentional use of visual principles applied to the visual elements that produces an art outcome. Intentional use of the elements and principles is orches-trated by a creator. The artist decides to create. At the point of intention there is a decision about several things. What are the materials? What is the desired outcome? Where does one start? Many times I have stared at a blank canvas, or a blank space, or a pile of wood, or sacks of concrete and wondered ... will anything good come out of this? But somewhere, an idea, a dream or a glimmer sparks action. The imagina-tion either suggests an outcome before-hand or during the process. The artist decides to engage the surface, idea or material. Intention yields to process.

UNINTENTIONAL INTENTION

As my friend's father got established as an architect in the Seattle area, two things set his course for the future. He was invited to join a young firm and he got involved in his church. There were the usual tensions between work, raising a young family,

and commitment to serving in his church. He was known to be one who would ask the difficult questions—the one who would place high value on practicality, regardless of the issue. This characteristic was not wasted. As his career progressed, he was valued more and more for his organizational skills, his practical sense, and his ability to create interesting design.

Humans are gifted with ability to imagine, and imagination leads to intention. The idea of intention is extended to the innate abilities with which humans are born. Leonard Schlain explains that the ability to imagine plays a significant role in both the individual and society:

> I propose that the radical innovations of art embody the preverbal stages of new concepts that will eventually change a civilization. Whether for an infant or a society on the verge of change, a new way to think about reality begins with the assimilation of unfamiliar images. This collation leads to abstract ideas that only later give rise to a descriptive language.[1]

The use of these abilities to imagine takes form in a work of art. In a sense, the language used to create art is similar to the concept of the incarnation. Something that is imagined leads to intention that results in physical form. More importantly, the implications of exploration within this language lead the way to shifts in underlying assumptions about how things ought to be structured. The components of this language include the elements and principles of design. Within the elements, line is often the primary beginning point for the incarnation of imagination.

Scientists tell us that there was a "Big Bang" in the universe and that our tiny little speck called earth, is just that . . . a speck. What is so riveting when we find out more is that in order for the conditions to be appropriate for life on earth, several highly unlikely factors must be present. The right balance of gases, and abundance of water, just the right temperature range, and so-forth, that would all contribute to sustaining life as we know it. As Hugh Ross puts it:

> The temperature and pressure requirements prove to be narrow. One key factor is that the temperature and pressure of the environment must be just right for liquid water to form and remain in significant quantities in just the right locations. These requirements mean that only a few billion years in the history of the universe's expansion is there any suitable habitat for life.[2]

Scientists can look at evidence in the present and deduce what may have happened in the past. For some scientists, the "Big Bang" theory explains intention and the process which led to human life, and for these scientists, it was not by chance.

Einstein saw this intentionality. Behind this intention was imagination. James Romaine expands this notion of intention eloquently in his chapter in this book.

It is line that gives evidence of what is in the creator's mind. Whether the line or mark is a random stroke, or whether it defines the boundaries of the images on the ceiling of the Sistine Chapel, line gives conceptual structure to ideas or explorations. There are times when the creator doesn't have clear intentions and line acts as a tool of discovery until the author senses something inherently important in a stroke or a combination of strokes. This can be dramatically witnessed in the large pencil drawings of Peter Mollenkof. For example, in *Planted,* a swirling mass of lines coalese to form a monolithic column that seems to rise as support for some ancient architectural mammoth, but instead, launches a glowing shape that is part foliage and part aeriform. It is only through a constant process of altering and questioning, adding and removing, that Mollenkof comes to understand what he was searching for through the drawing process. It is the creator who deciphers the significance of what he has done and makes adjustments. And in this piece, as in many of Mollenkof's works, he left many of his probing lines for you to see the path of his visual exploration and excavation. Like a process undertaken by the artist who discovers or bumps into an idea or a passage beyond their imagination, line is the expression of intention.

Exploration with line is different than definition by line. The difference between a flashlight and a laser acts as an illustration for this point. A flashlight spreads a beam of white light in order to illuminate what lies in its path, but a laser beam is light with waves of the same wavelength which create a tight line of a single colored light. General exploratory line is much different from controlled or deliberate line. Line is about intention and direction. A series of lines mark the thinking behind something that is imagined. Drawing with a flashlight may eventually lead to more deliberate laser-like lines. Creating lines that are focused may reveal clarified intention in the recognition of a deliberate form.

Of course there are different kinds of lines, having their own inherent characteristics. An organic line is not architectonic or geometric. Its character is expressive with variation and a certain unpredictable quality. An architectonic or geometric line is deliberate, and serves a different purpose than an organic line. In both cases, the lines have a trajectory. Looking at the beginning of a line, one can predict where it may end up. An organic line is less predictable than an architectonic line in this regard. When Jesus said to his disciples, "Follow Me," he was asking them to take on his trajectory, no matter where it led. Looking back gives us information that may help us understand where the line has come from and where it is likely to go. The early church looked back at the life of Jesus after his resurrection and realized more about his life and actions than when he was in their midst. It is the collection of lines that defines plane, shape, or volume. With the addition of linear perspective in the Renaissance, the artist began to describe

the illusion of three dimensions on two-dimensional surfaces and thus, line began to describe space with depth.

The typical definition of line is that it is a point in space that moves. As it moves, it leaves a trail of its past—evidence of its movement. The definition of a plane is similar in that if you move a line, presumably perpendicular to its direction, the result will be two dimensions—length and width. Take this conceptual plane and move it perpendicular to its planar surface and you will have a volume

PETER MOLLENKOF. *Planted,* 2006. Colored pencil on paper. 29 inches x 37 inches.

with length, width and depth. Although this is a simple understanding of three dimensions, it is profound. The fourth dimension in this type of discussion is time. It takes time for a dot or a plane to move in space. Without movement, you would have a speck, not a line. Without time you would have a floor, not a house. Time and forces acting within their boundaries along with intention result in form.

Our intentions may not be clear as we begin, but the element of line is often the vehicle for the journey. As line is an act of intention, it is also evidence of imagination. A brief encounter with line may be the beginning of something incredibly complex. Line can be the beginning of a thought process that leads to a highly sophisticated result. As soon as a mark is made on a surface, a dialogue between line and space has begun. The imagination contained within a brief drawing may yield to more imaginative explorations that build beyond original intention. As line grows, it may contain expressive qualities with contrast in weight and thickness or remain uniform in order to appear neutral. When line is used as an interpretive element, it activates space. This use of line as a vehicle of thought is evident when we create shape or plane. Shapes or planes combine to suggest volume. Volume may be real or implied. The illusion of volume based upon linear perspective and Euclidean space, however convincing, is still an illusion. That is, unless it is physical three-dimensional form, and not a drawing on a two dimensional surface.

REAL SUBSTANCE

The story goes that the young architect and his crew were handed a golden opportunity to be able to work on a major project. In the early stages the core designers were at a restraunt and were brainstorming about the possibilities. As creative people, they started drawing with pens on their napkins and by the end of their meal; they had the kernels of a major direction. These funny little line drawings were accurate conceptually. They had become intention *on a napkin.*

In the study of three-dimensional realities, there is another distinction that expands one's visual vocabulary. It's the difference between volume and mass. Volume has to do with external boundaries that define edges of planes as they meet one another at a corner or transform into other planes. These external boundaries simply clarify the intentionality of the form. However, there is no assumption that the volume has weight. The treatment of a plane may imply weight due to color or value, but it doesn't necessarily follow that just because you have volumetric definition that you also have internal substance or weight. When my studio was located at "The Brewery," a studio complex in Los Angeles, there was a building in the complex that had two giant sitting Lions on its roof. It turned out that the building housed a sculptural fabricator for the movie industry, and that these two "bronze lions" were actually painted fiberglass from the

movie *Greystoke: The Legend of Tarzan.* They looked like they weighed tons because of scale and color, but in actuality, they were hollow and weighed only a few hundred pounds. External planes may imply weight and volume, but in fact they define a hollow volume. However, there is another distinction.

Mass is similar to volume but adds another dimension to its reality. Mass implies some kind of authentic weight. It is the difference between a foam-core hollow box and a square cube of marble the same size. If the marble is white, it appears to be light in weight. Change the scale and color, and it appears to be imposing and heavy, even though it may be hollow. Volume is about external definition while mass belies interior definition. Mass has substance while volume is the facade of mass. Frank Stella critiques the vocabulary of much of twentieth century art and sees the need for something more substantial in abstract art:

> That is, abstraction must go on with what painting has always had—line, plane, and volume, the basic ingredients. The problem is that in the twentieth century modernist painting has not yet been able to put all three together. This does not mean that its accomplishments are suspect; it simply means that there is still a great deal of room for growth and improvement. Abstraction must find a more robust way to deal with the space around line and plane—our sense of exterior volume; it must also find a more convincing way to deal with the space that line and plane can actually describe—our sense of interior mass.[3]

Stella understands through his exploration the need for mass to have substance if it is to be convincing.

What is common to plane, volume and mass, is that it is line that starts the conversation. Without that point in space moving in time, you have nothing but a speck. I love the reference that Paul Klee used in his work when he "took a line for a walk." His interaction with line as an element became a dominant way of arriving at an ever-changing destination. Line is evidence of intention. Line is a beginning and may indeed become the end in itself. Line may be used as a primary element to create a structure, or it may be the beginning of the thought process that ultimately leads to shape, plane, form and volume, or a conclusion that results in mass.

WHAT'S YOUR POINT?

In 1987 I created a site-specific sculpture for a show in a gallery located beneath the Space Needle in Seattle. The title of the piece was "Point of You." This 22' long x 11' wide x 6' high structure was created in response to some research I had done on how humans remain upright in space. I learned that there are two primary perceptual mechanisms that we use to keep from tipping over. The first is to rely on visual cues by processing horizontal and vertical reference points,

and responding by aligning ourselves with what we are seeing visually. The second has to do with reliance on the inner ear with balance being maintained through this built in system of equilibrium. Most humans rely on both, but studies have been done to separate differences. In response to these distinctions, I created a sequence of walls and floors that came to a single triangular point.

ROGER FELDMAN. *Point of You* (detail), 1987. Wood, Concrete, Sheetrock, Paint. 21 x 11 x 6 feet.

Surrounding the point or apex was a curved wall. All of the walls and floors were perpendicular to one another, but the entire structure was tilted by 4 degrees in one direction. Imagine a large sailboat that leaned in the water, 4 degrees from being upright. There was one place in the entire structure that did not lean. The floor at the apex of this structure which was a 2 x 3 foot triangle was level with the floor and perpendicular to the vertical walls of the gallery. It was also a poured piece of concrete, while all of the other floors were made of plywood. When the viewer moved toward the apex, they were responding visually and kinesthetically to the fact that the walls and floors leaned, even though they were perpendicular to one another. By the time the moving viewer had gone through these leaning corridors, their bodies were conditioned to compensate for the leaning structures to remain upright in space. When they arrived at the level triangular apex, there was a moment of extreme disorientation as they overcompensated on the level spot. To me this was a successful experiential metaphor alluding to how the world around us conditions us to understand reality based on physical context. When we come to the level ground corresponding with a larger context and dimension, we are momentarily disoriented and must choose which reality to believe. This is exactly what the gospel does. It puts us in touch with eternal perspective and offers us an internal stability full of meaning and life.

INVISIBLE REALITY

There is a primary understanding of these particular elements that precedes all others. Who is manipulating line? Who is creating plane? Who is imagining possibilities? The elements of line, plane, volume and mass are simply ingredients of form that may be manipulated. The primary conversation is not about the elements themselves, but about their purpose, intention and organization. The artist is one who works with these understandings and utilizes them in their explorations. They learn through trial and error when to stop; it is the artist who recognizes that they have arrived at significant form. "And God saw that it was good." Underneath it all, and at the beginning, is intention.

As humans made in the image of God, we have the advantage of looking at our environment and makeup to discover the character of God. We see the external world and see beauty along with ugliness. We see human interaction that results in destruction and pain. But we also see grand accomplishments that go beyond what is normal or expected. Man-made structures often take their cues from nature. The Wright brothers and others, for example, looked at how birds fly and mimicked their structures resulting in man-made flight, which eventually led to airplanes that now take us on global adventures. We see man-made structures that seem to defy gravity through engineering feats such as the Space Needle in Seattle. As followers of Christ, we accept the notion that our present physical reality is the result of a master's act of intention. As extensions of God's creation we

are made in his image and it follows that we are somehow linked in our own creative processes. We do what comes naturally, and one of the things that comes naturally is making things with intention.

The relationship between forms can suggest invisible connections that imply some sort of order. The ability to see beyond the immediate is an indication of a larger sense of ordering. The human desire to arrange their environment is an extension of whose image they embody. The capacity to see connections and to align according to intention suggests visual if not conceptual intelligence. "Our visual intelligence richly interacts with, and in many cases precedes and drives, our rational and emotional intelligence. To understand visual intelligence is to understand in large part, who we are."[4] The human need to find or create order in one's mind spills over into the art-making process. Through the forces of organization, extending to concepts such as proximity, similarity, continuance and closure, we perceive our surroundings in order to understand our context and make meaning of our environment. The same is true in both the art-making process and its results. Spatial understandings are influenced by what is left out as well as what is intended.

Positive and negative space suggest a context for intended construction. On a two-dimensional surface, as soon as a shape or mark is defined, a positive/negative relationship is begun. Intended form is considered positive space and the space left around the form is considered negative space. When graphic designers arrange text and image mindful of the negative space they are creating, they can create dynamic images out of the positive/negative relationship. And as Garza points out in her essay, the choice to *not* use color is as significant as the descison to use color because the absence of intention is a substantial way of causing emphasis.

When shapes defined by line are placed on a plane, another organizing activity on the part of the brain starts to take charge. Both geometric and organic shapes have an imaginary center or an invisible axis that seems to help understand the organization between shapes. When several shapes are arranged in an ordered fashion, an invisible axis is being established. The invisible axis of individual shapes is a way of understanding relationships between shapes and aids in ordering space. Again the question arises, what intentions are behind their ordering?

If we think like artists and imagine that the Master of the Universe wanted to communicate with His creation, and that we have characteristic ingredients as are found in our Creator, perhaps we can imagine that the scriptural accounts from Genesis to Revelation would reflect His imagination. In addition, the biblical accounts are the form for the content, but even the form becomes content. The poetry of the Psalms leaves enough mystery and ambiguity for humans to imagine. The mystery of God is somehow captured in the ambiguity and truth of

poetry. I suggest that the scriptural accounts reveal structure that acts like a line drawing, which eventually takes shape, adds dimension to become volume, and ultimately, that volume transforms to mass.

The account of the Transfiguration has multiple connotations for us as artists. The narrative account tells us that Jesus takes Peter, James, and John with him to the top of a mountain to pray. Peter sees Jesus standing with two other figures and all three glowed with the brightest white you can imagine. The accounts indicate that one figure was the appearance of Moses who brought the law to the Jewish nation. The second figure was Elijah who is the epitome of the prophets, as they foretell the coming of the Messiah. Jesus was the third figure who is the fulfillment of the implications of the other two. In a sense, Moses represents the line work of the Master Artist. Elijah represents the volume of the one to come, as the implications are pieced together through time. It is Jesus, who is the fulfillment of the Law and the Prophets, and in this brief encounter, He is transformed from volume to mass. The line work of the law turns to plane and then to volume in the prophets, and the life of Jesus turns the water into wine, volume into mass, implications into substance. Of the three, Jesus emerges as the only Savior, and it is His glory that illuminates.

Pentecost is a turning point. Jesus has been resurrected, the believers are waiting in Jerusalem, and then God acts. First an earthquake, then the sound of a rushing wind and tongues of fire resting on people's heads herald the change. With the Spirit came the fulfillment of Christ's promise that the church would never be alone. The movement of the Spirit of God is transformative. It is an invisible transformation that fills and satisfies. It is a transformation from volume to mass for individuals and for the church.

There is a point of transformation where line defines plane or shape and eventually becomes volume, and where volume becomes mass. It is like the process where knowledge becomes faith, and where faith becomes reality. One can experience things they do not see and realize the reality of their experience—as is illustrated in my own work where I have utilized the invisible force of gravity to make intentional statements about balance. The transformation exists, whether it can be seen or not. An incident is no less real because it occured due to an invisible or hidden substance.

ROCK

This invisible transformation impacted visitors to three pieces I recently created for an installation in a gallery. The three pieces were within inches of having the same interior dimensions: 7 x 7 x 7 feet. Each piece had a floor perpendicular to the four walls, but each floor was not stationary and had different constructions underneath it. One piece had a center high point that ran underneath the entire diagonal distance from one corner to the other. Imagine a square with a diagonal line, and this

line was actually the high point on the floor, 12 inches from the surface of the floor, while the sides perpendicular to the main diagonal receded to 5.5 inches at each corner. Participants entered on their hands and knees, and as soon as they entered the space, the entire structure rocked to the entrance side because of their body weight. Although they couldn't see the information below their feet, their equilibrium and visual information were directly impacted by their participation. The structure rocked with a thud every time a person crossed that invisible line. The line was there but couldn't be seen, yet you could feel it with the rest of your body.

THE END OF THE LINE

When does an artist say to herself, "This is enough; I am not seeing any signs of success and I should choose another path?" At the beginning of an artist's career, there is no guarantee of success. There may be signs indicating promise, but as in any profession, success is based on consistent and insightful performance. To choose to be an artist is an act of faith. Any career for that matter is intention surrounded by preparation and choices acted upon that move us toward creative output. Artists above other professions take huge risks. Only a few artists enjoy financial success in this volatile arena, but for most, this is not why they make art. The trajectory starting out may appear encouraging, but the realities of life plus maintaining a productive career can cause the best of intentions to turn a resolute path in a different direction. Many times I have given a talk about my work and people will come up afterward to ask a question or make a comment and will also say, "I was on a path like yours, but I had to pay the bills or it was just more than I could handle, or this or that obstacle got in

the way." What most people don't know is how close I have come to packing it in myself. In so many ways we are left to figure out our own path. It is a huge risk on many levels to be a "creative." Why do we keep on?

This examination of the visual elements artists employ to make their incarnations reflects the larger process of the Creator. We may start with imagination, which gives way to intention and begins with line. Line leads to plane and plane leads to volume and volume may lead to mass. The transformation from volume

ROGER FELDMAN. *Rock,* 2005. Wood and Mixed Media. Each cube, 7 x 7 x 7 feet.

to mass, whether conceptual or actual is where significance lies. It is the artist, who mimicking their Creator, looks at what they have done and says, "It is good." Somehow, intuitively, the risking artist has an inner sense that water has been turned into wine.

Time is part of maturity. Not all of us will create truly significant work. We may not have our work in prominent museums or galleries, but we can participate in the body of Christ—by fulfilling our calling. I remember a friend in college who took figure skating lessons even though she would never be great at it. She died at the age of 20, and I recall asking her before I learned she was dying, why she continued with lessons. Her response was simple and profound. "Because, it makes me whole." What we don't see is how God orchestrates conversation, timing or insights gained by those around us. The importance of community surfaces when we think about the paradigmatic influence of artists as leaven in the body, perhaps for purposes beyond our understanding.

The project that began on napkins was on a fast track. The design team was working like they had never worked before. They knew they were onto something exciting and had the opportunity to invent something that had never been attempted at this scale. My friend's father was the project manager as well as one who contributed to the design. There were stories of his wife being afraid for his safety, as he would have to go and make on-site inspections in dangerous conditions. When it was finally built, it had instant acclaim. They had designed and monitored the building of an enduring cultural icon in the same year that Tony Smith had made a model of Die. *The 1962 Worlds Fair opened and there it stood . . . The Space Needle. Meeting him in the halls of our church, you would never know that he had taken the lead in making it happen. His humility preceded him. Early on in his journey Manson Bennett had responded to the same invitation to join a trajectory that Peter and the disciples had:*
 "Follow Me."

Endnotes
1 Leonard Schlain, *Art & Physics: Parallel Visions In Space, Time & Light* (New York: Quill, William Morrow, 1991), 17.
2 Hugh Ross, *Creation And Time* (Colorado Springs, Navpress, 1994), 135.
3 Frank Stella, *Working Space* (Cambridge: Harvard University Press, 1986), 77.
4 Donald Hoffman, *Visual Intelligence: How We Create What We See* (New York: W.W. Norton & Company, 1998).

THE OLD, old Story

The process of making art involves asking many questions. The artist asks questions of the composition, of art history, of the culture around us and more. In this section, an afternoon of questions and answers have been transcribed that offer insights into making art from a Christian perspective. In this conversation painter Edward Knippers touches on many themes, including Dutch painting, propaganda, the body, calling and the ultimate subject—God's Story of Redemption . . .

If artists are not dealing with the most profound subject and the most profound part of reality that they know, then they are playing in the shallows. For so long, artists in our time have played with the artistic means (the elements and principles of design) to the point that they have thousands of ways to say nothing. Christians should come to art-making knowing that the artistic means is not the highest goal we know. It is the language we use. How do we deal with that language? I remember from my college art history that the one thing Christianity brought to the art of the Romans and the classical world was a story to tell. In form, early Christian art was seen as a degeneration of classical Roman art. It doesn't really matter whether this decline was the decadence of the civilization that was Rome, or Christianity's untrained handling of the artistic means. The new thing that Christianity brought to the whole mix was that the Christians had a unique and compelling story to tell of God's sacrificial dealing with mankind, and they found a way to tell it. That is the mark of the Christian worldview—the story we have to tell. We may tell it in all kinds of ways as artists. But Christian art, to be Christian, must at least assume that Christ has come in the flesh and is a living agent in our world.

How would you define "Christian art"?

If art is a poetic parallel to reality, then Christian art is a poetic parallel to Christ's presence in the world. The art may be Christian in the more predictable sense of either openly or obliquely affirming His abiding presence and work in the world. Then again, the art may be created in a negative sense as non-believing artists assume that they are making Christ's presence obsolete by attacking the evil in the world without reference to Him. They may even use their art to attack God's people for their real or perceived sins. But even the moral indignation of these artists can only have meaning in the context of a world created by a Righteous God. In both cases the art is dealing with His presence and the truth of the Gospel. God uses whom He will to speak His truth. If He doesn't have his witnesses within the Church at a given time, then he will find them outside the Church.

How does this influence your work?

Christ's immanent presence is the foundation of my work as a Christian artist even when I am not painting the Christian narrative. At graduate school I did still-life painting as I grappled with the role of the Christian artist. How in the world could my still life speak of the Gospel? My painting finally evolved from being borderline decorative into religious still-lives in which I was using objects on a table as a metaphor. Interiors became very unstable with objects in the roles of idols piled on top of each other. Chairs became little human thrones.

Even then I felt it necessary to make a link to earlier Christian art. I began to look at ancient illuminated manuscripts. I saw the possibility of a relationship between those ancient works on paper and the contemporary watercolors on large buckled paper with borders that I began to make. The primitive nature of some of the manuscripts was even more interesting to me. The primitive, as we have learned in the twentieth century, can translate into the painterly with rhythmic mark-making creating patterns, which in turn can create space. I was finally striving towards a larger metaphor for how the world works. The theme of the place of humanity in the world was ever present. So simple still-life painting increasingly held a human significance that I never suspected possible at the beginning.

How did you get from still-life painting to what you paint today?

The still-lifes increased in size and finally began to incorporate small figurative vennettes such as in *Christ at the House of Mary and Martha*. Now my paintings are, for the most part, large biblical narratives that attempt to portray Christ's presence in the world. I tell people that the paintings are too large for homes (6 x 8 or 8 x 12 feet), too nude for churches, and too religious for public spaces. They don't seem to fit our society, but the size and the nudity are important to my Christian statement.

Since the focus of your artwork is on biblical narrative, is the church your primary audience?

My calling is not necessarily to the Christian community. My paintings can and have benefited Christians and I hope that they will continue to do so. But Christians are not my target audience. Contrary to what many people think when they first see my paintings, I am not making Sacred Art, which I would define as art intended for worship and the sanctuary. My art is religious, but why should that exclude it from the public square? I see my job as an artist as making an art powerful and engaging enough that the society at large must deal with it.

EDWARD KNIPPERS. *The Stoning of Stephen,* 1988. Oil on panel. 96 x 144 inches.

Can you give an example?

A middle-aged American woman visited my studio and was standing in front of my *Stoning of Stephen.* I told her the title. She seemed intrigued by it but looked at me with no recognition at all. I thought she hadn't heard me so I repeated the title and added, "That is an account in the Bible." She said "Oh yes, the Bible. Is that Old or New Testament?" I said it is New Testament, the first Christian martyr. Then she said, "Now I know why you used so much blue. That is the color I see when I meditate." I said, "No, that's the color of the sky." That is indicative of the society in which we live. Our contemporaries don't know the Bible stories, but have almost unlimited understanding of New Age spirituality. We do not have the luxury enjoyed by the artists of seventeenth-century Holland of living in a world with common understandings, and common readings of visual things.

I think that this is what Cal Seerveld was saying when he warned us, "Christian culturing must not generate museum pieces."

Yet as Christian artists we must do our work well enough so we do not give the museums, our cultural storehouses, over to exclusive pagan use. Therefore I do have some disagreement with Seerveld on this point. One of the clearest Christian witnesses that we have in Washington, DC is the National Gallery. I would therefore ask, "are contemporary Christians producing art that is important enough and clear enough in its Christianity to be a part of that witness?" Museums are an important part of our art culture and should not be overlooked as a proper place for speaking of the Gospel.

Aren't museums too elitist a place to be be forums for the Gospel?

No. Art museums are important historically and aesthetically. They let us know something about where we stand as a people. The existence of the museum does raise the question of good and bad art as there are decisions that must be made about what will be included in a collection and what will not. Egalitarians don't like designations such as good and bad, high and low, better and best, but I find such distinctions helpful. And such distinctions are more than a mere matter of personal opinion. They really exist. But it often takes a period of time to sort out the personal opinions from fact. The museum, because of its long life, often acts as an arbitrator in this matter.

Since Christians call themselves "people of the Word," and narrative is central to your work, what relationship do you see between art and text?

We had a big show here in Washington of the Pre-Raphaelites. Victorian painters have never been my favorite, but I tried to go with an open mind. The Washington gallery-going public was excited about this show. As usual, I was glad I went even though my prejudice against Victorian painting was generally confirmed. A few pieces were wonderful paintings. But the exhibit helped me clarify my thinking about literature and painting. These are painters who extensively use literature—and I very much find them wanting. I am a painter who uses the written word extensively, too. So how was my work different?

What I finally could articulate was that much Victorian painting is obscure in meaning because of its love of literature over painting, and emotionally false because of its prim and thoughtless romanticism. The Victorians seem to have forgotten that there is much that words can say that painting cannot, but paint can speak in its limited way in that silent realm beyond speech. One might say that painting is entertained in that silent knowledge of the heart and then in the mind, whereas literature is first entertained in the mind. The Victorians too often chose the path of the literary. A case in point was William Holman Hunt's *A Hireling Shepherd*. In it, a shepherd boy is having a dalliance with some woman

WILLIAM HOLMAN HUNT. *The Hireling Shepherd,* 1851. Oil on panel. 30 x 43 inches.

while in the field, and the sheep were wandering off. The museum's explanation was that this painting was a criticism of the Church of England because the Bishops were playing around with new theologies and the sheep of the Church were being scattered. Such a reading was in no way readily apparent in the work itself. I realized that much Victorian painting used literature as a crutch outside the aesthetic consideration of picture making. Appealing to the mind first of all, literature in much Victorian painting was used as a *deus ex machina* for weak painting—it was hoped that a worthy moral would add the necessary depth of meaning and emotion to an inadequate art.

Our visual world today is dominated by a need for information. Once we have the information, the visual is disposable. Because of our long history of painting in the Western world, a work of art makes one look for meaning—emotional and/or intellectual meaning—not merely factual information. Therefore, contrary to our visual age of information, a painting demands that one not turn off the heart when one starts to think, nor does one turn off one's mind when one starts to feel. If you can produce art that is on the razor's edge between the two, then your work will have sustained impact. When the meaning engages in a symbiotic relationship with the visual object—you can never quite separate them. Otherwise, the art becomes propaganda or becomes so dependent on the literature that the literature is really the point, and therefore it becomes illustration. There is nothing wrong with illustration as long as it is good, but illustration should not be confused with fine art. The Victorians often did confuse the two.

They produced some wonderful period pieces, but on a whole their art lacks the universality that is the hallmark of great art.

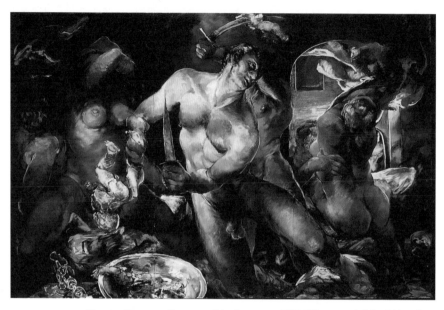

EDWARD KNIPPERS. *Massacre of the Innocents,* 1987 Oil on panel. 96 x 144 inches.

Can you give an example from your work that is different from that with which you fault the Victorians?

In my painting *Massacre of the Innocents,* there is a biblical narrative, but the scriptural account isn't necessary in order to look at it with some understanding. If a painting does not embody its meaning in visual forms that address both the heart and the head, its visual presence will soon become dated and stale because of its irrelevance to the declared meaning of the work. The great art of the past has dealt with universals of what it is to be alive and functioning in this real world—the way it functions spiritually and emotionally and physically. When dealing on that level, there is plenty of room for the creative spirit. What is more universal than the Gospel?

But in a pluralistic society can the Christian artist really communicate at all?

Communication is exactly why biblical narrative has become important to me as a Christian artist. I'm trying to couch my artwork within the history of Western painting, which is a noble tradition about which one can learn. I'm also working from a Christian worldview by using the biblical narrative. The viewer has at least these two threads that he can follow in trying to decipher what I am trying to say visually. My job is not to lean too heavily on either of these coordinates of meaning, but to make the painting as rich and powerful as it can be so the viewer might want

to find out about those things. But once they want to, if I have done my job well, then they have a place to go and find out about it. Perhaps they'll find themselves intellectually curious enough to investigate exactly what the claims of Christ are.

This book contains an essay by Makoto Fujimura and this conversation with you. Two more different visual styles would be hard to find, but you both have each other's work in your personal collections and there is mutual admiration for the other's work. How do you view abstract artists' communication verses your narrative approach?

The abstract artist is trying to communicate with a much more limited means than the narrative painter. For the abstract artist the formal artistic tools of line, shape, color, etc., are stripped of their need to serve the visual world in which we live. This frees these tools to try to express more directly the interior emotional landscape. It also allows these artistic tools to be displayed for their own intrinsic beauty and power as they respond to the workings of the human mind and heart. This is particularly true of Mako's work with its emphasis on the ancient materials and techniques of his Japanese culture. He is also an American Christian who has married his Japanese training to the New York School of Abstract Expressionism. This is, most likely, a gross oversimplification, as Mako's work is not easily explained. Nonetheless, his struggle is to redeem the totality of his art, and its influences for God's glory is common to all Christian artists regardless of the mode of individual artistic expression.

Narrative painting is often now viewed as mere illustration. How do you see it differently?

In my biblical narrative paintings I am not trying to make an illustration of the text but a poetic statement *about* the text. This, I think, is an entirely different thing, and I think it is very much the stuff of good art—the poetic statement. By poetic statement I mean to be allusive to multiple layers of meaning. I also mean to portray and heighten the emotional truth of an episode—the terror of Jonah, the shock of Jesus's encounter with the woman at the well, the cataclysmic nature of Paul's conversion, the frenzy of the prophets of Baal—beyond what a photograph of the event would reveal. This gets us back to the question of abstraction. The poetry is present in a work of art in how the artistic means addresses and serves the subject emotionally and intellectually. In this way all good painting is abstract at its core. The subject and how the subject is made must live in a symbiotic presence. This "life of the work" is abstract by its nature, in the same way that incarnation is abstract, but this does not mean that it must be any less concrete than the real world because of its abstraction—we don't have to be vague to be poetic. But if the poetry is removed, we are left with prosaic illustration that at its worst becomes didaction and verges on propaganda.

How would you define propaganda in this context?

I would say that we are handed propaganda in the political correctness of much of the current performance and installation art. The object that carries the meaning is a disposable thing, as we said earlier in talking about our information age. With propaganda I can look at the art object, get the idea, and then retain the idea with no further reference to the art object. I think fine art, in contrast with other forms of communication, embodies a symbiotic relationship between the idea and the object. In fine art you cannot have the fullest meaning being communicated totally separate from the created object at hand.

I like to use, as an example, Rembrandt's portraits of Christ. I never have anyone challenge me when I talk about 'portraits' of Christ. Of course, Rembrandt never painted a portrait of Christ. What he has done is create an image, and his painted image and the reality of Christ somehow have a symbiotic relationship. So if you really come to grips with a painting of Christ by Rembrandt, you can't quite think of Christ in the same way again. It is not that I look at it and say, "Oh, a good man," and I can run with that idea of Christ as a good man and I no longer need the painting— that would be propaganda. After seeing the painting, I somehow need the painting to complete the idea of that

REMBRANDT VAN RIJN. *Head of Christ,* 1650.
Oil on panel.

particular goodness of Christ that Rembrandt has shown me.

A lot of the politically correct art today is simply propaganda. Although the object is made to be destroyed after the exhibition, it is thought that the idea will live on. What you usually have are engaging one-liners that lack the allusive visual presence that I think is a definition of good art. This is propaganda no matter how correct or true its message might be. Christian artists must remember this. The importance of the object and its rightness in embodying the idea is our defense in the making of non-propagandist art, even while we proclaim the great truth of the Gospel.

*You spoke now of the "rightness in embodying the idea" which is as good a segue as any for us to discuss your "fleshing out" of the Faith. Many would assert your **wrongness** in embodying the Gospel. Why is the nude a major component in your art?*

HENRY OSSAWA TANNER. *The Annunciation,* 1898. Oil on canvas. 57 x 71 1/4 inches.

The body is the common denominator of humanity. When dealing with biblical subject matter, I do not go back to archeological sources, as did Henry Ossawa Tanner. He wanted to go back to the Holy Land and find out what the dress was like, as well as the vegetation. I am not interested in all of that botany, anthropology, and sociology. What I am intrigued with are the people and the events, which is a whole different thing. I paint the nude. The nudity allows me to have a timelessness in my narratives that will not quite be pinned down to the specifics of the biblical era. The nudity allows me to show that God truly dealt with those people and at the same time to establish our human commonality with them. In other words it is my hope that the nudity establishes a universality. They had bodies in the same way we have bodies regardless of our divergent sociology. The body is the straight line—the common element—through human history. If God could talk to them then, then God can talk to us now.

I get in trouble with the nudity in my work. One guy in Tennessee actually attacked my paintings and tore three of them up. In an interview, he claimed that I made the Old and New Testaments into a nudist colony. I got to thinking about it—and he's right. That's exactly what God does. He strips us of all our pretenses. The Spirit isn't hidden somewhere behind our bodies. It's all one—we are spirit and flesh all wrapped up in something we call a human person.

The human body is at the center of my artistic imagination because the body is an essential element in the Christian doctrines of Creation, Incarnation and Resurrection. Unfortunately too many American Christians may be orthodox in theology but emotionally they are gnostic. As Christians we must rethink the physicality of life—develop a decent theology of the body.

As Christians, we believe that God paid the ultimate price for our redemption. That would not be true if He had given us only His mind (and thus been merely a great teacher), or only His healing (a great physician), or even only His love (a compassionate friend). Without His body broken for us, His sacrifice would be incomplete, and we would be lost. For without the broken body there can be no redemptive resurrection.

Disembodiment therefore is not an option for the Christian. Christ places His body and His blood at the heart of our faith in Him. Our faith comes to naught if the Incarnation was not accomplished in actual time and space—if God did not send His Son to us in a real body, and therefore gender specific, with real blood. And His real bodily resurrection not only affirms our faith ("if Christ be not risen your faith is also in vain," I Corinthians 15:14) but points to our real bodily resurrection as Christ is the firstfruit of what is to come (I Corinthians 15:23). It is a mystery, but for Him and for us the body never goes away. It is eternal.

And there is something about the physicality of a painting that reminds us that we can never escape our physicality. When a person comes to a painting—and I think this is one of the most important parts of easel painting as a continuing art form in the twenty-first century—it is an object in real space. Yes, it has virtual space, but it is always in a real space and in real time. A painting truly exists in only one place, and you have to go there to see it.

Human beings truly exist in only one place, too. There are those who act as though the real essence of humankind is found in the computer when we are sending back and forth messages to one another in some little chat room. In other words, our essence is our mental capacity. But that is not true and can lead to the horrors of eugenics and euthanasia—if the mind goes or is impaired the person can be destroyed. Coming and sitting together in conversation is a different thing entirely than chatting online. The computer cannot engage our full humanity or personhood because it is inadequately physical. Even further afield, some of our thinkers are playing around with the idea that someday we will have computers perfected to the point that the body will be dispensable. How arrogant and how truly absurd! When reality is denied to that extent, we end up with death camps— if the body is not necessary, let's destroy it. Ideas that ignore God's creation and laud only man's creation are destructive. In professing ourselves to be wise we have become fools. The fact is, we are stuck with the body. Without the body, there is nobody there. We must deal with it. We must explore the mystery of its meaning.

Would you say that the body has a special ramification for a Christian understanding of the world?

Yes, absolutely. Because of Christ's incarnation, death, and resurrection, and God's dealing with the human race throughout history, to deny the body is inconceivable for the Christian. Yet we are in an age that denies the proper understanding of the body in two ways. In one way it denies it through its extreme emphasis on sensuality and the worship of the physical as seen in contemporary sexual idolatry, including pornography. On the other hand we deny it by resorting to a kind of gnosticism, prudishly rejecting the physical creation's importance and disdaining as evil what God Himself called good. Neither response is Christian. If we get too far from the body and the blood, either our own or Christ's, we are in trouble. Deny our body and blood, and we are in a fantasy world. Deny the body and blood of Christ, and we are lost. The body is therefore at the center of our faith. That is the reason John said, "These things are Him who we've handled and touched and felt," which gave weight to his observations, his insights, and his inspired words.

Having a body is a prerequisite for being human. For us, as inconvenient as this fact can be, it is a constant reminder that we are human and not God—that we are a part of the created order. Yet even as part of creation we are able to make our bodies a living sacrifice to God because of Christ's real and complete sacrifice for us.

Still, as central as the body is to our Christian understanding of the world, many Christians have a particular problem with nudity in art. Why do you think this is?

For those outside the art/museum culture the primary place that one encounters nudity in our culture is in pornography. Therefore, in the minds of many Christians nudity equals pornography. For a right understanding, though, a distinction of categories must be made. Nude is not necessarily dirty anymore than clothed is necessarily clean.

In an essay called "A Christian Perspective on Nudity in Art" the artist Matthew Clark pointed out, "There is . . . art that is quite charged with erotic content that doesn't show so much as an exposed ankle."

Excellent point. As an artist who sometimes comes under fire for nudity, I take comfort in Titian's *Sacred and Profane Love*. In that painting two women are presented, one exquisitely dressed, the other nude. The nude is the sacred love, and she in no way seems pornographic or even immodest.

Modesty is a part of the question, isn't it?

Yes, the Bible has quite a bit to say about it. Therefore I would never suggest that we run around naked, particularly to correct a false view of the body among Christians. It would simply be an ineffectual and arrogant act. But there are appropriate times for nudity even within the Christian community.

Later in the same essay, Clark made a distinction between modesty and prud-ishness. He said, "Modesty reserves the exposure of the body to appropriate times and places, whereas prudishness sees the body as sinful in and of itself." Would you agree?

To a point, yes. There are major questions that need to be entertained con-cerning the body that never occur to many Christians. I think that this is because they deny a place for our physical life in the spiritual world. At least they deny a positive role for the physical. There is much said about the negatives of the body, and negatives do exist. I, for one, do not see the great divide between the body and the soul that many Christians do. For any practical purpose, our bodies are who we are here and now. Therefore the pagan dichotomy that leads to a vague spiritual-ity in a solid physical world is not as Christian as we have believed it to be. The spiritual and physical are of a piece. That is the practical meaning of incarnation.

MATTHEW CLARK. *The Agnostics.* 2000. Etching and ink on paper, 16 1/4 x 8 inches.

But what about the "weaker brother" argument? Should we make sure that our art doesn't offend those who have problems with nudity, or have difficulty understanding the visual language?

We must remember that art is not for everyone. If a weaker brother has a personal problem with the erotic aspect of nudity that leads him astray, then he should work out his own salvation with fear and trembling which might mean that he will not look at paintings with nudes. As for the offense of a difficulty with the visual language, I see no reason to dumb down the art that our Lord has called us to make so that everyone will be able to understand it. The viewers have a respon-sibility. If they are interested they should learn something about the language of art. On the other hand, I am not speaking for some kind of esoteric art that is only accessible to a self-appointed elite. An art of clarity, I think, is the best art, but clarity does not exclude an art that is complex in form, emotion, or allusiveness.

At the beginning of our conversation you said, "If artists are not dealing with the most profound subject and the most profound part of reality that they know, then they are playing in the shallows." Yet it has been fashionable to see the narrative, and subject matter in general, as extraneous to a pure art. As a narrative painter, how do you see it?

I once heard Philip Pearlstein speak at Messiah College, and he talked about how he wished people would stop talking about his subject matter (the nude) and start talking about his art. I realized that for me, the subject matter is the point. I use all my artistic means in order to clear the way to my subject matter.

The fact is, when you have something to say, you want to find a clear way to say it. If you don't have much to say then your statement, as Pearlstein was saying, is the artistic means. It goes back to what I was saying at the very first, that we have a hundred thousand ways of saying nothing. That doesn't mean that just because an artist is concerned with technique he has nothing to say. Some new techniques and materials are exciting. After all, this is our language. I firmly believe, though, that the material should express a larger meaning than itself. Poets can enjoy sitting around talking about metaphors, but talking about metaphors is not writing poetry.

Ted Prescott pointed out to me a long time ago that we can't do without narratives. When we threw narrative out of painting what happened? We started talking about the artists' lives. *That* became the narrative. Today it seems the artist with the best biography gets the press. Keith Herring and Jean-Michel Basquiat died young. Vincent Van Gogh had bouts with insanity according to some, or temporal lobe dysfunction according to others. If the life story is interesting, that must mean the work is all the more important. I don't know about that. Van Gogh is interesting to me, and I think he is a fine artist, but I really like his contemporary, Camille Pissarro. The general public doesn't hear as much about him, yet Pissarro is every bit as good a painter as Van Gogh. The only artist that had work in all the Impressionist's shows, he was a hard worker, a plodder. How can a plodder stand up in the modern court of art opinion to Van Gogh's dramatic self-mutilation? The best biography wins. Yet Pissarro did equally wonderful paintings.

Speaking of the general public, since you described your art as "too nude for churches, and too religious for public spaces," who do you see as your audience?

One journalist asked both Henri Mattisse and Georges Rouault whether they would continue to paint if they never had an audience again. The pagan Mattisse said, "Of course not." The Christian Rouault said, "Of course." There is such a thing as an audience of One. God may call us to work simply for His own pleasure. What greater privilege could there be? As far as here on earth, anyone who is interested in looking at what I do is my audience. And I find those individuals both inside and outside of the Church.

CAMILLE PISSARRO *Landscape with Farm Houses*. Oil on canvas.

How do you speak clearly to such a diverse audience?

Considering our society I find myself taking to heart Flannery O'Connor's advice to shout to the almost deaf. What I am doing is setting the stage. Maybe that is why I am interested in the Baroque. Baroque is pure theater. Practically speaking, space is a key element, whether the space is open or closed, or whether there is a way out or in. Is it a shallow space? Or deep? Are the forms and images pushed out to you? Are you able to penetrate the surface of the painting? All of that has a very direct relationship to the viewer's emotional response. Directly related to space is color and light. With these components I am able to create an 'in your face' presentation (which I think grows out of my earlier interest in German Expressionism), as well as encompass the viewer in an extension of the pictorial world. It is in this context that the drama of the narrative takes place. In this way I hope to force the viewer to deal with the meaning of what he is seeing. And since I am painting with scriptural themes I am addressing much of Western painting. As my audience grows in their understanding of the large themes of Western culture, they are able to engage better with my art as well as our faith.

What role does prayer play in your work as an artist? Some Christian artists feel God is painting through them. Is that true in your case?

No, not in any magical sense. But He is a very present help in the studio. Allow me to share an example of what I mean.

A major painting of mine is *The Interrogation Room.* It has two diptychs and two triptychs that form a small room. One viewer told me that was "awfully site specific" and wondered where it was going. I said I didn't know but I felt led to paint it. Then Howard Fox, a curator from the Hirshhorn Museum and Sculpture Garden saw it. He remembered it after he moved on to the L.A. County Museum in Los Angeles and put it in his first show there called "Setting the Stage." It was as sight specific as the visitor to my studio had said, so Fox had a room built to house it for the show. This was a great affirmation that I was moving in the right direction. The Lord had directed me and had answered prayers that I didn't know how to ask.

I pray about what the Lord wants me to do. A recent series I did is a good example. I was reading through Acts and came upon that long chapter of Stephen's sermon. The chapter was so long that I left it for a while. I started reading the shorter Psalms for my devotions. When I finished the series of paintings on which I was working I didn't know what to do next. I prayed. My devotions brought me back to Acts, and as I read through Stephen's sermon I realized that I was reading a condensed version of the Old Testament. It was an unbelievably rich thematic ensemble. I did one large painting of the stoning of Stephen, and then I did seven smaller works dealing with themes from his sermon—*Jacob Wrestling with the Angel, The Gift of Circumcision, The Rejection of Christ, The Killing of the Prophets, The Golden Calf,* and so forth. God is truly present when I paint. But I don't blame my work on Him.

Are there theological propositions in your art?

Only when it is appropriate to the language of visual art. There are ideas and insights through which we see the world, and there are theological presuppositions that I, of course, hold. But propositional theology usually makes a poor subject matter for painting. It most often is inappropriate to the visual task. I have tried to get back to the large themes, theologically, such as in my early works of the Prodigal Son. The theme of the prodigal gets at the very core of the Gospel. It encapsulates, theologically, the major themes. The lostness of mankind. The coming back to God. Grace. All of it is there. The prodigal son is truly one of the large themes.

I have just started a painting called *Ash Wednesday.* We perform the imposition of ashes at our church on Ash Wednesday. This year as I looked around I was shocked once again to see friends and family with the mark of our mortality on their foreheads. There with the rest was my sweetheart—my dear wife. My painting, *Ash Wednesday,* is an image of Christ and the wild man at the tombs. This seems to be a metaphor for who we are—the demon-possessed among the dead. The sacrifice of Christ is our only hope in such a world. His stripes truly do heal us. I hope that the painting will poetically be able to carry such a powerful meaning.

EDWARD KNIPPERS. *Ash Wednesday (Christ and the Demoniac)*, 2002. Oil on panel. 96 x 144 inches.

Do you think that God calls individuals to be artists?

I think that the beginning and the end of artistic life for the Christian is God's calling. If He has called us to this work, then we can give it all we have to give. If He has not called us, then we are stealing time from God. Once our calling is settled there is an unexplainable freedom in which we live and do our work. There is also a strength beyond our own available in those difficult times that we all have in the studio. If we have a true calling, a true vocation, then we have Him as our major resource. "Lord you called me to this. I am having trouble. Please help me." It is very interesting when this happens periodically in my studio. I have thrown brushes at my paintings in frustration when I can't see something clearly. Finally I'll say, "Lord, help me see this." Time and time again He will be immediately there. This is very sad in one sense because it is as though God was standing there beside me the entire time and I wouldn't ask for His help.

One of the clearest examples of this happened some time ago when I was doing a large painting of an angel floating over a desecrated land. Something was wrong, and I didn't know what it was. In frustration, I prayed, "Lord help me to see this, what do I need?" Immediately I knew that I should go down to the National Gallery and see Poussin's *Holy Family of the Steps*—a neoclassic painting. Then I got angry because I thought, "Lord what are you doing to me? I am not a neo-classicist." I stomped onto the Metro and went downtown. I wandered around the gallery until I was exhausted. I was looking at wonderful things, but then I knew

I had to see the Poussin. One second in front of this canvas, and I knew what was wrong with my painting. I had not been using clouds as structural elements. I had used them simply as a backdrop. I would have never thought to look at that painting on my own, but there it was—God had answered prayer. Other times it is being able to see a hand, or some particularly anatomical proportion and develop it as I should, or of being trapped, not being able to see past what I have already done. He has called me to the work of painting pictures and my art is in His hands, to the point that He could ask me not to paint and I would stop. Because of this call I can go unashamedly and ask for His help.

If God's call is central to your life as an artist, then do you see yourself first as a Christian and then as an artist?

Exactly. There is much in life more important than art and being an artist. But once our priorities are straight and our calling is clear it is amazing what our Lord can do with us—even in the arts. We are called to sacrifice ourselves to His will. So often when we are looking for God's will for our lives, what we really want to know is God's option as a possibility—we want to check His will against our other wants and desires. We may even want Him to rubber-stamp our choice. Neither one will work. If you are just looking for God's way as another option or to validate what you have already decided to do, you could be looking for the rest of your life. But if you say, "Lord I want your will, period. I am going to do what you want no matter what it means and where it leads." Then He truly will give you the desires of your heart. Like every Christian, I am called to witness to the gospel of Christ. He lets me do it in paint. But I'm not alone. Take Howard Finster, who was a preacher that turned to art to "get his message out"—God's message.

He had something to say, and God gave him a way to say it. Not only that, he has been called the most exhibited American artist.

So he was still a preacher first.

Yes. Finster's popularity because of his primitive character can sometimes hide the message. But his persona also allows the message to get planted. People like him because he is this crazy guy in Georgia who paints on the top of his sausage cans. They like that crazy off-centeredness of his, but his message is clear. He was readily criticized in the Christian community for painting a Talking Heads album cover. But he wanted the kids who listen to rock music to have an album cover in their world that says "God loves you." I think that is what his work is about. He had a story to tell and a call from God that visually sent him on a quest beyond what anyone could have dreamed.

I think the same was true of Georges Rouault, a truly mainstream artist who was simply a Christian at work. His art has embodied the Gospel in a modern vocabulary that speaks to the heart.

Christians have a story to tell.

Yes. I think 'the story' is at the very core of what Christian artists are to do one way or the other, though it has to be more than a personal story.

It has to be the Story —Creation, the Fall, Incarnation, Sacrifice, Resurrection, and Redemption —the meta-narrative. Nigel Goodwin asks, "If the meta-narrative has left the stage because its tellers no longer know how to tell the story, how might the Word find flesh again?"

We have abandoned the story and isolated the Truth to such an extent that it comes down to be 'my truth' and 'your truth.' I think we have to talk about the Truth. It is unpopular, but I

HOWARD FINSTER. *Angel (#47,000541)*, 2000. Wood and paint. 10 x 9 inches.

think that is what we have to do. We have to say that there is not just a truth, but the Truth. That leads us to universals. Then we can express universal truths that transcend the provinciality of multicultural concerns.

Christian artists must connect with this visual heritage of the Christian tradition. Seerveld says it this way:

> Distill a fruitful Christian art historical tradition in your own blood and pioneer its contribution in our day. Christians have no right to be ignorant of history just because they stand in the truth. As guardians of culture Christians should explore omnivorously whatever men and women have done in the Orient and Africa, Europe and the Americas, in ancient times and today, not to paste bits and pieces eclecticly together and not to assimilate a nondescript "best" that has been artistically done throughout the ages, but in order to know surely the consistency and contours of one's own particular Christian tradition . . .

Do you agree with this?

Yes, and there are some encouraging signs. One is a major exhibit that was at the National Gallery in London called "Seeing Salvation: The Image of Christ." Bryan Appleyard in the *Sunday Times of London* (13 February 2000) started his review by proclaiming,

> Western art was Christian, is Christian and, for the foreseeable future, can only be Christian. Believers or not, we cannot evade the Gospels' continuing presence in our culture. Their meanings, their imagery, have determined the way we think, the way we create.

He called that exhibit "... London's most accurate celebration of the millennium as a period since the birth of Jesus," contrasting it with the Millennium Dome which he called "... empty—in every sense—because it is in embarrassed denial [of the centrality of Christianity to our culture]."

In the "Seeing Salvation" article Appleyard recounted the statement of Jonathan Miller, who is an atheist,

> If, ... there is a God, then He could have thought of no more powerful, creative and imaginative way of expressing His presence than through His incarnation in Christ, an 'ordinary' man. For, of course, from this ordinariness springs the entire western way of making art. The novel, with its dependence on the material drama of human life, and the emotional repertoire of the old masters were inspired by the intense significance of everyday objects and activities in the story of Christ. Without the physical detail of the Gospel story, there would have been no novel; without the face of Christ, there would have been no coherent fine-art tradition.

To be in that tradition is quite a heavy burden for the Christian artist to carry.

Yes, but there is a road map for the future in that tradition. I think Christian artists need to steep themselves in art history and find out how Christians have done certain things—what has worked and what hasn't worked. We have a two thousand year history that we need to know. This is the tradition out of which we work whether we like it or not—whether we are coming from Asia or America. As Christians this is our way of getting at the Faith, visually. For instance, one can do the biblical narrative as though it were right out of the biblical time and research every little thread of Palestinian dress. Or one can use a more generalized approach such as mine, expressing the timelessness of the icon through the nudity, yet with the sense of place and time and action through a western sensibility. Another approach to biblical narrative is poetic extrapolations of the world from a Christian viewpoint, as used by the seventeenth century Dutch painters.

As we have said, this is harder to do now because of our pluralism, but the record is there, and as Christians we should know our heritage. The Dutch idea is carried forward by Flannery O'Connor when she says, "My faith is not what I write about or what I paint about but it is the light by which I see." In other words, we don't paint light bulbs but we paint what is in the room with that particular, peculiar light of which is our Faith. But as our society gets more pagan, the language options become narrower (O'Connor's Christian point was often missed even in her day). Or, perhaps they become broader. We are in a time in which we can retell the biblical narratives in a fresh way because nobody knows them. We are like first century Christians; we have a fresh story to tell everybody. They think that it is a wild, intriguing story. And it is.

Clearly you believe a viable Christian art is possible as we move into the twenty-first century.

Without a doubt. A viable Christian art is one that will communicate with our time. If it can communicate clearly now it might be able to speak in the time to come. But regardless of whether or not it will speak to the future, if it speaks well now, it can bring the gospel alive for today. This is what I am trying to do. In reality I can't redo what has been done in the past. I can work from the same foundational milieu but what I do will be different from the past. It is the way that the animal style led to the Romanesque. Charlemagne was trying to rekindle Classicism in the ninth century, but of course all that was available in vocabulary was animal style and some classical examples that were theoretically misunderstood. When he tried to go back to the glory of the earlier age, he failed. But his artisans, in trying to fulfill his dream, created a whole new language, which we call Romanesque. I think that is what we do. We go back in order to move forward. As artists, we plow fresh ground in our time by trying with God's grace to be true to the vision He has given us, not in trying to be new. We must remember that our chief aim as Christian artists is to glorify God and to make His Truth plain for all to see.

CREATOR,
CREATION
and Creativity

There are numerous examples, from every dimension of our society, of the high premium we put on creativity. We are repeatedly urged to think "outside of the box." Technology continues to unleash the imagination of researchers in science and medicine to achieve what was until recently unthinkable. Teachers give credit for creative answers, even if the correct answer remains at large. Indeed the very idea that there is one correct answer leaves some concerned that this might stifle the development and expression of our precious but elusive creativity. This anxiety that creativity could be so easily extinguished is an indicator of both how important it is to us and how little we understand or can control it. Creativity, like spirituality, intangibly and mysteriously defines us as being human yet continues to evade all attempts to be defined.

We could begin to explore our creativity by comparing it to moonlight. In some cultures, the moon is worshiped as a god. A lunar eclipse is enough to provoke frenzy, even sacrifices. In other cultures, the moon is understood as a rock that orbits the earth. There are even some among us who have walked on its surface. However, this scientific perspective does not prevent us from taking long walks when the moon is full and allowing its luminous magnetism to evoke within us an indescribable warmth and romance.

Without certainty of the origin, nature, and purpose of their creativity, many artists have rituals and objects that they hope will maintain their powers, and a creative eclipse is enough to send them tumbling into turmoil. Conversely, a biblical understanding of human creativity sees it as the reflected light of divine creativity. This perspective neither overestimates the glory nor underestimates the magnificence of our human creativity and, by extension, the value of things that

relate to our creativity: language, imagination, love, faith, vocation, worship, and art. The moon is no substitute for the sun, but, if it were not for the moon as a reflector, we would not have any contact with the sun through the hours of the night. Similarly, human creativity can be evidence or revelation of God's presence, even when it seems like He is on the far side of the earth.

In her book *The Mind of the Maker,* novelist Dorothy Sayers considers the question of how human creativity might reflect its divine source. She begins by wrestling with the meaning of Genesis 1:27, "Then God said 'Let Us make man in Our image, according to Our likeness . . .'" Despite the fact that God is often represented as an old man with a long gray beard, there are very few who actually believe that the God of Genesis 1:27 resembles us in appearance. Sayers asks,

> How then can [we] be said to resemble God? Is it [our] immortal soul, [our] rationality, [our] self-consciousness, [our] free will, or what gives [us] claim to this rather startling distinction? A case has been argued for all these elements in a complex nature of man. But had the author of Genesis anything particular in his mind when he wrote? It is observable in the passage leading up to the statement about man, he has given no detailed information about God. Looking at man, he sees in [us] something essentially divine, but when we turn back to see what he says about the original upon which the "image" of God was modeled, we find only the single assertion, "God created." The characteristic common to God and man is apparently that: the desire and the ability to make things.

If our creative capacity is a partial image of God's revealed character, exploring and exercising our creativity can be a means of better knowing Him; art making can be a form of visual theology. Although theology is commonly a contemplative endeavor, employing human reason to interpret divine revelation, it is also possible to actively study God by practicing that creativity that is both central to His nature and part of His image in us. This is surely an imperfect means of knowing God, but no less so than seeking to understand Him with our limited minds. Visual theology is more than simply illustrating biblical subjects; it involves self-consciously employing human creativity, studying how that creative process operates, to explore the creative character of God. Although the knowledge of God that we can get from this method is incomplete, as is all our knowledge of Him, if human creativity is what it means to be "in the image of God," it may also provide a unique sort of insight into His nature. This study may also be combined with reveling in the creative gift which is a form of worship. (There must also be a caution noted here about the potential danger of using the image of God that He has placed in each of us as a means of knowing Him. Not only is

this image marred by sin, as is all of our capacity to know Him, there is a danger that we might confuse our being made in the image of God with a false sense of divinity. Nevertheless, the romantic problem of confusing our creativity potential with divinity is no less recurrent than the enlightenment replacement of God with human reason. As we employ our creativity as a means of knowing God, we should be consistently aware of its unique potential and common risk.)

If the capacity to create is a quality unequally shared by divine and human creators, not only can we study God by examining His reflection in our own creative experience, we can, conversely, gain insights into the function and purpose of our creativity by meditating on the divine Creator at work.

THREE IN ONE

Dorothy Sayers describes God as a trinitarian creator, Father, Son, and Holy Spirit, and a corresponding understanding of human creativity in terms of "Idea, Energy and Power." Allowing that the Trinity may be among the most mysterious of all Christian doctrines, Sayers proposes that a meditation on God's trinitarian relationship may enlighten the experience of the artist.

The Christian Trinity describes one God in three persons. The Nicene Creed affirms faith in the Trinity as follows,

> I believe in One God the Father Almighty, Maker of Heaven and earth and of all things visible and invisible; And in One Lord Jesus Christ, the only-begotten Son of God, begotten of his Father before all worlds, . . . By whom all things were made; Who came down from Heaven and was incarnate by the Holy Spirit and was made man. And I believe in the Holy Spirit the Lord, the Giver of life, who proceedeth from the Father and the Son . . .

Sayers takes from this creed that each person of the Trinity is described in creative terms and each relates to a particular aspect of the creative process. Works of art are the product of three elements: the concept, the material, the meaning—one work with three elements. Each part is separable in theory but no work can succeed if its concept, material, and meaning are not bound in a balanced unity.

The work of art first exists as an idea in the imagination of the artist. This is an aspect of the work of art that Sayers relates to God the Father, the creator of heaven and earth who commanded creation into existence from his imagination. Sometimes the idea comes to the artist as they are engaged with the material but the idea is the point from which the creative process toward a work of art begins. The idea conceptually encompasses the whole work from beginning to end yet is still abstract and formless.

Without form, the idea exists only in the artist's imagination. The artist must proceed through a creative struggle with his or her materials for the idea to be

incarnate in the art object. This physical nature of the work of art is very important to its being, just as the incarnation of Christ was important to his purpose. His suffering, death and resurrection were not a conceptual suffering, death and resurrection; they were necessarily physical, but had spiritual consequences. Works of art are physical (even "conceptual art" requires some form of material documentation) but they also have equally important non-physical dimensions. The physical work of art gives form to the non-physical idea of the artist and conveys meaning to the viewer.

The result of the creative process is a unity of the invisible idea and the visible form from which meaning extends, which, in Sayers's trinitarian description of creativity, is analogous to the way the Spirit proceeds from the Father and Son. This connection of idea, form, and meaning generates the power of the work of art that the viewer senses. By tapping into the viewer's own creative spirit, the work addresses each individual in his or her own way.

Just as the Trinity cannot be grasped simply in theory—it must be taken by faith and known personally by the believer—a biblical understanding of creativity as it relates to the concept, material and meaning of creativity is best explored

MICHELANGELO BUONARROTI. *Sistine Chapel,* 1508–12. Fresco, 134 x 44 feet.

through the example of an actual work of art.

The fresco cycle by Michelangelo Buonarroti on the ceiling of the Sistine Chapel at the Vatican in Rome depicting the Genesis creation narrative makes for an appropriate study of the origin, nature, and purpose of human creativity from a Christian, trinitarian, paradigm. Not only is this work undisputed as a zenith of human creativity, but, I will argue, Michelangelo intentionally used his subject to explore questions of the creative process itself and how human creativity might fit into a divine plan of creation and redemption as it attempts to reflect and represent the source, practice, and end (both purpose and completion) of creativity.

ART AS AN EXPRESSION OF FAITH

Every year, according to Vatican sources, more than 3,000,000 pilgrims and tourists come to the Sistine Chapel from around the world to crane their necks in awe of this achievement of Renaissance creativity. Our fixated attraction to Michelangelo's work epitomizes our insatiable desire to understand and add meaning to our own creativity spirituality by admiring his. However, to meaningfully approach this work we have to understand certain fundamental assumptions about Michelangelo's Sistine Chapel ceiling fresco cycle's program and purpose as a work of religious art, both in terms of its relation to the artist's personal faith and our understanding of art as a form of visual theology and creative worship. The theme, form, and function of Michelangelo's frescoes are interrelated and derive their power as much from the artist's faith as his creativity—two factors that cannot be successfully separated when discussing the Sistine Chapel.

Artistically and theologically, Michelangelo was one of the dominating personalities of the High Renaissance. According to Robert Clements in *Michelangelo's Theory of Art*, "Michelangelo was one of the most devout men of the Renaissance, lay or cleric." His faith was central to his life and art; for him "religion was not a set of opinions about reality. It was . . . reality itself." In his biography of Michelangelo, George Bull states, "Religious faith was second nature to Michelangelo in every unguarded utterance . . . He had absorbed Catholic piety and belief almost through his pores . . ."

Virtually unchallenged as the greatest artist of his day, Michelangelo was continuously in demand. As many as a dozen workers may have assisted Michelangelo in aspects of the project, their exact contributions are unknown. Although it is generally agreed that, considering the size of the project, Michelangelo did a surprising amount of the work, we should not romanticize Michelangelo as a lonely genius in ways that detract rather than add to our understanding of him as an artist.

It is possible that Michelangelo intended his frescoes on the ceiling of the Sistine Chapel as a personal treatise on the creative process itself. By exercising his own creativity to visualize God's creative nature, Michelangelo may have

hoped to better understand the connection between divine and human creativity. In imagining the Genesis creation, Michelangelo stretched his own creativity and the limits of his medium in developing an appropriately majestic visual vocabulary to convey the awe-inspiring implications of what it means to be an artist creating in the knowledge and faith that one's creativity is in the image of God's sovereign power. In his book *The Christ of Michelangelo*, John W. Dixon notes:

> Few works are so immediately, overpoweringly accessible to us as Michelangelo's [It] doesn't fit our normal categories, something inaccessible to our normal procedures. Critics offer their solutions to these problems; these solutions are not only different, they are often irreconcilably contradictory. We should acknowledge the implications of this situation. Anomalies, ambiguities, contradictions, paradoxes, are an inherent part of Michelangelo's work and have to be dealt with as what they are. They are outside explanation or resolution.

Michelangelo's art on the Sistine Chapel ceiling so magnificently captures the story of creation and deftly evades our explanations because it is a work of worship. Because his art was so deeply rooted in his Christian beliefs, it became what words cannot describe; however, his intention was that we should share in the rapture of his devotion as we are uplifted by his art into the heavens. Michelangelo's art only comes into its own as part of a worship experience.

THE CHAPEL AND ITS LITURGICAL FUNCTION

John W. Dixon states that, "The Sistine Chapel is one of the best known, the most studied and the least understood of great works of art." James Beck, a preeminent scholar of the Italian Renaissance, illustrates Dixon's point when he states, "A basic feature of the chapel itself, so obvious that it is sometimes ignored, is the papal function, as the pope's chapel . . . " and then proceeds to discuss the ceiling frescoes divorced from their liturgical context. The mistake that I think Beck, like many others, makes is that he treats the Sistine Chapel as a site for passive aesthetic contemplation rather than as a sanctuary for active spiritual engagement.

Before and after it is a temple to human creativity, a Vatican tourist attraction that has been aesthetically Disneyfied in its most recent restoration, the Sistine Chapel is a chapel where God is worshiped. In addition to being the place where each new pope is elected, it is a chapel in which he can celebrate mass. With ceremonies that stretch into several hours, the pope and his ecclesiastical and secular officials have ample time to contemplate the theological density and liturgical structure of Michelangelo's work.

Perhaps more than any other scholar, Dixon has contemplated the complexities of this fresco cycle in relation to the liturgy of the mass and the context of the

chapel. His discussion of the liturgical nature of this work both expands our appreciation of Michelangelo's work and has wide-ranging implications for our understanding the spiritual in art.

The fullness of true liturgy requires full participation in the transforming action; the principle of the true liturgy is the same as the enterprising principle of so much art,.... It is in this sense that Michelangelo's work in the Sistine Chapel is participant in the liturgy, an instrument of the liturgy. As the true art work requires a participation of the sensibility of the spectator in the structure of the work, so these paintings are a means for the total liturgy that is not exhausted in the service at the altar but is in the whole, requiring participation Every painting of whatever style is an element in such a transaction and, in ways we are only timidly beginning to understand, great paintings shape the imagination of those who participate in them.

Working on the chapel for four years, between 1508 and 1512, it is possible that Michelangelo himself took mass in the chapel and had an experiential knowledge of how the liturgy was practiced in relation to the art that he was creating. For such a devout artist as Michelangelo, faith and creativity were united in acts of worship, both art and liturgy. This inseparably links his ceiling frescoes to the chapel's liturgical function.

In examining his art, we should not fear overestimating Michelangelo's knowledge of and reflection on the scriptures. He had been educated in the Medici courts in Renaissance humanist concepts of art, theology, and philosophy. Furthermore, although Michelangelo claimed to have had the artistic freedom to paint his Sistine subjects as he saw fit, his Vatican employment gave him access to the Pope's own theological advisors. As we explore Michelangelo's exegesis of scripture on the ceiling of the chapel, his art becomes a form of visual theology, the study of God by means of exploring His image as reflected in creativity, that brings the theme of divine grace, foretold and fulfilled from the very first moments of creation, into the present moment of the church's worship.

Michelangelo's frescoes on the Sistine Chapel ceiling represent the Genesis narrative of Creation, Fall, and Redemption as an epic history of divine action. His storyline of grace, foretold through the prophets, incarnate in Christ, and present in the sacraments of the church makes his frescoes a magnificent example of how a Christian artist can interpret scripture through art. The central program of the Sistine Chapel ceiling is constructed of nine scenes divided into three groups of three. In order beginning from the altar, these are: *The Separation of Light and Darkness, The Creation of Land and Vegetation* and *The Creation of the Sun and Moon, The Bringing Forth of Life from the Waters, The Creation of Adam, The Creation of Eve, The Temptation and Expulsion, The Faithfulness of Noah, The Flood,*

and *The Drunkenness of Noah.* The nine scenes that run the length of the chapel thematically group into three triads: God's creation of the world before humanity, the creation and fall of humanity, and the life of Noah.

Each of the nine scenes from Genesis, set in horizontal-rectangular frames that act as stage sets for the drama they contain, are oriented to be viewed from the west end of the chapel where the altar is located and this fact should guide our interpretation of them. The placement of *The Creation of Light and Darkness* over the altar at which the mass is celebrated calls attention to its perfection in Christ's struggle and triumph over evil and death as the light of the world. As the priest holds up the sacrament to enact the mystery of transubstantiation he sees above him the image of God initiating the mystery of creation.

Just as the grace of Christ's passion that is celebrated at the altar spiritually sustains the believer, the chapel ceiling program is sustained by a catalytic spiritual energy that advances from the abounding power of the first moments of creation to the disaster of the fall and the hope of salvation. The first triad of scenes focuses on God's creative character as he shapes the universe into being out of nothingness. The second three scenes show how man was created for a perfect relationship with God and that this relationship was broken. These scenes represent God as active in the creative process and are also dominated by the most overt representations, literal and symbolic, of Christ as the restorer of our relationship to God. The final triad represents the faithfulness, deliverance, and transgression of Noah. These works demonstrate how the Holy Spirit, who sustains the faithful in worship, protects our spirit and prepares us for facing death and judgment, supported Noah's life and faith. In the liturgy of the mass, the worshiper enters the chapel from this temporal end of the narrative, under *The Drunkenness of Noah,* suggesting we must approach God naked, in full awareness of our shame, and seeking his covering.

The frescoes of the Sistine ceiling connect the Genesis narrative to the liturgical function of the chapel, joining heaven and earth. The Sistine Chapel ceiling cycle suggests that Michelangelo approached the Genesis narrative through the lens of the Gospel. One of the ceiling's central themes is the Genesis creation narrative as a prophesy of Christ and the artist found in the first era of creation prefigurations the Gospel. Michelangelo's imagery represents a storyline of grace, foretold through the prophet's promise of the Messiah, incarnate in Christ, and present in the sacraments of the Church.

Michelangelo's intention of using the Genesis narrative as a device for prefiguring Christ as the redeemer of creation may explain why he chose to represent such lesser known subjects as Noah's sacrifice and not more popular, and particularly dramatic, scenes of Cain's murder of Abel and the Tower of Babel. Michelangelo's choice of scenes, their order, and how he treated his subjects suggests that his concerns were not to show all of the significant moments in the Genesis narrative, as if he were simply a transcriber of a historical record, but,

instead, to use a highly selective process to construct a specific structure of divine and human action through the creation, fall and redemption.

The Christ of the Sistine Chapel ceiling is the Christ of the cross. Seven of the nine central scenes that span the ceiling and mark the liturgical procession of the mass makes reference to His death and/or resurrection. As the redeeming sacrifice of Christ is celebrated in the mass, the temporal reality of the acts of man in the present and the eternal reality of the acts of God represented above become one chorus of worship. The mass completes the frescoes and the frescoes set the eternal and theological context for the mass. This is the spiritual in art functioning at its highest level.

THE GENESIS CYCLE IN ITS CHAPEL CONTEXT

The commission Michelangelo received to paint the ceiling of the Sistine Chapel was part of a larger program to rebuild, expand, and strengthen the prestige and authority of the Roman Catholic Church. Pope Julius II was a prolific patron with an almost insatiable appetite for art and architecture. Julius II sought to impact his own times and shape his legacy through ambitious campaigns in both war and art. Although some historians have faulted Julius II's extravagance for precipitating the Protestant Reformation, his patronage was guided by the recognition that the visual arts are a form of expression and debate that shape cultural and social change. It should not at all surprise us that a work that many consider to be a high point in the history of art was the product of a period of outstanding patronage by the Church,

Two years into his pontificate, Julius II called Michelangelo to Rome to design and construct his papal tomb. This grand project, which would include Michelangelo's famous sculpture of Moses, would overshadow the majority of the artist's life. The pope soon became distracted with his total renovation of St. Peter's Basilica, to which Michelangelo also contributed. Without the funds to complete what had become a stalled tomb commission, the pope devised another way to keep Michelangelo in Rome. That plan was to have the sculptor become a painter and decorate the ceiling of the pope's private chapel. It had been Julius II's uncle, Pope Sixtus IV, who had commissioned the Sistine Chapel's construction and the frescoes on its walls, and Julius II undoubtedly saw commissioning Michelangelo to paint the ceiling as a way of completing a family project.

The original commission, according to the artist's own accounts, was for the representation of the twelve apostles. It was Michelangelo, probably with the help of a theological advisor, who conceived of the much grander program from the creation of the world to the life of Noah. There is little to confirm or rebut what Michelangelo wrote in a letter, saying that the pope "gave me a new commission to do whatever I wished ..." To say that the artist could do as he pleased with this commission overstates his freedom. The very nature of the Vatican commission

would mean that any major changes would require papal approval. Certainly one of the issues Michelangelo had to incorporate into his designs was Julius II's views of the Church's historical and theological place, as well as that of the papacy as the representative of Christ. That he was given artistic freedom in how he could treat the subject would be a more accurate description of the liberties Michelangelo was permitted.

Perhaps because its magnificence is so dominating, Michelangelo's central fresco cycle for the ceiling of the Sistine Chapel has too often been taken out of its context. However, Michelangelo's designs for the Sistine Chapel ceiling, which were meant to be the final conclusion of a chapel decoration campaign that had taken thirty-five years, completed as well as surpassed two cycles of frescoes on the life of Christ and life of Moses, by artists including Pietro Perugino, Domenico Ghirlandaio and Sandro Botticelli on the north and south walls of the chapel. These two cycles parallel each other as the active presence of God through the Old Testament law and New Testament grace. Over the altar was a representation of *The Assumption of the Virgin* by Perugino emphasizing this chapel's, and Julius II's, particular dedication to her and the triumph of the Church, which her assumption was used to signify.

Although Michelangelo's later commission of *The Last Judgment* would replace the chapel's original altarpiece as well as one scene from each of the cycles on the lives of Moses and Christ, his work on the ceiling theologically complemented the works already in existence. The parallelism between the Old Testament law and New Testament sacraments set the precedence for Michelangelo to represent the Genesis narrative of creation as a mirror of the New Testament and the contemporary liturgy. By intentionally connecting his work to that already in the chapel and creating layers of complexities through intricate relationships, Michelangelo was able to elevate his own work exponentially and create a unified space for worship.

It is possible to read the chapel's three cycles of frescoes in terms of three eras of God's revelation: Creation, the Law, and Christ. Michelangelo's works represent the era before the Law, beginning with Creation and ending in the judgment of the flood. The second period of time spanned from God's promise to Abraham to its fulfillment in the Christ. The third age began with Christ and continues through the Church and the Papacy to the present. Frescoes on the wall and ceiling of the Sistine Chapel tie these three stages of revelation to the present time and space of the liturgical function of the chapel.

Before Michelangelo's frescoes, the ceiling itself was decorated with a deep blue sky studded with stars. This design would have been understood in terms of a tradition going back to antiquity of associating the ceiling with the heavens. Michelangelo's imagery of God's creation of the heavens also connects to that tradition.

In subject, style, and splendor, Michelangelo's work was a potent representation of the Church's enduring power and divine institution. The cycle of nine events represents the initial unfolding of history along a divinely ordained plan that unifies all of time and space from beginning to end. Each scene has literal and figurative meanings, which must be read individually and as part of the whole cycle in its liturgical context.

Michelangelo began to paint the cycle in reverse of the biblical narrative from the life of Noah to the Creation. Perhaps he anticipated that his inspiration would grow and the process of painting this narrative would prepare him to deal with the momentous and sublime subject of God's creation of light itself. Moving in the order in which they were painted, three of the first four scenes contain more than one event. The conflation of events that occurred at different times into one image was a common practice in Renaissance painting and served to give the viewer a greater sense of narrative movement. Michelangelo largely abandoned this practice in the final five scenes of which four are dominated by single events.

Michelangelo framed the nine central Genesis scenes with a company of witnesses made up of Old Testament prophets and classical sibyls. As they progress toward the altar, the figures of the male prophets and female sibyls increase in size until they begin to spill out of their niches—only the graceful precision of Michelangelo's line holds their volume in check. The most monumental of these prophets and sibyls is the figure of Jonah enthroned directly over the altar. Jonah's three days and nights in the belly of a fish foreshadow the death and resurrection of Christ. He is the only Old Testament prophet who seems aware of the central cycle of the Genesis narrative as he turns in wonder at the sight of God creating the universe.

Michelangelo's inclusion of so many women, in such prominent places, is emblematic of Michelangelo's attitude. Although Renaissance Italy, and the Vatican in particular, was a predominantly patriarchal society, women in Michelangelo's art, despite being drawn from male models, were treated as individuals equal to men in personal character and spiritual strength.

The prophets and sibyls balance each other as Jewish and gentile seers who anticipated Christ. They establish a vital link between the nine scenes of Creation and the rest of the chapel. Not only do these figures visually frame the Creation narrative, they act as historical and conceptual bridges from it to Christ, thus reinforcing a christocentric understanding of Creation as well as connecting that reading to the rest of the chapel. In contemplating and reveling in the awe of these Genesis events, the prophets and sibyls establish a sense of the connectivity of God's work through Christ and the Holy Spirit in the Church as natural extensions of his first creative work.

These prophets and sibyls, vessels used by God to prepare the way for creation to be restored, have postures of anticipation as they ponder what grace may still lie ahead. The Hebraic prophets foretold of the coming Messiah to the Nation of

Israel and the classical sibyls were named by St. Augustine as recipients of glimpses of truth that prepared the way for Christ within the Gentile world. That God would work through Jewish and non-Jewish, biblical and non-biblical figures to accomplish this task would have been an important statement in reinforcing Renaissance humanist theology that attempted to unite Christian doctrine with the philosophy of classical antiquity. Michelangelo's visual theology echoes this dialectic. His figures, like those of the prophets Daniel and Zachariah, are clearly modeled on Roman statuary, to which Michelangelo considered himself an artistic heir. At the same time, these enthroned sibyls and prophets, with their unfurling scrolls and hefty books recall Christian manuscript illuminations of Gospel authors (once again drawing an unbroken line of grace though pagan antiquity, Hebraic prophecy, the Gospel revelation, and the modern church) or representations of Christian scholars, like the 1480 frescoes by Botticelli and Ghirlandaio (both of whom had previously contributed frescoes to the walls of the Sistine Chapel) of Saint Augustine and Saint Jerome, respectively, at the church of Ognissanti, in Michelangelo's native Florence. Michelangelo's Zachariah, in particular, bears a strong resemblance to Ghirlandaio's Jerome, although, exemplifying the influence of classical sculpture, Michelangelo's figure is significantly more solid in its form.

At the corners of the chapel ceiling are four scenes of salvation and sacrifice. Over the entrance at the east end of the chapel are scenes of *David and Goliath* and *Judith and Holofernes;* in each case the hero or heroine saves the nation of Israel. At the west end of the chapel, over the altar, are scenes of *Moses Raising the Brazen Serpent* and *The Death of Haman.* These two scenes more explicitly connect the theme of sacrifice and salvation to the redemptive sacrifice of Christ celebrated at the altar below. The connection between Moses raising the serpent and Christ was made in the Gospel of John where Christ said, "And just as Moses lifted up the serpent in the desert, so must the Son of Man be lifted up so that everyone who believes in Him may have eternal life."

The Death of Haman is a scene taken from the book of Esther where the Jewish Queen saves her people from a plot by Haman by exposing him

The Separation of Light and Darkness

to her husband King Ahasuerus of Persia. The connections between this narrative of the salvation of Israel and the salvation offered by Christ are less direct than in that of Moses raising up the serpent in the desert and Michelangelo has taken license with the story, by crucifying Haman rather than hanging him. Nevertheless, the visual link between the outstretched body of Haman and the death of Christ is one of the most direct references to Christ's redemptive sacrifice in the entire chapel.

The christocentric theme of the Sistine Chapel ceiling continues on the upper sections of the chapel walls in sixteen lunettes and eight spandrels that depict the generations listed in the Gospel of Matthew as the ancestors of Christ. Just as the ceiling represents the first chapters of the Old Testament, the lunettes represent the first chapter of the New Testament. The Old Testament prophets and classical sibyls represented the spiritual or visionary connection between Creation and Christ; these ancestors represent the human lineage from Abraham to Joseph. It is noteworthy that although Matthew names principally the male ancestors of Christ, Michelangelo has represented both husbands and wives. It is also significant that Michelangelo chose the lineage from Matthew's gospel, rather than Luke's, which lists only men. Furthermore, just as the prophets and sibyls represented both Jewish and non-Jewish precursors to Christ, his ancestors named by Matthew included both Jewish and non-Jewish figures.

All of these figures and scenes that encircle the nine central frames of Genesis, including the prophets and sibyls (except for Jonah and Zachariah at the far ends of the chapel ceiling), the ancestors of Christ, and the four corner scenes are unified by the illusion of a single light source, not the natural light from the windows along the north and south walls, but rather the illusion of a spiritual light emanating from the direction of the altar as well as the scene of *The Separation of Light and Darkness* above it. This light not only visually unifies the entire ceiling but it also theologically suggests how the light of God that now flows out of the Church and the sacraments at the altar connects Jew and gentile, east and west, man and woman, and all who live in light of the Gospel.

Although Michelangelo's nine frescoes of the Genesis narrative across the ceiling are the best work in the chapel, perhaps some of the best anywhere, their magnificence is only enhanced if we continue to remember the liturgical and artistic context in which they were created to fit.

THE FIRST TRIAD

The three scenes closest to the altar, *The Separation of Light and Darkness, The Creation of Land and Vegetation* and *The Creation of the Sun and Moon,* and *The Bringing Forth of Life from the Waters,* depict God's creation of the universe. As Michelangelo visualizes God setting a stage on which the rest of the drama (the creation, sinfulness, and judgment of humanity) will be played out, he often finds motifs that allow him to foreshadow God's ordained plan of salvation before

Adam and Eve are even created. Nevertheless, these first days of Creation are in and of themselves important moments in the establishment of God's creative character and Michelangelo imagines Him as the perfect artist whose work in concept, matter, and meaning is unsurpassed.

Michelangelo's representation of Creation begins with *The Separation of Light and Darkness*. Like the next two scenes, this first frame is dominated by God as a physical form in action. As our gaze crosses the image from the lower left to upper right, we move across the powerful figure of God as he stretches across the entire frame and turns in space. As He holds darkness in one hand and light in the other, they seem to have real substance. The face of God is obscured from our view as He looks ahead in space and time directly into the gap He is creating between light and darkness.

Since God's facial features and expression in *The Separation of Light and Darkness* are unreadable, our attention is drawn to movement of His body, the expressive gesture of His limbs, and the gentle power of His hands. One of the moods that characterizes the ceiling is struggle; as His fingers disappear into the dark and light clouds in *The Separation of Light and Darkness,* even God seems to turn and strain as He labors against the forces of nature that He created. Genesis describes God creating by calling things into being but Michelangelo visualized this creation process as a corporal struggle, perhaps in order to foreshadow Christ's Incarnation and Passion by which the first moments of creation were fulfilled. The raised arms of God in *The Separation of Light and Darkness* echo those of the priest at the altar below as he holds up the host. This connection to the mass celebrated in the present with the very first moment of Creation impresses on us that God's plan for salvation and the Church was part of God's initial plan. This scene has been symbolically read as Christ's triumph over sin and darkness and/or the Last Judgment when God will separate the saved from the damned.

The Creation of Land and Vegetation and The Creation of the Sun and Moon is among the ceiling's most dramatic scenes. As we read the image from left to right, we first see God creating land and vegetation, on the third day, and then we see him again in the creation of the sun and the moon on the fourth day.

The immediately more visually engaging of the two creative moments occurs when God's power is unleashed as He creates physical matter and commands the celestial spheres into their orbits. The other half of the image is dominated by a figure of God creating dry land. Considering the plethora of discussion of the program of the Sistine Chapel ceiling there is a remarkable silence regarding why Michelangelo chose to represent God from the back. One explanation for representing God from behind may be that since God is represented twice in the same image performing actions done at different times, Michelangelo might have desired to show this figure in radically different poses in order to help distinguish the two scenes for the viewer. Whereas in the first scene Michelangelo showed

God creating light and darkness in *The Creation of Land and Vegetation and The Creation of the Sun and Moon* God creates and occupies space; by turning God around, Michelangelo shows God moving in the space He has just opened up and emphasizes the connection between His action and our space.

In the third scene, *The Bringing Forth of Life from the Waters,* the majestic figure of God soars above a boundless space as He commands life from the deep. Our attention focuses on the creative energy evident in His massive hands as they seem to break through the plane that separates His eternal space from our temporal existence. The work of art is the point of contact between heaven and earth.

There has been considerable disagreement about this third scene, beginning as early as the 1550's, Vasari and Condive—two of Michelangelo's biographers who knew him personally—respectively described it as the separation of land and water and God bringing forth life from the water. The absence of both dry land and marine life requires us to look outside the scene itself to identify it. The fact that Michelangelo had shown God creating dry land and vegetation in the second scene undermines the argument that this is also the subject of the third scene. Furthermore, no convincing argument has been made to explain why Michelangelo would intentionally disrupt the order of creation by representing the separation of water and land of the second day of creation after the formation of the sun and moon on the third day.

Scholarly focus on which day of creation this scene is supposed to represent has distracted them from the central point of this image. The artist's emphasis in this third frame, as with the preceding two, is on the continuing significance of God's creative energy. In this third scene, the palms of God's hands in fact are not turned down towards the water (in which case, we would be looking at the tips of His fingers) but are open and active towards the liturgical mass that would pass beneath it. More than any of the other eight scenes, *The Bringing Forth of Life from*

The Creation of Land and Vegetation and The Creation of the Sun and Moon.

the Waters depends on its physical context in which the viewer stands beneath the fresco and looks up over his or her head at the image of God bearing down on them. This work could be read in terms of baptism of the Holy Spirit and it creates an immediate intensity emphasizing God's life-giving energy as still present and moving in the chapel's activities.

Collectively, the first triad represents the trinitarian character of God's creative imagination. The first scene shows the sovereignty of God's power as He created space out of nothingness and order out of chaos. The second scene shows God's creative touch as He crafts the earth by molding the land into shape and forms the sun and moon. The third scene demonstrates the life-giving power of God, which the Nicene Creed attributes to the Holy Spirit.

IN THE IMAGE OF THE CREATOR

The Sistine Chapel ceiling's first triad of scenes represents three significant moments of creation before humanity. The creation of space itself; the creation of physical matter; the creation of living things. In each scene God emanates a power that creates light and life wherever it radiates. Michelangelo may have been attracted to the subject of the Genesis narrative because it touched him as a Christian and an artist; it laid out a biblical understanding of creativity that he found necessary for his art. An encounter with the Creator has to be awe inspiring as well as terrifying, even for an artistic genius regarded in his own lifetime as *Il Divino,* the Divine One.

The Genesis account of creativity emphasizes it as an act of personal expression by a previously unknowable, invisible, and infinite being. Too often, the theological debate surrounding how or when God created blurs the simple fact that He did. The emphasis of the Genesis narrative is that God created order out of chaos, light out of darkness, life from the void.

Michelangelo represents Creation in terms of a process of relationships: light and darkness, night and day, heaven and earth, land and water, deliverance and damnation. Likewise, art finds significance in relationships; meaning in works of art proceeds from the internal unity created by the tension and fittingness of content and form. The esteemed scholar of Renaissance art Frederick Hartt notes, "Moreover he was able to find in each of the scenes and each of the figures a content so deep and a formal grandeur so compelling that it is generally difficult to think of these subjects in any other way."

Hartt is right in pointing to Michelangelo's equal dedication to form and content. Recognizing that meaning emanates from the union of these two, Michelangelo was able to create a truly commanding magnificence, sometimes awe inspiring and sometimes terrifying, appropriate to his subject. Hartt continues, "Michelangelo rose to heights from which he alone, among all Renaissance artists, saw the Creator face to face."

THE SECOND TRIAD

The central triad of the Sistine ceiling, *The Creation of Adam, The Creation of Eve,* and *The Temptation and Expulsion,* depicts the creation and fall of humanity with an emphasis on relationships. While the first three frames dealt with the creative character of God, the second triad of scenes represents who we are as created in God's image. Perhaps the most prominent theme that spans the entire ceiling cycle, though nowhere more pronounced than in the center triad, is Michelangelo's belief that the human creative imagination is a muscle that is most effectively exercised in relationship with the Creator whose actions are represented in the first triad.

One of the most famous images in the history of art, *The Creation of Adam* is also one of the most theologically complex scenes of the entire cycle. As our eye enters the frame from the lower right, we immediately find ourselves standing on solid ground. This allows us to better imagine ourselves in the drama. We are meant to identify with the figure of Adam and experience the rest of the drama of this scene from his vantage point.

The most spectacular of God's creations, Adam has been fully and wonderfully formed but his limp body still stretches across the earth from which it was made. God is about to give Adam the final touch of life. This will cause Adam to stand up, distinguished from the material from which he was formed and the rest of creation. (This gift is the inverse of the curse that God put on the serpent by condemning it to spend the rest of its existence crawling in the dust of the earth.) Adam's body is almost completely enveloped by the earth; this reminds us that we were formed from the earth and will return to it, where we will wait to be resurrected at the Last Judgment. *The Creation of Adam* is a picture of the origin and end of man.

In *The Creation of Adam,* Michelangelo prefigures Christ as the second Adam by His incarnation, death and resurrection. The reclining figure of Adam echoes that of Christ in many representations of the lamentation of the dead Christ. Adam's creation becomes a foreshadowing of the death and resurrection of Christ. Just as Adam is the first man created and raised to life from the earth, Christ is the first man resurrected from the tomb in a restored relationship with God. All those who participate in the mass celebrated in the chapel find themselves in between these two creative acts.

One of the complexities we have to contend with in *The Creation of Adam* is the fact that Adam appears to be alive before God has endowed him with His power of life. If Adam already has a living body, what is he about to receive from God? This problem has troubled many scholars who have even faulted Michelangelo for this seeming contradiction. It is possible that Michelangelo was very conscious, even intentional, about not representing the physical creation of Adam but rather God bestowing on Adam the power to create. The creativity we have already seen God demonstrate in the first triad is now his gift to Adam. Michelangelo's repre-

sentation of Adam as already alive before God has touched him is actually an ingenious way of solving a subtle but theologically important potential problem in this scene. What does it mean to be created in the image of God?

A superficial reading of this image would concentrate wholly on Michelangelo's representation of Adam's physical body as the perfect human form, but is it his physical beauty alone that shows that he is created in the image of God? The figure of Adam is demonstrative of Michelangelo's obsessive study of anatomy, his knowledge of his art, his passion for the forms of antiquity and the yearnings of his spirit for God. Michelangelo's representations of the human figure are so spectacular that we can become distracted by the body in a way that Michelangelo never was. While Michelangelo did use the visual vocabulary of physical beauty to express the dignity of man and his special place in creation, this needs to be understood in the proper context of his approach to physical beauty and spiritual perfection.

Michelangelo's approach to the human body is a study in itself and remains a difficult question for two reasons. First, Michelangelo's understanding of the human figure was anything but one-dimensional. It was at the center of his identity and relationship to God. A second difficulty we face in understanding Michelangelo's approach to the body is that his worldview, both faith and philosophy, was radically different from many modern viewers. Our contemporary culture more often celebrates sexual self-indulgence than a restraining the flesh in order to grow spiritually. It is not surprising then that we have often mistaken the spiritual dimension of Michelangelo's devotion to the human form as sexual in nature.

Despite an almost complete absence of solid evidence, popular myth has defined Michelangelo as a homosexual. The problem of Michelangelo's sexuality grows out of a desire to read this into his art. John Dixon notes that Michelangelo himself denied any homosexuality and puts the question to rest quoting Jean Paul Sartre, "If a man say[s] he is, he is. If a man says he isn't, he isn't, he isn't." Creighton Gilbert argues that it was because of Michelangelo's sexual attraction to women that he turned to representing the ideal human form as male. He argues, "The frustrating difficulty of reaching spiritual calm through excitement over beautiful women can be circumvented in one way. This is by loving a man, since sexual excitement there is not involved." He goes one to say, "Michelangelo's fears that people would apply their own standards to him are all too justified. The matter has been the center of sensational gossip . . ."

Michelangelo's focus on the beauty of the human form was based on a belief that this splendor was the most eloquent earthly manifestation of God's order and glory—greater than any sunset or mountain range. It was in the divine creation of human form that Michelangelo saw the most complete revelation of God's creative character. Since all of life flows from this divine source, its beauty is not only a mirror but also a direct line to God. The artist, consumed by the brilliance of his

art as though it were a mirror of heaven's glory, is drawn upwards through it to God. The body's beauty was a reflection of the soul's splendor. Nevertheless, Michelangelo does not show us God creating for Adam a physical body, which, no matter how beautiful it might be, was terrestrial, mortal, and common across creation. The artist focuses our attention on God's act of completing his creation by endowing Adam with the distinguishing ability to imitate his Creator with creative worship.

The Creation of Adam contains a curious interchange of likenesses. On the one hand, we see God creating man in His image. At the same time, Michelangelo represented God in the image of man. It would be wrong to think that Michelangelo believed that God the Father had a physical body. He represents God as an old man with a long beard, not unlike the one Julius II had, but he knew that his image was only a symbolic representation of God. Michelangelo represented God in the image of man, because he had no other model. This makes it even more important that Michelangelo does not show God, as a physical being, creating Adam as a physical being. If Adam seems already partly alive before God has touched his finger, it is because Michelangelo meant to show God creating man in his own image, but this likeness is of a creative and spiritual resemblance not a physical similitude.

The Creation of Adam has such enduring power not only because of what we can see in it but what we can see in light of it. Through his composition and forms, Michelangelo conveys the reciprocal love and longing between God and Adam through their reaching for each other. By causing us to imagine God's touch, rather than showing us that act which will awaken Adam's creativity and make him completely human, Michelangelo arouses those same qualities in us and leads us to a more creative faith as well as a conception of creative activity as something divinely ordained.

Frederick Hartt notes that the arm of God is naked as nowhere else on this ceiling or in any previous representations of Him. It is as if God had removed all encumbering garments, rolled up his sleeves, to free his creativity for this one, His most magnificent, work of art. The absence of any garments allows the arm of God to visually match the naked arm of Adam. The fluidity of their forms, allows our eyes to move seamlessly across that finite divide, which nevertheless contains within it all of eternity, between the limp hand of Adam and the thrusting gesture of God. We travel that distance to be face to face with the omnipotent Creator.

A company of heaven surrounds the sublime figure of God, enveloped in His flowing robes. Noting that its form resembles the cross-section of a human brain, scholars have suggested that Michelangelo, who dissected corpses in his study of anatomy, was attempting to represent what existed in the mind of God at that moment. Balancing the figure of Adam at the other end of God's outreached arms is a young child who stares directly at the viewer. Since He is held in the hand of

God between the thumb and index finger just as the priest would hold the Host, it seems likely that this child is Christ. Michelangelo's placement of Christ in this scene reinforces the theology that "all things were created through him."

Beside the child, at the center of this company, is a beautiful young woman nestled in God's arm. There have been those who have interpreted this figure as Eve. The supporting evidence for this reading is her intent gaze at Adam, as though she were yearning in anticipation of their union. However, this figure has few resemblances with Michelangelo's depiction of Eve in *The Creation of Eve*. They have different facial features and their body types are different. God creates Eve as a fully-grown curvaceous woman. The female figure in *The Creation of Adam* is a younger girl whose body is scarcely developed. There are more reasons to suppose, as other scholars have, that this teenage girl is the Virgin Mary. First, although this figure does not resemble other representations of Eve by Michelangelo, she does resemble the Virgin Mary who is represented with very similar facial features in one of the lunettes of the Sistine Chapel where Michelangelo depicted the ancestors of Christ.

Since, when Michelangelo created this work, the Annunciation of Virgin was the chapel's central image, it is more likely that the Virgin Mary would be present at this supreme moment of creative action than Eve. The fact that this figure of the Virgin Mary is between God the father and the Christ child with the Father's arm around her is a visualization and foreshadow-ing of the Virgin birth. Her breasts are oriented towards her son whose arms wrap around her leg. Her gaze at Adam, whose creation is also a metaphor for the Incarnation, is in anticipation of her own role in that miraculous and glorious event. The presence of the Virgin Mary in this scene connects it to the chapel's altarpiece. This serves to reinforce one of the central themes of this fresco cycle, namely the connection of the Church to God's initial creative plan foreseen in the mind of God from the first moment of humanity.

The central scene of the second triad is *The Creation of Eve*. It depicts a landscape that slopes down to the left, suggesting proximity of location with *The Creation of Adam*. The sliver of water that separates land from sky in *The Creation of Adam* has become an

The Temptation and Expulsion (detail of Eve).

The Creation of Adam (detail of Mary).

expansive and tranquil sea. Eve is lifted out of Adam's side at the command of God's gesture. Although He is not physically taller than Adam, his form is given greater monumentality by the fact that He appears like a column holding up the top of the frame. Whereas God had reached out to Adam who remained more limp than active, the figure of God is the stable pillar of this composition and Eve is drawn to Him.

Michelangelo used form and design for their psychological and spiritual, as well as visual, impact. As our eye enters the scene from the right, it passes over the body of Adam, by the visual bridge that his arm forms, and, like Eve, we rise towards a face-to-face encounter with a benevolent Creator. Eve responds to her being created with the sort of devotion that we are meant to imitate. Michelangelo's suggestion seems to be that worship is the purpose for which we were created and everything we do, including art making, should be part of that worship.

The reclining figure of Adam in *The Creation of Eve* leans against a tree, partially cut off by the painted architectural frame, which echoes the form of the cross. This posture echoes the figure of the dead Christ in many representations of the Lamentation. *The Creation of Eve* could relate to the birth of the Church from the blood that poured from the side of Christ. The image also contains a reference to the Virgin Mary as the second Eve. Eve was seen as a precursor of Mary, who, by her carrying Christ in her womb, prefigured the Church as containing the body of believers. It may have been Michelangelo's intention to set this scene in the center of his cycle as a way of giving it greater prominence and connecting it to The Assumption of the Virgin represented over the altar. God is dressed in a violet mantle that matched the vestments of the priests and the coverings of the altar during Advent and Lent. This connects the priests to the figure of God and the body of God to the altar.

The last scene of the second triad is *The Temptation and Expulsion*—one is tempted to say that the frame contains two scenes but Michelangelo's point, in part, is that sin and judgment are one and indivisible. As we enter the scene from the left, we find ourselves in the Garden of Eden. The lush vegetation extends across the entire upper regions of this half of the scene forming a protective

canopy over Adam and Eve. Our eye travels across their powerful bodies as it is irresistibly propelled toward the temptation that awaits us.

Because there is no break in the form or action, our eye does not stop at the tree, but is expelled from the garden as if we know that we cannot remain there. As an angel of God banishes Adam and Eve from Eden, their anguish is palpable. One could go as far as saying they have become less physically attractive because of sin. This would certainly conform to Michelangelo's spiritual connection of the human figure. The space between the body of Adam and the last edges of the garden creates a gaping space that seems as expansive as the space between the fingers of Adam and God had been intimate.

Although the *Temptation* and *Expulsion* are often represented as separate scenes, Michelangelo brings them together as one force of cause and effect. Representing the Temptation alone, could create the impression that sin has no consequence. Likewise, the expulsion from Eden isolated from Adam and Eve's sin might create an image of a cruel God. Michelangelo has attempted to bring God's holiness, justice, and mercy together in this one scene. It is theologically significant that Michelangelo has united the scene with a central device in the form of the cross. It was on the cross that God's justice was poured out on Christ and His mercy made available to us. That Michelangelo was able to compositionally unite such complex scenes as the Temptation and Expulsion in one image is a demonstration of his powers as an artist; that he represented both the fall and redemption of humanity in one image is a statement of his faith.

Together the three central scenes of the Sistine Chapel ceiling cycle show us what man and woman were created to be and what we have become. As representations of the spiritual impact of our being created in the image of God and the real effects of our fallen condition, these scenes are the hinge between the perfection of God's creation and need for His intervention through Christ. As works about the creative nature, Michelangelo's Sistine Chapel frescoes explore both the affinity and distance between human and divine invention.

THE VALUE OF CREATION

The relationship between divine and human creativity is an issue that continues to be debated. Not only are there differing opinions concerning what it means to be created in God's image, but there are also debates regarding sin's impact on this relationship. Richard Niebuhr's *Christ and Culture* lists five different approaches Christians have taken to creativity. Although each of these positions may represent a sincere desire to know and follow the Creator, they are radically different approaches to creativity and incompatible assessments of the continuing value of creation. Michelangelo's achievements give us the opportunity to consider in what ways our human creativity is similar to God's creativity and in what ways it differs.

In *A Theological Approach to Art*, Roger Hazelton asks rhetorically, "Must there not be some continuity, some common denominator of meaning, between what man does in the arts and what God does in creation?" The narrative of creation in Genesis lays out a continuing paradox of contrasts and relationships between the Creator and the created.

As we have already noted, Sayers concludes in *The Mind of the Maker*, "The characteristic common to God and man is apparently that: the desire and the ability to make things." Sayers quotes Nicholas Berdyaev saying, "God created man in His own image and likeness, i.e. made him a creator too calling him to free spontaneous activity and not to formal obedience to His power. Free creativeness is the creature's answer to the great call of its creator. Man's creative work is the fulfillment of the Creator's secret will."

If we are created in God's image, we reflect His light and glory. God's revelation of Himself is in and around us; our creative impulse reveals God's divine mark on His creation. However, not everyone who has examined the Genesis account of creation agrees with Sayers.

In *Rainbows For The Fallen World* Calvin Seerveld argues, "There are no biblical grounds either for the usual talk about artistic "creation." Comparisons between God as a capital A Creator Artist and man as a small, image-of-God creator artist are only speculative and misleading." Seerveld goes on to say, "Art is no more special (nor less special) than marriage and prayer and strawberries out of season . . . art is not, therefore, suddenly mysterious or supernatural." However, many find art to be deeply mysterious and supernatural; no less than love (marriage), communication with God (prayer) or nature (strawberries). In contrast to Michelangelo's visual display of monumental power and spiritual inspiration, creativity as described by Seerveld seems to have lost almost all sense of having been formed by a divine imagination.

Perhaps Berdyaev's assertions and Seerveld's reservations can balance each other. When talking of artists being God-like in their creativity, we should recognize the beauty of this analogy, but also its boundaries. Unlike God, human creators are confined by limitations of materials and talent. Genesis describes God creating from His sovereign will and free imagination, out of no obligation and under no confining circumstances. Artists do not create out of nothingness, in this way they are not sovereign as God is; however, by giving form to their materials, they are creating meaning. As the artist brings forth life from his art, his creativity reflects the image of his Creator. The notion that humans create in the image of a divine Creator is one of the principal contributions of Christian theology to the western understanding of art and is explored in every frame of Michelangelo's majestic work on the Sistine Chapel ceiling.

Michelangelo's account of creation is an ennobling view of mankind, placing us above the rest of creation, as beings uniquely created in God's own image. This

understanding of the creative artist sets him between genius and craftsman. Perhaps better than both of those descriptions of the artist is that of gardener. The artist's vocation is an extension of God's mandate to Adam to cultivate the earth. The gardener neither destroys the ground he works nor leaves it as it is. Like the artist, he cultivates his material in order to bring forth its hidden potential.

After the fall, God did not revoke this mandate but He added that Adam would eat by the sweat of his brow. The artist's creative struggle is an effect of the fall. The human artist must know how to master his materials but this mastery is the result of knowing and loving that material. The artist must know what their materials can and cannot do. The artist works with intention, the idea, but they also have to work through the nature and will of the materials. If the artist works against their materials the result will be failure. The artist chooses their material with its characteristics in mind, knowing how to gracefully work this material to their intention.

There are times during the process of giving the idea form through the material elements of the work when the work takes its own direction. The artist who knows their materials will recognize this and patiently work what some would consider mistakes back into the art. We should remember that Michelangelo took a block of marble which had been badly damaged by several artists who had unsuccessfully worked on it and which had then been abandoned to the weather to create a figure of David which has endured as a standard of corporal and artistic beauty.

Michelangelo found confidence and comfort in the fact that his creativity was derived from God. He does not show God forming Adam's body out of the dirt, rather he represents God endowing Adam with the spirit that is his creativity. Adam receives this spirit with an expression of adoration, as does Eve. God created man and woman, before the fall, not as toilers but as creative beings meant for relationships with Him. To exercise our creativity is to imitate and glorify that Creator.

THE THIRD TRIAD

The final triad of scenes, *The Sacrifice of Noah, The Flood,* and *The Drunkenness of Noah,* represents the life and deliverance of Noah. God is no longer physically present, depicted as an old man, in these scenes but His spirit is still active in preserving the believer through faith, death, and redemption. For an artist like Michelangelo, these narratives provided the opportunity for exploring how to approach creativity in a fallen creation.

In *The Sacrifice of Noah,* the aged patriarch stands at the apex of a powerful triangular composition made up of his wife, his three sons and their wives and some livestock. At the lower right, a sacrifice has been made and part of it is being passed towards the altar where a fire is being lit to make a burnt offering.

Several scholars who assume that it had to take place after the flood have described *The Sacrifice of Noah* as a break in the narrative. There are reasons to question this conclusion. Why would Michelangelo hesitate in painting the

beauty of the rainbow that God sent as a sign to Noah after the Flood? Its absence has to raise at least some doubt about the scene taking place after the flood. Furthermore, there is no indication in the scriptures that Noah made sacrifice to God only once in his life. Therefore, if Michelangelo depicts Noah sacrificing to God before the flood, and there are no grounds to question it, we can suppose that Michelangelo selected what scenes to depict and the order to depict them to serve a particular purpose in the function and meaning of his work. As Noah officiates this act of worship, his upward gesture indicates the direction our eyes should take and connects this image to the one that follows it, *The Flood*. Noah's faith points to the reason for his deliverance. As an event of global destruction, the Flood is a precursor to the Last Judgment. Michelangelo's Noah is modeling how the worshiper might find salvation.

The eighth in order of the Genesis narrative, but the first of the nine scenes to be painted, *The Flood* is the most visually complex of the nine scenes with multiple points of action. While a painted, illusionary, architectural frame compositionally limits the cycle's other eight scenes, *The Flood* suggests action that extends beyond the frame. The turbulent landscape of falling and broken off trees and billowing winds embodies the emotion of the scene. As in *The Creation of Adam, The Creation of Eve* and *The Temptation and Expulsion,* the viewer enters the scene on a landscape that slopes from left to right. The tranquil waters of *The Creation of Adam* and *The Creation of Eve* have risen up against their descendents as we find ourselves as refugees on what seems to be one of the last plots of dry land. The disorientation we feel as our eye wanders across the drama without finding a particular figure with whom we can definitively connect creates a similar experience to that of those who did not board the ark that floats away in the distance. The human drama intensifies as the waters rise and survivors begin to crowd onto hill tops and makeshift rafts carrying with them whatever belongings and loved ones they can salvage. Near the center, a father strains to carry his full-grown son while others swim towards a boat only to be clubbed back into the water by its occupants; humanity with all of its compassion and violence is on display. As we know the frightful end that none of those outside the ark will survive, the scene is a reminder of the futility of depending our own resources for salvation.

We should remember that, as Michelangelo painted the ceiling of the Sistine Chapel, he had no way of anticipating the future commission of *The Last Judgment.* He may have conceived these scenes from the life of Noah as both a way of closing his own cycle and also of pointing toward the final end of all human history. These three scenes intentionally play the double role of literally representing the life, salvation and death of Noah and symbolically representing the life, salvation and death of humanity.

Although we enter the scene of deluge and destruction as one of the damned, salvation remains within our view in the form of the ark itself. Along the central

axis of this scene, Noah leans out of a window of the ark in a gesture towards God in heaven. The shape of the ark echoes that of the Sistine Chapel itself and could be read as symbolic of the Church. At the apex of this triangular composition, in one of the upper windows of the ark, is a dove, which stands out even more prominently because it is the lightest form in the composition. This dove points to the hope of deliverance that awaits Noah and his family. However, it also can be read as a reference, at least as a foreshadowing presence, to the Holy Spirit, which is the hope of deliverance that awaits the faithful worshipers in the chapel. This connection between the Holy Spirit to the form of the dove of course derives its origin from the baptism of Christ. The inverse role of water, as symbolically life-giving in baptism and life-taking in the Flood would probably not have escaped Michelangelo's attention.

A third sign of our salvation in the midst of the Flood is a figure, scarcely participating in this drama, who may prefigure Christ. There is one figure— only one individual in this crowed scene—who looks out at the viewer. This single point of connection is very easy, intentionally easy, to overlook. As we enter the scene from the left, we immediately encounter a family who are preparing to leave by donkey, something that might iconographically connect them to the Holy Family in the Flight into Egypt. There is a remarkable degree of calmness in the faces of this family who seem as though they are

The Flood.

framed by the architecture into a scene of their own (indeed they are cropped out of many reproductions). The child looks directly at us with a knowing expression. Given the christocentricity of the entire ceiling, it would not be surprising to find a figure, even in *The Flood,* who foreshadows Him. The fact that we are meant to relate with this child as the only figure in the entire scene with whom we can connect eye to eye further supports the idea that this child is a foreshadowing of Christ who is our salvation.

All three members of the Trinity are present in *The Flood.* The Father is the invisible subject of Noah's gaze, Christ's incarnation and death are both prefigured, and the Holy Spirit presides at the apex of the picture's composition. Through the presence of God in the Trinity and the hope of the ark, which Michelangelo connects to the Church, the artist turned the terror of the Flood, and the Last Judgment it foreshadows, back into hope by reminding us that it is not yet too late—while there are still a few patches of dry land—to call out to Christ and be saved.

The final aspect of *The Flood* that needs to be recognized concerns two trees clinging to their respective rocks in order not to be blown away. Hartt connects these to the Tree of Life and Tree of Knowledge. While this is a possibility, the fact that both those trees were in the Garden of Eden from which Adam and Eve had been banished makes it seem unlikely that they would reappear at this time. Throughout the frescoes of the ceiling there are several connections between trees and the cross. It would be consistent if this were the case here as well. The presence of only two trees may call this interpretation into question. That is unless we recognize that the ark was also constructed of wood and stands in as the third tree and the third cross. The two trees that remain on dry ground frame the central ark, which stands in for the cross of Christ. This arrangement further connects the ark and the cross as means of salvation. In a final brilliant maneuver, Michelangelo's composition causes the tree on our left to seem, by the compression of space in perspective, to be reaching out for the ark. This may be a reminder of the final redemption of the condemned man to Christ's right who received this salvation when all hope of it seemed to be lost.

Our helplessness to save ourselves is once again emphasized in the final scene of the fresco cycle, *The Drunkenness of Noah.* We are confronted with the nude figure of the patriarch reclining on a mat, slightly elevated off the ground. His three sons stand over him in a hut, which is barely taller than they are as they are about to cover him with a cloak. In the background, in a second scene in the same frame, we see Noah planting the vineyard that would ultimately lead to his drunkenness. This digging is a reminder of his toiling under the curse of the fall and his eventual death when his own grave would be dug and his body would return to the earth. Here is an instance where there can be a definite connection between Michelangelo's work and the work of another artist previously done in the chapel. This scene, which alludes to Noah's death, is at the far-east end of the

chapel. On the east wall of the chapel, directly over the doors through which the liturgical procession would enter the chapel are the scenes of *The Archangel Defending the Body of Moses from the Devil* and *The Resurrection and Ascension of Christ*. These works point to the life after death that could be Noah's.

Noah parallels Adam since he becomes in effect the second father of humanity. *The Drunkenness of Noah* shows not only his sin and shame but also foreshadows the fact that this sin will be covered over. The figure of Noah echoes that of Adam, except that Adam's gesturing finger pointed toward God from which his life came and Noah's gesture is down toward the earth to which he will return. However, this is not where the Bible or Michelangelo's frescoes end. The means for that redemption begins with the prophets, sibyls and ancestors of Christ with whom he surrounds the central narrative. What is significant to our discussion of the Noah trilogy is that Michelangelo shows how the judgment of God, through the Flood and Last Judgment, and the mercy of God, through saving Noah and Christ's sacrifice, as direct extensions of God's primary creative act.

There may be some question why Michelangelo would end his cycle on such an anti-climatic point as representing Noah, and by extension humanity, in such disgrace. First, as we have noted, the chronology of Michelangelo's cycle of frescoes was faithful to the scriptures. Noah's drunkenness is the last episode in the life of the patriarch. Furthermore, this scene is meant to be the beginning of the cycle as well as its end. Not only is this scene at the place of the chapel where Michelangelo began working on the project but it was also the first scene under which the liturgical procession would pass. What we see in this image is Noah's shame being covered over. His sins are covered over just as the sins of humanity can be covered over by the death and resurrection of Christ, which are being celebrated in the mass.

In the chapel context, *The Sacrifice of Noah* can be read as a foreshadowing of Christ's sacrifice celebrated in the mass. Faithful to the Catholic doctrine which sees the Eucharist as central to our spiritual life, Michelangelo uses Noah as a precursor of the priestly sacrifice in the mass and *The Drunkenness of Noah* could be read as a warning against abuse of the mass. The same wine that properly sanctified is the cup of salvation that can also be the means of sin. The wine is the same; the sin or sacredness of it depends on our use of it. The same could be said about the gift of creativity that God endowed us with.

THE GIFT OF CREATIVITY

The three scenes of the life of Noah could be examined as statements by Michelangelo on how to, and how not to, use the creative gift in a fallen world. This understanding begins with not forgetting the giver of creativity and the way in which his trinitarian image is reflected in the three dimensions of the work of art, what Sayers called its "idea, energy and power." However, it is not enough to stop there. In his book *Art in Action,* Nicholas Wolterstorff notes,

The Creation of Adam.

though I agree [with Sayers] that the systematic reflections of the Christian on the arts must begin with the 'doctrine' of creation, I think the existence of a significant similarity between man's composing and God's creating is only a peripheral component on that doctrine. Man's *embeddedness* in the physical creation, and his creaturely *vocation* and creaturely *end* within that creation, are where we must begin if we are to describe how the Christian sees the arts.

In addition to echoing the principles of creation which he had focused on in his first triad (*The Separation of Light and Darkness* as an image of God forming the very *idea* of creation itself, *The Creation of Land and Vegetation and The Creation of the Sun and Moon,* representing God's creative energy, and *The Bringing Forth of Life from the Waters* emphasizing His power), Michelangelo's last six scenes, from *The Creation of Adam* through *The Drunkenness of Noah,* complete the artist's understanding of creativity by emphasizing our embeddedness in the creation, our vocation and end.

Adam's, and by extension our, connection in created matter is visually under-scored by the way in which the creation, the landscape, envelops him. Adam's pose is again echoed by the inebriated Noah, reinforcing our connection to the material reality and suggesting our struggle within it. After the flood, Noah planted a vineyard in partial fulfillment of God's command, originally given to Adam, to cultivate the earth. The artist who cultivates their materials into forms that create meaning can look to this command as a creative mandate affirming their vocation. However, Noah overstepped the parameters of God's design. He allowed the fruit of his labors to take control of him and this led to his shame.

Our vocation, according to Michelangelo's frescoes, is worship. Michelangelo

demonstrates this point first and foremost by practicing it, his art is worship, but also by devoting two scenes, *The Creation of Eve* and *The Sacrifice of Noah*, to figures worshiping God. These are the scenes that immediately precede and follow *The Temptation and Expulsion. Before and after the Fall*, our vocation is unchanged, but the way that we practice it becomes dramatically altered. Eve is depicted communing with God personally and directly; Noah, by contrast, requires a blood sacrifice (which prefigures Christ's Passion). In *The Sacrifice of Noah*, we see the patriarch's obedience as he leads his family in worship. He is a picture of the true priest and artist. That his faith is not in vain is demonstrated in the scene of the Flood as he and his family are delivered from judgment. Following Roman Catholic doctrine, Michelangelo emphasizes the need for the sacrament at the altar as an intermediary for worship. Nevertheless, *The Creation of Eve* and *The Sacrifice of Noah* suggest that the highest vocation, in which our creative potential is most powerfully fulfilled, is worship.

Our "creaturely *end* within . . . creation," as Wolterstorff put it, is repeated twice in the last two scenes of Michelangelo's narrative. *The Flood* and *The Drunkenness of Noah* include references to death, judgment, and salvation, all of which are crucial to his statement about human creativity. Michelangelo's work on the ceiling of the Sistine Chapel traces the Genesis narrative of creation, sin and redemption as continuing rather than finished. This structure, that begins with God's creation of the universe and concludes with his preservation of humanity through Noah, reflects an understanding of God's creative role as actively ongoing rather than as passively observing it from above. Human creativity, his art suggests, finds meaning only when in the service of God's unfolding work of revealing Himself and redeeming His creation.

God continues to work through His own imprint on our creativity. Every time an artist creates, whether or not they are conscious of it as Michelangelo was, they act in the image of the Creator. This is an opportunity for the Creator Himself to continue His own creative and redemptive work in that person. The gift of creativity, understood as created, redeemed and sustained by the Trinity, is a gift to humanity that we may know Him more intimately. Although not everyone would acknowledge the trinitarian source of our creativity, there is recognition that this creativity is an important aspect of who we are as human beings. Created in the image of God, our own creativity is a ringing echo of His image within us. The Christian faith, so powerfully represented on the ceiling of the Sistine Chapel, names the source of this mystery of creativity which empowers every artist who creates in a way that reflects the fact that they were lovingly created in the image of their Creator.

Why We
need artists

In considering the place of artists in our world from a Christian perspective, we need to understand the answers to three simple questions. Why do we have artists? Why do we need artists? And, how are we to be artists? I may not give you all the answers in this short discussion, but I hope that my ideas will stimulate your thoughts with respect to these questions.

Why Do We Have Artists?

C. S. Lewis said that reason is the organ of truth, but imagination is the organ of meaning. When people talk about the difference between human beings and animals, they often conclude that one of the greatest distinctions is that animals do not do art. Why don't they? It appears to me that humans have art because they understand, perhaps at an intuitive level, that there is meaning in what we do. Our lives are filled with meaning that is greater than a simple factual evaluation of actions and consequences. We show that we recognize this when events touch our emotions and affect our behavior.

Consider how people react when a relationship breaks up. We could take a completely objective view of the situation with all emotions removed. Or, it is suggested that the only reason anyone experiences sexual attraction and the only reason that a person falls in love is because someone wanted to insure that his genetic code is passed on to the human race. Since that is all the "relationship" meant, we could admit that it didn't work, that it was a failed effort, and we could go find somebody else—another spouse, another mate. But that is not what happens. We feel pain at the loss of an important relationship. When we break up we

want to think about why it ended, what it says about us. We do this because dating and marriage relationships mean more than genetics.

Think about the significance of a funeral. Animals don't have funerals. If we consider a funeral as an objective event, it involves the disposal of a decomposing organism. It would be wise to avoid the decomposing body to prevent the spread of disease. But that is not how we behave. People gather around the body. They sometimes hug or kiss the dead person. A funeral has more meaning than the disposal of a body. A funeral is art in and of itself and it is filled with art. Why? Because we deny that when a person dies it is no more important than a stone falling to the bottom of a pool. In an artificially objective way a funeral would be something we do to handle a particular type of inanimate matter. In reality, a funeral is a ceremony filled with meaning, so we must have art.

What this shows us is that art is always involved in events and circumstances that have significance and meaning. Arthur C. Danto, from Columbia University (by no means either a conservative or a Christian) said, "Art is getting across indefinable, but inescapable meaning." This is a helpful definition, because he is saying that if in your art you are getting your meaning across in a way that is too definable, it is really preaching rather than art. Of course preaching itself can be an art form, but it is an art form that is and should remain distinct from the other arts. Art has to have a place for the observer to explore and wrestle with the message. If the meaning of a work is apparent, allowing the audience with little effort to say, "of course, that is what it means" and if the message can be simply stated in one sentence, the work is not art. You may have heard the famous statement by a dancer who was asked, "What did the dance mean?" She responded, "If I could have said it, I wouldn't have had to dance it." According to Danto, if an artist can enunciate the message in his work, perhaps saying, "Oh, that is Mary rocking the baby and putting him in the manger," then the work is not good art. Art has to be, in some sense, indefinable—but in another sense absolutely inescapable. What we say and do means something. We are not just chemicals. That is why we must have artists. Artists are people who know that, in spite of what we are told by our culture, everything is part of some bigger reality.

This raises an issue that I have been thinking about and that a number of people are constantly working on: What does 'meaning' mean? How do we define 'meaning?' Significance is really a synonym but it does not capture all that is contained in the word 'meaning.' Can we define 'meaning?' I believe we can. While it appears to some to be almost impossible to define, yet it is clearly something we know exists and understand at some level. Even people who insist that nothing has any meaning show that they don't believe their own words when they don't live as people who have no meaning. Many people do not know what it is that gives meaning to life but they know intuitively that life is meaningful. What I have found is that the meaning of life is the glory of God. All meaning is some aspect of

TYRUS CLUTTER. *Altarpiece and Reliquary of St. Clive.* 2005. Mixed media with oil on book pages, 32 x 42 inches.

the glory of God. If there is no God then nothing can have ultimate significance. The word glory means weight, it means significance—it basically means 'meaning.'

For those who want to deny life any meaning, the folly of their view is exposed by Christian artists who express the meaning, the glory of God, in a way that Christian non-artists cannot. C. S. Lewis in the *Weight of Glory* says,

> In speaking of this desire for our own far-off country, which we find in ourselves even now, I feel a certain shyness. I am almost committing an indecency. I am trying to rip open the unconsolable secret in each one of you—the secret which hurts so much that you take revenge on it by calling it names like Nostalgia and Romanticism or Adolescence; the secret also which pierces with such sweetness that when, in very intimate conversation, the mention of it becomes imminent, we grow awkward and affect to laugh at ourselves; the secret we cannot hide and cannot tell, though we desire to do both. We cannot tell it because it is a desire for something that has never actually appeared in our experience. We cannot hide it because our experience is constantly suggesting it, and we betray ourselves like lovers at the mention of a name. Our commonest expedient is to call it beauty and behave as if that had settled the matter…. The books or the music in which we thought the beauty was located will betray us if we trust to them; it was not in them, it only came through them, and what came through them was a longing…. For they are not the thing itself;

they are only the scent of a flower we have not found, the echo of a tune we have not heard, news from a country we have never yet visited.

Lewis is suggesting that every artist recognizes the secret desire for the other country, whether he calls it by one of those names Lewis mentioned or not. A person who is not a Christian doesn't really know what to call the other country. It can be terrifying for one who is not a Christian to even begin to try to identify the other world. But whether he gives it a name or not, he senses that this greater reality exists and gives everything meaning. So Lewis is right when he says, "It is only through imagination that we really sense something has meaning."

It takes the imagination to sense something has meaning because we cannot cognitively grasp the glory of God. The glory of God is beyond our ability to understand or describe. The imagination goes beyond what we can think of and rises to lofty heights where it contemplates the glory of God. It is those elevated thoughts that help us know that everything has meaning. We have artists to stimulate that imagination and to show us that things have meaning. Artists have a special capacity to recognize the "other country" and communicate with the rest of us regarding the greater reality. A good artist will reveal

MATTHEW CLARK. *Telperion and Laurelin*, 2006.
Woodcut with gold and silver leaf,
10 x 12 inches.

something about the greater reality in an indefinable but inescapable way. Having answered why we have artists, we now need to discuss why we need artists.

WHY WE NEED ARTISTS

Thinking specifically of Christians for the time being, why does the Church and why does Christianity need artists? While we have artists because they have the abil-

ity to see the greater reality, we *need* artists because, if Lewis is right, we can't understand truth without art. You see, reason tells me about the truth, but I really cannot

grasp what it means; I can't understand it without art. Jonathan Edwards, the third president of Princeton University, probably the most important American theologian and one of the most prominent preachers in the First Great Awakening makes this point as well. Edwards said that unless you use imagination, unless you take a truth and you image it—which of course is art—you don't know what it means. If you cannot visualize it, you don't have a sense of it on your heart. We see this in one of Edwards' sermons called *Sinners in the Hands of an Angry God*. It is unfortunate that this sermon is one of the only sermons by Jonathan Edwards that people ever read. He has so many others that are quite excellent. Edwards, at one point in the sermon, looks at the congregation and says, "Your righteousness cannot keep you out of hell." That is a truth. You may not believe it, but there is the principle. While that is the content of what he is saying, he says it in a way that better makes the point. He says,

> Your wickedness makes you, as it were, heavy as lead, and to tend downwards with great weight and pressure towards hell; and if God should let you go, you would immediately sink and swiftly descend and plunge into the bottomless gulf, and your healthy constitution, and your own care and prudence, and best contrivance, and all your righteousness, would have no more influence to uphold you and keep you out of hell, than a spider's web would have to stop a falling rock.

Now as soon as he said that, what has he done? He has used imagination, moving from truth into the area of visualization. As a result you have a clearer sense of

what he means. Even if you don't agree with the concept, you begin to recognize what is going on. You may not have understood what he meant until he crossed over into another mode—until he put it in the form of a sense experience and showed you what it looked and felt like. This sensual expression of the truth allows you to hear the truth, to see the truth, to taste it, touch it and smell it. The more various forms in which truth is described, the more we understand and can then communicate truth. We can't understand truth without art. In fact, a preacher can't really express the truth he knows without at least couching it in some artistic form.

The Church needs artists to assist the body in understanding truth, but just as importantly the Church needs artists to equip the Church to praise God. We cannot praise God without art. Within the Christian art community there is frustration for visual artists who observe the important place of the musical arts in worship. Music is easy to use in worship. It holds a prominent place in worship that the visual arts do not. I believe we have to find ways to use all the arts in worship. But there are important differences between visual and musical art that make musical art a more natural element in public worship. It is impossible to get a thousand people together to do visual arts in worship on a regular basis. A large group can appreciate a visual art display in a church setting but they cannot *do* it. In contrast, a thousand people can create and do musical art in a worship service and it is both musical art and worship. Only recently I have recognized that God over and over in the Psalms commands people to worship through music. He does not merely call on the congregation to proclaim his glory, he commands us to praise him with music, with the harp and with the viol. Now obviously he does not command us to worship with musical art exclusively rather than visual art. That is not what I am saying. But consider what the command requires. It is again what Lewis describes in *Reflections on the Psalms.* He says that when you experience the meaning of something, you need to praise it. One of the reasons why we non-artists have a lot of trouble praising God is that we can't enjoy the glory of God unless we praise it. When we praise God, we are not discussing our enjoyment of God, but the praising is the consummation and the completion of our worship as we glorify God. Therefore, one of the reasons we don't praise very well is because we are limited in how we bring forth what is in our hearts and minds. A great poem, an incredible piece of music or a marvelous painting—these are all ways to express our awe at the glory of God. Art is a natural vehicle for pouring out the praise we long to give God. Without art it is almost impossible to praise God because we have no means by which to get the praise out. We can't enjoy God without art. And even those of us who are terrible artists have to sing sometimes. We may not get God's praise out very well, but we have to do something because we have to praise God. So, without art we can't understand the truth, we can't enjoy the truth, and we can't praise God. But there is still another reason the Church needs artists.

The Church needs artists because without art we cannot reach the world. The simple fact is that the imagination 'gets you,' even when your reason is completely against the idea of God. "Imagination communicates," as Arthur Danto says, "indefinable but inescapable truth." Those who read a book or listen to music expose themselves to that inescapable truth. There is a sort of schizophrenia that occurs if you are listening to Bach and you hear the glory of God and yet your mind says there is no God and there is no meaning. You are committed to believing nothing means anything and yet the music comes in and takes you over with your imagination. When you listen to great music, you can't believe life is meaningless. Your heart knows what your mind is denying. We need Christian artists because we are never going to reach the world without great Christian art to go with great Christian talk.

FACETS OF GLORY

Having explained why we have artists and why we need artists, we now need to explore how to be an artist, if you are a Christian. When Lewis' best friend Charles Williams died, he thought that his other best friend J. R. R. Tolkien would fill the gap. Lewis felt that since the three friends were all together and shared so much with each other, the change once Williams was dead would result in his getting more of Tolkien. But he found to his shock that when Williams died he had less of Tolkien. Why? Because, he observed, "I'll never get out of [Tolkien] the particular kind of laugh that only a Charles joke could get." Lewis began to

STEPHANIE ARMSTRONG GORDON. *Untitled,* 2003. Digital photographic print, 9 x 6 inches.

realize that no one human being could call the entire person into action. What happened when Williams died was that Lewis got less of Tolkien because he lost the part of Tolkien that only Charles Williams could bring out. This clarifies how much we need each other. The Christian artist needs to interact in community because of what he will bring out in others and what they will bring out in him.

If artists pick up some aspect of meaning and if all meaning is some aspect of the glory of God, things mean something only because they have something to do with the glory of God. This is true whether we are Christians or not. One artist can express only one little ray of God's glory. We all need one another because we cannot possibly see the whole thing. We need one another because only together do we get some idea of the multifaceted array of God's glory. It is incredibly frustrating to only see one part of the glory and to never quite get it out. We need one another to help us express our part of the meaning.

This can be seen from an example in the life of Tolkien. Once, when Tolkien had a terrible case of writer's block, he sat down and wrote a short story. It broke through his writer's block, and he went back and wrote *The Lord of the Rings* very quickly after that. If you want to read this short story, it is called *Leaf by Niggle*. Go into any bookstore and find a Tolkien reader; it is in there. The story is very short. It is about a poor artist, a man named Niggle, who spent all of his life trying to paint a huge mural of a tree on the side of the post office in his hometown. Niggle had a vision but he was never able to get it out. Ultimately, all he ever did was draw one little leaf down in one little corner. Of course everyone in town asked, "Why did we commission you? We paid you all this money and what is going on?" Not long after, Niggle dies and suddenly finds himself on a train going to heaven. As he is looking at the landscape from the train he suddenly sees something off to the right and he tells the train to stop. When the train stops, Niggle runs over and at the very top of the hill is his tree. He looks up and realizes that this is the tree he had in his mind all of his life. He had been trying to draw it the entire time he worked on the mural and all he had ever gotten out was one leaf. For some reason, when Tolkien realized that the single leaf was all he ever would get out, he was able to go back to work. He realized that he would never produce the whole tree, the whole glory of God.

We get a leaf. But only together as artists are we going to see the whole incredible tree. We all have to "do our own leaf." Every one of us has something to contribute.

THE WORK
of our hands

Then the LORD said to Moses, "See, I have chosen Bezalel son of Uri, the son of Hur, of the tribe of Judah, and I have filled him with the Spirit of God, with skill, ability and knowledge in all kinds of crafts—to make artistic designs for work in gold, silver and bronze, to cut and set stones, to work in wood, and to engage in all kinds of craftsmanship.
—Exodus 31:1-5

The way we make things reveals our attitude toward the substance of creation and exposes the measure of our esteem for the receiver of our work. Some in the art world today invest little value in craftsmanship, but it has not always been that way, and must not be that way now for the Christian making art. Let us look to Scripture to hear the call to excellence and discipline in our craft that begins in God's mandate in Genesis, continues in the professional diligence of Bezelel, and is carried on in the quality of work produced by Jesus and Paul. With this knowledge of our high calling, we hope to carry out our creative work with great skill to the glory of God.

ART AND THE BIBLE
In the beginning God made everything and He made it well. Then He issued a call to all of mankind to fill the earth, subdue it, and take care of it. In Genesis 2:15, God set His apprentice up in the workshop of Eden where the man was to learn his craft in the work and care of the creation. Before the Fall a standard was set for the skilled mastering of the substance or "stuff" of creation. But that was only the beginning. To really hear the Bible's call to excellence, we need to skip to the next book.

Exodus contains some of the most quoted passages by scholars when examining Biblical attitudes toward making aesthetic objects. They include God's detailed instructions to Moses concerning the construction of the tabernacle and making the articles and garments necessary for the sacrificial system; the calling of Bezelel, Oholiab and others chosen to make all that was commanded; the events concerning the wrong use of artistic skill in the sculpting and worship of the golden calf; and most important, the filling of men with the Spirit of God so that the work could be accomplished. This was an enormous and complex project, taking a year to complete. Fourteen different materials were used, all brought from Egypt: gold, silver, brass (bronze), blue fabric, purple yarns, scarlet fabric, the finest byssus linen, goats' hair, rams' skins dyed red, badgers' skins, acacia wood, olive oil, spices, and precious stones. The tabernacle must have been well built, because once it was completed, it was used for about 500 years. Exodus 36 details the actual making of the tabernacle, beginning with a reiteration of the naming of Bezalel and Oholiab while citing the qualifications of the craftsmen:

> Now Bezalel and Oholiab, and every skillful person in whom the LORD has put skill and understanding to know how to perform all the work in the construction of the sanctuary, shall perform in accordance with all that the LORD has commanded.

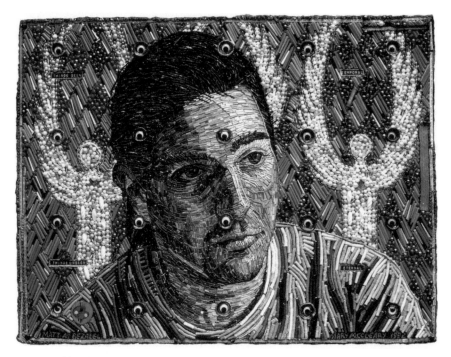

MARY MCCLEARY. *Matt as Bezalel*, 1992. Mixed media collage on paper, 22 x 30 inches.

The Hebrew words for skill and understanding in this passage speak of the artist's wisdom, ability, intelligence and insight. Gene Veith's book, *State of the Arts: From Bezalel to Mapplethorpe,* is helpful in clarifying how these qualities are prerequisites to any artful endeavor. The craftsmen had been prepared for a lifetime of craftsmanship while slaves in Egypt. This was not a fun art class at the YMCA. There were expectations of excellence, and the recognition that talent requires cultivation.

Craftsmanship is the skilled manipulation of materials in object making. The best craftsmen, artisans and artists have the ability to "transfigure matter," transforming it through hard work to reveal beauty and occasional magnificence. Throughout history humans have made things to help meet their physical, emotional, spiritual, and intellectual needs. Craftsmanship is only one aspect of art but usually involves the hard work of making art well. You can have craftsmanship without art, but seldom art without some level of craftsmanship.

Many of us get spectacular ideas for artworks, but few of us see those ideas manifested. Without the flesh of the materials of wood, metal, paint and paper, these ideas are little more than daydreams. Good craftsmanship reflects the maker's respect for himself, the materials of creation, as well as a high regard for the user or viewer.

OLD-FASHIONED AND OBSOLETE

Is craftsmanship obsolete? We wonder when we learn of the 2004 poll of 500 arts figures ranking French surrealist Marcel Duchamp's 1917 piece *Fountain,* an ordinary white, porcelain urinal, the most influential work of modern art. Or Andy Warhol' s comment that "Art is what you can get away with."[1] And what about the studios that fabricate work for artists who send plans for projects but have no hand in their execution? The Mark Smith Studio in England has produced work for around 400 artists from all over the world, including such names as Damien Hirst and Rachel Whitehead.[2] Or what about disputes about the relevance of quality over the past years, discussed in the 1990 *New York Times* article by Michael Brenson, "Is 'Quality' an Idea Whose Time Has Gone?"[3] Perhaps we are so overwhelmed by the stuff cluttering up our lives that individual objects are devalued. Craftsmanship requires time, whether time spent acquiring skills or the actual time needed to make an object. But time costs money, and most of us, as either makers or consumers, want things cheap, instantly and without effort.

The bottom line is that there is no such thing as a free lunch. Someone has to make the thing, no matter who had the idea originally or who gets the credit. For all the controversy about quality in the last fifteen years, the handful of collectors who might value poorly crafted paintings still expect to have them framed well. It's easier to discuss craftsmanship when we consider objects with practical use. We all want our vases to hold water and our cars well designed and efficient. The

woman on the frontier who made a quilt for her family wanted to add beauty to the cabin, keep her family warm in the winter and have something to pass down to subsequent generations as a prized heirloom. She would take great care in selecting the fabric and planning the design. Pride was taken in stitches that were small, uniform, and consistent. They were evidence of her disciplined hand but also practical, wearing better through numerous washings. Human actions are often symbolic and full of meaning. That object was a physical manifestation of love for family, the love of beauty, and the love and redemption of worn out useless things. Just as it was the incarnation of a whole system of values and things held dear, other handmade things represent the values of the maker.

NATURALLY GIFTED JOURNEYMEN

It is helpful to recall that for much of human history art was indistinguishable from craft. Most artists worked by commissions turning out products or decorations for either the church or the palace. The same craftsman painted the shop sign as the altarpiece. Everything had to be made by hand, so craftsmen furnished goods you couldn't provide for yourself. This was the pattern in most of the world until the industrial revolution. The craftsman was accountable, because he was selling his ware to his neighbors who he would see everyday. Gradually the work of the altarpiece grew to be more valued than the sign or the ceramic pot, and there was a separation between art and craft. Art historians disagree on when this occurred. Some trace it to the Renaissance when spokesmen like Alberti wrote tracts claiming that painters, architects and sculptors like Michelangelo and Leonardo were not menial tradesmen but gifted humanists. Some point to 1563, when the *Accademia del Disegno* was founded in Florence, the first institution to separate the art of certain artists from the guilds of ordinary journeymen. This separation was made wider and influenced by the first art fairs, the emergence of art dealers, "the Enlightenment," the growing middle class, and the industrial revolution.

Although we liberally use the word "creative" to describe everything from our children's art projects to a friend's scrapbook hobby, the Bible only speaks of God creating, never people. Jacques Barzun reminds us that it is in the 18th-century novel, *Tom Jones,* where one finds the "first hesitant use of the word 'creation' applicable to a work of art."[4] In *The Use and Abuse of Art* he goes on to describe other influences that caused some to question craftsmanship as a priority. Romanticism developed in the nineteenth century, bringing the perception of the artist as creator, "genius, seer and prophet." With Modernism came the substitution of art for religion and museums for churches. The enemy of art became "bourgeois values;" each work of art was said to be a "universe that answered only to its own laws." Kant insisted that great art must seem spontaneous and be unhindered by inherited rules. Artists, feeling the weight of the advanced civiliza-

tions that had gone before, sought cures in such movements as Primitivism, Surrealism with its automatic writing, art of pure sensual sensation, and art dependent on the irrational and chance. Though far from universal opinion, some people valued art for its conceptual qualities more than its physical expression. Wendell Berry wrote:

> The great artistic traditions have had nothing to do with what we call 'self-expression.' Though they have certainly originated things and employed genius, they have no affinity with the modern cults of originality and genius.[5]

LEARNING FROM OUR CREATOR

"The heavens tell of the glory of God. The skies display his marvelous craftsmanship" (Psalm 19:1). The heavens and the earth God created were perfect. After six days of creation, "God saw all that He had made and behold, it was very good." What "good" means is explored elsewhere in this volume, but for this discussion let us reflect on God seeing that there were no flaws in His creation. The craftsmanship was impeccable. Think of the interrelated and interdependent unity of creation. And consider the variety. Scientists believe there may be as many as fifty million kinds of animals and four hundred thousand species of plants alive today. The balance between the design principals of unity and variety, so central to all of mankind's visual expressions and perhaps a "natural law" of design, reflect the variety and unity in creation as well as the three-in-one of the Trinity. Even though we are fallen creatures living in a fallen world, we are created in God's image as a creator. It follows that we might find guidance for our own "creations" by looking at aspects of His.

Good craftsmanship, and the design inherent in it, is also "just right," specific, and deliberate. In working out a composition for a collage, I make decisions about the overall size of the work as well as the relative size and proportion of the subject matter. I anticipate the colors that will be used and consider the angles of my shapes, looking for opportunities to repeat them in order to hold the composition together. This is hard work, I'm rushed for time, so often tempted to cut corners leaving areas "good enough." I make lots of mistakes and get tired of erasing over and over to get the proportions and placement right. Though the things I make have only a tiny significance, I can't help but think of the specificity of God's original creation when I am struggling with my efforts. For example, I remind myself of His deliberation in setting the slant of the earth at the odd angle of 23°. A small thing, but crucially important. If the axis were not tilted, the sun would always be over the equator making only half as much land of the earth available for cultivation and habitation. If the earth had not been tilted at that exact angle, vapors from the ocean would move both north and south, piling up continents of

ice. So it is fitting for those whom Tolkien called "sub-creators" and Dorothy Sayers called "little c" creators to similarly fine-tune our creations in our efforts to bring order out of chaos. Although play and spontaneity can be part of the process, the finished result is deliberate. We are told to "be perfect, even as your Father in heaven is perfect."

Carrying the "image of God" as makers implies working responsibly with compassion, purpose and love. Our work as artists/craftsmen is only accomplished through God's grace, His "unmerited favor," but as agents of God's grace, we alter the materials of creation into objects that benefit other people, also created in His image. Consider how these definitions of *grace* might guide our attitude toward those who eventually use our work: "The exercise of love, kindness, mercy, favor; disposition to benefit or serve another; favor bestowed or privilege conferred," and "To dignify or raise by an act of favor; to honor." We love, dignify and honor by offering our best work, sometimes better than the recipients desire or expect. In the movie, *Babette's Feast,* a famous French chef spent all she had to cook a sumptuous meal—the culmination of a lifetime's work—for a family that only belatedly came to appreciate her gift. God's grace is generous and lavish beyond our comprehension, as ours should be. Jesus tells us that we are to love our neighbors as ourselves. In our work, we take our viewers and users into account, not in some condescending or sentimental way as is generally supposed, but in an elevated respectful way, expecting the best from them and giving them our best efforts.

THE ALMIGHTY AS CRAFTSMAN

Anthropomorphic language in scripture describes God as a craftsman. As early as Genesis 2:7, God is a sculptor in clay, one so good He can actually bring forms to life: "The Lord God formed man from the dust of the ground, and breathed into his nostrils the breath of life, and the man became a living being." In Genesis 2:19 he makes animals out of clay: "out of the ground the Lord God formed every animal of the field and every bird of the air." God is compared to a potter over and over in Isaiah 45:9, Isaiah 64:8, Romans 9:20-22, and in Jeremiah 18:4-6 where He judges, destroys and remakes a pot not up to His standards. God is depicted as a tentmaker (Is. 41:22), a metalworker (Mal. 3:3, Job 23:10), and a carpenter (1Kings 11:38, 1Samuel 2:35, 1Samuel 17:10, 1Chr. 17:25, Psalm 69:35, Psalm 127:1, Hebrews 11:10). In other verses the description of God making things with His hands reminds me of our own bodily efforts as craftsmen on materials we use: "When I consider Thy heavens, the work of Thy fingers, the moon and the stars, which Thou hast ordained" (Psalm 8:3), and "It is I who made the earth, and created man upon it. I stretched out the heavens with My hands, and I ordained all their host" (Isaiah 45:12).

God is depicted not just as creator of the world, but also as a worker. Sculpting, pottery, tent making, metalworking, carpentry, and needlework are all deliberate

activities that require effort. No wonder the Hebrew attitude toward working with one's hands contrasts with that of other ancient cultures. The Greeks held manual labor in low esteem as did the Romans, whose wealthy citizens relied on slave labor. The Rabbis taught, "Whoever does not teach his son a trade, is as if he brought him up to be a robber." In fact the great teacher, Hillel, was a woodcutter; his rival, Shammai was a carpenter, and others were shoemakers, tailors, carpenters, sandal makers, metal smiths, potters, and builders. During building of Herod's temple, 1000 priests had to be trained as masons so that area would not be defiled. What a contrast to the division between sacred and secular vocations afflicting the church!

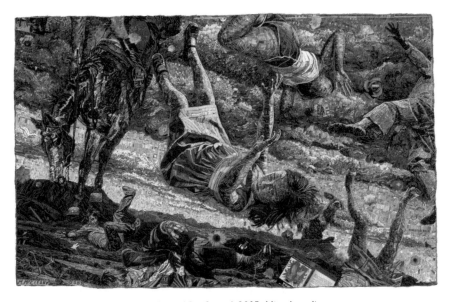

Mary McCleary. *9.81 Meters Per Second Per Second*, 2005. Mixed media collage on paper, 45 x 71 1/2 inches.

CRAFT IN SCRIPTURE

We have seen that all the way back to Adam, mankind has been called by God to work and shape the substance of the creation well. But the first actual craftsman we encounter in scripture is Tubal-Cain (Gen. 4:22), the "forger of all implements of bronze and iron." It's not surprising that the Hebrew word for artisan is *hadash*—a worker in metals or hard substances. Scripture mentions craftsmen as diverse as brick-makers, carpenters and wood-workers, carvers and engravers, potters, dyers and fullers, embroiderers, glassmakers, grinders, stonemasons, metalworkers (blacksmiths, silversmiths and goldsmiths), oil-makers, painters, paper-makers, perfume-makers, plasterers, spinners and weavers, tanners,

tent-makers, wine-makers and ship-builders. There are many examples of crafts-men in the Bible. Moses' brother, Aaron, was a goldsmith. In 2 Timothy 4:14, Alexander is a coppersmith, and in Acts 19:24, Demetrius was a silversmith. Although many craftsmen were slaves, it is believed that as early as Nehemiah's time, Jewish craftsmen had organized into guilds (Nehemiah 3:8, 31, 32). Their skills were valued by the powerful, "He carried into exile all Jerusalem: all the offi-cers and fighting men, and all the craftsmen and artisans—a total of ten thou-sand. Only the poorest people of the land were left" (2 Kings 24:14).

Though most of the artisans in scripture were men, women were also expected to be good craftsmen. In Proverbs 31, we discover an "excellent wife" held up and appreciated for the skill of her hands:

> She looks for wool and flax, and works it with her hands in delight . . . She stretches out her hands to the distaff. And her hands grasp the spindle . . . She is not afraid of the snow for her household, for all her household are clothed with scarlet . . . She makes coverings for herself; Her clothing is fine linen and purple . . . She makes linen garments and sells them, and supplies belts to the tradesmen . . . Give her the product of her hands, and let her works praise her in the gates.

This busy woman had high standards for the things she made and experi-enced the joy of doing something well. She sold her work, and had a reputation for her craftsmanship.

Were we analyzing the New Testament as a literary work, we would notice that the two main characters, Jesus and Paul, were both craftsmen. The New Testament tells us of Jesus that, "All things were made through Him; and without Him was not anything made that hath been made" (John 1:3). As the second per-son of the Trinity, Jesus made the creation. But then on earth as a human for the first thirty years of his life Jesus was a craftsman making things as we do—by shaping and combining the substance of creation. There are two passages in the New Testament that indicate that Jesus was a carpenter: "What is this wisdom given to Him, and such miracles as these performed by His hands? Is this not the carpenter, the son of Mary and brother of James, Joses, Judas, and Simon?" (Mark 6:2), and "Is this not the carpenter's son?" (Matthew 13:55). The Greek word trans-lated as "carpenter" is *tektwn*. A *tektwn* is someone who works with his hands, a sort of a general contractor or builder. As a woodworker, a *tektwn* would cut the trees for making beams, paneling, doors, doorframes, and windows for buildings. He might make furniture such as stools, tables, and chests, as well as farm imple-ments such as yokes, plows, gates and shovels.

During Jesus' time, the oldest son would be expected to follow the trade of his father. Some scholars speculate that Jesus may have helped in the reconstruction

in the town of Sepphoris—the provincial capital of Galilee only four miles from Nazareth. Artisans were called from all over Palestine to participate in the ambitious program of rebuilding this town, called "the ornament of the Galilee" and one of King Herod's headquarters. I think of these construction projects when I read Jesus' words to His disciples in John 14:2, "In my Father's house are many rooms; if it were not so, I would have told you. I am going there to prepare a place for you." There is a tradition that Jesus was famous in this farming region for his yokes, and people took pride in owning one. Os Guinness notes in *The Call*, that in the second century the Christian apologist Justin Martyr, who grew up not far from Galilee, wrote that it was still common to see farmers using plows made by Jesus.[6] It is appealing to those of us who also work with our hands to reflect on Jesus' wooden plows and yokes, which were of such quality that they could still be used in the second century, a hundred years after they were made. This speaks of Jesus' consideration and high regard for those using His tools and shows His confirmation of the significance of everyday activities.

The Apostle Paul was a tentmaker. He was a craftsman whose work could have also included leatherwork and upholstering. He likely learned this skill as a boy growing up in the city of Tarsus, in the province of Cilicia. This area was noted for its export of coarse goats' haircloth used for tents, cloaks, sacks, shoes and beds. To make his tents, Paul sewed together lengths of this cloth and then attached loops and ropes. In Acts 18:3 we are told that Paul left Athens and went to Corinth where he stayed with Aquilla and Priscilla and worked with them at tent making. I think of the roughness of the cloth and the monotony and difficulty of stitching it by hand when I read Paul's words in Acts 20:34, 35:

> You yourselves know that these hands ministered to my own needs and to the men who were with me. In everything I showed you that by working hard in this manner you must help the weak and remember the words of the Lord Jesus, that He Himself said, "It is more blessed to give than to receive."

In Ephesians 2:10, Paul writes, "For we (the church, the body of Christ) are His workmanship, created in Christ Jesus for good works, which God prepared beforehand in order that we would walk in them." Three kinds of making and working are described in Ephesians 2:10. The first is workmanship, from the Greek word *poiema,* which can also mean masterpiece. Poiema refers to something made, written or composed; it's where we get the English word "poem." Most of us will never produce a masterpiece in our lives, but here Paul describes Christ, the carpenter/craftsman creating His masterpiece, the church. The only other time the word poiema is found in the New Testament is in Romans 1:20 where it refers to the natural creation, God's physical masterpiece. The next making word is create, a derivative of the Greek word, *ktizo,* "creation by shaping something

already in existence, transforming or changing it completely." The third making and working word has to do with our good works, here *ergoin* from the Greek word *ergon*. *Ergon* has to do with our work, not work that leads to salvation, but the work initiated and pre-planned by God for us to live by His plan and purpose. It can mean, "anything accomplished by mind, hand, art or industry, a business, an enterprise or undertaking."

Paul uses *ergon* words frequently in his letters as he urges others to work hard in their occupations. For the many artisans in the ancient world, this would imply their practicing their best craftsmanship. Examples include: "Whatever you do, do your work heartily, as for the Lord rather than for men" (Colossians 3:23), and "Make it your ambition to lead a quiet life and attend to your own business and work with your hands, just as we commanded you" (1 Thessalonians 4:11).

THE CULTURAL MANDATE

The Christian view of the material world is full of paradox. It affirms the goodness and beauty of God's creation, yet recognizes that creation as blemished and disfigured by the fall. In contrast to Gnosticism—a theological view from the second century that holds that creation or anything material is intrinsically evil— Christianity sees material creation as evidence of God's glory. In Genesis 3 after his disobedience to God, man is told he will "toil all the days of his life," his work will be subject to futility. But this does not nullify his earlier charge, known as the cultural mandate, where he is given stewardship over creation: "God blessed them and said to them, 'Be fruitful and increase in number; fill the earth and sub-due it. Rule over the fish of the sea and the birds of the air and over every living creature that moves on the ground'" (Genesis 1: 28).

Can you imagine going through the trouble of making this glorious compli-cated creation and then turning it over to fallen creatures such as we? "Thou does make him (mankind) to rule over the works of your hands; Thou hast put all things under his feet" (Psalm 8:6). When you give someone a precious gift, you hope they appreciate and take care of it. God has given us the freedom and the gifts or talents to shape his creation. We were made to make things. Our charge is to reorder the stuff of creation as agents of common grace, satisfying human needs—our own and others. Barry Liesch writes:

> Reformed theologians take this passage as a command, a charge, to sub-due not only all living creatures, but to discover and use the potentials in all materials . . . To subdue means to tame, master, humanize, impose order, develop technique—to place our imprint on creation in a positive way. This takes effort, wisdom and experience and infers mankind is invited to work and extend God's creation. In that sense 'creation' is uncompleted, unfinished.[7]

This skilled mastering of the materials of creation describes craftsmanship. According to Wendell Berry, "To use gifts less than well is to dishonor them and their Giver. There is no material or subject in Creation that in using, we are excused from using well; there is no work in which we are excused from being able and responsible artists."[8] So we paint, attempting to rearrange His created molecules of cadmium red and hydrated ferric oxide (sienna) on a titanium dioxide and acrylic resin ground coating woven linen. We make an etching using His elements—hydrogen, nitrogen, and oxygen (nitric acid)—to bite indentations in a plate of zinc into which we can push ink of boiled linseed oil and soot to make impressions on paper made of His cotton pulp. As makers we manipulate our materials, while the inherent qualities of materials shape our decisions as makers. We dominate our materials, but are subordinate to them. Some of the greatest artists/craftsmen take their manipulation of materials to extremes, amazing us like high wire walkers, helping us realize the unimaginable potential in God's creation. Their efforts bring delight, but are also a tangible demonstration that "this is important—pay attention." Our selection of one material over another to better suit our purpose; the detail and care we lavish on the surface; and our sensitivity to the characteristics of our medium demonstrate appreciation for the resources God gives us.

Aesthetic experiences are practiced through the bodies we have been given— our hands, fingers, eyes, and brains. Through our bodies, magnificent though imperfect, we live out our service to God and others as makers. There is sometime selflessness in making, as we forget about ourselves, absorbed in directing our media. The irony is that the finished product exhibits the unique evidence of the hand of the workman. Just as we practice our craft through our bodies, we enjoy it through our senses, whether viewing the rich surface of the Ravenna mosaics, rubbing our hands over a Grinling Gibbons wood carving, or feeling the weight of a silver teapot by Hester Bateman. Our attraction to the highest quality work only slightly less than perfect may remind us of the paradox of man, flawed, though created in God's image "a little lower than the angels."

TEACHERS, WORK, YADA, YADA, YADA

So how should an artist proceed in developing skill in his craft? Those contemplating a career in art should study with the very best teachers they can find. Don't just depend on someone in the neighborhood, but seek out the best. Most people head to universities for training, but some departments emphasize career strategies as much as making objects well. Although there are hundreds of university art departments across the United States, they may not have professors trained in the skills you expect to learn. Recently my art department decided to hire a new drawing teacher, someone with not only traditional figure drawing skills, but design ability, taste, and a sophisticated understanding of contemporary

issues in representation. We conducted an extensive search and had several hundred candidates over a two-year period, yet there were only three candidates that met our criteria. The candidates we rejected may be fine artists and many will get teaching jobs and gallery representation, but they did not have the skills to teach the figure. Research may be required to identify teachers with specific skills, whether it's bronze casting or installations. When you visit museums or look at art books and magazines, make note of the artists whose abilities you admire. Then check in *Who's Who in American Art* to discover if they are teaching or at least where they studied. If they weren't in school too long ago, you might have a clue where to learn your craft. Students can also serve as apprentices with artists they admire. Am I only advocating the study of traditional techniques? Absolutely not. Skills are not static. Certainly drawing is fundamental, even when you are using a Wacom tablet and stylus in Photoshop. But artist Tim Hawkinson crafts remarkable and ambitious sculpture using everything from fingernail clippings to electronics, and Andy Goldsworthy displays amazing craftsmanship with leaves, sticks and other found materials from nature.

Bezalel and Oholiab were likely exposed to some of the finest craftsmanship in the ancient world while slaves training in the workshops of Egypt. Like them, those who aspire to great craftsmanship should regularly look at as many examples of fine art and craft as possible. For us this would include work from all periods of time and all geographic regions. Without this informed perspective one easily develops a narrow-minded view of contemporary art, assuming it is always the work of greatest significance. There is plenty of good art being made today, but with bad art and craftsmanship so prevalent, we need reminders of the standards we should seek. The pursuit of quality is never ending, however. The more we learn, the more we expect of others and ourselves. Don't be content just viewing art in magazines or on the internet. Aspiring to make great art without seeing it in person is like aspiring to be a great chef when you have only eaten at McDonalds. Your work will only be as good as the art you have seen over and over.

TIM HAWKINSON. *Bird*, 1997. Fingernail parings and superglue, 2 x 2 1/2 x 2 inches. *Andrea Nasher Collection.*

The Hebrew word for construction, *abodah,* means labor. Put yourself in the place of these Hebrew

craftsmen hard at work in the middle of the nowhere, as they endeavor to fulfill the Lord's detailed instructions. Construction of the tabernacle was tedious and hard. Making the sixty pillars of acacia wood with copper bases and silver capitals for the outer court, the one hundred and twenty silver hooks attached to them, and one hundred and twenty brass pegs for anchoring them to the ground was exhausting. It was tedious and tiring constructing the forty-eight boards of acacia wood for the dwelling place, each covered with gold, resting on a silver base. On each of these boards were attached four gold rings (one hundred and ninety-two in all) to hold the poles that kept them in place. These days we consider this sort of repetition "obsessive," using a term for a psychiatric disorder for an activity that would have been considered commonplace in the past. Lewis Mumford wrote:

> We may easily underrate the amount of dull and repetitive work even the freest craftsman is compelled to do, though he work under ideal conditions. Indeed, the overemphasis of the creative moments in art, the tendency to picture esthetic creation as one long, fervent, spontaneous activity, without severe toil and painful effort, without constant mastery of techniques, is one of the sure indications of the amateur or the outsider.[9]

Repetition can perfect one's skills. Though difficult, work done well has its pleasures. One is reminded of the comment runner Eric Liddell made to his sister in the movie, *Chariots of Fire,* "God made me for China, but God also made me fast, and when I run, I feel his pleasure."

In Exodus 36:1, the word "to know" is the primary Hebrew term for knowledge, *yada,* which means, "to know by experience." The type of knowing the Lord gave Bezalel and the craftsmen was not just a theoretical, intellectual knowledge of the medium, but an experiential, intimate knowledge that involves the whole person—his intellect, emotion and will. It is the word found in Genesis 4:1, to describe sexual relations, "And Adam knew Eve his wife; and she conceived, and bore Cain, and said, I have gotten a man from the LORD."

It would be hard to find a clearer description of the relationship between a craftsman and his tools and materials. You can't just read a book to develop expertise in mixing a paint color. You have to put in hours and hours of your time so that the process becomes second nature. There are no short cuts to this kind of knowing, and the intimacy reflected in it is found in the expression of a craftsman's tool being "an extension of one's hands." Scripture does not command that we know our materials and have skills like this. It assumes that someone charged with the task of making has that sort of knowledge.

TIME AND TALENTS

Commitment is required for anyone to have that familiarity. In the medieval guild system a person aspiring to learn a trade would start as an apprentice, agreeing to work for a master craftsman for a specific length of time and in return receive an education, food, clothing and shelter. Their time as an apprentice usually lasted from five to seven years, but could last up to fourteen years. Working from sunrise to sunset, six days a week, an apprentice was subject to his master and so focused on his work, he was not allowed to marry. Once an apprentice had a certain degree of skill, he could become a journeyman or day worker who was paid wages in the shop of a master craftsman. Finally if he aspired to membership in a craft guild, he would work with his own materials on his own time to produce his masterpiece, demonstrating his technical and artistic skills. If these were accepted by the guild, he could become a master, set up his own workshop, and take in apprentices himself. Just as in our own time, the number of artists and craftsmen who rose to the top were limited. It takes as long to develop appreciable skills today. Painter Alex Katz wrote,

> It takes most painters at least eight or ten years to master the craft and become proficient, and perhaps another eight or ten years to become a master Many of the more interesting artists usually don't emerge until they are well into their thirties or forties.[10]

Not every work of art takes time to make, but time is required for "yada" familiarity with materials and their potential. Viewers perceive this dedication, sometimes on a subconscious level, and respond to it. Because humans tend to devalue what comes too easily, if a new technology is used to make an object with less difficulty, perhaps a compensating skill is necessary to draw the viewer's interest. One senses "grace" in good craftsmen who make their work look easy, even though this often fools the amateur. Tiepolo's drawings can look like scribbles, but a closer look reveals an understanding of form that comes from years of hard looking and analysis. At first glance the paintings of Jerome Witkin look effortless, because of the flourishes and vigor of his brushwork. It's not until you learn that he constructs elaborate stage sets for his models and will repaint areas twenty times that you understand that the effect does not come so easily. Some people over-spiritualize art these days, perhaps influenced by the "art as religion" condition described by Barzun. Professionals realize it requires commitment and hard work, and avoid the emotionalism generally expressed by those who do art as a hobby.

The effort at becoming a good craftsman is not unlike the discipline and commitment needed to excel in any other activity. Olympic athlete Joan Benoit Samuelson, one of the all-time great marathoners the world has ever seen, would run up to 200 miles each week training for her 26.2 mile races. Valerie Sterk, a

member of the U.S. Olympic volleyball team, once said, "Sometimes I think it's a little silly that I spend seven hours a day, six days a week trying to keep a little white ball off the ground, but God has given me the ability to play and put me on this team for a reason."[11] Steve Jobs discussed some of the attitudes and practices that make Apple a successful company:

> Our primary goal here is to make the world's best PCs—not to be the biggest or the richest. We hire people who want to make the best things in the world. You'd be surprised how hard people work around here. They work nights and weekends, sometimes not seeing their families for a while. Sometimes people work through Christmas to make sure the tooling is just right at some factory in some corner of the world so our product comes out the best it can be. People care so much, and it shows. We do things where we feel we can make a significant contribution. That's one of my other beliefs.[12]

Although I'm not advocating ignoring Christmas or one's family, we need reminding that the individuals who give the most of themselves often receive the greatest reward. Time and effort does not guarantee that each of us will become a Velasquez or a Bernini, but we must not forget what it takes for excellence. With every gift comes the requirement to use it well, "to whom much is given much is required." One is reminded of the parable of the talents in Matthew 25:14-30. Although the talents Jesus describes are measures of gold, the teaching that people receive varied gifts is applicable, as is the expectation that we invest those gifts to multiply them.

Bᴇɴᴇᴅɪᴄᴛɪᴏɴ
Wendell Berry wrote:

> The artistic traditions understood every art primarily as a skill or craft and ultimately as a service to fellow creatures and to God. An artist's first duty, according to this view, is technical. It is assumed that one will have talents, materials, subjects—perhaps even genius or inspiration or vision. But these are traditionally understood not as personal properties with which one may do as one chooses but as gifts of God or nature that must be honored in use. One does not dare to use these things without the skill to use them well.[13]

There is a paradox in a life spent refining and sharpening our abilities as craftsmen. We know that "nothing seen is permanent," but we believe along with Pope John Paul II that "human actions once performed do not vanish without a trace: they leave their moral value, which constitutes an objective reality."[14] There

is a connection between the "things seen and the things not seen." The objects we make as artists and craftsmen are incarnations of our deepest beliefs. Just like the quilt made by the homemaker for her family on the frontier, they demonstrate our commitment to beauty, hard work, discipline, respect for God's creation, and love of others.

A rabbinic tradition holds that Psalm 90:17 was the blessing invoked by Moses at the dedication of the tabernacle. His words bear repeating at the completion of our own aesthetic endeavors: "And let the favor of the Lord our God be upon us; and do confirm for us the work of our hands; Yes, confirm the work of our hands."

Endnotes

1 Jacques Barzun, *From Dawn to Decadence* (New York: Harper Collins, 1987), 791.

2 Kieran Long, "Art Factory," *Icon Magazine* (November 2003).

3 Michael Brenson, "Is 'Quality' an Idea Whose Time is Gone?" *New York Times* (July 22, 1990): Sec. 2, Page 1.

4 Jacques Barzun, *The Use and Abuse of Art* (Washington, DC: The AW Mellon Lectures in the Fine Arts, Bollingen Series, Princeton University Press, 1975), 31.

5 Wendell Berry, "Christianity and the Survival of Creation," in *Sex, Economy and Community* (New York: Pantheon Books, 1993), 112.

6 Os Guiness, *The Call* (Nashville, TN, W Publishing Group, 2003), 191.

7 Dr. Barry Liesch, "Creativity: The Reformed View," 1999, www.worshipinfo.com/materials/creatpt1.htm.

8 Berry, "Christianity and the Survival of Creation," 113.

9 Lewis Mumford, *Art and Technics* (New York: Columbia University Press, 1960), 48.

10 Alex Katz, "Starting Out," *The New Criterion* (December 2002). Also available at www.newcriterion.com/archive/21/dec02/katz.htm.

11 Pam Mellskog, "Hearts Full of Hope," *Vibrant Life* (September 2000).

12 Peter Burrows, "The Seed of Apple's Innovation," *Business Week* (October 12, 2004).

13 Berry, "Christianity and the Survival of Creation," 112.

14 Karol Wojtyla, *The Acting Person: A Contribution to Phenomenological Anthropology* (*Analecta Husserliana*) translated by Andrzej Potocki (Boston: D. Reidel Publishing Co., 1979), 151.

SEARCHING
beneath the surface

I remember from my childhood a magazine entitled *Highlights for Children.* I recall one issue in particular that contained a drawing of a landscape, which included a tree filled with hidden images. I was engrossed in searching for the embedded pictures. The investigative process employed to locate all the hidden items challenged my sense of discovery and developed in me an interest in the interpretive process.

As a graduate student, I studied Italian and Northern Renaissance art history. Renaissance artists would fill their paintings with symbolic images. I identified with the layering of images to convey meaning. The artists utilized a visual vocabulary of symbols from which to speak to their audience. This idea helped form the pattern for my own visual creativity.

It is interesting to look at how people approach a work of art. Presuppositions are an important aspect of one's interpretation of what one is seeing. One's worldview or personal philosophy coupled with personal experiences determines one's reading of an art work. Sometimes, the content or information of a painting is complex and difficult to understand. People react to a complex message in different ways. A few viewers engage in a visual dialogue with the art and gain personal benefits from the interaction. Some come to the work determined to understand the work and try to exhaust its possibilities. This may lead to "pigeon-holing" an artist. Others feel overwhelmed by the subtlety of the message in the artwork and give up in their quest to connect with it. Some may be intimidated by the unfamiliar visual language of the art and feel that understanding the work is not within their grasp and reject the art outright as too difficult or too simplistic and not worth their time or effort to investigate. However, each person does react in some way.

Art is similar to other disciplines in that artists have their own language—a visual vocabulary. Like a spoken vocabulary, this language is developed diachronically and synchronically. If one is to understand the artist's work, beyond a subconscious response, one must learn the language in its context. Some people may view art and artists as elitist and feel isolated from them. However, not often are other disciplines (science, medicine, finance, politics, etc.) criticized as elitist for similar circumstances (i.e., speaking a "foreign" language or that their work is difficult to decipher). Today, many artists make an effort to communicate with their audience and desire to help educate the public in order to bridge the "language" barrier. In addition to the artist's effort, it is also important for the general public to educate themselves in the language they are trying to understand or communicate. This communication takes place through symbolic imagery.

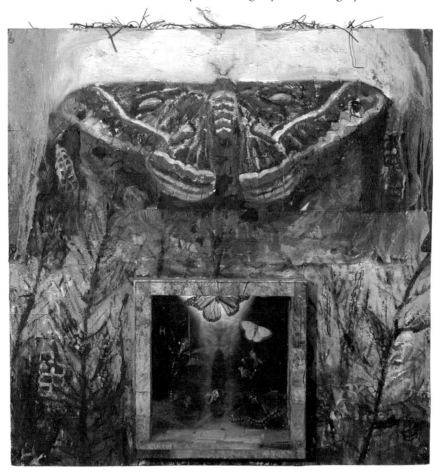

GAYLEN STEWART. *Wounds of a Perfect Life,* 1994–1997. Watercolor, acrylic, oil, photos, insects, copper wire, x-ray, light. 24 x 24 inches.

WHAT IS A SYMBOL?

The idea that the mere repetition of an object creates an effective symbol is perhaps too simplistic. At some level there needs to exist a shared understanding between the artist and the viewer of the relationship of the image and its intended content or message. A symbol may not come about easily and risks the potential of being overused and falling into the realm of cliché. This invalidating comes about via uninspired, mechanical repetition or excessive simplicity. Where fine art is being created with the intent of conveying a more complex content as opposed to a work of superficial significance, the artist can sometimes slip into a mode of patronizing didacticism. Sometimes an artist who desires to make a significant statement about concepts that they are impassioned about find that their thoughts have been reduced to heavy-handed, illustrative representation. The visual culmination appears too obvious, overly self-conscious and overworked. In actuality, the artist may be too "close" to the content and not see this obvious obsessiveness.

Often this happens when an artist is technically gifted. If artists rely solely on their technique at the expense of the idea, the resulting work may come across as being shallow or trite. There are some artists who successfully make art that combines elements of technically superior representation and illustration. A successful artwork may contain an illustrative aspect, but there is a point where that illustrative quality may become excessive and undermine the overall accomplishment of the work. There needs to be balance. If an artist is technically strong and this becomes a pitfall, he may need to develop a working method that disrupts the process and forces new creativity—bypassing his "safe" routine. For example, some may utilize techniques that are outside their comfort zone in regard to art-making in order to create problems or "accidents" that must be resolved in an unfamiliar way so as to produce a new image or symbol.

An example that may clarify the difference between the successful and unsuccessful use of a symbol is found in the dove as representing peace. In one context the dove could be used effectively by an organization such as the United Nations or by any group whose main theme is an advocacy of peace. As a logo or a symbol, the dove communicates quickly and efficiently the idea of peace because of its tradition—its shared historical and contextual meaning. But the dove incorporated into a work of fine art takes on a new significance, possibly, one less desirable. One of the interesting aspects of fine art is that it isn't easily interpreted. Many artists wouldn't use the dove image to refer to peace in their painting because they would see it as overly obvious. The idea of peace could be more interestingly conveyed through the result of a trial and error process which could produce a more complex relationship between the images and the painting's content. The most obvious solution to a problem isn't always the most interesting. In this line of thinking, much could be said in favor of the struggle to stretch oneself to new dimensions of creativity, rather than doing what comes most easily.

The Efficacy of Symbols

In dissecting symbols, we can look at the validity of symbols used historically throughout Christianity or secular society and see if they are still vital. Do they continue to communicate and fulfill their original intent? In our current society there are limitations in the ability of the average person to understand the concepts of Christianity. Someone who is well-read in the Bible may understand references for numeric symbols like 3, 7, 12, or 40 or sacramental symbols such as water, wine or bread. Anything more subtle, requiring a substantial knowledge of Scripture, will possibly be misunderstood. Additionally, attempts to communicate using biblical symbols can be difficult due to misinterpretations of the referential imagery, especially for non-Christians. For example, art based on a Christian worldview might utilize the triangle as a symbol of the Trinity. But among non-Christians, this symbol might not convey any meaning or be misinterpreted as something totally different than that of the original idea. In this context, the triangle as a symbol can be confusing or useless.

Symbols often have a tradition connected with them. There are also presuppositions/associations tied to certain symbols. The challenge is to balance the possibility of their overuse, which depletes them of meaning, with the stability that comes from their longevity, and to be aware of contextual associations. Historical symbols can be good communicators, but their value and/or efficacy depends upon the context in which they are used. For example, a laced string of thorns is a somewhat common and recognizable symbol and could be viewed as trite if used without some forethought. At the same time thorns can be a powerful symbol depending on their contextual relationship and how they are visually combined with other objects. The same is true with other symbols of Christianity like hammers, spikes, lilies, a rose, and butterflies. All of these symbols have a historical and Scriptural source but their impact is dependent on interrelationships between them and other images.

The impact of symbols may affect a viewer at a subconscious level. A painting may be powerful even though a viewer may not understand the meaning of the symbols or the content. The strength or success of a painting is not based solely on the efficient use of symbols. Paintings without symbols may be equally as powerful in their impact on the viewer as those that include symbols. Symbols add another dimension to the visual language which communicates some idea, experience or emotion to the viewer. They are like monads strung together to create a phrase—a larger structure. In my opinion, if the content of an art work is effectively communicated with integrity through the images (including symbols), conceptual idea, or physical media, it is a successful painting. The work may still move people even when the viewer doesn't completely understand it. This subliminal connection with the viewer is one of the powerful aspects of the visual dialogue that the artist strives toward. The symbols should serve the painting, not the other way around.

There are certain elements in Western art that are being challenged and broken down—like rules or absolutes (good art/bad art). This imitates society's current philosophical view of truth. Yet, there is a lingering tradition in Western art that there is still some standard by which to determine whether a work is good or bad. In Western art, this tradition is supported using particular techniques and sensibilities that are still being taught in universities in regard to Western ideas of composition, color theory, design theory, representational drawing, painting techniques, aesthetics, and so forth. These aspects of this lingering tradition may be applied to the usage of symbols within a painting to defend for or against the success of the art work overall. It seems that a good/effective symbol could exist in a bad/unsuccessful painting and vice versa. Just incorporating a well-thought-out symbol in a painting doesn't make the painting successful. There is so much more that determines the success of an art work. The symbol is only one element— one phrase in a sentence. Much of what determines the overall success of a painting is purely subjective. Beyond the symbolic elements there still needs to be some communicative ability of the painting as a painting. Even if the art is devoid of representational images and is reduced to the abstract qualities of colors, shapes, composition or concepts which may evoke a feeling or reaction, the painting itself still conveys or communicates something. This communication is as dependent on the interrelationships of those characteristics as if they were recognizable images.

CREATING SYMBOLS

Leland Ryken has written that:

> ... symbolic art can be defined as the use of physical images to stand for a corresponding spiritual reality. Such symbolic art is a familiar part of everyone's religious experiences, and it appears in verbal form all through the Bible. We think at once of the cross, water, bread, wine, shepherd, and light.
>
> Symbolic art was prominent in the tabernacle and Temple. A golden altar symbolized atonement. A golden table with sacred bread on it pictured God's provision for human life. Various types of vessels with water in them made a worshiper aware of spiritual cleansing. Lampstands of pure gold were a picture of the illumination that God's revelation affords.
>
> We can profitably link the Christian sacraments of baptism and communion with the symbolic art of the tabernacle and Temple. We do not ordinarily think of the sacraments as art, but they are based on the same principle on which symbolic art is based. The sacraments use the physical elements of water, bread, and wine to express spiritual realities.[1]

In a forthcoming collaborative art project, elements such as blood, tears, spit and sweat will be incorporated into the work. These fluids are intimately related to the life and ministry of Jesus. These objects/symbols will be utilized in the context of scientific discovery. For example, there exists software that will transcribe DNA structure into music. Again, these symbols have potential to be powerful or trite. The effectiveness of these symbols will be context sensitive and are dependent upon the integration of all the elements of the work—paint, sound, environment, etc. Many elements need to be considered during the entire process of art-making.

GAYLEN STEWART. *Bread of Heaven,* 1989 Acrylic, gesso, charcoal. 36 x 96 inches.

I begin the process of creating art by searching for meaningful ways of express-ing myself through my visual language, my repertoire. During the formulation stage of musing, praying and dialoguing (even, if it is only to myself), I visualize images that I'm connected to already or have an affinity toward and imagine them in context with the concepts that I'm weighing. I search my mind for the best way to visually represent a particular thought, idea or experience in a painting. An historical exam-ple of this was my use of hay bales. Since I am from the West Coast, I hadn't seen the large round bales that dominate the Midwest. Upon my arrival in Ohio in the

mid-eighties, the hay bales had a powerful visual impact upon me—like an ominous presence. It was more than merely their size that impacted me. The hay bales connected with my inner sense about symbolically powerful images. The effect was subliminal. I tried to rationally decipher their significance. It wasn't until I viewed them as spiritual metaphors that I came to a realization of their symbolic meaning. I began deliberating about their association to my spiritual ties, historical roots, and personal experiences. The obvious fact was that they were, in their simplicity, food for domestic beasts. At the same time, they were, in the past, living growing plants—now dead,

and yet sustaining life. The connection to the death/life cycle of the resurrection became a clear association for me. As a metaphor, the hay bales became visual transliterations for Christ, Jesus' disciples, myself, and even the Trinity.

A symbol (as well as the art work as a whole) gains substance from the viewer's interpretation. However, there seems to be a referential element to much of modern art. The audience is helped by knowing the experiences, the interests, background, historical influences or passions of the artist. In regard to symbolism, knowing the artist's world view, personal philosophical leanings, religious devotion and interests, gives insight into the connections, choices or relationships that the artist pulls

together in his or her work. This information should encourage the viewer to consider the thought process that led the artist to use these particular symbols in the art and their significance.

If one's desire is to clearly communicate through the use of symbols, it is necessary to consider the viewer's position. If the relationship between content and symbol is too abstract, viewers might give up too early on their quest for understanding. Cultural demographics, ethnicity, and education factor into the interpretive process. These aspects should be taken into account and considered. It's important to me to speak into the lives of those who view my work. I want them to connect with me. This doesn't mean I speak in a patronizing fashion, though. I don't speak down to them, but try to meet them at connecting points of shared experiences. I expect a certain amount of exchange in the relationship. I anticipate that the viewers will work at educating themselves in regard to what they're viewing. Although I know this isn't usually the case, I continue to believe in the possibility. If I speak down to the viewer I will come across as condescending. I want my art to say something about what I'm experiencing in a relevant way to the audience. I continue searching for creative ways to share my experiences. If a symbol or image communicates a concept well it can be repeated—especially in new dynamic juxtapositions. If not, then, it may be discarded or filed for later use.

Just as those viewing the art may give up, in the same way artists sometimes tire and quit. This may be a contributing factor to why some artists succeed (i.e., continue to make art) and some don't. For those that persevere there seems to be an inner drive that won't allow them to give up. At times, ideas are difficult to express or even formulate in my mind. The images don't connect, the symbols are overly simplistic and the art is belabored. I try to shake up the routine at this point, creating "accidents" that force me to "fix" them. My desire to make art is not so much a feeling as it is a decision. I choose to continue in spite of my ineffectiveness. I try to do something— anything— to force myself to continue. It doesn't have to be successful. Many times, I paint over what's visible to push myself into a new level of creativeness and thinking. If the symbols or images are really important to me, I may retain them, in spite of my concern that someone will not understand them. However, the danger lies in the preciosity bestowed onto an individual image at the expense of the entire painting.

Pursuit of Symbolism

I remember a phrase one of my professors used when I was a student; he said that preciosity kills the painting. The artist can fuss over the work obsessed with the technical rendering (or any individual elements) at the expense of the painting overall. This typifies the cliché about not seeing the forest for the trees. I believe effective symbols are selected based on close inspection of an object and relating that object to one's ideas and experience, whereby a connection is made between the two independent elements.

It is dangerous to approach my work by looking for a specific, effective symbol. This mindset can lead to simple illustration (in a pejorative sense). There is nothing wrong with an illustrator doing illustration, but there is a problem when I intend to make art that involves complex concepts or self-exploration and yet rely on mere illustration of those concepts. A person who is an illustrator has that as his goal. He intends to make pictures that supplement a story line. The good illustrator accomplishes this purpose without compromising his integrity. However, if an artist illustrates rather than expresses experiences then there is a problem with integrity being compromised. I admit this distinction is very difficult to verbalize—or even to defend. It is purely subjective. But there seems to be a line where an artist crosses over from one area to the other. This crossing over without a conceptual reason to do so is where, I believe, the compromise takes place. In this situation, there is the possibility of being overly didactic in a patronizing manner. This conveys that the artist's inner feelings, experiences, or concepts are trivial, simplistically stated in a superficial way, rather than worked out with integrity through the art-making process. If the artist tries to make art that says something personal and reflective, but the result is illustrative of that idea rather than relaying that information honestly as a concept, then the illustration dominates the work and the importance of the content is marginalized. Using a symbol for it's own sake at the expense of the painting as a whole falls into this illustrative, story-telling area. If an artist resorts to mere illustration, he undermines the work by subordinating the impact of the concept or visual imagery to a formula. Rather than working diligently to mature a concept through a complex process, the artist is relying on a gimmick to achieve a fast solution.

As an artist who uses symbols, I constantly tread a fine line. Symbols have positive potential, and they can be misused, compromised or treated as a "slick" trick. On this subject, the artist's credibility is tied to how symbolism is utilized. There is no absolute standard for the proper use of symbols. The artist has to convey the content of the painting through the symbols via a thoughtful process of integrity. All this aside, one can take something that is cliché and transform it beyond cliché. Some artists have pushed kitsch so far that it has mutated beyond kitsch and somehow works as high art.

COMMUNICATION

One type of visual communication composed of individual symbols (letters or characters) is the printed word. In some cultures the symbolism is more evident than in our alphabet, in that the characters may actually convey "pictures." More specifically, one could think of ancient Egyptian hieroglyphs and other types of written communication. Through time, societies have come into agreement about the given meaning to their symbols (letters/characters) and groups of those symbols (words). Even though language is not set, but changes, the meaning of these individual units and varied combinations has been agreed upon. Some liken

language to a living, breathing organism. In many ways there are similarities to a growing organism. As symbolism, words, phrases, etc. (written or spoken) carry meaning that is communicated as the writer/speaker and the reader/hearer agree on the associated meaning to these symbols. The meanings of symbols can change as well. The reason people have agreed upon certain correlations throughout history is the need to communicate an idea as clearly as possible.

Word phrases or word pictures (like hieroglyphics) function similarly to modern day logos. Like hieroglyphics, a logo is a symbol designed to communicate more than is represented—it carries deeper meaning than the immediate image. Business logos intend to communicate instantaneously through an image conveying a concise idea or impression. So an effective logo connects with the viewer, bringing to the surface thoughts of the name or the products of a particular business. The idea is to communicate very quickly, at a glance, so that someone who sees the logo thinks of that business, feels connected to it, and remembers whatever is most important to that business. In both logos and symbols, the more elemental the image, the more quickly the viewer understands the meaning. During a discussion of his *Eclectic* series, Brian Sooy—the designer of the typeface you are reading right now—addressed the tensions involved in distilling down ideas into logos:

BRIAN SOOY. Selections from *Eclectic One, Eclectic Two, Eclectic Three and Eclectic Medley,* 1994–8. Type One, TrueType and Open Type fonts.

> A communicator is obligated to design an icon or symbol using our common visual language: a chair has to look like a chair, and not a piece of pie. So if I want my icon to be recognized, it has to capture the essence of an object in such a way as to enable the viewer to receive—and remember— the meaning I have designed into it. When designing icons I try to capture the crux of what the object is *to its intended audience.* If I misperceive the audience, I run the risk of miscommunication. A good example of this is the shopping cart icon—universal on the Web, but show it to a person with no web experience and they might only think of their local grocery store.

In art, the challenge is to balance the easy communication that can be had with simple symbols and the need for a message with substance. Simplicity enhances communication, but sometimes the need for more content requires a

more complex visual language. A complex image will take longer to read and decipher. It may provide more information but there is always the danger that the viewer may lose what is being said. Interpretation is part of symbolism and art in general. Total misunderstanding can be negative in terms of connecting with the artist's content—especially if a particular statement is being communicated.

Many logos include words with the image. In my art, I also incorporate words with the visual images. We live in a word-based society. People can connect with a word and relate it to whatever image is surrounding the word. Both the word symbol and the image symbol together help strengthen the connection with the viewer when they are used in tandem.

Communication is not always clear. One aspect of life in a world which is in a "fallen" state is the amount of miscommunication that occurs. An early example dates back to the Tower of Babel and the confusion of languages which severely impaired effective communication and the accomplishment of the goals of the people. Similarly to words, images as part of a visual language can be combined to describe a larger idea. Layered images that interrelate yield even more content as well as visual interest. Visual images have the power to communicate content, though perhaps less precisely and in a different way than words. In my art, I combine words with images because the words themselves are also symbols and they convey information that the images cannot. As mentioned before, there are limitations to any language whether picture symbols or words. If someone does not know me personally, they may not understand my references or the context from which I speak. The viewer may not relate to my experiences any more clearly through the symbols I use. A person's own experiences and presuppositions might skew what they perceive me to be saying. Of course there is always the additional difficulty that I may not express myself effectively. It is difficult enough to express feelings, emotions or experiences that might not translate easily into words, much less images. Yet, the two combined add an extra dimension to the interpretive process.

MADE IN THE COMMUNICATOR'S IMAGE

For an artist, communication is important but its exactness is not absolutely imperative. The interaction between artist and viewer is a kind of give and take. Art has limitations that prevent the artist from communicating absolutely. "Seeing" and "hearing" are imperfect. The attempt to express abstract ideas, share experiences and explore spiritual issues is not always going to connect with the viewer. Powerful content is often difficult to communicate. It should be noted that these limitations and imperfections in communication do not support the currently popular state of existentialism that says true communication is not possible. The lack of being able to communicate is an inherent aspect of humanity, but I believe true communication (even with its limitations) is possible. This makes

the act of creating art through an unfamiliar language still worth the effort. For me, there exists an element of hope in this.

As a Christian, I stand against such an existentialist view. If true communication is not possible, then Scripture cannot be meaningful (because it cannot truly communicate) and God cannot hold anyone accountable (because He cannot truly communicate His requirements). In the first chapter of the gospel according to John, there was communication—God communicating with all humanity through the Word. God chose to communicate with us and then created us in His image. As a result, we also have the desire and the ability to communicate. This is one reason why I use symbolism.

Art of the past few decades that claimed to be without content ("pure expression" or any variations thereof, including Postmodernist reworking of this idea), all contain content, message, information, and worldview—and none is truly without content. The very idea of trying to make art with no content is its own content. The artist who removes meaning from art presents his own worldview and doctrine. In a similar vein, I think of Jackson Pollack's "chance" paintings created by swinging cans of paint over his canvases and allowing the paint to run from holes punched in their bottoms to create the paintings. His intent, as I understand it, was in part to avoid content using images and to show that everything exists by chance—the earth and the universe was formed by chance, that human existence is by chance, life is a product of chance and there is no meaning other than ourselves and our own self-existence.

At this point, this humanistic thinking produces a level of nihilism which concludes that since we can't communicate there is no purpose for it or ability to achieve it. Christians believe that we were created with purpose by a Communicator. We were designed to be in relationship with God and with each other. So it is not surprising that we have an inherent need for communication, nor should it be surprising that we benefit from communicating. Practical experience shows that any husband and wife relationship (or any relationship) does not last very long if there is no communication. Communication is as necessary to our existence as water. So, in my thinking there must be ways to communicate, whether in words—or in art.

I am an artist and I don't believe I merely chose it. God, through his Spirit endows us with gifts—some to make art. In Exodus, Moses details the account of the artist Bezalel being chosen to make the most important portions of the Tabernacle. The biblical text says the Lord chose Bezalel and, "filled him with the Spirit of God, with skill, ability and knowledge in all crafts—to make artistic designs for work in gold, silver and bronze, to cut and set stones, to work in wood and to engage in all kinds of artistic craftsmanship." I feel a calling and an enabling to make art that glorifies God. As Christians we are challenged to do everything with our whole being, to the best of our ability as if we're doing it for God directly.

Very early in my art career I realized I had to be myself rather than the most recent permutation of the *avant garde* artist. This required that I analyze myself and determine what makes me the person that I am. Only through this introspection would I know what to communicate. My worldview is inseparable from who I am, and to avoid that would be dishonest in my work. To embrace one's own worldview and give it life in visual terms conveys a level of integrity that is missing in much art. Defending the status quo is still a pit— even if it's the *avant garde's* version. The most powerful artists throughout history appear to be driven by an inner force such as experience or belief. For me, this is best expressed by way of symbolism. I have found that nearly every form of art carries a message of some type and depends upon symbols to make that content known. There is so much similarity within various artistic disciplines in their use of symbols. Music notations are symbols. Poetry has its own cadence, structure and patterning just as paintings do. Even disciplines such as chemistry, biology, mathematics, physics, and engineering, rely upon a symbolic language within their respective fields.

The better I assess what I am trying to say, how to say it, how to make it relevant and what images best convey those concepts, the better the viewer can connect at varying levels with my work. This is, of course, balanced with overkill. I know that this—the idea of "message" and meaningful content—flies in the face of much contemporary art that wants to ask more questions than speak about anything in definite terms. This is only symptomatic of our society, which holds a view that everything is relative. It's almost anathema to speak clearly on a subject. But, this has not been true for most of history or for all cultures.

The rather recent notion that art is better if it asks questions rather than gives answers appears to rely on the notion that there are no absolutes, and therefore art can offer only questions. Even those who claim that absolute knowledge does not exist nullify there own claim by making it. One can not say absolutely that absolutes do not exist without contradiction. Likewise, a Christian has answers to some of life's questions—specifically, questions that are connected to the life of Jesus Christ, the purpose of life, eternal existence, natural and supernatural phenomena, communication with one's Creator and many other areas of existence.

For those who are not Christians it is popular to suggest we are all equally confused. Such worldviews, even in their diverse "doctrines" deny that there are universal truths. So they would say that no one can know what a person is saying because our different experiences and perspective prevent us from understanding what the artist is trying to communicate. In contrast, I believe that people can understand in part what another artist is trying to communicate. I am not averse to putting a statement with my work to explain some of my background, but I don't think it is necessary. In such a statement, I don't try to explain the work exhaustively because I myself don't know everything there is to know about it. There is more to the work than what one intentionally puts into it. To try to describe the entire content of my work would

suggest that I know myself perfectly. However, I know myself in part, as every artist does, and I express what I know through my paintings. I incorporate the things that I have learned or the things that I have experienced in what I say because I find those things interesting to talk about. I share spiritual truths that I believe are factual based partly in faith and evidence. On the other hand, one who does not believe in truth has a similar faith in holding that certain things are not true. Everyone is on the same

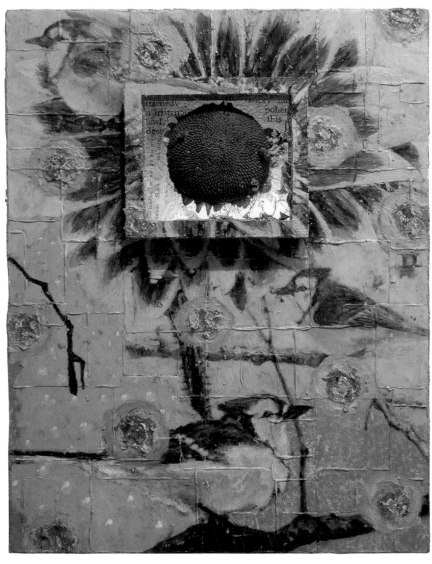

GAYLEN STEWART. *Wounds of a Perfect Life,* 2002. Acrylic, sunflower, bees, wax, transparencies, fabric on board. 30 x 24 inches.

ground. What we say in our work comes from a personal faith. Since personal experience, feelings and/or one's own intuition are relative in terms of truth, the Christian artist must always be careful that his faith and his truth is consistent with the Scriptures interpreted in context— this is the pure source of Truth.

The deconstructionism, historical revisionism, and propagandism that is so chic today is, in my opinion, empty or dead. One can look at the lives of the philosophers, artists and other purveyors of this thinking and time after time their lives end in tragic misery. I think of it as fashion that will fade out of existence. I believe that purposeful content has exciting and far-reaching possibilities.

So I view my work as more hopeful because of my belief that there is an initial source and purpose for doing it. Likewise, I believe I can convey a certain amount of meaning from my personal experience that can be rewarding to another individual. The audience may relate to my own personal life and spiritual experiences. Hopefully, if they connect with my experiences, they will be able to understand and be able to grow along with me through the work.

UNDERSTANDING SYMBOLS

Hieronymus Bosch was the king of symbols. Sometimes his symbols were so complex they were very difficult to decipher. His overall message can hardly be missed, however. Even with a loss of references from which to read the symbols, his work is still very powerful. Time and culture can obscure meaning due to the nature of a constantly evolving language. In Bosch's day his symbols may have been more colloquial, integrated into the vocabulary of the time, where the reader would understand more immediately the metaphorical images. It is a concern to me that time and culture can obscure meaning in a work. For example, one of my paintings might have an entirely different meaning to a person in another part of the world or at some future period. I hold onto the belief that if I continue to communicate through this visual language that it will supersede these limitations and speak generally, if not specifically, and impact those viewers in spite of these limitations.

Someone might think that symbols need to be explained by the artist for the viewer to understand their meaning. The objective of the artist is to communicate without explanation, although this is not always possible. Probably the most difficult paintings for both artist and viewer are those that don't have any images in them. They consist of color, abstracted shapes, values, marks, composition, patterning or something more conceptual. Through these colors/shapes, based on cultural stereotypes or even possibly physiological responses to colors and what they represent in art, these can create a mood or a feeling that communicates something on a deeper level. This is similar to an intuitive, "natural" interpretation of images or objects (discussed later). The viewer may not be completely conscious of what is being said but the parts of the work to which they relate can

have meaning for them. Conceptual art is more difficult to understand without specific referential information, but there is still an overall understanding or a grasp of what's being said.

If my art is dominated by dark or drab color, that tone communicates dark or depressing emotions at a subconscious level. Likewise, the colors and level of brightness create a hopeful, resilient quality. In a painting, light emanating from darkness can give the feeling of hope or inspiration. Rembrandt often utilizes this technique in his works. He tends to use light and darkness in contrast to represent hope while focusing attention on some particular element in his work. He communicates using light or a lack of light to represent an idea or theme. Light itself can be symbolic. Light can convey the idea of hope; light can represent God's presence or healing. Typically light makes people feel better emotionally than darkness. For most people it provides a feeling of safety and security. Some symbols rely on shared, universal, emotional responses or understandings of our experience of life. Light and darkness are good examples of something in our shared experiences that produce a natural reaction.

CONVENTIONAL AND NATURAL SYMBOLS

Dorothy Sayers makes a distinction between conventional symbols and natural symbols. The idea is that symbols have both an inherent meaning and a meaning by contemporary association. For example a mountain naturally symbolizes strength, majesty, longevity. That is its natural meaning, and is how it could be used as a natural symbol. The same image of a mountain can be used conventionally as a symbol for an insurance company. A natural symbol is directly connected to the universal understanding of something or the intuitive response to something. So hay bales, for example, would naturally bring thoughts of harvest, suggesting a time of plenty, the experience of farming or autumn events like Thanksgiving. In my early work, my use of hay bales and the ideas that I connected to them would make them a conventional symbol.

The red equilateral cross is so widely used as a conventional symbol that we tend to think about the organization it represents rather than what might be inherent in that symbol. As a natural symbol a viewer may experience an emotional response to the red by itself. It appears that the organization chose red purposefully. Whatever other intuitive thoughts occur when a person sees red, one of the first connections we make to a deep red is a connection with blood. The reaction to red can vary depending on the context. Red used in an abstract painting is less likely to be associated with blood. Suppose the red symbol is in the shape of an octagon?

One aspect of the effectiveness of a natural symbol is that it communicates with a broader group of people. In addition, a natural symbol may have a longer life span. However, conventional symbols may more directly relate to the artist's ideas and experience which would seem more important, even though a conventional symbol may not have as long a life span.

In looking at my audience, I consider their history, background and cultural issues in regard to the usage of the symbols I am considering. However, I don't spend a lot of time psychoanalyzing. In thinking about this relationship, I try to get an overall feel whether the symbolic information will detract or add to the content of my work.

Another question is, "How does one determine what is resonating with people?" The answer to this question is subjective. Unless an artist gets feedback from the public, it may be difficult determining if the viewers are engaging or not. Feedback is often limited to a handful of people at an exhibition who may have written down responses on a comment sheet. If I happen to be at the opening and people talk about the work, I may overhear a few responses. But the amount of feedback that I get as a practicing artist is so small that I have to rely on the subjective quality of what I have learned. I have to be true to my art and my experience. I try to produce a work that speaks to me first and then addresses the audience.

GAYLEN STEWART. *New Covenant,* 1989–1997. Oil, butterflies, gold leaf, photos, x-rays, light. 70 x 44 inches.

X-RAYS

One of the better symbols I have used was my own x-rays. During the period I was using them, I was very introspective about my healing from cancer. I would use the x-rays to convey my pain and healing and a discussion about the frailty of human existence in a spiritual context. While that was an effective symbol at that time, my work is now changing. I am currently using natural images as well as found objects (insects, etc.), coupled with scientific imagery and patterns to talk about the inherent design, order, complexity, and structure of life as evidence for God as Creator. My hope is that if I use a wasp nest or a butterfly—items that show complexity and design—it will challenge a viewer's thoughts about origins and the purpose of existence. When I combine those elements with words, the juxtaposition creates a new context for these interrelationships to speak in a new way. First, the audience might see a butterfly and relate to its natural beauty, but if I combine a

butterfly and a word written next to it, perhaps "death/life," the context changes. Some of my butterfly works have appeared in combination with quotes. In one piece, I quote Michael Denton, an Australian research scientist in molecular genetics, talking about the inherent complexity and order—"an elegance and ingenuity of an absolutely transcending quality"—that falsifies the belief in chance as the origin of things. So when I combine a visual like the butterfly with that quote, I am recontextualizing the butterfly symbol. In this case, it says something new and unexpected from the natural, intuitive interpretation of that image.

This recontextualizing of symbols is a furthering of the investigation and exploring that began years ago with my fascination of discovery sparked by the cartoons in the *Highlights* magazine. The discovery is more conceptual now, but the process is similar. Understanding my work reminds me of how children learn to speak when they are very young. Children learn by repetition. They become familiar with repeated sounds and patterns which they eventually connect to meaning. In a similar way, seeing many works which encompass the artist's visual language, one can begin to decipher individual elements. As people view the images and as they read the words, they begin to make associations between dissimilar objects, imbuing them with new meaning. This is what I find challenging and exciting about symbolic imagery—connecting with people and facilitating the process of rediscovery.

Endnotes
1 Leland Ryken, *The Liberated Imagination* (Wheaton: Harold Shaw Publishers, 1989), 54–55.

NO TIME
like now

You Must Change Your Life
—Rilke
We'll take the trail marked on your Father's map
—Sixpence None the Richer

I returned recently from an arts conference in the People's Republic of China, with many of the questions the students asked still ringing in my ears. We had sat together in the lecture hall, looking at the slides of Gaylen Stewarts' paintings, and talking about the gallery installation they were part of. The questions ranged from issues having to do with "modern art" to concerns with our fragile natural environment. All these concerns with culture and nature, for me, link in some way to our root questions and concerns with the idea of "Truth."

Accordingly, I want to talk about truth in art making and art observing in a number of different ways.

The following remarks break into three broad sections. Section One deals with my responses to other people's art. Section Two briefly explores some of the history and philosophy behind some trends in modern art and also talks about "interpretation" as a central key to understanding our place in the modern world. The final section tries to take the suggestions of the first two and weave them together in a description of a) my response to more art and b) my own creative process from seedling idea through to performance. If you can read these remarks as a kind of collage of reminiscences, experiences, concerns and questions, then you'll not only experience something of my working method, but you'll also get a glimpse of some of "the truth" I am trying to describe.

Just after I became a Christian in 1967, a friend took me into London to see a film called "The Gospel According to Matthew." I knew very little about the director, Pierre Pasolini, or his other films. I knew even less about Italian cinema, "Neo Realist" or otherwise. The film, shot in black and white, had an almost rough documentary feel to it. There were shining angels and miracles to be sure, but also you could almost feel the parched soil and taste the dusty air. The skin stretched across the peasants' faces looked parched, and weather beaten too, almost like maps to a place that few of us rarely, if ever, visit. The exception would be the almost childlike Virgin Mary. It was nothing like any greeting card or even "high art" painting I had ever seen. And the music! Folk music, country blues mixed in with classical, the combination as rough-edged and rich on the ear as the images on the eye. The film, as I remember it, offered a multidimensional marriage of form, content, material, medium, and message in which the realities and limitations of the chosen media were somehow harnessed and harmonized with the underlying "truth" of the story.

When I came to the USA for the first time in the mid 70s, I spent a few days in New York soaking up as much of the richness and vibrancy as I could. This involved not only hanging out in Greenwich Village, but also the Museum of Modern Art. It

GAYLEN STEWART. *Other Tongues*, 2002. Acrylic, plaster teeth, gum prints, mushroom, transparencies, fabric on board. 24 x 30 inches.

was here that I saw the fabled *Guernica* by Picasso. In order to view this famous painting—with its distorted forms and muted colors—I had to make my way through an entire room of preparatory sketches by the artist. I could see how the painter tried variations on theme and form and painstakingly hammered out the "logic" of the composition. One might say that some exposure to Picasso's experimentation, plus a passing acquaintance with the genesis of this (commissioned) composition played a role in my overall response to the finished painting.

But there is more to it than that, isn't there?

How can we best describe or analyze what happens when we experience art? And how does this experience—however we define it—link back to "truth?" Aesthetic theorist Arnold Berleant talks about an "aesthetic field" (Berleant 1970, 1991). Berleant adopts the "field metaphor" to locate and articulate the components that go into making up the experience of art. Berleant's model is one in which object, viewer, viewing environment, and historical background all weave together to create a single experience. The aesthetic experience (or what we designate as such in our culture) occurs in the overlap of those four categorical fields. The Polish psychological theorist Czikszentmihalyi, most known for his work describing the phenomena of "Flow," writes of "the Art of Seeing" (Csikszentmihalyi and Robinson 1990) and maps some of the historical and educational factors that play into the process of our reception of art. Rather than demystifying the art experience, the authors are trying to help us grasp the different dimensions of our "aesthetic field." They proceed to suggest ways in which museums can best curate and display art in a way sensitive to the many dimensions of how we see. In the light of these writers' insights into the "aesthetic field" and the many dimensioned "viewing experience," we can understand that "art" is more than simply the object in front of us. It is also more than just a subjective experience.

Back to our concerns: How are we supposed to build a bridge between "Art" and "Truth" in today's world? Does "truth" reside in the object, the individual experience, or the artist's intention? Or somewhere else entirely? *Surely not the object.* Everything from the invention of photography to the unfolding of the world wide web has contributed to the ongoing erosion of the cult status of the art object. It was Walter Benjamin who theorized about how the technological developments in image reproduction and duplication would strip the "unique art object" of its power and aura. For Benjamin and the theorists who followed him, the power base shifted from the aura around the object (and the guardians who controlled access to the object) to the technology of reproduction (and therefore whoever controlled reproduction and distribution), or more succinctly "from ritual to politics."

Objects—art objects—are important, to be sure. The evident power of Picasso's *Guernica* is unavoidable. *But surely there is more to the "truth" of art than the object and its aura.* For example, I wasn't watching the only print of Pasolini's

film. It still spoke to me as an individual. *It still spoke truth.* And the truth it spoke was linked to another kind of power than that of the governing interests behind the reproduction and distribution of images.

Some would suggest, given the recognition of different overlapping factors that help us define the shifting boundaries of an "aesthetic field," that it is not so much the "object" that has a singular aura, as the experience. We know that many elements play into *how* we experience *what* we experience. I have suggested, with our complex theories of "the aesthetic field" and "the art of seeing" in hand, that it is possible to talk and think about art and truth in ways that are not entirely dependent upon privileged objects. Nor do I believe that we have to link the artwork to some mystical realm or conversely reduce its truth quotient to technologically driven power plays. However, I believe that it is possible to link this experience to some sort of conviction about the nature of truth in the mind and the hands of the art maker and the faithful expectation of the public. If the critics are right, however, and the factors involved in appreciation are local, historically and culturally relative, what happens to our understanding of any "truth" that art may intend or convey? Is what is "true" for you, "true" for me, also? These questions have deep and somewhat tangled roots, as the variety of learned treatises on Modernism, modernity and postmodernity are only too eager to point out.

SHIP OF FOOLS?

At this point we have to push off into some deep waters. Please bear with me.

In our cultural history some thinkers, responding to the subjectivist and skeptical intellectual trends of their day, proposed an almost transcendental realm of artistic experience in which the value of the aesthetic experience was pure, self-sustaining and not reducible to any explanation that might claim to reveal its underlying social or moral agendas and interests. At first this realm was argued for by Idealists who wished to talk about the Beautiful and the Sublime as universal categories of human experience. Such categories had to be protected against the skepticism and the overbearing rationalism of the day. This same category, according to one thinker, was refined and reinterpreted by succeeding philosophical and social schools of thought, until it became the potentially subversive "aesthetic dimension"—a refuge from the world of alienated consumption, commodities and kitsch (Bernstein 1987). These ideas, in all stages of their development, conceivably, touched on elements of "truth" that we need to consider in relation to the arts. They all made vital contributions to what is called Modernism in the arts. Modernism in the arts can be looked at as a combination of several strands, both "conservative" and *avant garde*, that argued (variously) for the purity of the art object, the sanctity and prophetic dimension of the artistic vocation, the authenticity of raw artistic expression, and the ongoing questioning and challenging of previously established cultural categories in the name of "new art" or

even "anti-art." This "Modernism" drew upon artistic theory and cultural practice to wage war upon the linear-minded and technologically driven "modernity" (Calinescu 1987). Modernity, as understood by these cultural theorists, was dominating, alienating, dehumanizing and soul-deadening. It linked technology with rationalism, expansion and consumption, and in doing so crushed human and culturally diverse resources in the wake of "progress." For the modernist artist, it was a conflict that was almost a Holy War. However, it was not really a fair fight. According to some, art itself, as a self-conscious, self-defining activity, was the ungrateful offspring of the era of modernity. "Art" came into its own as a specialized discipline, seeking "progress" and "refinement" in the parental shadows of technology and science, and looking inwards for its "true self," in the shadow of the philosophical developments of the era. (*I am paint on a surface, therefore I am.*) So Modernist Art, somewhat of a stepchild of modernity, was seriously compromised as it went to war with that very same modernity. This, plus other critical observations led some theorists to insist that the fight was lost by "Cultural Modernism," almost before it began. I have mentioned Walter Benjamin's prophetic insights into how the technologies of reproduction and distribution influence the artist and the art-making process. Art critic and theorist Suzi Gablik asks, "Has Modernism failed?" (Gablik 1985), and suggests that cultural Modernism was, in fact, neutralized and (re)absorbed by this modernity. She goes on, in company with other "postmodern" theorists, to dissect many of the social and historical dimensions of the emphasis on "art for its own sake," laying bare both the exclusionary and prejudicial roots of such an idea, while at the same time pointing out the ineffectiveness of such an idea to challenge and change the market-driven gallery system and institutional world of art. In essence, the era and aura of modernity gave birth to the possibility of the idea of "Art," and the latter day, more market-driven aspects of modernity simply defanged, neutralized and absorbed Modernism back into the system it was complaining about without so much as a whimper, much less a kick and a scream.

NOT A PRETTY PICTURE?

As well as the myriad secondary truths that might arise incidentally from such all these excursions, there is also, in my opinion, one observable truth available to us. From ancient idealist philosopher to contemporary postmodern skeptic, the unquestioned "true" response to our problematic world has been to seek transcendental *escape,* either in the realm of eternal forms or the ether of deconstructive theory. However, whether we are premodern, modern or postmodern, we are "bound to this world by (among other things) language, history and culture." We are bound by the very means by which we identify our distinction from the world and by which we articulate our desire to escape. This means that in even *thinking and talking* about "truth" we have to continually deal with the issues of

culture, language, and our interpreta-
tion of these things. And this is one of
the benefits of postmodern skepti-
cism. We recognize that we are some-
where in the picture, and we are
bound up in how we know what we
know. We have replaced the mod-
ernist arrogance of "analysis" with its
detached god-like observer and neu-
tral tools of investigation with the
humbler stance of interpretation. We
are somewhere in the picture, and
how we get our information has some
influence on *what* information we get.
A term for interpretation that is used
in a wide variety of disciplines is
hermeneutics. We are most familiar
with the term as it relates to biblical
studies, but the term is a central one
in a wide variety of disciplines, rang-
ing from cultural anthropology to
Renaissance art history. For thinkers
in a wide variety of disciplines, "truth"
is completely bound up with
hermeneutic practice, which in turn is
grounded in history and context, *both*
of the interpreted work and *also* the
cultural background of the inter-
preter. "Truth" occurs, according to
some, in the overlap of these horizons.

LOST HORIZON?

Many might ask again if there is
any possible hope of bridging the gap
between this seemingly relativistic,
context-bound understanding of
"truth" and the "absolute truths" of
the Christian faith. Some of us might
hope that at this point a seasoned

Christian apologist would skewer the vulnerabilities and the self-contradictions
of the postmodern position. Surely here, a Christian artist could offer something

CLAUDIA ALVAREZ. *The Bruised Sky* (details), 2003. Mixed media. 14 x 8 feet. Ceramic figures range from 36 x 9 x 10 inches to 27 x 8 x 5 inches.

substantial as an alternative to the fashionable ephemeralities of the contemporary art scene. William Dyrness, in an article in *Radix* magazine entitled "What Good is Truth? Postmodern apologetics in a World Community," acknowledges the prevailing atmosphere of suspicion about all authoritative claims to truth and suggests that the time has come for a shift in evangelistic strategy away from an apologetic base grounded in propositions (about "truth") and more towards an appeal to character—namely the fidelity and truthfulness of God, and the consistency and faithfulness of the community called by his name. Dyrness is not capitulating to a pragmatic/functionalist "whatever-works-for-you'" model of the truth. He merely suggests that the postmodern climate might be more receptive to ideas about truth grounded in character and observable practice. If it is true that the Church "exists for mission" as "fire exists for burning," as one recent missions theorist put it, then we might want to consider what Dyrness is suggesting about truth, character, and our mission field. After all, when you think about it, the Gospel of John says more or less the same thing.

The primary experience of hermeneutics for many of us is in reading and thinking about biblical texts and stories. If we go about it responsibly, we try to keep two things in mind. *On one hand* we will do our best to be sensitized to the nuances of language, context, structure, and

genre in the text in front of us. *On the other* we will be drawn to and involved with the character revealed by the text. The "truth" will emerge from an overlap of these horizons: our humility *in front* of the text, and our acquaintance with the Character *behind* it.

When we study the text we try to approach interpretation in an affirmative way, and use our reading and analytic skills to clarify and restore to full view what the author intended to say. We also revise and deepen our ideas about "truth" in the light of what we learn about the character of Jesus. We also employ a critical attitude, not so much to deconstruct the text, as some might, in the shadow of some prevailing literary or political theory, but to critically evaluate the other ideas about "truth" that the author of the text brings into contrast with the truthfulness of Jesus. As we learn to critically read our way into and through the Gospel material, we discover a world in which different ideas about truth prevail. And hopefully, this new world of "truth" affects what we do in our art as we engage the everyday real world.

This Sad Music

Which brings us back to where I began with Pasolini's *Gospel According to Saint Matthew*. This film, advertised as "made by a Marxist for the pope" seemed to grasp that there had to be a weave of medium, genre, method, message, context and character. This is fine, but by any stretch of the imagination Pasolini is to be considered an "outsider." Why is it that an outsider can furnish us with a deeper understanding of what can only be described as "the grit of the gospel" than much Christian art is able to? I believe it was the Victorian art critic John Ruskin who lamented that Raphael's pictorial treatment of Jesus' restoration and commissioning of Peter (John 21) at once obscured the story and also misled as to its intent, all through the artist's compositional subtleties and ethereal color schemes. In Raphael's picture, rough fishermen took on the appearance and dress of serene philosophers. The disciples did not crowd around their beloved master, but tellingly deferred to a leading disciple, upon whom, some believed, Jesus had said he would build his church. Ruskin lamented that a day would come when the story *itself* would seem as remote and as fabricated to the ordinary reader as this pictorial depiction. Ruskin's fears have been somewhat realized. The ordinary reader has indeed drifted away from a biblical text that has been attacked, dismantled and deconstructed by wave after wave of "expert opinion," but a good deal of what is marketed as "Christian art" offers an "alternative unreality" with more of nineteenth century German painter Heinrich Hoffman's sugar-coated pieties than Raphael's technical mastery. In order to suggest some possible ways of responding to this situation, let's talk about a very different painting on a biblical theme, and use it to gather together some of these threads. And by way of summary and conclusion I'll set forth some of my own working

ideas and methods. In the Russian museum in Saint Petersburg in 1992, I stood in front of Nikolas Ge's painting of the Last Supper. Here was a canvas in which conventional pieties and philosophic subterfuge were all but banished by the dramatic way in which the artist had handled the range of darkness and light and the palpable thickness of the paint. The downcast Christ and the astonished disciples are thrown into high relief by the single lamp in the room. The Judas figure steps towards us, at once shrouded in absolute darkness. His advancing figure completely obscures the light source in the room, leaving us only with its radiant echoes across the simple furnishings and the upturned faces. The story remains familiar, however, the dramatic moment is immeasurably deepened by the formal design and the tonal nuances employed by the painter. If I were to approach this painting as a "text" to be discussed in our exploration of 'truth' in Christian art, I would not only take refuge in the depths of despair and confusion caught in the faces of the gathered disciples and their Master. I would also want to explore the way in which the central figure all but obscures the light source in the picture, while setting out to put in motion the ecclesiastical and political machinery that would seek to extinguish the True Light. I would also use this dutiful, expedient and pragmatic aspect of Judas in order to caution us all about the dangers of

GAYLEN STEWART. *Cutbird,* 1998–2002. Acrylic, rose, wasp nests, photos, transparencies, fabric on board. 30 x 24 inches.

confusing portrayal and betrayal. Jesus' words to Judas, *"Whatsoever you do, do it quickly,"* were never intended as a general mandate for Christian artists and communicators. It seems almost a cliché to insist that for "Christian Artists" (a forgivable use of the phrase in this context), the limitations, idiosyncrasies and even flaws in our chosen medium—be it words, clay, paint, canvas, film, or sound—become essential ingredients in our vocabulary of "expressed truth." Our attempts to sidestep or ignore these limitations in our quest for "higher truth" often obscure the very light we are so confident we are shining before men. *We again betray even as we portray.* It was Ruskin who suggested that Raphael's serene and somewhat muted depiction of a biblical story did a profound disservice to the story itself. Ruskin mused prophetically about the day when the text itself would seem as remote and as fictitious to the general reader as Raphael's canvas did to Ruskin's indignant eye. It was Pasolini who showed me that the limitations of the medium of black and white film, and the contours and boundaries of a particular cinematic genre, only served to enhance and "make present" the truth and the reality of the story he was trying to tell. Every generation has its artists and writers who discover these necessary truths in a fresh way. But they are nothing new. They have a long, and some might say, hallowed history. Matthew himself may well have intentionally decanted the Gospel into a literary/biographical form amenable to the educated Roman reader. Nonetheless, what I did was try to respond to the truth I felt radiating from the painting, by writing a poem based on my experience of it. The challenge was not only to honestly explore my feelings and responses, but also to probe the limitations and the boundaries of the language, both in terms of the sound and also the images the words conjured up. I filled page after page with notes just to get something approximate down so that I would have something to work with. The very process of journaling, of finding my way through emotions and language, is as much about the "truth" as the finished poem. I tried to match the language and the imagery of the poem to the palpable intensity I felt radiating from the painting. At the same time I tried to sketch one or two of the "issues" I felt the painting brought to the surface. I sifted through the word sounds and the imagery to find elements that carried the same dark tonal qualities of the painting and reflective of the "inner darkness" of the subject matter. I hope it becomes obvious that, for me, "truth" is very present in the act of responding and the act of composing, from the earliest drafts to the final poem. For me, I am learning about "truth" even as I am revising, editing, deleting, abandoning and restarting. For me, it is part of the journey I have been called into by the ultimately Truthful One.

I then recorded a version of the poem for my spoken word album *We Dreamed That We Were Strangers* (Glow 1996). I further tried to enhance the poem by recording a musical background of repeating and colliding patterns of cellos and choirs. Again, the sampled instruments and the slowly repeating musical phrases

were used as part of my search for the "truth" of the painting's inner radiance (or darkness) and also an attempt to anchor the underlying truth of the poem. And of course I believe there is "truth" in the process of searching for the right sound— even enhancing it with the right kind of echo! In each case I attempted to use the limitations and boundaries of the given medium be it language, metaphor, or recording studio technology, to somehow make present aspects of my encounter with this particular painting and the story the painting told. As we have been suggesting all along, from inspiration to construction to appreciation, the "aesthetic field" is a location that occupies many dimensions. An idea invariably comes from several places at once, and of course it begins to mutate once you engage with the materials through which you wish to express. All these factors bear upon the truth of the work. I began to think of this poem in terms of the other poems and their background music.

All these factors bear upon the "truth" of the work. I began to "compose" the album as a whole, in terms of track and overall title. For example, the poem in question was inspired by a painting in a museum in Russia, but the title was taken from a poem by Indian poet, Tagore. The image on the album sleeve was lifted from a snapshot of some Sri Lankan refugee children taken some years before, and many of the pieces on the album did, in fact, concern children, childhood, and vulnerability. However, the "title" poem has little to say about overcoming cultural differences or teaching the whole world to sing. It uses a nineteenth century Russian painting of the Last Supper as a springboard into a meditation on our potential complicity with Judas Iscariot.

As I suggest, many fragmentary references and ideas are collaged together behind the scenes of this particular piece of work. But there is more to consider.

We Dreamed That We were Strangers was not merely written for the page or sounded out for the recording studio. It was also intended for performance in front of an audience. I've found that idiosyncrasies of live performance play into how certain aspects of the work are "realized." It surely belabors the obvious point to say that paintings exist to be seen, and music to be heard—and while I would never insist that an audience virtually constructs a new work each time it responds to an existing one, I would want to allow that the context of reception be every bit as complex and multifaceted as the process of inspiration and the messy business of actual art-making. Does an audience in a smoke filled-bar in Amsterdam hear and experience something different than an audience in a large Californian church that has obligingly projected a slide of the Russian painting during my performance of the poem? And where does "truth" come into this? I believe that it is linked, in some ways, to the idea of faith.

I believe it takes faith to think twice about an idea or image or musical fragment or a memory, and to believe that it has significance. I believe it takes faith to pick up a paintbrush, chisel, or to sit down at a piano or a computer keyboard and

crossing the boundaries

music and words by steve scott • images by galen stewart

Please take your place beside them
find your tongue,
Combine with them in their ascending song.

With gentleness, and with a craftsman's skill
I am reweaving all these shining threads
into a vibrant tapestry of forms.
Patterns unfold, they echo, resonate

This is the synthesis, at last unveiled
This is the vision/this was the first intent
and to this end the government and rule
are placed upon me, to administrate

to heal, restore, rebuild: to recreate

In that day The Master of the Feast
will say "I have saved the best
until the last. Let sleepers rise
now is the time to cast aside
the dark and bloody mantle of the past.

I have prepared your bodies opened your ears
and for your eyes, these golden keys are granted
Unlock this world. Breathe in this atmosphere
where hidden colors and unheard harmonies
are like flowers of the field now carefully planted

among the ringing choirs of wood and stone
among the clear streams,
pulsing from their source.
Rivers and waterfalls blend their melodious tones
And every creature lends its native voice.

Then you call us to the table for the meal
You'll point out the bread crust on the plate
The brimming winecup like an upturned bell.
The things you tell us now will bring to mind
(how)
These simple common elements
were once aligned
to draw us closer to our true estate
engraved upon your hands:
your broken heart enfolding us.
But now, in this new light
you'll sit among us, knowing each by name
our king, companion, first born brother, friend
Who knows when that will be:
But we still wait.

Until that time help us to understand.

STEVE SCOTT. *The Resurrection of the Body,* 1988.

entrust this fragile fragment of inspiration to the process of necessarily messy translation. And it takes faith to exhibit, perform, and display. But what are we putting our faith in? Is it the purity of our inspiration, and/or the goodness of our intentions? Are we putting our faith in our technical skills and tricks of the trade? Or are we trusting that our audiences will "get" everything we intended to communicate? Or can we learn to trust a process in which different ideas, media, audiences, interpretations, and questions all open the way to a kind of "truth" that is at once resolutely objective, but also profoundly personal? This is the process that I am trying to learn to trust. When I sit down in front of a blank journal page, or in a studio in front of a keyboard, I believe that there is something "truthful" in my initial explorations of words and sounds—even the ones that get erased or

crossed out. For me, there is plenty of "truth" that comes through the dead ends and the false starts. Given all that I have said about how the limitations and the contours of a chosen medium are part and parcel of how that medium communicates, then you should know that I have plenty to unlearn in terms of quick fixes and easy answers. I believe that we are disciplined by our chosen medium, and if we believe that we are in some way called to do— both in terms of artist's craft *and* spiritual formation—we are disciplined, shaped and transformed by the Ultimately Truthful One. I sometimes feel like I am weighing words like stones in my hands, turning them over and over to see whether they will drag a poem down or make the lines sing. Or I am holding up a phrase like a piece of broken glass to see whether it clouds the sunlight or bends it in a new way. Similarly, I listen to the musical phrases I put behind some of the poems, or I look hard at the words scattered on the white expanse of the page. Is the white space electric? Does it swarm around the words and lift them up? Or does it support and bolster the lines that allows them to truly *say* what they have to say? Does the music cloud the voice or carry it? Should the musical phrase be quieter, wetter with echo and reverb? In what way can we enhance these elements so that they serve 'truth'? There are some musical elements I have used that are so quiet that they are almost felt more than heard. And as I recall those poems, and reread my remarks and observations in this essay (as rambling and collage- like as it is), the questions come back to me. *Have I learned my own lessons? Have I been truthful even in the things I have written here?*

I have tried to bear witness to my own responses to art, in the context of a few things I have learned about art history and theory. I have tried to bear witness to aspects of my own working process, all the time seeking to anchor truth in both the learning process of "finding out" and also in the truthful character of the One who called me to 'find out' in the first place. But of course, there is always so much more to learn.

Epilogue: The Sound of Waves

When I was in England in 1998 for the C. S. Lewis conference, I had the opportunity to show slides and read poems from my mixed-media collaboration with artist Gaylen Stewart, called "Crossing the Boundaries." This work explored (among other things) the nature and the process of artistic collaboration through a vocabulary of words, sounds and images drawn from the world of nature. I remember on one occasion showing some of the slides to a small group of artists and thinkers and trying to put into words the things I felt about the relationships between the natural systems that inspired us, our various methods of collaboration, and the very environmental "feel" of the resulting installation. I am not sure if my descriptions, and my attempts to link them to the idea of the Trinity, made as much sense as the performance of one of the poems in an old church building

later that week. Here, because of the inadequate blackout, Gaylen's slides lost their jewel-like luminosity and took on the appearance of faded tapestry. It was the stained glass windows and the elaborate church fittings that almost sang with the light. Gaylen's images took on a new appearance and a new resonance in this context. The pre-recorded sound loops of birdsong and synthesizer acquired added depth and timbre in this hallowed space, and I believe that the reading of "The Resurrection of the Body" benefited also. Now I cannot say that when I was out with my children making recordings of birdsong one chill November dawn that I ever envisaged hearing these recordings in such a setting. I had scarcely begun work on drawing together the seeds and fragmentary roots of the ideas that would go into the poems. When I first saw the show installed in a gallery in Ohio, I never imagined that I would see Gaylen's images gain an aura of almost austere sanctity in a four-hundred-year-old church building. While I cannot objectively judge the performance of that day, I do believe that the interpenetration (without confusion) of all the elements—the seeds of inspiration, contours and limitations of the chosen media, the risks and rewards of collaboration, and the "givens" of that location and audience—all came together and made something quite specific. In the gallery installations the various relationships to natural systems were implicitly woven throughout all the art. But now in this environment, the work, for me, at least, bore traces of what some of the Church fathers spoke of when they described the dynamic and mutually affirming relationships between the members of the Triune Godhead. At least, this is what was true for me. I cannot speak for you.

Acting and
(the) Incarnation

What poetry should do in the theatre is a kind of humble shadow or analogy of the Incarnation, whereby the human is taken up into the divine.

 —TS Eliot[1]

Art belongs to the Practical Order. Its orientation is towards doing, not to the pure inwardness of knowledge.

 —Jacques Maritain[2]

At a performance of the hit Broadway musical *Wicked* you may be overwhelmed by the sheer preponderance of systems at work. The script, augmented by a score, has been fleshed out by directors, designers and choreographers with millions of dollars at their disposal. Casting agents have provided the enterprise with highly trained and credentialed actor/singer/dancers. Technicians have entered the process with state-of-the-art, computer-aided wizardry. After paying the ticket price which this many collaborators demand you are seated in a plush, conditioned auditorium with your glossy souvenir program ready to experience—theatre.

In a small black-box space, in the basement of a college building, with poles blocking some views of the unraised, concrete stage, a black painted drop ceiling, minimal lighting and poor acoustics, a single performer, sans script, sans props, sans scenery—sans everything but his body and his imagination appears. He is a mime, a physical theatre artist, and he is believing that the ceiling of that tiny space is lowering, slowly, onto our heads. He believes it so fully that we all look up, to see if it may be true. The performer, Ronlin Foreman, works without any assistance, without even a script or scenario; he is totally absorbed in the moment

and completely aware of his audience. We are experiencing—theatre; simply, essentially theatre.

Let us engage in a process which Richard Southern calls "stripping the onion."[3] First we peel back the environmental factors (lighting, scenery, props and period costumes). Then we eliminate a raised platform for the actor(s) and a space for the audience; eventually we get to the core of the theatrical event: an actor performing for an audience. This is not just a historical exercise. Elaborately produced theatre and simplified theatre may exist simultaneously and in the same cultures.

If we remove either the actor or the audience, we no longer have theatre. The essential art of the theatre is acting in the presence of a live audience. It is unique among the arts in that the artist presents his work directly to his audience, and though he may have a text, costumes, scenic reinforcement, etc he is not obligated to use anything other than *himself.* He does so in order to communicate with them, to share a portion of his life with them and to ask for a portion of their life from them. He gives and he takes. He asks for a relationship with them.

Describing or defining acting is a slippery prospect; identifying *good* acting is even more problematic. We know it when we experience it. Acting involves the use of three resources, two physical and one mental. The actor uses her voice and body (external) and her imagination or spirit (internal). The quality of the physical instruments is both natural (inherited) and artificial (learned). Actors with exceptional vocal and physical range, power and flexibility, will have an advantage over their less gifted colleagues. Disciplined training of those resources through classes and production work is essential to the success of an actor. You can't sustain a career as an actor just on native talent or on vigorous preparation alone—they work in tandem.

Furthermore, the actor must have equal felicity with his internal resources. Setting aside the necessity of training the voice and body, actor-artists can learn something about the internal process of acting by reflecting on the Christian doctrine of *incarnation.* This is not to suggest that acting *is* incarnation, or that the Incarnation (of Christ) was a theatrical event. It is to suggest, however, that acting is a dynamic process of incarnating a character which exists only imaginatively until it is given flesh by a living actor in a particular time and place and in the presence of living auditors. The Incarnation of Christ is essential to the Christian faith, just as the incarnation of a character is essential to theatre. Both also create relationships; they bring people together in physical proximity. They are at once material, and ephemeral, endued with physicality but limited by the transitory nature of the flesh.

Before we proceed, a word about words. Incarnation is both a specific event (the Incarnation—of Christ) and a principle (incarnation—giving something flesh that previously existed only immaterially). It has application to the arts in

both senses, but they must not be confused. Acting is both a process and a product. It is the exercise of certain instruments and techniques while developing a performance and it is something that is presented to an audience after that process is "complete." The process is related to the product, but they are not identical. Some things an actor does in the work of preparing a performance are not repeated on stage, particularly the incarnating of certain imaginative, emotional or spiritual images/experiences.

INCARNATION AND MIMESIS

Plato and Aristotle referred to artistic communication as *mimesis* in the fifth century BC. They meant by this that the artist, whether writer or actor, creates by imitating some preexistent reality. Plato viewed mimesis, or imitation, as an inferior reflection of a spiritual reality; Aristotle viewed the artistic representation as having value and a reality of its own. If Plato saw imitation as a mirror, Aristotle saw it as a stamp.

It has been customary since the work of Aristotle to differentiate the mode of communication in theatre from that of narrative. In narrative a speaker retains his own identity while communicating a story. In theatre an actor takes on another identity and tells the story as a character in it. Theatre therefore requires heightened use of the resources of voice and body to first neutralize the mannerisms of the actor and second take on the mannerisms of the character being portrayed. On these points most schools of acting would agree.

Disagreement begins when the third resource, the internal, imaginative or spiritual resource, is engaged. To what extent does an actor *become* another person on stage? Does the actor really believe that she is someone else, in another place, time and situation, for the duration of the performance? At what point does this believing slip into a psychologically dysfunctional state: schizophrenia? At what point is acting not an artistic (consciously controlled) activity but a ritualistic possession by another living spirit?

The Russian actor/director Constantin Stanislavski struggled to understand and codify a method by which he, and other actors, could create their roles. He experienced moments of inspiration and truth on stage; moments in which his mimetic storytelling was so powerful and effective it seemed to surpass his conscious control. His method, though complex and widely investigated, added considerable weight to the internal process of the actor and placed greater emphasis on the third resource of the spirit than had previously been used. Emotional memory (the recovering of the actor's prior, real, experiences in the process of creating a character's emotional state) blurred the line between actor and character. Public solitude pulled the actor into a state of partial unawareness of the audience for which he was performing. Mimesis, the imitation of a character in a script, in history, or in contemporary life, was far more than mimicking voice and body patterns.

The blurring of acting and ritualistic embodiment of spirits was furthered by twentieth century theorists bent on restoring some higher significance to the theatrical art than mere entertainment. They continually stripped away the onion skin of environment, dedicated theatre space, even text/script to get at the core reality of an actor channeling the spirit of another presence. This is what Antonin Artaud and his progeny sought, and it is why Peter Brook concludes his chapter on "Holy Theatre" with a visit to a Haitian voodoo ceremony.[4] Jerzy Grotowski spoke of the actor allowing the character to "penetrate" him. He called the performance a sacrifice, a gift to the spectator. The religious imagery is deliberate and evocative.

Even if the actor, as a Christian, refuses to engage in a mystical process of engaging spiritual forces (via Eastern religions, commonly taught in acting schools) she must deal with the proportion of imaginative surrender she will utilize in the process of mimesis, bringing a character to life on the stage. As a Christian she believes reality is not merely material and physical, it is spiritual as well. So mimesis must include the spiritual realm. But is the pattern of gesture, movement and voice merely a reflection of another reality (a re-presentation) or is it in itself a new reality (a presentation = present). Actors both enflesh the imaginative creations of authors and bring to life their own personal imaginative constructs.

The Incarnation of Christ stands in history as a unique event. Never before and never since has God, who is a Spirit, taken human form in a particular place and time for the purpose of living among and revealing Himself to his human creation. God became human, without surrendering any of His Deity in the process. Jesus, the Son of God, was fully human and fully divine. The implications of this event are significant to every Christian; to the actor it offers a paradigm by which the engagement of the

imaginative/spiritual resource can be affected without surrendering the consciousness of who she is as a person, created by God. When Jesus was born to a virgin he was born as a baby, helpless, unencumbered by the accoutrements of culture, and he presented himself in the flesh, in the living presence of his "audience," and for the purpose of establishing a relationship with those who attended his birth and later, his humanity.

"The Word," says St Augustine, "is in a way the art of Almighty God."[5]

Bruce Herman. *Annunciation* (from the series *Elegy for Witness*), 2002. Oil & alkyd resin with silver leaf on wood panels framed dimensions: 81 x 108 inches (diptych). *Collection of Mr. and Mrs. William R. Cross.*

The willingness of Christ to surrender His glory, literally empty Himself (Phillipians 2) of it, in the act of the Incarnation is one of the evidences of God's grace and one of the great mysteries of our faith. Like the Trinity itself we are left without words to describe how it could be. Christ subjected Himself to the limitations, including suffering, of humanity in His incarnation. So too the actor surrenders the vocal and physical patterns which he has inherited and learned in the service of imitating a character on stage. As Christ retained his consciousness of being God (see His numerous references to His deity in John's gospel) so too the Christian actor retains a conscious awareness of his identity. To ever surrender that would be to disvalue the work of God in creating him a unique person.

The Christian has an identity beyond a creature of God because in the new birth the Christian is given an identity *in Christ*. This new status positions the believer "in the heavenlies" and makes him "a new creature" and "an alien in this world." Denis Diderot said that actors frequently lack character, because in playing many characters they lose their own. This is not an

option to the actor who has tasted of the grace of God and been made a member of His family, a child of God. No calling should ever take any believer out of the consciousness of his status in Christ at any time. This sense of identify is not just reflexive, it extends to the position of the believer in the community of faith. Being in Christ carries obligations to live in relationship with others who are in Christ; Paul addresses one facet of this in the Corinthian letters where he exhorts Christians not to cause other Christians to stumble in their faith.

The Incarnation of Christ, though it is fixed in time and space, is also a dynamic event. The birth of Jesus gave way to his growth as a young man, his public ministry and ultimately his death, resurrection and ascension (bodily) to heaven. His Incarnation continues to resonate through history, by the eye witness accounts to his bodily presence among the early believers and by the witness of the Holy Spirit to believers of every generation. So too the actor considers his

DOUG BERKY. *KAIROS* (2006). Ongoing touring production.

work as dynamic, not static. What happens on stage happens in time and space with a unique audience; it also resonates through memory and experience.

Jacques Maritain says the arts (he emphasizes the Fine Arts) "like man himself are like a horizon where matter comes into contact with spirit. They have a spiritual soul."[6] This means that the arts go beyond imitating external reality to embodying transcendence: "to allot to it [art] for essential end the representation of the real is to destroy it."[7] Indeed, "representation" or re-presenting suggests something less vital than a "presentation." The latter implies a living exchange, an experience alive with presence and spirit. Symbols in art function both as imitation (representing something we apprehend by our understanding of the external, real, sensual world as physical beings) and pointing beyond themselves to a reality in the realm of the spirit (representing something we intuit from our existence as spiritual beings). Imitation, the representation of observable or sensual reality, is therefore a companion to the presentation of spiritual reality.

For example, when an actor is called upon to portray a historical character she faces the challenge of making the character believable and recognizable. She must not, however, become a slave to that end and miss the purpose for the character in the play or her own imaginative response to the role. In the recent biopic film of Bobby Darin, *Beyond the Sea,* Kate Bosworth struggled with playing Sandra Dee, who was married to Bobby Darin (played by Kevin Spacey). In her initial research on the role, she says "I freaked out, worrying about doing her voice and her style." She consulted Spacey, who also directed the film, and she related his counsel that "It's not an imitation. The performance had to come from my heart."[8]

Acting as mimesis, therefore, happens because of a tension: reality (both physical and spiritual) is re-presented and at the same time the actor's living presence is presented. It parallels the duality of the God/man—wholly God and wholly man in the person of Jesus Christ. "So the picture is wholly of the brush and wholly of the painter; there is nothing, absolutely nothing, in it but proceeds from the brush, and nothing in it but proceeds from the painter."[9]

THE PASSION OF THE INCARNATION

Any actor or director can describe how their imagination of a role is always superior to the performance of that role. It is rather like listening to your own voice as you speak, as opposed to hearing it played back electronically. The resonation of the voice in the head gives it a pleasing timbre which is missing in a recording. So too the imaginative construction of a role is layered with possibilities that are necessarily truncated by the limitations of voice and body. Making the spiritual physical is limiting. Actors (and directors) recognize the limits of fleshing out, or incarnating, a role on stage. God took on human flesh, and in so doing placed the limitations of humanity on His Son, even to the point of suffering and death on a cross.

If the condition of the artist is more human and less exalted than that of the wise man, it is also more discordant and painful, because his activity is not wholly confined within the pure immanence of spiritual operations and does not consist in itself of contemplating, but of making. Unable to enjoy the substance and the peace of wisdom, he is caught by the harsh exigencies of the mind and the speculative life and condemned to every servile misery of temporal practice and production.[10]

We return to Plato: he characterized the body as inferior to the soul, not just separate from it. The body not only encapsulates the soul, it "encumbers and even defiles it."[11] The senses are not windows for the soul, they are prison bars. Plato believed the body was corruptible but the soul was immortal, destined to eternal life in the world of ideas. This body/soul dualism carries through in the writing of Descartes, but he admitted a symbiotic connection between body and soul—a sympathetic relationship in which what affects one also affects the other.

Plato echoes biblical truth in some points, but his bisection of humanity into material and spiritual is off the mark. The Old Testament speaks of the soul (*Nephesh* in the Hebrew) as tied to and inseparable from corporeal reality. Nephesh encompasses all that man is (in Genesis 2:7 it is translated "breath"). There is no dividing line in human existence, soul from body. The Old Testament word for flesh is *basar,* and again it is used to describe the totality of man's existence. Man is all flesh, as man is all soul. There is coherence, a unity and a symbiotic relationship between the material and immaterial natures of man. The body and soul are interwoven, intermingled, there is no dualism. The body is not

ANITA HORTON. *Texas T-Bone* (left) and *Stand Up Straight* (right), 2005.
Charcoal and gesso on paper, each 22.5 x 22.5 inches.

merely the housing for the soul; though such spatial terminology may be employed in order to communicate their disparate characteristics. In the New Testament the body is man, not just a repository for man's soul. Romans 12:1 makes this explicit in its reference to the whole of man. Paul's use of "flesh" (Greek *sarx*) refers to the transitoriness of the material world, his "manner of life in this world."[12] He may at times echo Plato, but he nowhere relegates the life of the believer to a purely spiritual existence, burdened by the sinful hindrances of a body. The ascension of Christ, bodily, is testimony to the future physical resurrection of believers and their bodily eternal prospect.

So Christ's incarnation was totally physical, even to the extent of experiencing physical suffering as a man. Any artist knows the pain of incarnating an imaginative idea through the use of artistic techniques, tools and instruments. The actor feels this most personally, as the instruments by which he will incarnate his idea are his own voice and body. A Christian actor knows it even more, because he recognizes the fallenness of the very instruments by which he seeks to make known his artistic images. He seeks to bring his imagination and his physical members (Paul's term for the body) into subjection to the Spirit of Christ. By doing so he improves himself as a Christian, and also as an actor. By making the spiritual fleshy the actor/artist also makes it ephemeral, transitory, fleeting. Incarnation always involves the paradox of concrete reality and temporary existence.

If incarnation is painful, does the artist then resist it, seeking instead to live solely in the world of ideas and images, the world of the ivory tower or intellectual seclusion? To retreat to such a place would discredit the example God set in the Incarnation of Christ. No, artistic incarnation is not only essential it is advantageous for the production of art. The tension of incarnating images into words, paint, musical notations, or vocal/bodily presentation is what brings about the full expression of the artistic image. Because art is for humans who live physically in the world, art must also take physical presence in that world; it must be incarnational. God's final stamp of approval on the Incarnation is that when His Son returned to heaven after his redemptive work on the cross He ascended in His glorified body, not as a spirit, but in the same body which began its life in a manger in Bethlehem thirty-three years earlier.

> ... whatever removes an obstacle removes a source of strength, whatever removes a difficulty removes a glory.[13]

All art is created in the face of tension, resistance and limitations. While the artist may like to think an unlimited time frame and unlimited finances would result in unfettered creativity it is probably true that the opposite would occur: artistic output would falter. Solo performers know that their new show will be up and running as soon as they get their first public performance scheduled. It is the

pressure of a deadline that brings the process to finality. Maritan goes on to write that art, "must have the constraint of rules and the opposition of matter. The more obstinate and rebellious the matter, the better will art, by its success in mastering it, realize its own end, which is to make matter resplendent with a dominating intelligibility."[14] No artist faces more "obstinate and rebellious matter" than the actor. A fallen body and imagination, tainted by sin but still retaining the image of God in them, present the actor a frustrating potential for good and evil work. Even a cursory reading of Jeremiah reminds the artist of how far his imagination has fallen since Adam and Eve first imagined they could be like God in the Garden of Eden. It is against this "matter" that actors push in the incarnation of characters. Ironically, as they mature and their techniques sharpen, their bodies offer more and more resistance. Not to worry: it is in the effort to overcome the limitations of the instrument that great work is done.

Actors also experience the pain of incarnation as they fulfill the prophetic dimension of theatre. A case could be made, from Old Testament examples of theatre in Ezekial (chapter 4) and Jeremiah (chapter 19), that theatre is by its nature prophetic, potentially anarchic and revolutionary, at the very least disquieting. Enfleshing spiritual reality, especially the disease and decay of sin caused since the Fall, is not comfortable to watch. This is one reason acting has been such a suspect art throughout the thorny history of church-theatre relations. Actors bring us face to face with our fallenness; and they do it by making concrete in real time and real space the ugly truth about humanity. We don't like to see or hear or be reminded of our sinfulness, but we certainly don't want to experience it incarnated. Acting, as incarnational art, makes us face ourselves intellectually, emotionally and also kinesthetically; we don't just sympathize, we empathize in the theatre. It is indeed a powerful mode of communication and sometimes the messenger gets discredited for bringing the message.

LIMITS AND LIBERTIES IN THE PRINCIPLE

> Beauty has an infinite amplitude, like being. But the work as such, realized in matter, is in a certain kind . . . and it is impossible for a kind to exhaust a transcendental No form of art, however perfect, can encompass beauty in itself as the Virgin contained her Creator.15

There is much to be learned by laying incarnation as a principle and the Incarnation as an event beside the art of acting, but there are limits to this endeavor. It isn't just that actors can't be Christ, or that as fallen creatures their work is always tainted by sin. It is that as incarnation the art of acting is at best a pale comparison to the Incarnation; all human creativity pales in comparison to the creative activity of God. Furthermore, acting has even been considered a

Tom Key. *C.S. Lewis On Stage* (top left), *Hard Times* (top right, with Jim Donadio) and *Cotton Patch Gospel* (bottom, with Eric Moore, Buck Peacock, Rick Taylor, John Grimm and Ryan Richardson). Theatrical Outfit, Atlanta, GA.

process which works in the opposite direction as the Incarnation.

Christ was revealing God in the Incarnation (see John 1). As a human He did not lose anything of his deity nor did he misrepresent anything of the spiritual reality of the Father. In theatrical incarnation actors may be said to be concealing themselves behind a character. The fifth century B.C. Greek word for actor was *hupokrite,* a word Jesus later used to characterize the Pharisees of his day. Hypocrisy is a sin. Pretending to be something or someone you are not for the purposes of deception is wrong. Acting is, of course, fictive and is not (or should not be) intended to literally deceive. If a person feels deceived by acting (or art in general) they have a developmental problem. An audience member who cannot distinguish between fiction and reality in a theatre, at a film, or reading a story has missed a vital phase of growth as a human being. No artist is responsible for this kind of uninformed response.

The Greek word *hupokrite* is literally "mask wearer." Classical Greek actors incarnated characters in plays by wearing masks. The mask accomplished two things: it revealed the character being portrayed and it concealed the identity of the actor. Modern actors may not wear masks (or even makeup) but the concept of the mask is central to the art of acting. Mimetic performance is a concealing of character and those physical/vocal mannerisms that betray it, and it is a revealing of another character

DEBORAH GILMOR SMYTH. *Into the Woods* (top), *Pump Boys and Dinettes* (middle), and *Private Lives* (bottom). Lamb's Players Theatre.

through physical/vocal mannerisms taken on by the actor. Many actors, as people, hide themselves behind whatever character they happen to be developing; some even hide themselves as artists because of their discomfort with who they are, with their self identity. Actors tend to be, generally speaking, an insecure and emotionally vulnerable lot.

What the believing actor can learn from the Incarnation as a biblical event and model is that wearing the mask of another character does not obviate the personal character of the actor. Indeed, secure in their identity in Christ, the Christian actor can confidently build each performance by combining an incarnation of an imaginative creation (a character in a script or in history) with those characteristics they possess as a creature and child of God. In directing terminology this is developing a *characterization,* the combination of a character in a script with an actor's own personality. Each characterization of a character is unique to the particular actor taking the role, and indeed each performance of that characterization is unique as the audience and its response changes.

Like the very experience of salvation this is a limiting, as well as a liberating, realization. It is limiting in that the Christian actor declines some roles because they hinder her relationship with Christ at that time in her growth in grace. It is liberating because the truth of her position in Christ gives a confidence and security that He is indwelling and guiding her, even on stage. Acting is not her religion. It is not the ultimate avenue for self fulfillment. It may be her passion, her love, but like all of life it lies under her fundamental position as a child of God.

When God came in the flesh He did not become a new entity. He took upon Himself a new form, the form of a servant. Jesus revealed the love of the Father through the Incarnation. It was a one-time event. When an actor incarnates a character he brings his personality to the event and is motivated by the same love to share his creation with his audience.

The cause of much confusion and error among Christian actors is the divorce affected between themselves and their work. For any artist in any medium, but especially for one whose instrument is his own body, such a divorce is belied by the principle of incarnation. Jaques Maritain, whom we have quoted liberally in this essay (in the hopes of drawing the reader's attention to his excellent essays) wrote, "As God makes created participations of His being exist outside Himself, so the artist puts himself—not what he sees, but what he is—into what me makes."[16] What distinguishes a Christian is obedience to the great commandment: love. Love first for God and then for our neighbors. It is the motivation for the Incarnation (John 3:16) and it should be the motivation for any action by the believer, even the activity of incarnating in the theatre.

Endnotes

1 T.S. Eliot, "The Aims of Poetic Drama."

2 Jacques Maritain, *Art and Scholasticism with Other Essays.* Trans J.F. Scanlan (Kessinger Publishing, nd.) 3.

3 Richard Southern. *The Seven Ages of the Theatre* (NY: Hill and Wang, 1961) 21f.

4 Peter Brook. *The Empty Space.* (NY: Atheneum, 1969) 63–64.

5 Cited in Maritain, p. 102.

6 ibid., 27.

7 ibid., 43.

8 Joe Neumaier, "Bosworth Agonized over Dee Role" Greenville News 27 Dec 2004 Section D p. 1.

9 Maritain, p. 103.

10 Maritain, p. 28.

11 C.A. Van Peurson, *Body, Soul and Spirit: a Survey of the Body-Mind Problem.* OUP: 1966, p. 37.

12 Van Peurson, p. 99.

13 Maritain, p. 42.

14 Maritain, p. 100.

RGB, CMYK
and Joy

> I have so loved all sense of Him, sweet might
> Of color and sound,—
> His tangible loveliness and living light
> That robes me 'round.
> —John Hall Wheelock, *Exile from God*

Zooming through the universe, photons pour the world into our eyes. The full spectrum of color affects every aspect of humanity, including the sciences, the arts, and our faith. Even in the mundane, color populates our closets and signals when we stop and go. Memories throughout our lives become intertwined with color—the rooms we've inhabited, the school pride of our formative years, a special sunset that made us stop in our tracks. Every waking moment color floods our field of vision and shapes our perceptions, to the point that we take it for granted. Let us look with new eyes and regain a sense of wonder at the world of color.

THE CREATION OF COLOR

Before the question "What is art?" could possibly enter into the human consciousness, God, in His goodness, created all of the natural laws, raw materials, and examples that prefigure art. "Then God said, 'Let there be light;' and there was light. God saw that the light was good; and God separated the light from the darkness."[1] At this point in creation, God had already formed the heavens and the earth; the light created was simply light, not bodies that emanate or reflect light. In separating the light from darkness, God set the framework for every act of creation that follows.

Light is paradoxically both particle and wave. Light is life-giving energy. And of particular interest to artists, light contains all colors. Sir Isaac Newton first made this observation in 1666: sunlight, when refracted through a prism, displays all of the colors of the spectrum; the colors, when refracted through a second prism, merge back into white light.[2] With four simple words, God uttered the brilliant potential of color into being.

The creation story in Genesis can read like a daily roll call of created matter collected into physical categories. But why not meditate on creation with a different system of classification? Imagine that God created with the expression of color as a purpose:

Day 1: *white, black* (heavens, earth; light, dark)

Day 2: *blues; transparency* (expanses of water, sky)

Day 3: *earthtones, greens, violets; iridescence* (seas, land, vegetation)

Day 4: *yellows, oranges; luminousity* (sun, moon, stars)

Day 5: *florescents, reds, yellows, oranges, greens, blues, violets* (fishes, birds)

Day 6: *neutrals* (animals, humans)

Day 7: *all of the colors mingle together* (rest)

The Creator of the universe could have made any kind of universe, but He chose this universe, one full of the diversity of color. After creating the physical fact of light, God set about exploring the infinite combinations and uses of colors in nature. Over 28,900 species of fish sport different color markings, color combinations, or color nuances[3]. From the simple palette of the red-winged blackbird to the extravagant color combinations of the parrot, nature inspires artists with harmonious and exciting color choices. God also considered practical things like survival: think about the shifting color of the chameleon that makes it invisible to predators or the ultraviolet markings of flowers that draw bees to pollinate them. And if it were not enough that the sun's energy, nature's beauty, and practicality were part of light, God threw color into the very chemistry of nature. The green chloroplast plant cell takes energy from sunlight and turns carbon dioxide into oxygen in photosynthesis; the energy transfer makes sugars and carbohydrates that provide food for our bodies and, over time, fossil fuels for our machines. Then when the chloroplast cells die, leaves turn from green to the blazing colors of autumn.

All the days of creating were good and brought pleasure to God, but two days of creation hold particular interest to the artist studying color. On Day 3, God created the means to fill the artist's paintbox amidst the dry land and its vegetation. Mix mercury with a little sulfur and add fire to make brilliant vermilion; extract the sap from the tall *Garcinia hanburyi* tree to produce Gamboge yellow; suspend copper over a bath of vinegar to prepare the vibrant green verdigris; grind the

semiprecious stone lapis lazuli, mined from deep within the ground, to produce ultramarine blue.[4] The raw materials for making color pigments, dyes, glazes, and patinas were locked away in secret places until we had the need to create. On Day 6, when God created male and female in His image, He gave the significant gift of sight. In the eyes, light passes through the lens and falls on the retina. The retina holds two types of cells: rods register value in white, grays, and black; cones differentiate between red, green, and blue wavelengths. The defined sensations of light move along the optic nerve to the brain, which reassembles the image, assigns meaning, and orders the body to act or react. Pure visual perception then, without mental associations or other sensory input, relies strictly on two retinas compressing the world into value and color.

Throughout His creation, God manifested His goodness in color. Artists imitate God by creating anew from His original palette. Yet to do this requires training to understand the tricks of our eyes and minds and to see color as it lives.

THE THEORY OF COLOR

The best way I've found of understanding this is to think not so much of something "being" a color but of it "doing" a color. The atoms in a ripe tomato are busy shivering—or dancing or singing; the metaphors can be as joyful as the colors they describe—in such a way that when light falls on them they absorb most of the blue and yellow light and they reject the red—meaning paradoxically that the 'red' tomato is actually one that contains every wavelength except red. A week before, those atoms would have been doing a slightly different dance—absorbing the red light and rejecting the rest, to give the appearance of a green tomato instead.
—Victoria Finlay, Preface of *Color: A Natural History of the Palette*

Every visual artist must make decisions about color: choosing to avoid the use of color, to limit the palette, or to indulge in an intense profusion of color. The sheer multitude of options can be daunting for any artist beginning a new work, especially considering that the human eye/mind can perceive several million color variations.[5] Yet artists must consciously compose color as they do any other element of their craft. In order to develop an approach to color beyond an instinctual level, artists need to know something about color theory.

Although thinkers and artists as far back as Aristotle have been interested in color relationships, Isaac Newton laid the foundations for modern color theory in the late seventeenth century. Newton's observations with the prism led him to coin the term "spectrum," to arbitrarily choose its seven colors, and to place the colors in a circular formation to identify relationships between them, such as complements.[6] Moving forward to 1810, the publication of Goethe's *Theory of Colors*

brought the issues of perception and visual balance into the discussion of color relationships.[7] In the early twentieth century, Johannes Itten created a curriculum for the Bauhaus focusing on color harmonies. His pupil Josef Albers went on to teach a curriculum at Yale on the interactions of color. Taken as a whole, color theory serves as a set of guidelines to make informed decisions about color.

The Properties of Color

A color has three different properties: hue, value, and saturation. Hue is the most ambiguous property: the color's name. The spectrum of visible light exists as a small range of wavelengths—from red to violet—in the larger electromagnetic spectrum that includes long radio waves to extremely short gamma rays (*below*).

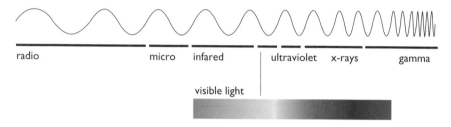

radio micro infared ultraviolet x-rays gamma

 visible light

ELECTROMAGNETIC SPECTRUM, not to scale

However, colors within the visible spectrum do not have definite edges. A range of wavelengths define each hue and its name; for example, yellow includes wavelengths of 580–550 millimicrons.[8] But unless you have a spectrophotometer to measure wavelength, the definition of a hue is left entirely to each person's perception. There are as many versions of pure blue as people who think about blue—one person visualizes it a little more green or more violet, another a little lighter or darker.[9] The hues on a color wheel help allay confusion and bring sense to the spectrum for the artist by grouping colors into primary, secondary, and tertiary hues. The three primary hues are the hues that can combine to mix any other hue. The visual center between two primaries creates a secondary; and the visual center of one primary and one secondary creates a tertiary color. With the twelve resulting hues, an artist can use a color wheel to set up basic harmonious relationships: monochromatic, one hue; analogous, adjacent hues; complementary, opposite hues; triadic, hues that form an equilateral triangle; split-complementary, hues that form an isosceles triangle; tetradic, hues that form a rectangle.

The second property of color is value. Value is the lightness or darkness of a hue. Adding white lightens a hue's value, creating tints. Adding black darkens a hue's value, creating shades. Another term for value is luminance—the measure of the amount of light reflected from the hue. A traditional color wheel depicts pure hues, untinted, and unshaded. An artist can easily create a value scale

VALUE SCALE, yellow

within a hue by mixing white or black with the pure hue in equal visual steps (*above*). But seeing value across the spectrum is more difficult. Each pure hue does not carry an equal value: yellow is much lighter in value than violet; yellow and orange are closer in value to one another. Therefore, to match the value of violet or orange to yellow, the artist must add a larger proportion of white to the violet than to the orange. One can train the eye to see value by artificially changing the colors of a picture into grays by making black-and-white digital photos, scans, or photocopies. Another method is squinting at an image to blur the edges of forms. Colors close in value side by side create a soft edge, but the edge sharpens with a high value contrast. Value is essential for bringing light, shadow, and depth to two-dimensional images.

The third property of color is saturation. Saturation is the degree of purity of a hue along the continuum of bright to dull. Unlike the variations in value between hues, all hues on the color wheel are fully saturated. Full saturation equates to strong, vivid colors. Desaturation creates a muted, weaker impression of the color. A saturation scale exhibits the gradual neutralization of a color either by mixing in a complementary color or by mixing in gray to create a tone (*below*). In a tone, less of the original hue escapes to the eye, creating a muddy, dark effect. Subtle, rich tones balance the stark contrasts of fully saturated complementary hues.

SATURATION SCALE, violet to yellow

The Mixing of Color

Light works on the principle of additive mixing—the presence of all colors creates white/light, and the absence of all colors equates to black/darkness. Our eyes decipher light with red, green, and blue receptors, yet we see in "full color." Therefore, red, green, and blue are the primary colors of seeing (RGB). Red combined with green makes yellow; green with blue makes cyan; blue with red makes magenta (*left*). In combination with value receptors, the RGB additive system recreates the full

RGB SYSTEM, additive

range of the visible spectrum from light.

However, light cannot be emitted from within pigments, dyes, clay, canvas, paper—only absorbed and reflected. For these, additive mixing turned on its head becomes subtractive mixing: the absence of colors equates to white, the presence of all colors creates black. In the reversal, the secondary colors of the additive system become the primary colors of the subtractive system: cyan, magenta, and yellow (CMY). Cyan combined with magenta makes blue; magenta with yellow makes red; yellow with cyan makes green (*top right*). As light hits cyan pigment, the pigment absorbs red wave-

CMY SYSTEM, subtractive.

lengths and reflects green and blue wavelengths back to the eye mixed as cyan. The subtractive system essentially tricks the additive system at its own game. Commercial printing uses CMY plus black to produce colors through subtractive mixing.

The traditional artist's color wheel exhibits the primaries of red, yellow, and blue (RYB). Red and blue have always been more practical colors than magenta and cyan, not to mention easier to manufacture. Red combined with yellow makes orange; yellow with blue makes green; blue with red makes violet (*middle right*). As

RYB SYSTEM, subtractive.

light hits red pigment, the pigment absorbs green and blue wavelengths and reflects the red wavelengths back to the eye alone (*below*). The absorption of two

PIGMENTS ABSORBING/REFLECTING LIGHTWAVES

sets of wavelengths makes the RYB system less pure and one step off from how the color receptors work, Therefore, the range of colors that an artist can mix in the RYB system is smaller than in the CMY system. When you mix pigments, the trapped wavelengths in the separate pigments combine in a cumulative effect. The only way to release the trapped wavelengths would be to add transparency.

For maximum color range and control, artists can use white and black pigments and move freely between the RYB and CMY subtractive systems, while the RGB additive system only applies to the realms of lighting and digital color.

LIGHTER ON BLACK

BRIGHTER NEXT TO COMPLEMENT

COMPLEMENT IN NEUTRAL FIELD

The Relativity of Color

In context—with different lighting, next to other colors, on various materials—color appears to shift and change. The context of a color ultimately determines how we perceive it. For instance, a color on a black background appears lighter than the same color against white; green appears greener next to its complement red; and a neutral field takes on a hint of the adjacent color's complement (*left*). In addition, colors carry temperature relationships. Warm colors—reds, oranges, yellows—advance out of a composition; cool colors—greens, blues, violets—recede. Yet one red could be warm and another cool when viewed side by side. An extreme example of contextual color is partitive mixing: fine dots of color combine into new perceived colors. Textiles, pointillism, and offset lithography all rely on the eye to mix rich palettes from a few original hues.

Color can also be manipulated to purposefully trick the eye. Color optical illusions force the eye to see something that does not physically exist. A number of Josef Albers color theory exercises involve creating color tricks: make one color look like two colors; make three colors look like one; make one of three colors look translucent. Albers' exercises require the artist to make refined, subtle observations and to slightly shift hue, value, saturation, temperature, and other color affinities. A common color manipulation used for special effect is the after-image, or successive contrast: after focusing on a flat color for an

extended period of time and looking away, the same shape appears in the comple-
mentary color. Other fascinating color phenomena include Benham's Top, a top
with a black and white pattern that shows the spectrum when it spins; and the
Munker-White Effect, where one color looks different each time it appears in a
scene depending on its surroundings (*below*).[10] The simplicity of optical illusions

THE MUNKER-WHITE EFFECT

betray even the trained eye and expose the utter complexities of visual perception.

The study of color theory brings to light new principles, relationships, and
power. Since color is ever-changing, the artist must translate theory into experi-
mentation and discovery.

THE ROLES OF COLOR

Just as the knowledge of acoustics does not make one musical—neither on
the productive nor on the appreciative side—so no color system by itself
can develop one's sensitivity for color.

This is parallel to the recognition that no theory of composition by itself
leads to the production of music, or of art. What counts here—first and
last—is not so-called knowledge of so-called facts, but vision—seeing.

—Josef Albers, Introduction to *Interaction of Color*

Understanding the science, practicing the theory, and seeing the nuances all
stop short of grappling with the multiple meanings that color can hold. Color can
add dimension and physicality to two-dimensional work. Color can tap into rich
symbolic histories. Color even holds sway over the psychological mind. In the
variety of roles it can fill, color becomes a tool to remind, provoke, warn, instruct,
prompt, honor, or surprise the viewer.

The Realism of Color

A primary use of color is to represent the "seen" world. The representational role
of color seems at first to be simple and obvious because color represents the world
to our minds. But by choosing the representational role for color, the artist must
make many decisions. For example, the medium and tools used determine the range
of color options available. Watercolors behave quite differently than oils; patinas,

differently than glazes. Subject matter decisions narrow the choices for color: landscapes, portraits, and still lifes bring unique color palettes and challenges. Stylistic decisions also influence color choices. For example, the amount of color-related detail varies greatly among styles: photographic or photorealistic work requires acute attention to minute shifts in value quite different from the direct, flat blocks of color appropriate for impressionistic or iconic work. Decisions about working from life or from a constructed reality bring additional color choices. Representational color also carries meaning through content and compositional choices. The viewer perceives awe-inspiring beauty, a quirky personality, or the drudgery of work in large part because of the artist's meaningful color decisions.

Conveying reality through color is a difficult task requiring intense observation of modulations in color. Multiple light sources and ambient light throw shadows, highlights, and reflected color across a setting, complicating the colors we assume we are seeing in objects and textures. Generally, shadows thrown by an object include the complement of the surface the object is sitting on. The color of the light determines the temperature of the shadow as well: warm light creates cool shadows; cool light creates warm shadows.[11] Though the altered colors might not look correct isolated from the setting, the eye will balance them in the composition. For example, three mixed yellows will look like different hues on a palette, but will look like one yellow when painted on the three sides of a two-dimensionally represented cube. The overall compensation the eye makes in this situation is known as color constancy.[12] In observing and capturing color nuances, the artist is able to create convincing realities.

SHAUN FOX. *Island Greenery*, 2005 Color photograph. 4 x 6 inches.

Shawn Fox captures the vibrant diversity of the realism of color in his detail photography. In *Island Greenery,* sunlit plants on Kaua'i display an analogous range of yellows to blue-greens. The warm yellows and yellow-greens pop out of the image while the cooler and darker greens recede into the background. Fox captures a lush image with a limited palette; the contrast arising from alterations in value and saturation rather than through the hue contrast typical of bold tropical blossoms likely twenty degrees to the left or right of Fox's viewfinder.

The Symbolism of Color

Color can carry associations that have no direct connection to the inherent physical properties of the hue. By standing in as a representative of something else, color becomes symbolic. A symbol represents a concept, a thought, an abstraction, or an object. One type of color symbolism is to directly correlate a hue to a similarly colored physical object—blue stands in for sky and water; green for vegetation or land; yellow for the sun; red for fire. Direct correlation symbols allow us to quickly identify abstracted forms and fill in the details ourselves. A second type of symbolism is an indirect correlation to a characteristic of a similarly colored physical object. Yellow and black symbolize danger due to their association with stinging insects and poisonous snakes that carry yellow and black markings.[13] A third type of color symbol is a concept specific to a cultural group or time period, such as reds vs. whites in the Bolshevik Revolution or the

DAYTON CASTLEMAN. *The End of the Tunnel— North Wall,* 2005. Steel pipe, industrial acrylic enamel, pressure treated lumber, hardware. 36 x 6 x 3 feet.

psychedelic colors of the sixties. A fourth type of symbolism is commercially motivated, or driven by corporate branding. Any number of corporations have co-opted colors as symbols: Coca-Cola red, IBM blue, UPS brown. No matter the type, all symbols depend on the context. If the artist provides no clues for deciphering the symbol, the color choice will remain either representational or a complete mystery.

Religious symbolism falls under the cultural-conceptual category. Western culture has widely used Christian color symbolism in both religious and secular contexts. The color palette standardized by Pope Innocent III in 1200 still serves the liturgical church calendar today.[14] The colors emerged as symbols from the Scriptures, theology, metaphysics, and church history. Red stands for the blood/martyrs and the fire of Pentecost; yellow for the presence of God; green for life and renewal; blue for heaven and royalty; violet for suffering and royalty; gray for mourning and repentance; black for death; and white for purity, holiness, and virtue.[15] Other religions assign different meanings to symbolic colors. The Islamic color palette carries different meanings: white stands for the sun; black for concealment; sandalwood as a neutral base; green for water; yellow for air; blue for earth; and red for fire.[16] In Buddhism, colors symbolize behaviors: orange stands for humility, which the monks wear; black for killing and anger; white for rest and thinking; yellow for restraining and nourishing; red for subjection and summoning; and green for exorcism.[17] Embedded religious color symbolism can add layers of meaning to a piece. However, a multicultural climate could have the effect of subverting the intended religious meaning.

Two bold examples of the use of color in a symbolic way can be seen in the works of Dayton Castleman and Allison Luce. In *The End of the Tunnel*, "safety" red competes with the frigid green, gray, brown and black that

ALLISON LUCE.
The Grand Finale, 2001. Glitter on fired clay. 22 x 10 1/4 x 3 1/4 inches.

overwhelms and suffocates the world's first penitentiary, a place as famous for the madness produced in those it held captive, as for its innovative penal plan and architecture. *The End of the Tunnel* was a public, site-specific sculpture located at Philadelphia's Eastern State Penitentiary Historic Site. Castleman's installation was composed of over 600 feet of steel pipe meandering throughout the eleven acre site, pulsing with warm veins of bright color symbolizing life, humanity, and hope.

In *The Grand Finale,* Luce sculpted a hollow tombstone and covered it in the blood-red of martyrs and lined the interior in the blue of heaven. Inside and out are covered with glitter that creates shimmering values of the base colors when moving around the object. The red symbolizes the reality of death. The inside of the tombstone signifies that the soul was made for another place—heaven—as represented by the blue. Hope springs from the sorrow of death in a piece made ethereal by Luce's addition of glitter.

The Psychology of Color

Color cannot be tasted, smelled, touched, or heard; it engages our senses only by sight. Associations for color exist in the mind, or the realm of psychology. The perception of a color begins with cultural identification, then rapidly moves on to gather other kinds of information about the color. Each person has a collection of memories, experiences, and emotions that influences his or her reaction to every color. Some associations piggyback off of cultural symbols: the yellow smiley-face icon connects yellow to cheerfulness. Other colors can produce nostalgia for

JEREMY BOTTS. *The Mountain of Mercy,* 2005 digital poster, variable size.

things of our youth—as retro color scheme trends demonstrate. In addition, colors can trigger physical reactions: red triggers a chemical process in the body similar to the fight-or-flight response.[18] Using color to tap into mental associations can bring emotional depth to visual artwork.

Even in choosing not to use color, the psyche is engaged. Black and white—

the absence of all color and the presence of all color, respectively—provide the ultimate contrast to the mind. Our responses to black and white imagery have been conditioned by prominent use in the past. Historical woodcuts and engravings, old family photographs, and black and white reproductions in textbooks present a view of history without color and can trigger nostalgia for some imaginary "golden age." Within the early cinema, the genres of thriller film, horror film, and film noir capitalized on the strong contrasts of black and white film to capture man's darkness; low light and long shadows imply impending danger. For over a century, photojournalism, news in photographic images, was presented to the public in black and white. The authority and authenticity created by news therefore extends to black and white photography, photojournalistic or not. Perhaps the use of black and white, by removing the noise of colors, allows the imagination to create an emotional backdrop and fill in the details.

Two graphic design pieces illustrate this psychological use of color well. In a poster announcing a Holy Week tenebrae service, Jeremy Botts creates a thoughtful, multi-layered composition using shadows, solid branches, and an outer halo of darkness to create a contemplative scene that parallel a service which will focus on the death and burial of Christ. Although printed in four-color process, Botts limited his palette to earthy oranges and browns to convey human frailty: to dust we all shall return. The saturated hues are rich, full-bodied, and comforting; the immanent resurrection makes the darkness palatable. In the fifth volume of CIVA's publication *SEEN*, Kathy Hettinga also uses a limited palette, but in this case it is to communicate a sense of melacholy. Hettinga surrounds Tony

KATHY T. HETTINGA. *SEEN, Volume V: Art Faith Depression,* 2005 journal cover, front/back. 21 x 12 1/2 inches (opened).

Caltabiano's stark landscapes with enlarged photos printed in duotone of black and Pantone 7509 to evoke a feeling of bleakness and cheerlessness, while at the same time introducing a glimpse of hope through fragments of white that break across the images and typography.

Many business ventures have emerged from the study of color psychology. Color consultancy firms research people's reactions to specific colors or color schemes for corporations. For instance, fast food restaurants are designed to get people in and out as fast as possible through colors with a sense of urgency. On the opposite end of the spectrum, coffee houses are decorated with rich, warm tones to encourage a cozy, comfortable, extended visit. Other businesses proctor personality tests based on color. For example, Max Lüscher developed a system to reveal aspects of a person's personality by analyzing his or her choices among a group of colored cards.[19] The business of color forecasting predicts the next season's trend colors in self-fulfilling prophecy. One such "color guru," Leatrice Eiseman, spends time soaking up fashion, technology, and art trends. For every season, she selects a set of colors, assigns psychological meaning, and suggests uses.[20] Color trends and common psychological associations suggest a plethora of color palettes for any theme.

For artists, cultivating a conscious awareness of the various roles of color can allow a rich mixture of references to emerge in their work. In material or

GUY CHASE. *REALISMplus* (key), 2004.

metaphorical works, color has the potential to become another character in a visual narrative or an underlying current that stimulates the senses.

THE PRACTICE OF COLOR

Imagine an eye unruled by man-made laws of perspective, an eye unprejudiced by compositional logic, an eye which does not respond to the name of everything but which must know each object encountered in life through an adventure of perception. How many colors are there in a field of grass to the crawling baby unaware of "Green"? . . . Imagine a world alive with incomprehensible objects and shimmering with an endless variety of movement and innumerable gradations of color. Imagine a world before the "beginning was the word."

—Stan Brakhage, *Metaphors on Vision*

Being aware of the sensations of color will ultimately impact any artist's work. In addition, studying how others manipulate color can deepen the color relationships in the artist's own work. Following are color analyses of selected pieces from three artists that are working in different mediums and using color in very specific ways.

The Flexibility of Color

Guy Chase was looking for a way to create work that was about being present in the act of painting, but where many of the creative decisions were made for him. He came to this desire through meditating on John 3:30, where John the Baptist declares that Christ ". . . must increase, but I must decrease."[21] One

GUY CHASE. *#30 Where the Birch Emerges from the Earth* (left), *#15 Haunches and Back of Doe, Alert to Some Presence* (middle), and *#3 Blue Sky through Autumn Leaves* (right), 2004. Oil on panel, 7 x 9 inches (each).

Christmas paint-by-number kits captured his imagination as an ironic gift for an artist to give. But as he worked on a kit with his daughter, he became conscious of the methodical and obsessive nature of mark making required to complete the painting; he had found exactly the source to afford him freedom from decisions about color and composition.[22] Chase began deconstructing paint-by-number kits by applying arbitrary sets of rules over the rules the kits imposed. His paint-by-number paintings evolved from small explorations into the large-scale installations described below.[23] Chase chose kits in the narrative realism style—generally landscapes with animals—to explore the use of color in representing reality.

REALISMplus, a set of thirty paintings, derives from a paint-by-number kit of deer in the woods. The original image includes a fair amount of density and detail due to the thirty included colors. To subvert the kit, Chase drew thirty rectangles spaced equally across the original image. He then transferred the contents of each rectangle to individual panels and painted with the colors specified by the kit's key.[24] True to the nature of paint-by-number kits, each color works in as many places as possible. However, the relationship of adjacent colors can make the same hue and value appear bright in one area of the image and muted in another area. By isolating parts of the image, Chase allows the viewer to compare the different uses of one color across the set. The burgundy used for an autumn leaf on the ground also serves as a shadow on the brown coat of a deer. The fluorescent orange of fiery leaves also

GUY CHASE. *Actual Things with Their Own Colors* (key), 1999.

appears as a highlight on a deer's back. If the original image were completely filled in, that fluorescent orange would seem to be two different values of orange.

By choosing the size and placement of rectangles, Chase ensured that most of his paintings use fewer than five colors and that none of the images is recognizable. Removed from the context of the key, the paintings become a set of highly abstracted color compositions—sometimes jarring in their combinations. The viewer must reconcile the abstract compositions with the titles that tie each painting to what it represents in the original image: *Blue Sky Through Autumn Leaves*. The compositions become about the dialogue between the abstract, the represented, and the seen reality around us.

GUY CHASE. *#1 Sunlight on Dead Grass in Foreground* (above), *#5 Sunlight on Boulder* (below), 1999. Oil on panel, various sizes.

In *Actual Things with Their Own Colors,* Chase created a painting for each of the twenty-one colors in the kit. Rather than painting on a rectangular panel, Chase cut shapes out of Masonite that matched the largest continuous area that each color was assigned to in the kit.[25] The paintings appear to be paint rising off the wall—strange shapes that are similar to one another in contour. The set of twenty-one colors—muted greens, browns, and grays with several brighter oranges and yellows—make up a small range of variation in hue, value, and intensity. By leaving the full image unpainted and using descriptive titles, Chase invites the viewer to imagine how the twenty-one colors combine to make two hunting dogs on an autumn morning come alive. Surprises emerge from paying attention to the paintings' titles. For example, *Sunlight on Dead Grass* and *Sunlight on a Boulder* both depict sunlight, but one is yellow and the other is gray. By isolating the colors, Chase requires the viewer to question simple color relationships such as "the sky is blue" and "the grass is green." What we see seems that much more rich, varied, and complex because of the simple exercise of viewing a subverted paint-by-number kit.

At first glance, one might question the fine line Chase is walking as an artist by taking a prefabricated kit and using its colors and shapes to create his own work. But the co-opting of a creation by an anonymous other logically follows the trajectory of art during the past century: Marcel Duchamp took ordinary objects and declared them art in his readymades; Andy Warhol used images not of his own making from pop culture; and Quentin Tarantino steals scenes from obscure kung-fu flicks for his own films.[26] By reinterpreting the assigned colors and artificial contours of the kits by arbitrary methods, Chase creates color compositions reminiscent of those by

Josef Albers, Piet Mondrian, Ellsworth Kelly, and Gene Davis. But where these artists used geometry as a starting point for their explorations of color and composition, Chase uses color representations of landscapes to create a "resonance between realism and abstraction."[27] Chase has repurposed quintessential 1950s kitsch to allow the viewer an entry point into abstraction.[28] Ultimately, the paint-by-number paintings are, according to Chase, "redeemable only by a miracle;"[29] viewers must use their own imaginations to reconcile the abstracted colors, shapes, and descriptive titles.

The Brilliance of Color

When Christ Lutheran Church in Anderson, Indiana, asked glass artist Arlon Bayliss to create a piece of art for the church, he began by asking himself, "What would a cross of light look like?"[30] Bayliss's conceptual question led him to a type of glass with iridescent properties: dichroic glass, made by spraying ultra-thin layers of metal oxides onto its surface, has the unusual property of displaying more than one color. When light moves directly through the glass, one color is transmitted; but if the glass is held at an angle, a different color is reflected.[31] After a year of formal experimentation aided by lighted models and digital imaging, Bayliss installed *A Cross of Light* in December 2004.[32]

A Cross of Light is 6 feet by 9 feet and hangs 9 feet above the altar. From a distance, the intense white of cross-shaped light and colored reflections are the only visible elements of the installation. However, twenty halogen light fixtures are mounted behind a false wall and shine through the beveled slits onto ninety mounted pieces of dichroic glass, 4 inches by 2.5 inches. Bayliss chose cool white halogen as the light source because it brings out the most intensity in the twelve

ARLON BAYLISS. *A Cross of Light* (left) and a detail (right), 2004.
Dichroic glass installation, 6 x 9 feet.

colors of dichroic glass used in the installation.[33] Some light travels through the glass pieces and their original colors fall onto the altar. The remaining light is reflected off of the metallic coating back onto the white wall. Precise attention to angles and distance of the glass pieces from the wall determines the value, length, and shape of the reflected colors. Essentially, Bayliss was painting with light as he manipulated the overlapping reflections between the glass and the wall. With all of the transmitted and reflected light bouncing around at various angles, rainbows occasionally appear in different parts of the sanctuary.

In the installation, Bayliss blended the traditions of light in church architecture with contemporary explorations of light in art. Relatively early, light played an important role in church architecture and the experience of worship. Built in 537, the Byzantine church of Hagia Sophia is famous for the mystical quality of its light. Light enters through forty windows at the base of the dome and refracts off rich mosaics and multi-colored marbles, filling the church with a dazzling brilliance analogous to heaven.[34] In the twelfth century, stained glass decoration was incorporated into cathedrals due to the technical advances of Gothic architecture. Chartres Cathedral has 173 stained glass windows that bathe its interior with red and blue light.[35] The Gothic cathedral is an architectural metaphor for God: "For with You is the fountain of life; In Your light we see light."[36] With *A Cross of Light,* Bayliss had to work within the existing church architecture and no natural light sources. And yet, he created a piece that upholds church traditions and cues off more recent explorations in the perception of light and space by James Turrell and the architectural glass installations of James Carpenter.[37]

The very materials that make up *A Cross of Light* inherently hold spiritual significance. Bayliss's way of combining the materials results in a cross that contains no darkness: when all the colors come together, they create white light according to the physical properties of mixing light. *A Cross of Light* visualizes the darkness of death being dispelled and driven away by Christ's sacrifice. The cross also symbolizes the promise of a New Jerusalem, when Christ will return for His bride, the Church. Bayliss chose to use twelve of the sixteen available colors of glass, which can be seen to correspond to the twelve foundations of the New Jerusalem that St. John describes: "The construction of its wall was of jasper; and the city was pure gold, like clear glass. The foundations of the wall were adorned with all kinds of precious stones; the first foundation was jasper, the second sapphire, the third chalcedony, the fourth emerald, the fifth sardonyx, the sixth sardius, the seventh chrysolite, the eighth beryl, the ninth topaz, the tenth chrysoprase, the eleventh jacinth, and the twelfth amethyst."[38] The metallic coating of the dichroic glass suggests the translucent metals of heaven, an ideal match of concept to form.

Bayliss was keenly aware of his responsibility to create an object that would be meaningful for worship, not simply a successful formal exercise. His decision to keep the reflections as abstracted shapes affords the opportunity to see many

images: a crown, hands, a heart, a bird of peace.[39] Besides conjuring the beauty we instinctively respond to in light, Bayliss leaves room for the imaginations of each worshipper and the prompting of the Holy Spirit. *A Cross of Light* floats on the wall, transparent but for the light, life, and hope pouring into the space.

The Poetics of Color

In his experimental filmmaking, Greg King taps deeply into the sense of a place. By carefully juxtaposing images, King exposes a view of the landscape that is beyond eyesight, but equally as real.[40] His films echo the reality of the unseen spiritual world: "... while we do not look at things which are seen, but at the things which are not seen. For the things which are seen are temporary, but the things which are not seen are eternal."[41] Although the images in King's films are familiar, they are combined in ways that create new perceptions, or "narratives of sensation."[42] King's selective color palettes tease out a color's many moods in value and saturation in a few minutes of carefully edited footage.

GREG KING. Stills from *Glasgow x, y, z,* 2003. Super 8 film transferred to DV, 3.5 minutes.

Glasgow x, y, z captures the changing sky of the city. During filming, King structured every shot so that a skyline of Glasgow architecture appears along one edge of the frame and the sky fills the rest of the frame. When assembling the footage, King overlaid and rotated multiple shots. In most of the film, shots are rotated so that the skylines are along the outside edges of the image and the sky fills the center. Quick cuts move through morning, noon, and evening skies on rainy, cloudy, and brilliantly bright days, creating a jittery kaleidoscopic effect of silhouetted architecture that pierces the sky and dissolves the rectangular frame. King edited the film more about to show a formal visual progression of shapes and colors rather than a repre-

sentation of one day to the next. Neither gray skies nor bright overwhelm the piece, and yellow-tinged sunsets appear occasionally as punctuation.[43]

For King, making the film became a poetic, visual journal that allowed him to experience Glasgow in a new way.[44] The film provides a unique glimpse into the moods of the city, quite different in approach from a documentary travelogue. King's focus on the sky draws the viewer into the film immediately. The color of sky and clouds taps into specific emotional associations for each viewer; bright blue skies could represent limitless possibilities to one and trigger regrets over a sunburn for the next. The faster portions of the film free the imagination to see things that are not there; the slower portions prompt longings for other times and places, like daydreaming through a window. Overall, the skies merge into a progression of shifting atmospheric color. The sky isn't always blue after all.

In *romafirenze*, color tells the story of a journey through a landscape. The journey and landscape are specific— a train trip from Rome to Florence— even though the viewer may not immediately recognize it. The film's screen is split in half. The bottom half represents the window ledge inside of the train; spots pulse irregularly up and down with the rocking of the train. The top half of the screen captures the scenery as it rushes past the train; forty-eight interlocking rectangles each act as a frame for a portion of the landscape. The image in each rectangle is blurred to the point of being identifiable only by color. In addition, the color in each rectangle is constantly shifting (imagine a set of Legos where every block is changing colors at its own pace). At times the colors in adjacent rectangles align, leaving the screen less fragmented.

The colors map the journey: the stone of Rome dissolves into the lush countryside, past villas, through more vineyards, olive groves, and small towns

GREG KING. Stills from *romafirenze*, 2002. Mini DV, 2 minutes.

into Florence. Likewise, the color moves gradually through muted neutrals, light cool colors, bright warm colors, and black, with a constant undulation through the green spectrum, from cool to warm, dark to light, dull to intense. King considered the overall color arc of the film, pacing the color shifts to prompt an emotional response as jarring elements appear within, and usurp, the predominantly green landscape.[45] By "digitizing" the landscape and assigning different parts of the journey to each rectangle, King was able to keep the feeling of landscape intact while manipulating color for greatest impact. The abstract nature of the color shifts and lack of detail (in combination with muffled conversations and track noise) allows the viewer to participate: daydream out the window, re-imagine the actual landscape, reminisce about travels, or create a new narrative.

King trained as a printmaker and painter before he began working in film as well. His knowledge of other mediums positively affects his approach to filmmaking. From printmaking, King incorporates a respect for the limited color palettes found in traditional Japanese woodcuts and monotone/duotone etchings. The dense etchings and engravings of Piranesi affect King's spatial and structural framing.[46] From painting, King finds inspiration in Anselm Keifer's metaphysical transformations of everyday scenes; Franz Kline's abstract interpretations of railways, scaffoldings, and bridges of New York; and Van Gogh's use of color to express emotional realities.[47] Within film, King works in the tradition of non-narrative filmmaking along the lines of Dziga Vertov, Stan Brakhage, and Godfrey Reggio to explore landscapes through visually poetic compositions.[48] King's methodical approach is synthesized from various mediums to create films that compel an emotional connection to the familiar.

In his films, King manipulates color in a way that arouses emotions more readily than our unedited world usually does. His limited palettes allow him to "focus the [viewer's] eye and . . . make the colors sing in particular ways."[49] Rather than literally documenting a place, King sweeps the viewer into its visual poetics in a rich, imaginative excursion that is satisfying on many levels.

Let us drink in the light with new eyes and create boldly with color, reflecting the glory of God through the realism, symbolism, psychology, flexibility, brilliance and poetry of color. But above all, let us exult in the goodness of God's gift of color, for, as John Calvin said, "There is not one blade of grass, there is no color in this world that is not intended to make us rejoice."

Endnotes

1 Gen. 1:3–4 NAS.

2 Kurt Nassau, *The Physics and Chemistry of Color: The Fifteen Causes of Color* (New York: John Wiley & Sons, 1983), 5.

3 R. Froese and D. Panly, eds., 2005. FishBase, www.fishbase.org, 28 July 2005.

4 Victoria Finlay, *Color: A Natural History of the Palette* (New York: Random House, Inc., 2002), 165, 220, 267, 281.

5 Sidney Perkowitz, *Empire of Light: A History of Discovery in Science and Art* (New York: Henry Holt and Company, 1996), 3.

6 Nassau, 5.

7 Tom Fraser and Adam Banks, *Designer's Color Manual: The Complete Guide to Color Theory and Application* (San Francisco: Chronicle Books, 2004), 48.

8 Johannes Itten, *The Elements of Color* (New York: John Wiley & Sons, Inc., 2003), 16.

9 Some cultures do not define color in terms of the spectrum and only have words pertaining to light, dark, textures, and patterns. Rachel Adelson, "Hues and views," in *Monitor on Psychology* (Feb 2005), www.apa.org/monitor/feb05/hues.html, 5 Aug 2005.

10–12 Fraser and Banks, 30–31.

13 Leatrice Eiseman, *Pantone Guide to Communicating with Color* (Sarasota, FL: Grafix Press, Ltd., 2000), 33.

14 Fraser and Banks, 14.

15 Dennis Bratcher, "The Meaning of Church Colors," in *The Voice* (World Wide Web: Christian Resource Institute, March 2005), www.cresourcei.org/symbols/colorsmeaning.html, 7 June 2005.

16 Fraser and Banks, 14.

17 "Color Symbolism in Buddhism" (World Wide Web: Religion Facts, 2005), www.religionfacts.com/buddhism/symbols/color.htm, 31 July 2005.

18 Eiseman, 19.

19 Fraser and Banks, 48–49.

20 Eiseman, 125.

21 John 3:30 NKJV.

22–25 Guy Chase, artist, interview by author, 14 December 2005, e-mail.

26 Beth Pinsker, "QT: King of Theives," *Wired*, July 2005, 120–121.

27 Chase, interview.

28 "Every Man a Rembrandt," in *Paint by Number: Accounting for Taste in the 1950s* (World Wide Web: Smithsonian National Museum of American History, Behring Center, April 2001), americanhistory.si.edu/paint/rembrandt.html, 26 December 2005.

29 Chase, interview.

30 Arlon Bayliss, artist, interview by author, 21 December 2005.

31 Brian Kerkvliet, "The Mysteries of Dichroic Glass" (World Wide Web: Gossamer Glass Studios at Inspiration Farm, 20 September 1996), wwww.inspirationfarm.com/GG/articles/article9.html, 2 January 2006.

32–33 Bayliss, interview.

34 Lawrence Cunningham and John Reich, *Culture and Values: A Survey of the Western Humanities*, 2d ed., alt. vol. (Chicago: Holt, Rinehart and Winston, 1990), 146.

35 Cunningham and Reich, 191, 193.

36 Psalm 36:9 NKJV. Theory discussed in *Robert Barron, Heaven in Stone and Glass: Experiencing the Spirituality of the Great Cathedrals* (New York: The Crossroad Publishing Company, 2000).

37 Bayliss, interview.

38 Rev. 21: 18-20, NKJV.

39 Bayliss, interview.

40 Greg King, artist, interview by author, 13 December 2005, e-mail.

41 2 Cor. 4:18, NKJV.

42–46 King, interview.

47 Ibid. Supplemented by artist overviews from *The Art Book* (New York: Phaidon Press, Inc., 1994), 189, 253; and *The 20th-Century Art Book* (New York: Phaidon Press, Inc., 1996), 233.

48–49 King, interview.

A SENSE OF
God's Presence

Light is integrally tied to God. "And God said, 'Let there be light'; and there was light. And God saw that the light was good" (Genesis 1:3–4). Before God created light there had been "a formless void and darkness." Light is synonymous with life. Jesus says, "I am the light of the world . Whoever follows me will never walk in darkness but will have the light of life" (John 8:12).

The light-darkness theme in the context of faith can be placed in three major categories. First, Jesus Christ is the Light of the World, and the light-darkness contrast comes to signify the mutually hostile worlds of good and evil. Second, just as the sun lights us on our way, so anything that shows us our way to God can be thought of as light. And third, light is symbolic of life, contentment, and joy, as darkness is of death, unhappiness, and misery.

In the Gospel of John the word *light* is used to refer to a spiritual phenomenon. In his book *Mystical Christianity: A Psychological Commentary on the Gospel of John,* John Sanford observes that the Evangelist uses light and darkness "metaphorically to signify the light of truth and spiritual illumination on the one hand, and the principle of moral and spiritual darkness on the other."

And Jey Kanagaraj writes in *"Mysticism" in the Gospel of John:*

> [T]he light is perceptible to the mind . . . and to the eye of the understanding. [It becomes] the source of enlightened consciousness [and transforms] the darkness of unbelief and sin to a life that will exhibit divine characteristics and deeds.

Even more important, the light that Jesus brings shows things as they are. It strips away the disguises and concealments. It shows things in all their nakedness. It shows them in their true character and their true values. That is why it is difficult to be in the light of Jesus. That light reveals our faults, our sins. When the light of Christ exposes who we really are, we may not like what we see. It may be threatening. John speaks of the experience of sinners upon seeing their lives in the light of Jesus Christ (John 3:19–21):

> Light has come into the world, but men loved darkness instead of light because their deeds were evil. Everyone who does evil hates the light, and will not come to the light for fear that his deeds will be exposed. But whoever lives by the truth comes into the light, so that it may be seen plainly that what he has done has been done through God.

Spiritual light is stronger than spiritual darkness, just as the smallest ray of light has the power to pierce the deepest darkness, and the darkness is unable to extinguish it.

> What has come into being in him was life, and the life was the light of all people. The light shines in the darkness, and the darkness did not overcome it (John 1:4–5)

Spiritual light and darkness should not be confused with natural light and darkness. John Sanford writes in his commentary on the Gospel of John:

> The distinction between light and darkness as natural phenomena on the one hand and light and darkness as spiritual principles on the other hand needs to be kept clearly in mind.

Although Jesus himself uses night as a symbol of spiritual darkness ("We must work the works of him who sent me, while it is day; night comes, when no one can work." John 9:4), there is nothing intrinsically wrong with the darkness of night. But the spiritual principles of light and darkness struggle against each other, and constitute a pair of moral opposites that requires us to choose between them. As spiritual principles we cannot follow both the light and the darkness, for the darkness seeks to overcome the light.

When we follow Jesus Christ we cannot follow the darkness at the same time. Jesus Christ is our spiritual light which points to a truth inaccessible to sight and touch but apprehensible by the eyes of faith. Christ points to our Father, who can bring us from the darkness into light, from death to life, from anxiety to peace, from fear to love, from pain into joy, from our helpless poverty into the limitless abundance of God, to God's undeserved grace, God's sheer loveliness, God's

awesome beauty. Jesus opened a window for us so we can see God. As Rudolf Bultmann puts it in *The Gospel of John,* Jesus points to God

> ... just as all the waters of the earth point to the one living water, and as all bread on earth points to the one bread of life, and as all daylight points to the light of the world.

LIGHT IN THE ART OF LA TOUR AND TURRELL

Light and darkness have been explored in the visual arts for centuries. I would like to discuss two artists who are separated by time and medium: the French baroque painter Georges de La Tour (1593–1652) and American light and space artist James Turrell (b. 1946).

Georges de La Tour was known for his *Nocturnes*—"night scenes." In the *Nocturnes* of the 1630s and 1640s La Tour depicts figures engulfed in shadow, dramatically illuminated by a concentrated beam of light. The darkened interiors enabled the artist to play with the theme of light and reflected light in contrast with the surrounding obscurity. The *Nocturnes* set a mood conductive to contemplation and meditation, both in the subjects of his paintings and in the way they are treated artistically. Light and darkness have symbolic value on several levels, most obviously in the contrast between the spiritual darkness of our mortal world and the light of the divine.

In La Tour's *The Repentant Magdalen,* Mary Magdalene is shown in profile seated at a table. A candle concealed behind a skull emits a bright light that

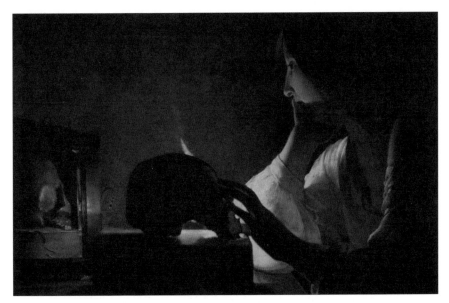

GEORGES DE LA TOUR. *The Repentant Magdalen* (detail), 1640. Oil on canvas.

illuminates those parts of the scene that are meant to convey its meaning: Magdalene, her body and face. The chief visual interest is in the flame that casts its light on the holy text, through which the divine truth is communicated, on the skull, and on the face of the young Magdalene. These parts of the painting are glowing with light against the surrounding obscurity and produce an evocative, melancholy poetry. We can follow Magdalene's gaze as she looks at the skull and flame and contemplates the mortality of the flesh. The skull is reflected in a mirror. The skull and mirror are emblems of *vanitas,* implying the transience of life.

Magdalene was a direct follower and witness of Christ, yet she had been the most worldly of sinners. After her conversion and repentance, Mary Magdalene matched her former sinfulness with the intensity of her pure and enduring love for Christ. She is called "light-giver" because she received light that enlightened others. The light-filled imagery adopted by La Tour shows her repentance with her inward contemplation. The light the Magdalene sees reflected in the mirror is understood as a symbol of God, as in St. John's description:

> In him was life, and the life was the light of men. The light shines in the darkness, and the darkness has not overcome it (John 1:4–5).

It is a light that we can come to understand only gradually in this life, after long contemplation:

> For now we see in a mirror dimly, but then face to face. Now I know in part; then I shall understand fully, even as I have been fully understood (1 Corinthians 13:12).

Such contemplation eventually leads to spiritual enlightenment:

> And we all, with unveiled face, beholding the glory of the Lord, are being changed into his likeness from one degree of glory to another; for this comes from the Lord who is the Spirit (2 Corinthians 3:18).

In *The Newborn Child* (c. 1645), the theme of inward contemplation is taken to its most concentrated degree. Mary is holding the Christ child as Saint Anne illuminates the scene with a lighted candle. The light it casts is extraordinary, miraculous in feeling, establishing the immanence of the moment. The metaphor of light is to assist us in the interpretation of the theme.

In *Christ with Saint Joseph in the Carpenter's Shop* (c. 1640), with tightly packed forms, the candle flame lights a dramatic and humble setting in which St. Joseph passes on his worldly knowledge to the young Jesus, with a painful premonition in his eyes of the tortures of the Cross. It is a virtuoso treatment of the light from the candle, as it shines through the fingers of Jesus.

James Turrell is an internationally acclaimed light and space artist whose work can be found in collections worldwide. Since childhood, Turrell has been fascinated with the qualities of light. Turrell's work is compared to the gothic cathedral in its ability to evoke the ethereal, supernatural qualities of light.

Light Reign in the Henry Art Gallery in Seattle, Washington is a skyspace, a twenty- by twenty-eight-foot oval structure acting like a giant aperture. It is the very first to combine two aspects of James Turrell's work, skyspace and exterior architectural illumination, making it accessible to viewers from both the inside and the outside. From the outside, the elliptical chamber becomes a luminous light work as the glass panels covering its exterior are softly illuminated from within with slowly changing color.

Inside the skyspace, visitors sit on a bench and view the sky and atmospheric changes through an opening in the roof. On rainy days a movable dome covers the opening and a secondary light source creates a seemingly infinite visual space beyond the roof "aperture." It is a place to encounter light physically and spiritually. Turrell's fascination with light reveals his personal, inward search. He remembers his grandmother telling him, "Go inside and greet the light." She meant the invisible light, the inner light, but also the sunlight that poured from ceiling windows—a light often used to represent spiritual light.

James Turrell uses light as his medium. Turrell's work involves explorations in light and space that speak to viewers without words, impacting the eye, body, and mind with the force of a spiritual awakening. Since opening in 2003, the skyspace has hosted many prayer and meditation sessions and thousands of individual visits for quiet reflection. Turrell's work uses light to communicate with God. The inward light represents an immediate sense of God's presence. This mystical light is to guide us and to bring peace. Turrell's work is meant to be taken in slowly, quietly, and over time. The skyspace experience varies at different times of the year and different times of day. Visitors are encouraged to stop in again and again to sit back and absorb the effects of the skyspace over the course of the seasons.

Turrell says, "Light is powerful substance. We have a primal connection to it. But, for something so powerful, situations for its felt presence are fragile. I like to work with it so that you feel it physically, so you feel the presence of light inhabiting a space. I want to employ sunlight, moonlight, and starlight to empower a work of art."

LIGHT AND THE FACE OF GOD

As a photographer I have been working with light for over 30 years. Photography is about light, and its complement, darkness. I love light rushing into and juxtaposing itself with darkness. I love shadows contrasting with illumination. I love the contrast and drama of light wrestling with dark, invading the dark and challenging it. I love the ever-changing patterns of shadows opposing their

twin structures of light. I love the power of light, its presence. When light meets dark, it has enormous energy. It rushes in, it fills the darkness, it takes over.

John Szarkowski wrote in the exhibition brochure for *Photography Until Now,* a show held in 1990 at the Museum of Modern Art:

> Toward the beginning of the 19th century it occurred to an undetermined number of curious minds that it might be possible to fix the enchanting, fugitive image on the ground glass of the camera not by drawing it, but by causing the energy of the light itself to make a print on a sensitive ground.

As a photographer I find the process of working with light and darkness extraordinary. The spiritual aspect of photography—making the invisible visible—is close to miraculous. As Deborah Sokolove, Director of the Dadian Gallery in Washington, D.C., has written:

> [T]he task of the artist is to make the invisible visible, to capture glimpses of a certain kind of truth . . . to look with the eye of the soul. . . to preserve the fleeting passage of something real in the shadows cast by an inner light

My first in-depth explorations with the camera led to my series *Masks.* I had always been fascinated by people's faces and even more by photographs of faces. There was a mystery behind the face that I could not explain. I saw the face as a mask that concealed rather than revealed the inner person. While I was working

KRYSTYNA SANDERSON. *Indian Princess #3* (top) and *Sally #8* (bottom) *Masks,* 1981. Silver-gelatin photograph. 11 x 14 inches.

on a series of large portraits with moderate success, I realized I wanted to include only the face and exclude hair, ears and neck. I wanted to stress the essentials of the face: eyes, nose and mouth. I designed a board, cut a hole in it just big enough to frame a person's face, and covered it with black fabric. The Texas light—very bright, hot and piercing—was an excellent vehicle for portraying the drama of the human face. The result was that the skin of the little girl was almost transparent and glowing (*Melonie*), the skin of the elderly black woman shone like a black diamond (*Sally #8*), and the furrows of the Indian woman's face showed magnificently against the pitch black background (*Indian Princess #3*).

I photographed all the faces straight on from the front and at the same level as the camera lens. When I printed the photographs, I enclosed the image of the face within a rectangle or square which I placed on a white or, occasionally, a black background. The visual order and clarity of this arrangement served to counterbalance the emotional aspect of the photographs. A.D. Coleman described the portraits as using "light and silver in a highly sculptural fashion, emphasizing the plastic, dimensional characteristics" of each subject. The faces of people of all ages, sexes and races—in some cases because of lack of hair it became impossible to tell their gender—became archetypal and iconic, exemplifying Paul's words in Galatians that "there is no longer male or female, for all are one in Christ Jesus."

I photographed twelve people, with four to ten poses each. The images of each person are sometimes similar, with only minute differences. The viewer has to make a mental comparison and contrast among them. The individual images also produce motion as if the photographs are individual frames from a movie. A.D. Coleman continues in his foreword to *Masks*:

> Think of it as a soundless dream, a vision—or what you would see in your mind's eye as you come out of the ether. This peculiar succession of faces—all ages, races, and sexes—alternately receding and advancing, expressions constantly changing (but sometimes recurring) . . . they seem to be on the verge of telling us something, seem in fact to have messages to deliver. Their lips shape words we will never hear, their frowns and smiles inflect inaudible sentences.
>
> On this level the book becomes an act of the imagination, with an almost cinematic structure: it has rhythms and tempos, pacing and movement. Scale and juxtaposition are employed adroitly, yet never obtrusively; even if we stop to admire the craft involved in their making, these images always return us to their subjects, the faces, the masks. That they seem by and large benign—or, at least, not overtly threatening—is small consolation. Their muteness is what creates our compelling urge to add a soundtrack, to project personal histories upon them, to put words in their

mouths. What we want to know—and what [Sanderson] makes clear we will never, in any case, know—is: Who is behind all this?

When I made the *Masks* series I did not know who was behind the faces. I did not know who was behind each human being. I was drawn to the beauty and mystery of the people I photographed. The camera became a carte blanche for that connection.

Before photographing *Masks* I talked with each subject, usually for several hours. I asked about them, about their lives. My deep interest in "who they were" fascinated the people. They saw me as an exotic visitor from another world who saw beauty in them and their lives. They reached out to me and talked. I opened up and talked too. The distance between us dissolved, and we connected.

While we talked, the presence of the camera built an excitement and tension between us. We did not know exactly what would happen—an element of the unknown was always there. When I made the photographs I found myself under such emotional tension that my hands were trembling and I could not keep the camera steady. I was so excited that part of me became part of my people. I would exclaim, "Oh yes, yes, you are great, hold it, hold it." The moments were so enchanting and hypnotic that they became for me timeless. I never knew how long it took—it could have been moments or maybe hours.

When I worked on *Masks* I was not a Christian. Three years after photographing *Masks* I experienced a Christian conversion. I saw the faces I had photographed as revealing the image of God in which all people are made. Ted Prescott wrote that we are "created by God, bear His image, and are known by Him." I found a tremendous sense of peace when I realized I was God's creature. Adam Gaymou, in *Images of God,* describes the human face as a mirror in which God appears, a mirror of the soul that bears the imprint of the invisible God.

> Perhaps there is no better way to have a vision of God than by looking in the eyes of our fellow human beings. In the gleam of joy, the wince of pain, the gaze of desire, there dwells the image of the imageless God.

Each face has a message to deliver—behind each face hides the Creator. Jesus Christ had a face very much like yours and mine. God used the physical light reflected from the faces of my photographed subjects through the lens and F stop of my camera to bring His sacred light to illuminate me with His love so I can love Him and others.

> "You shall love the Lord with all your heart, and with all your soul, and with all your mind." This is the greatest commandment. And a second is like it: "You shall love your neighbor as yourself" (Matthew 22: 37–39).

It is paramount for me to know that I am an artist and a Christian. They are inseparable for me. It helps me to put my life in perspective when I see that my art, what I create, is not for my own glory but for the glory of God.

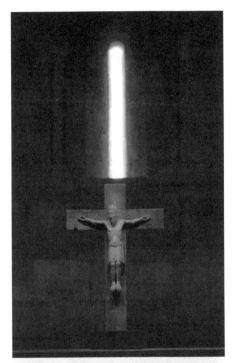

KRYSTYNA SANDERSON. *Places of Light # 12* (top) *#4* (bottom), 1995. Silver-gelatin photograph. 8 x 10 inches.

PLACES OF LIGHT

My series entitled *Places of Light* is all about light pouring through open doors and windows to illuminate dark places. My soul makes a parallel between my own darkness and Him who rescues me from my darkness. There are different kinds of spiritual darkness—the darkness of fear, the darkness of poverty, the darkness of self-hate, the darkness of hating another, the darkness of addiction, the darkness of self-centeredness, the darkness of loneliness. To be in darkness is to be without hope, to be desperate, to give up. But there is nothing more joyous than light when one is in darkness. Light means hope. Light means freedom. Light means life. How much more hope, joy and life there is if it comes in the person of our Lord Jesus Christ who is our hope, our joy, and our life.

There have been places in my experience that evoked a certain feeling of peace, where I felt at home, where I felt joy for no other reason except being there, being with God. One of these places is the Cloisters in New York City. The Cloisters is a complex of medieval monasteries standing on a hill 250 feet above the Hudson River. It is a contemplative and meditative place not far from the bustle of the city. One sunny, crisp October

morning I went there to set apart some particular time to meet with God through prayer and meditation. I found myself in the Cuxa Cloister, reconstructed from the Benedictine Monastery of Saint-Michel-de-Cuxa, founded shortly before 878 in the northeast Pyrenees. I could almost hear the plainchant of medieval monks. The light pouring through the arcade of columns casting repetitive shadows, forming a soundless rhythm, caused my camera to be more like a string of rosary beads, and my photography a meditation. My perception of a division between the physical world of my camera and the world of the Spirit melted away. In my photograph *Light #1*, my experience of the prescence of God through the light was as concrete to me as the physical world of arcades and columns made out of stones.

The photograph of the deep and narrow window, *Light #11*, came from another Cloisters location—the Pontaut Chapter House from the abbey in Notre-Dame-de-Pontaut in Gascony, south of Bordeaux, built in the twelfth century. The Chapter House, where Benedictine monks met to discuss the business of the monastery, was built in Romanesque style and was distinguished by fortresslike walls and enclosed dark interiors. The deep and narrow windows were designed to create a maximum concentration of light. The photograph shows light rushing into pitch darkness, exposing the rough texture of the stones. In the photograph the power of light "burns" into the stone the same way the power of the light of Christ burns into the darkness of humankind.

Another image from the Cloisters is the view of the Fuentidue, a Chapel from the Church of San Martin, about 75 miles north of Madrid, built in the mid-twelfth century with no aisles or transept. In *Light #12*, the extremely narrow window of the majestic apse allows a beam of light to penetrate the massive walls and illuminate the Romanesque crucifix.

Light #4, from *Places of Light*, is the open door of the north aisle of Grace Church at Tenth Street and Broadway in New York City. The massive wooden doors with their decorative iron reinforcements are slightly ajar, with light gently trickling into the dark French gothic church. The door

KRYSTYNA SANDERSON. *Solitude: Light and Stillness #14*, 1998. Silver-gelatin photograph. 11 x 14 inches.

is a powerful symbol in Christian faith. Jesus describes himself as a door: "I am the door; by me if any man shall enter in, he shall be saved" (John 10:2). In another place Jesus describes the door as the opening to our heart: "Listen, I am standing at the door, knocking; if you hear my voice and open the door, I will come in to you and eat with you, and you with me" (Revelation 3:20).

Another sacred place that was photographed in the *Places of Light* series was the Friends Meeting House on Rutherford Place, New York City, a Federal style building with strong neoclassical elements. In *Light #2*, light pours through the panes of the large windows, making rectangular spots on the floor and benches of the empty house of prayer, where the whole space has been saturated with prayer as light overcame the darkness.

Among the secular "Places of Light" that I photographed was the window of my beloved friend's apartment in Greenwich Village, New York City. His home was an oasis of love and tranquility for me for many years. *Light #7* shows the roofs and steeples of the West Village with the Hudson River and New Jersey beyond. In the foreground, on the windowsill, stands a lamp. It is an odd place for a lamp, right where the maximum light is coming into the apartment from outside. This circumstance accentuates the spiritual significance of the lamp. "Your word is a lamp to my feet, and light to my path" (Psalm 119).

SOLITUDE: LIGHT AND STILLNESS

The inspiration for my latest photographic series, *Solitude: Light and Stillness*, came to me through the image of a painting "Interior" by the turn of the century Danish painter Victor Hammershoi. It depicts a solitary woman sitting with her back to the viewer in a sparsely furnished room, undeniably European, with door upon door receding into the background and a luminous window beyond.

In the series *Solitude: Light and Stillness*, I place a solitary female figure in an almost empty interior near a window. Poul Vad comments on the dynamic function of the window in his book on Danish art made around 1900:

> [T]he window [is] a connection between inside and outside, between the interior space's reassuring order and intimacy and the free, scenic space's boundlessness and light—with sensations of infinity.

My subjects range in age from ten to ninety. The light is either soft and reflective, gently illuminating the interior and bathing the figure, or strong and direct, flooding into the room through the window and producing a powerful chiaroscuro. The light casts shadows and produces the shapes of the window-panes both on the faces of the subjects and on the floor and furniture. The light illumines the face and causes it to glow, and that contrasts with the dark clothes and interior. In one case a lace curtain leaves a patterned spot on a girl's neck.

Light coming through the window into these interiors is like a gentle yet powerful visitor. It is like the visitation of the Holy Spirit to our spiritual interiors.

Light has immaterial presence, but at the same time it has the unique character of the moment. Poul Vad writes:

> The light in the sense of a particular lighting is bound to the moment: a point in a stream of time whose continuity is never interrupted . . . The intense experience of the moment is the entrance into the marvelous: every moment the world is new, every moment is a unique locus in a never-ending coming into being. The camera gives these fleeting moments a sense of permanence. The action gets suspended in time.

The eight women whom I asked to photograph, all of whose lives are closely linked with mine, are usually sitting in a chair, sometimes reading, occasionally standing. Most of the time they look away from the camera, looking out the window as if remotely aware of the presence of a viewer peering into their private worlds. Sometimes they look up from the book and stare out at the viewer. They are motionless. There is a spirit of stillness and tranquility. There is a tremendous tension and energy in just being.

As a photographer, but also strongly identifying with the photographed subjects, I see not only light streaming through the window into the dark interiors,

KRYSTYNA SANDERSON. *Light at Ground Zero #28*, 2001. C-Print. 5 x 7 inches.

but also light streaming into my heart and soul, and am able to experience the contentment of being me, the stillness and peace that can only come from God, and the joy of beholding God's beauty. My soul soaks up the gentle and soft light that illuminates the everyday activities of being in solitude with God, being content doing simple everyday activities like sitting, reading, being ... the profound miracle, mystery and beauty of human existence.

LIGHT AT GROUND ZERO:
ST. PAUL'S CHAPEL AFTER 9/11

As a visual artist I was thrust into the darkness of evil and the Light of God as a result of the cataclysm of September 11, 2001. St. Paul's Chapel was separated only by Church Street from the World Trade Center buildings, and yet when the towers fell on September 11, St. Paul's Chapel stood virtually unharmed. For the next 260 days St. Paul's became a 24/7 relief center, serving as a dormitory, cafeteria, pharmacy, chiropractic center, podiatrist's office and clothing distribution depot, all the while continuing its primary function as a place of worship. During that time over 5,000 people served as volunteers at St. Paul's.

For eight months I photographed the light of God's radical grace, mercy and love at St. Paul's. The brilliant morning light poured through the east window over the altar, and the warm late afternoon light from the south windows bathed the 18th-century chapel's pastel pinks and blues and its delicate Waterford crystal chandeliers in pure gold. In contrast was the monochromatic moonlike landscape of Ground Zero with its associations of dread, horror and agony. During this time I created over 2,500 images, 100 of which, accompanied by prayers from the *Book of Common Prayer,* and fragments of Scripture were published by Square Halo Books in 2003. My ministry was to witness and to record the work of the Holy Spirit in action. The 18th-century symmetry of the chapel formed an ideal backdrop for the rainbow colors of children's cards and letters and the large and small banners from all over the world. Here God's love was poured out through thousands of hearts stretched to the breaking point, through sore hands and aching feet. Firefighters, firemen's chaplains, FDNY paramedics, sanitation workers, construction workers, national guard, police officers, crane operators, rescue workers and demolition experts came from Ground Zero. They were there getting their brothers and sisters out. They were our heroes. They came to St. Paul's to rest, to eat, to talk, to let go. Nobody asked questions. We didn't know who identified body parts and who worked with twisted girders and crumbled concrete. We chatted, cried, joked, prayed. The mood was strangely upbeat but we could see the exhaustion, and sometimes the despair. We also saw the courage, the selfless service, and the determination to carry on. Workers and volunteers shared their lives, their stories, a cup of soup or coffee. We prayed and cried, sometimes alone, sometimes together. We hugged, and we refrained from

hugging. One time during Eucharist the snoring was so loud that we barely heard the words of the liturgy. Nobody raised an eyebrow.

The ashes of those who perished were everywhere—on the boots of the relief workers, on our clothes, in the air we breathed. We all knew we were walking on holy ground. Like diamonds that are created when carbon is under tremendous pressure, diamonds of heroism and love emerged from the explosions of September 11. I witnessed these diamonds emitting a luminosity too bright to photograph, God's love and mercy and grace that comes only from extreme stress.

LIGHT AND DARKNESS

Light is made more evident in contrast to darkness. Day is brighter as it stands in comparison to night. Good is shown to be more noble, more glorious and truly holy in opposition to evil. The beauty and power of light contrast with the presence of darkness. Georges de La Tour's *Nocturnes* depict the mystery, obscurity, and poetry of darkness vibrantly juxtaposed with piercing, physical light like a candle that represents God's spiritual illumination. James Turrell's medium is also light but he harnesses it through an "aperture" that acts like a gathering device to stress the role of light that brings us to God's presence, guides us and brings us peace. And in my own photography—whether in the dramatic illumination of the face in *Masks,* the streaming light in *Places of Light,* the pensive light in *Solitude: Light and Stillness* or the healing light in *Light at Ground Zero: St. Paul's Chapel After 9/11,* I find light wrestling with darkness to be a powerful metaphor of the spiritual struggle between good and evil, between God's will and all that opposes God.

WHY IS THE LIGHT
given to the miserable?

"I speak through my music. The only thing is that a poor musician like myself would like to believe that he was better than his music."
—Letter from Brahms to Clara Schumann, September, 1868)

C. S. Lewis once said that the Christian writer should have blood in his veins, not ink. What he meant was that if an artist sets out to make a Christian statement in an art object, the chances are it will not be art, but a contrived pronouncement. Rather, the believer, like anyone else, should first be passionate about his chosen medium, work in it, and let any "message" emerge almost as a by-product. If one is a writer, then let him be captivated by words. If a painter, let him be fascinated by colors and shapes. Living in the real world, being human, knowing about life and people, believing in truth, and wrestling honestly with the troubles and sufferings that inevitably come along, these are the best ways to prepare to create.

Perhaps the most challenging part of artistic work in any medium is how to handle the problem of evil. Music presents a particular difficulty, since its medium is sound. How to say it in notes? Given that music is not merely a vehicle for words, how does the Christian composer articulate a view of the world which has been profoundly polluted by sin and yet that provides for genuine hope at the same time? I believe this question provides us with a kind of test of authenticity. Artists often fall into one of two extremes. For simplicity's sake, we could call them optimism and pessimism. The optimist arrives at a happy ending, so to speak, without honestly passing through the valley of the shadow of death. A good deal of music today is optimistic in that it tells of joy and peace without

reckoning with evil, the evil from which we can be redeemed in order to know that joy and peace. Obvious (and extreme) examples would include jingles written for commercials, or the mindless music in shopping malls. The pessimist is realistic about evil but has little or no hope. The element of redemption is the missing dimension. Some of the darker music of the Punk style, Grunge music, and the violent pessimism of various rap singers would qualify. Optimism and pessimism are not simply temperamental characteristics of the artist; they stem from a worldview, a philosophy of life. In fact, it is crucial to remember that one can never finally separate a work from the artist. The creator informs the work out of the rich material in his or her own soul. Beginning in the soul, though often not self-consciously, the worldview then transpires into artistic production in distinctive ways.

A joke has it that the only difference between an optimist and a pessimist is that the one believes we are in the best of all possible worlds, while the other fears this may be so! In contrast, the biblical worldview is neither optimistic nor pessimistic. It begins with God's Creation as good ("very good," according to Genesis 1:31), because God the creator is good. But then it confesses there has been the introduction of evil into the world by the treasonable revolt of mankind. The fall, then, brought both sin and misery, evil committed and affliction received. This is a crucial distinction, one which unique to revealed religion. Albert Camus once captured the non-biblical understanding of evil in the efforts of his hero, the Doctor Rieux from *The Plague*, with the catchphrase, "fighting against Creation as he found it." But if this is right, according to the Scriptures, then all is lost. Rather we fight against the plague, which is an alien invader of Creation's goodness. And therefore, finally, redemption has come into the world, and is working its way toward a new heavens and new earth, through Jesus Christ, the savior. This is utterly different from the two extremes of optimism and pessimism. Unlike optimism, this biblical worldview tells us to look evil in the eye. It is real, though not some substance or thing. Because of the great fault there will be oppression, struggle, doubt, tension, so that with the Psalmist we often may ask the questions, "Why, O Lord?" or "How long, O Lord?" But unlike pessimism, it proclaims genuine hope because Christ has inaugurated a great reversal of the fault, centered in the Resurrection. As a result, beginning substantially now, and concluding in the great day of the consummation, death, the result of sin, and guilt, its cause, are fully eradicated. We will live in an unbroken communion with God himself.

Music that voices this philosophy will be both realistic about the darkness and unashamed of the light. There will be trouble, "tribulation," as our Lord put it. There will be tensions and doubts along the way. But there is always reason for hope (1 Peter 3:15). One could not find a more fascinating illustration of this double-edged sword than in the life and music of Johannes Brahms. This most extraordinary composer from the golden era of German choral and symphonic music

was well aware of the need for authenticity. He often compared the quality of his works to the quality of his own person as he judged himself, and hoped that his life was somehow more noble than his music. Considering the glories of his music, he set very high standards for his person! A word about his life and times.

THEOLOGICAL MOODS

Just before the First World War a building went up at Harvard University to be called Emerson Hall. Because it was destined to be the Philosophy Building, just before completion the professors in that discipline were asked to choose an appropriate motto for the outside wall. After a series of meetings, the likes of George Santayana, William James and others decided what should be engraved for all to see was Pythagoras' famous epithet, "Man the measure of all things." A pause came because of the war years. When the professors finally came back to take up their work in the new building, they looked up to see, to their horror, quite a different motto from what they had requested: "What is man that thou art mindful of him?" No one knows for certain, but apparently a local architect could not abide the arrogance of the first choice, and so substituted the biblical phrase from Psalm 8. It is still there, all the more clear in that the ivy has been removed, for the world to ponder today.

The received wisdom about the nineteenth century is that it was a time for optimistic thinking. The spirit of self-reliance and especially confidence in reason gave assurance that indeed man was at the center of all that mattered. Then, so the story goes, the Great War came to disabuse everyone of such confidence. In his famous *Römerbrief,* Karl Barth proclaimed a theology of crisis in the place of the naive liberalism of Schleiermacher and Ritschl. The twentieth century brought a sobering wind which blew away the self-possessed outlook of the nineteenth. This account is plausible, and true in part. But it ignores the prophets of a troubled world and the honest doubters who were present all along. We need only think of Dickens' novels, with their unmasking of the poverty in London, or the passionate concern for the human condition in the works of Dostoevski and Zola. And while indeed Schleiermacher and Ritschl tended to reduce theology to its horizontal, human level, this approach is hardly the vision of all other contemporary theologians. Consider the strange and wonderful Dane, Søren Kierkegaard, whose notion of paradox and faith powerfully challenged the cold, institutionalized dogmatism of the church. Not satisfied with the complacent trust in unaided reason in the surrounding philosophies, he treated the deepest questions of life with a combination of respect, anger, and mystery that belie logical answers.

A number of the Romantic composers were similarly perplexed by the problem of evil and the inadequacy of unaided human reason to resolve basic dilemmas. Standing in a very different place from many of his peers, especially in consideration of the problem of evil is the prodigious genius, Johannes Brahms (1833–1897).

NECESSARY SHARP SHADOWS

In the spring of 1877 Brahms wrote a letter of congratulations to the Joachim family upon the birth of their new son. Josef Joachim was one of the great violinists of the day, and the family's friendship with Brahms was so deep they named their first son Johannes. This latest child was born on Brahms' forty fourth birthday. He wrote the Joachims the following line: "One can hardly in the event wish for him the best of all wishes, not to be born at all." Then, as if shaken out of a bad mood, he added, "May the new world citizen never think such a thing, but for long years take joy in May 7 and in his life." It would be hard to find a more apt summary of the paradox of Brahms' life, one which pervades his music as well.

In the summer of that same year, he came to Pörtschach, a lovely village outside Vienna on Lake Worth. It was an inspiring setting for writing music, one that

WILLY VON BECKERATH. *Brahms at the Piano* (detail), 1911. Tempera.

included the snow-capped mountains and lots of good food. There he wrote his Second Symphony in the space of four months. Writing this piece in his full artistic maturity was in marked contrast to the fifteen years of agony it took him to compose the First Symphony. Responding to a self-imposed pressure to do honor to his hero, Beethoven, he needed to build on the nearly insuperable legacy of the immortal Ninth, while yet moving the genre further and deeper. Written in C minor, Brahms' First Symphony was undoubtably such an achievement. Immediately after the premiere of the monumental work, Hans von Bülow, always ready with a *mot juste,* labeled it "The Tenth." While it carried strong echoes of the past, it was a strikingly original composition. The first movement is one of the most dramatic symphony beginnings ever written, taking us into a nether world of angst, questions, revolt. Throughout the piece, light battles as it were against darkness, joy against sorrow, and finally, hope emerges triumphant. The last movement, unlike most classical symphonies, is as weighty as the first, with its chorale-like resolution in the last section (using the trombones for the very first time!) moving the piece to a final C major.

By contrast, the Second Symphony appears effortless, almost entirely tranquil and confident. Almost! Written in the bright, "positive" key of D major, it begins with a pastoral serenade in slow 3:4 time. We are put into a bucolic mood. Then, suddenly, in the 33rd measure, the trombones enter with a dark and gloomy theme that mars the tranquility of the scene. Here, unlike the First Symphony, the trombones are introduced right away. No sooner do we hear these disturbing tremors than the movement resumes with the main theme again, as though dark clouds had threatened, then disappeared. So troubling is this interruption that one of Brahms' greatest admirers, the conductor Vincenz Lachner, inquired about it. He wrote two warm and complimentary letters to the composer, showing remarkable understanding of the beauty and intricacy of the work. But then he inserted two queries for the master. First, why such "gloomy and lugubrious tones" at the outset of a luminous piece? Trombones had long been connected with death in music. The *Dies Irae* in the Mozart Requiem is perhaps the most poignant example of this, connecting the low brass sounds with the Day of Judgment. The idea is also present in the Lutheran Bible. So why such a contradiction? Second, why does Brahms make the ending phrase so dissonant, superimposing two harmonies (plagal and tonic) that do not belong together? Brahms answers characteristically:

I'll tell you just as fleetingly [as this word of thanks] that I very much wanted and tried to manage without trombones in that first movement. (The E minor passage I would gladly have sacrificed, as I now offer to sacrifice it to you.) But that first entrance of the trombones, that belongs to me and so I cannot dispense with it nor with the trombones, either . . . I would

have to admit, moreover, that I am a deeply melancholy person, that black pinions constantly rustle over us, that in my works—possibly not entirely without intent—this symphony is followed by a small essay on the great "Why." If you do not know it (the motet) I will send it to you. It throws the necessary sharp shadows across the lighthearted symphony and perhaps explains those trombones and kettledrums. But I also ask you not to take all this so very seriously or tragically, particularly that passage! But that A in the G minor in the coda, that I would like to defend. To me it is a sensuously beautiful sound, and I believe it comes about as logically as possible—quite of its own accord.

What are we to make of these ambiguous statements? As we saw above, first, Brahms, like many artists, is anxious for his music to speak from its own logic, and not depend on a "key" to the work or a program that would explain it. After guessing he might have been thinking of ultimate questions, he says not to take such a speculation too seriously. The meaning of a piece of music is there in the composition, in its inner logic. Attempts to connect with an outside program are often artificial at best, and reductive at worst. Yet Brahms said it himself, he struggles with melancholy. Black wings flutter threateningly over his life. And he volunteered that it may be no coincidence that he wrote that most hauntingly powerful motet, *Warum?* immediately afterwards.

In our own day, trends in literary criticism have cautioned us against making too much of an author's life story as background for a text. They have a point. Limiting our interpretation to events in the author's life or to the psychology of the artist risks missing the text itself, which has a life of its own. Once the work is finished, it may carry meanings not intended by the author, much as a child develops independently from the parents. Still, it is erroneous to imagine, as some of the more radical theories do, that there can be no connection at all. According to the Christian view of the world, everything is connected. Human beings, made as God's image, are not mere vehicles of a text, but creators in their own right. And they leave their own imprint on the work of their hands, whether intentionally or not. Their art says something. It narrates a meaning, however difficult to elucidate.

Brahms was aware of the problem. In an important letter to Clara Schuman he once said, "But the artist cannot and should not be separated from the man. And in me it happens that the artist is not so arrogant and sensitive as the man, and the latter has but small consolation if the work of the former is not allowed to expatiate his sins." One of his life's desires was to be a man of integrity, a *Menschenbild,* the very picture of an ideal human being. So, while Brahms himself wanted to ward-off simplistic explanations that might spoil the mystery of his work, he also sensed the reality of a connection to the larger philosophical

questions posed by the man. These were questions that followed him throughout his life, questions that simply wouldn't go away. Though at one level they are our perennial struggles, undoubtedly for Brahms they were triggered by personal events in his life as well.

ALL FLESH IS AS GRASS

It was Josef Joachim who had urged him as a young man of twenty to visit the great composer Robert Schumann, a visit that would change his life forever. For one thing, Schumann made him play the piano. Upon hearing this young genius he hailed him as a "young eagle" who would save German music! This had the effect of giving the young composer great notoriety, and gave him the freedom to develop more rapidly than most into a consummate artist. For another, he met Clara Schumann, Robert's devoted wife, perhaps the major feminine figure of nineteenth-century music. Theirs was to be a stormy friendship, full of tenderness, but fraught with misunderstandings and disappointments. Schumann was severely ill. Recently published medical diaries give evidence it was from syphilis. Just five months after this first meeting with Brahms he attempted suicide by jumping into the Rhine. He spent much of the next two years in an asylum. He spoke nonsense and was plagued by sounds in his head of sustained, screaming pitches. He finally died after weeks spent in a delirious state.

The tragic condition of Schumann would haunt Brahms throughout his life. Without resorting to speculation one can find many references to Schumann's agonies in his music. For example, the First Piano Concerto begins with dizzying ambiguity, giving the effect of falling, like the suicidal plunge into the water. In other well-known examples, we can think of the insistent pedal points of the First Symphony and the German Requiem's "All Flesh Is As Grass," which could well be echoes of Schumann's screaming hallucinations. They are sounds of anger. In his more mature years these sounds become more lyrical, even dream-like, but still melancholy.

Schumann had surely expected the young Brahms to take care of his widow. Clara no doubt wanted him to marry her. Johannes certainly loved her, but could not accept such a permanent commitment. Shocked and hurt by his decision, Clara saw a change in him which spelled the end of his innocence. She eventually rose above it and forgave him, even writing her children: "That I have never loved a friend as I loved him; it is the most beautiful mutual understanding of two souls." But Brahms had become distant. What reasons might Brahms have had for his refusal? He loved Clara deeply. It seems to have been, however, a spiritual love, nurtured on the fantasy of a woman from another era, in a word, romantic love. If he got too close, the imperfections of real human friendship would intrude and he might not know how to handle them. And yet if he stayed too far away he would deny his own feelings, let alone ignore and afflict his closest friend. Brahms was awkward, not always tactful. But he was also painfully honest.

His music illustrates his struggles. Deceptively so, because his compositional art is so remarkable that we resist looking for qualities much beyond the unsurpassed craft of the music. He is a near-perfect contrapuntalist, as well as a master of harmony and an endless source of melodic invention. He had all the technical ability he might need to be the most competent composer in the world. But because of the insistence of his doubts, his struggles with depression, and no doubt his refusal to accept easy answers from the church, Brahms rises far above mere excellence. He indeed lived with the question, *Warum? (Why?)*. Did he find answers?

LET US LIFT UP OUR HEARTS

The music tells us he did, at least to some extent. In any case he found resolution, perhaps even joy, at times. But there is a lingering doubt, something not quite settled nevertheless. Consider now the great motet written during that extraordinary summer of 1877 in Pörtschach. Opus 74 No 1 is a polyphonic choral composition in four movements. The first is based on Job 3:20-23:

Warum ist das Licht gegeben den Mühseligen	Wherefore is light given to him that is in misery
und das leben den betrübten Herzen?	And life unto the bitter in soul;
Die des Todes warten und kommt nicht,	which long for death, but it comes not,
und grüben ihn wohl aus dem Verborgenen;	and dig for it more than for hid treasures;
Die sich fast freuen und sind fröhlich,	which rejoice exceedingly, and are glad,
daß sie das Grab bekommen?	When they can find the grave?
Und dem Manne, des Weg verborgen ist, und Gott vor ihm denselben bedecket?	Why is light given to a man whose way is hid, And whom God has hedged in?

The introductory four measures are strongly stated open chords (the directions state, "slowly and full of expression"), asking, plaintively, perhaps even defiantly, *why?, why?* These same chords with their insistent question will reemerge four times, acting as hinges separating the richly expressive settings of the text from Job. The main body of this first movement is, then, a series of statements, gradually weaving together the voices in a prayer of perplexity before God. It is, of course, a display of Brahms' mastery of choral art. Though profoundly indebted

to Bach's craft, with Brahms' style we are no longer in the liturgical world of the weekly cantatas of the Leipzig church in the eighteenth century. Rather, we have here, combined with the artistic intricacy, an intensely personal statement. Brahms here has made some use of elements of the Mass, but in a manner not quite appropriate for a service of worship. It is more like a Psalm for private moments. Honest moments. The final statement of the question, *warum?* is so compelling it is almost heart-breaking.

One can almost feel the presence of all the suffering of the world, here, crying children, starving people, broken marriages, and the haunting question: what is the good of it? Then comes the second movement to quiet the storm of the first. It does not answer the question, but, using words from Lamentations 3:41, it tells us to worship God:

Lasset uns unser Herz samt	Let us lift up our heart with
den Händen aufheben	our hands
zu Gott im Himmel	Unto God in Heaven

This beautiful, shorter movement is in answer to the first. From the stormy D minor, we move to the serene D major. It has the effect of a mother comforting her child after a bad dream. But it is more than comfort. It articulates a response to the *warum?* It begins with confidence in a hymn-like texture, a canon in four voices. It then builds in intensity until, adding two more voices, we are born-along, exhorted to heaven in worship. Do we believe God is there for us? Here Brahms clearly states that we must look to the place where He is. Although music is not a philosophy book, it is hard to miss the transition. Brahms clearly joins company with the many Christians who have wrestled with the problem of evil and concluded that while the question is insistent, and human suffering is all too real, tragic things cannot always be explained, but yet we had best to turn to God for solace.

The third movement is a lush composition which continues the "argument," but adds a personal element. Using the section of James where Job's patience is emulated, the song encourages us to endure and persevere, because of God's mercy. The movement is in two parts. The first is a simple, slow, but beckoning statement on the theme of the need for patient endurance. It is in C major, with all the depth and solidity that key tends to signify:

Siehe, wir preisen selig,	Behold, we count them happy
die erduldet haben.	which endure.

Then the second part is rather animated, stressing the vivid nature of the basic communication, "ye have heard." It moves up to F major. The final line, "That the Lord is full of pity and of mercy," returns, almost literally, to the radiant conclusion of the previous movement, stressing the presence of God in his mercy:

Die Geduld Hiob habt *ihr gehöret,*	Ye have heard of the patience of Job,
un das Ende des Herrn *habt ihr gesehen;*	and have seen the end of the Lord;
denn der Herr ist barmherzig *und ein Erbarmer.*	That the Lord is full of pity and of mercy. [James 5:11]

Finally, a chorale tune, based on Luther's version of the Nunc Dimitis. It is in the modal key of Dorian D major. This is truly a consummating thought. Bach's cantatas and passion music are all punctuated with these wonderful chorales which bring resolution to the narrative or prayer of the body of his works. Brahms here echoes this approach with his perfect craft:

Mit Fried und Freud *ich fahr' dahin*	In peace and joy I now depart,
In Gottes Willen,	According to God's will,
Getrost ist mir mein *Herz und Sinn*	Comforted are my soul and heart,
Sanft und stille.	Calm and still.
Wie Gott mir verheißen hat,	As God has promised me,
Der Tod ist mir Schlaf geworden.	Death has become a sleep to me.

A journey, a departure indeed. Peace and joy are not easily won. They are possible because God is sovereign. He comforts the afflicted, and gives sleep to the weary, the sleep that ushers into eternity.

IS IT THE WHOLE GOSPEL?

It has not escaped the Brahms connoisseurs that this shorter sequence of four movements, with its combination of anxiety, its sense of the ephemeral, but then also its sure confidence in the Providential care of God which takes us through life's trial right into heaven, is a reproduction of the German Requiem. This greatest of all the Brahms choral compositions did not come into the world without controversy. To begin with, it was not a standard requiem mass, but is in the vulgate language, German, and based on texts from the Bible or the Apocrypha, chosen by Brahms himself. Though with roots in the liturgical music of Heinrich Schütz and J. S. Bach, it is an intensely personal reflection on mortality and on the comfort of God. One might call it a sermon in music, or even a personal testament. Furthermore, for those standing in the Christian tradition there is a significant concern about the German Requiem. Brahms deliberately left out any

explicit mention of the person and work of Jesus Christ. What are we to make of this? Many biographers have argued that Brahms was a humanist, albeit one who had a general hope in immortality. He did tend to resist dogmatic theology. But does this make him a humanist?

Brahms gave some credence to this when he called it a *Human* requiem, meaning that it was meant to be universal, and not a specifically German threnody. And he then seemed deliberately to want to leave out texts such as John 3:16, which are an appeal to the gospel of Christ. A now well-known exchange occurred between Brahms and the conductor of the premiere, Karl Reinthaler, which illumines the issues. The latter, actually a great friend and admirer of Brahms, writes, "For Christian sensibility the central point about which all else turns is missing—namely, redemption through the death of our Lord," adding that he could insert a more directly Christian reference in the place of the last two words of the Revelation 14:13 text, "Blessed are the dead which die in the Lord *from henceforth.*" To this Brahms replies:

> As far as the text is concerned, I will confess that I would very gladly omit the "German" as well, and simply put "of Mankind," also quite deliberately and consciously do without passages such as John ch. 3 verse 16. On the other hand, however, I did accept many a thing because I am a musician, because I was making use of it [i.e., the biblical text], because I cannot challenge or strike out the text of my revered bards, not even a "from henceforth."

So while he refused to change the text on aesthetic grounds, he did also seem to want a broader vision than traditional Christianity appeared to afford, on philosophical grounds. The point was not lost on the first listeners. Other clergy shared Reinhalter's theological qualms so that at the first performance of the *Requiem* in Bremen (April 10th - Good Friday - 1868) the aria from *Messiah,* "I Know That My Redeemer Liveth," was inserted half-way through the program! (This tradition continued in Bremen for some time.)

All the same, the German Requiem is hardly a statement of just any hope in a better world. There is here no apotheosis, no idealization of the future of man, but rather a deep joy, one that could only be nourished by God himself. Friedrich Nietzsche erroneously believed Brahms to express colorless and careworn kinds of joy. On the contrary, when Brahms portrays the life to come, it is profoundly real. Like Job, he can say, "I shall see him again ..." Consider also the setting of "death, where is thy sting?" from 1 Corinthians 15. It powerfully combines a defiance of death with the certainty of lasting treasures in heaven. The final chorus, "they rest from their labors," brings the same feeling of resolution that we have seen in the great Opus 74 motet *Warum?*

Still, we wonder at the absence of any reference to the pivotal point in all human history, the event that made death (and its cause, sin) to die. Why is that

central ingredient of our hope, the resurrected Christ, not presented in the music? What are we to make of this paradox?

AGAIN, WHY?

We noted earlier that there was in Brahms' music a certain resolution, perhaps even joy, but also a lingering doubt. Surely these relate to his own spiritual pilgrimage. Did Brahms' understanding of evil and hope fully express the biblical worldview described earlier? Before answering that question, one other should be considered. As Brahms himself had declared to Clara Schumann, it is possible that the man be better than his art. That is to say, his personal moral and theological qualities could have been far more orthodox and mature than what comes across in the music. It is possible, but not likely, in my opinion. We know Brahms to have been a good person. He was not judgmental. He had high ideals. His correspondence is simple and to the point, usually to interact with someone on a particular practical matter. In any case, it shows no sense of grandeur or a provision for a legacy of greatness. He was also very generous. He gave away money to those in need, often giving anonymously. He loved children. But we also have certain clues that Brahms was not altogether at home with the standard doctrines of the church. He had a deep knowledge of the Bible, and was educated in theology, but it is not certain how much of it he personally believed. In his great song, the *Schicksalied,* he sets a poem by Friedrich Hölderlin, which is at best a statement of alienation, and the impossibility of achieving the Elysian bliss of the gods. In any case, if Brahms the man was a "better" Christian than Brahms the composer, there is not much evidence for it.

The truth is, the music is as discrepant as the man. Brahms could say what he felt. The greatness of Brahms' music is that he could voice his thoughts with amazing craft, with great melodic and harmonic depth. He truly writes as a man in whose veins flowed the most vigorous human blood. We will have to be satisfied to admit that as far as we can tell, Brahms did not see Jesus Christ as the epicenter, either in his life, or in his music. At least, he did not focus his outlook on the God-man in the way recommended by traditional orthodoxy. This does not mean he was not a believer. He had a deep trust in God, and had the highest regard for the Scriptures. We cannot know what at various points he departed from standard evangelical theology. In fact we cannot be altogether sure exactly which parts of Christian doctrine he accepted and which parts he struggled with. About such hidden things of the heart we simply cannot know with certainty.

But here is my thesis. At the very least Brahms' treatment in music of the problem of evil was an extraordinarily powerful rebuke to the sentimental romanticism of his times. We could liken him, as mentioned earlier, to Charles Dickens or Fiodor Dostoevski because he faced the drama of human suffering with passion, but not always with clear answers. In fact, a sub-theme of his life is surely the

struggle to make sense of the human condition. He began with the question *warum?* He knew quite a good deal about the answers. One of them, which he believed dearly, is captured in the text from his motet: "Ye have heard of the patience of Job, and have seen the end of the Lord; That the Lord is full of pity and of mercy." But he never could state unambiguously that evil had been overcome in the expiation of Jesus Christ. At least, we have no evidence of such complete confidence. The question *warum* would remain with him throughout.

Brahms is not unlike his excellent neighbor from the North, of the previous generation, Søren Kierkegaard. He wrote extensively against the careless complacency of the official church with essays on the problem of evil that still make us sit up and listen today. In his masterpiece of 1843, *Fear and Trembling,* he examined the dilemma of Abraham, faced with the divine requirement to sacrifice his only son. Using the heteronymous mouthpiece Johannes de Silentio, he comments that, "He who struggled with the world became great by conquering the world, and he who struggled with himself became great by conquering himself, but he who struggled with God became the greatest of all." This for Kierkegaard is the greatness of Abraham's faith. I would venture to say this too is the greatness of Brahms' faith. It is a struggling faith, but he is struggling at the greatest level, moving in the right direction.

DEEP SORROW, DEEP JOY

Despite obvious contrasts, the church in our time faces the same issues. Artists who are followers of Christ still need to avoid both optimism and pessimism, and forge a third way. Often, we fall over on one side of the cliff: we have not been able to face the ugliness of evil and "tell it like it is." As a result, our work may be romanticizing the world. But then, to rectify that, we fall over again on the other side of the cliff. We then are in the opposite case, describing evil so powerfully that there is no relief, no redemption. The ability to avoid both errors in our art and steer a different course, based on the biblical motive of Creation-Fall-Redemption will depend on our artistic skill, of course. But it will also depend on our very convictions. Faithfully articulating our theological convictions in an artistically credible fashion begins with faithfully viewing the world through biblical lenses.

Here is the crux of the matter. How does one describe a world in which God's good creation has been spoiled by sin, but is being redeemed by the his grace? Brahms could be our model. Often in art that claims to be Christian, the balance is wrong. Either there is a "happy end," without really admitting the depths of sin and evil. Some (not all!) of our traditional American Evangelical music unfortunately falls into this category. It tends to praise God and focus on the believer's confidence without any significant acknowledgment of sin. At the other extreme, some of the music of church musicians is so pessimistic about the human condition that it fails to bring any hope. In my judgment, works such as Leo Sowerby's "Epilogue" from

Forsaken of Man fits in to that category. Perhaps also Healey Willan's "My Soul Is Exceedingly Sorrowful" from *Tenebrae of Maundy Thursday.* My examples could be disputed, but the point is that a truly biblical approach in music, as in doctrine, will be neither optimistic nor pessimistic, but hopeful, even joyful.

This balance can only be fully achieved, at least in theory, when one's experience of the world is interpreted in the light of Christ. The great French apologist Blaise Pascal had it right, when he said:

> Knowing God without knowing our own wretchedness makes for pride. Knowing our own wretchedness without knowing God makes for despair. Knowing Jesus Christ strikes the balance because he shows us both God and our own wretchedness.

This is no less true of artistic endeavor. Brahms has taught us much about the two equally opposite errors of pride and despair. And although he may not have been altogether clear about the centrality of Christ in resolving the tension he certainly pointed us in the right direction, inspiring us to yearn for great faith. We could cite a number of musical traditions which parallel Brahms' achievement. Many contemporary musicians have taught us elements of this third way. Few people have as powerfully stood with integrity, neither yielding to optimism nor pessimism, as African-Americans. Forged in the clandestine church, hammered-out on the anvil of oppression and immense suffering, spirituals, gospel music, the blues, jazz, ragtime, these are so many related styles that express the central message of deep sorrow and deep joy. The theme of sorrow and joy in black music is a subject in itself.

The negro spiritual, one of the treasures of American indigenous music, is replete with biblical themes and imagery. But it centers on the sufferings of the people of Israel, the agony of Christ on the cross, and the promise of victory over all oppression and evil. The story of the conversion of African slaves to Christianity is complex. Plantation heads and slave owners were not anxious for their laborers to discover a message of liberation. Yet through the efforts of tireless missionaries, and because of the power of the message itself, the gospel did spread far and wide in the slave community during particular episodes over three centuries. Music was always a central aspect of the encounter. From the rather opaque references to the music of African-Americans in the chronicles of the times we gather that it was lively, haunting, and biblical. A certain Edward Alfred Pollard records hearing the hymns or religious chants of the "Negroes," describing them as "... sung with a natural cadence that impresses the ear quite agreeably. Most of them relate to the moment of death ... [for example:]

'Oh, carry me away, carry me away, my Lord!
Carry me to the buryin' ground,
The green trees a-bowing. Sinner, fare you well!
I thank the Lord I want to go.
To leave them all behind.

On the surface the stylistic difference between the spiritual and the sophisticated choral music of Johannes Brahms is considerable. At a deeper level there is remarkable similarity. Looking squarely on at death, yet seeing it as a release from the burdens and injustices of this life, hope in the mercy of God, a quiet confidence in the world to come, these themes, and even the soulful way of singing about them, are in common.

It in encouraging to find in our day a number of musical trends emerging which strive for this third way. Some are in a popular or folk style. Some comes from the classical repertory. The music of the Estonian composer Arvo Pärt is in stark contrast to much in the modern Western canon. He has been labeled a minimalist, because he specializes in stark texture, and subtle changes. His choral music exemplifies our third way, but in a style that is more reminiscent of the Eastern Church than the Western approach to spiritual music. For example, his *De Profundis*, a setting of Psalm 130 [129 in the Vulgate], is a scored for male voices, punctuated by the tones of a bell. It moves ever so slowly from the Psalm's beginning supplication, "Out of the depths have I cried unto thee, O Lord," to the open assurance of, "Let Israel hope in the Lord: for with the Lord there is mercy," and finally it returns to the quiet confidence that, "He shall redeem Israel from all his iniquities." It is Brahms' *warum?* Or the negro spiritual's "Sometimes I Feel Like a Motherless Child," but in a mobile-like liturgical stillness.

A CALL FOR CANDOR

Perhaps because there is so much confusion and hostility in the surrounding culture, followers of Christ have been tempted either to retreat into tribal safety, or, worse, to lash-out in a winner-takes-all fundamentalist assault on the enemy. The reason for this is simple. We don't quite dare walk between the flames trusting that God can guide us and deliver us. We refuse to admit of tension and ambiguity. Because of that we can't honestly ask with the Psalmist, "Why, O Lord?" Our artistic production is not surprisingly one-dimensional. Being real in art is only possible when we can be real with God. Brahms was. The slaves in the antebellum South were. Arvo Pärt is. They are among the many in "misery" to whom the light has been given. And so they have asked, why? When we have recovered their candor we may be able to say it in our artworks.

End Notes

I am well aware of the trends in criticism in recent decades which have urged the separation of the text from the author, and will make a brief comment about it below.

1 Jan Swafford, *Johannes Brahms: A Biography* (New York: Alfred A. Knopf, 1999), p. 435.

2 Styra Avins, *Johannes Brahms Life and Letters*, selected and annotated (New York: Oxford University Press, 1997), 552–3.

3 Quoted in Jan Swafford, *Op. Cit.*, p. 164.

It is interesting to note the parallels here with the liturgy of his own Mass. The first movement, with its passion, is analogous to the Agnus Dei, the second to the worship of the Benedictus, and the third to the patience of the Dona Nobis. Malcolm MacDonald makes this parallel in his book, *Brahms*, New York: Schirmer Books, 1990, p. 259. Musically, this is right, although Brahms does not follow the sequence of the standard Mass.

In an otherwise helpful introduction to Brahms' life and work, authors Jane Stuart Smith & Betty Carlson mistakenly affirm, "The *Requiem* by Brahms professes faith in the resurrection and reunion with God through the atoning death of Jesus Christ." *The Gift of Music: Great Composers and Their Influence*, revised edition, Westchester: Crossway Books, 1987, p. 137.

4 Letter date c. 9 October, 1867, in Styra Avins, *Op. Cit.*, p. 353.

There is some question about whether the coda to this cycle is an attempt by Brahms the "Christian" to undo the more pessimistic side of Hölderlin's philosophy. See Malcolm MacDonald, *Op. Cit.*, pp. 203-4.

Perhaps, though, the music was better than the man. This could be the case of many composers whose art was more clear than their own walk. But from all that we have argued above, this is incorrect. There seems to be a nearly perfect harmony between the art and the man.

Walter Niemann states hopefully, but without grounds, the fact that Brahms began his creative activity with the German folk song and closed with the Bible reveals better than anything else the true religious creed of this great man of the people." *Brahms*, (New York: Alfred Knopf, 1941).

5 Søren Kierkegaard: *Fear and Trembling in Fear and Trembling/Repetition*, transl. By Howard & Edna Hong (Princeton: Princeton University Press, 1983) 212.

6 Blaise Pascal: *Pensées*, No 192, Krailsheimer transl., (London: Penguin Books, 1995) 57.

7 Accounts of the evangelization and Christian practices of slaves are not as numerous as one might presume. Albert J. Raboteau: *Slave Religion: The "Invisible Institution" in the Antebellum South*, (New York: Oxford University Press, 1978) remains a classic. A number of more recent studies examine the entire passage from Africa to America, but conversion is only a sideline. A few give more detail from particular regions. Sylvia R. Frey & Betty Wood's account, *Come Shouting to Zion*, (Chapel Hill: University of North Carolina Press, 1998) is a fine example. Theological issues are more squarely addressed in works such as Eugene C. Genovese: *A Consuming Fire: The Fall of the Confederacy in the Mind of the White Christian South*, (Atlanta: University of Georgia Press, 1999).

8 This example, with many others, is reported in the marvelous book by Dena J. Epstein: *Sinful Tunes and Spirituals: Black Folk Music to the Civil War*, (Urbana: University of Illinois Press, 1977) 225.

MAKING ART
like a true artist

The artistic journey begins with a simple desire to create. But this is only the beginning. This seed to create will in time grow into a full blown philosophy of art-making. And like plants themselves, these philosophies come in all shapes and sizes, from weeds to roses to lilies. All practicing artists whether Christian or non-Christian are driven by some philosophy of art-making whether they are able to articulate it or not.

In what follows, I've tried to articulate a philosophy of art-making that is both practical and spiritual. Christians making art need to be concerned with two main things: excellence in their craft—offering our work to God for His glory; and an imitation of Christ—the prime artist, for by Him the Scriptures say "everything was made."

EXCELLENCE IN CRAFT

Artists pursue excellence in their craft for a variety of reasons. First among them is the responsibility to develop skill and ability on par with the talent given them. This responsibility is all about response.

Artists are called to live in response to the talent that God has given. They are to cultivate it responsibly and to pray for the Holy Spirit of God to fill them with skill, ability and knowledge. In short, they work hard as men and women doing their work before the Lord, for as the wisdom of Proverbs reminds us, "All hard work brings a profit, but mere talk leads only to poverty." They study models to learn why some things work and others don't—why some work is compelling, lasting, and excellent. They form opinions and cultivate taste. Though

imaginative and innovative, they don't waste valuable time reinventing the wheel when it's simply not necessary. They get on with it.

Often 'to get on with it' involves letting your taste or aesthetic sense guide you to some work you admire. Once the work is before you, you can both enjoy it and ask questions of it. In my work, which is music, I find myself practicing this all the time. If I hear a song or a particular production style that I enjoy I want to know what it is about the music that intrigues me. Why do I find it to be excellent? Not only do I always learn something new about music by analyzing various pieces, but I add to my understanding of what excellence is. The process helps me to define a standard with which to measure my own work. It's worth noting that the culture around us (beyond the Christian subculture) has standards of excellence that are often very high and worth reaching for.

Though there are also notable exceptions to this, Christians should take the artistic standards of culture seriously. Seriousness will mean admitting that people who do not profess Christ often do excellent work worthy of our attention and study. And, it will also mean being serious enough about the disciple's life that we don't let supposed standards of excellence that are incongruent with Scripture pollute our own good definitions of excellence. Christians ought to be able to recognize and name various models of excellence found in the fullness of reality, never forgetting that God has shown great genius, skill and imagination in Creation. As little creators made in the image of God we should do likewise with whatever talent we have. God has also shown great love to people through his plan of redemption. Following this good pattern, love should also be at the heart of all excellent art created by disciples of Jesus. This is the most excellent way. An artist filled with the Spirit, skill, and ability, asking what it means to love the Church and the watching world as one uniquely gifted, is likely an artist who is making the invisible kingdom visible.

Finally, regarding skill and ability, I'm reminded that Peter Kreeft in his book *Making Choices* wrote, "A ballet dancer becomes free to make beautiful moves only by conforming herself to laws and principles in disciplined practice. A scholar becomes free from ignorance only by conforming to truth, to data, to facts." The ideal for a Christian making art is to be one who is set free to imagine good and to create it. By dedicating yourself to acquiring skill and ability in your craft, to living by a standard of artistic excellence, you greatly increase your chances of actually being able to create all that you imagine. Good intentions will not do, but hard work might.

This is something that one of my jazz heroes John Coltrane knew well and lived by. Coltrane possessed an ability to make creative choices that others either did not know existed, were afraid to make, or simply could not execute because they had not prepared for such strange and wonderful possibilities. He stretched preconceived boundaries and erased limitations that many thought to be

intrinsic to the instrument. In the world of jazz saxophone, Coltrane narrowed the gap between what a musician could imagine and what he could actually create. The pursuit of excellence to God's glory through practice and study, through the cultivation of God-given talent, for reasons of love, is the way that Christians can and should go about narrowing the gap.

MAKE THE MOST OF EVERY OPPORTUNITY

True artists purpose not to live in a world of "if onlys," but instead make the most of every opportunity. They do not wait for a national platform to really apply themselves. They give their best to God in their home church, community or university—being seen as faithful in the little things that they might be found ready and prepared for the bigger. They recognize that contemporary tools are nice to have, but are no substitute for astonishing ideas.

Art is not simply a product of the mind and emotions, but rather the whole person. Therefore, rest is just as important a tool to access in truthful art-making as anything. I maintain that true artists purpose to find balance between work and rest. Only a fool thinks he's succeeding because of all the chatter about how hard he is working. As Scripture says, "Better a little with the fear of the Lord than great wealth with turmoil." Rather than anxiety regarding basic provisions, true artists memorize and trust God's promises to provide. Endless cycles of trying hard to make things happen will only lead to the worst kind of poverty: ways of thinking and doing incongruent with faith.

Thus, true artists pray for humility and don't struggle endlessly against circumstances designed to humble them. Instead they see that even difficult circumstances can be a provision from God and an answer to their prayers. They welcome the discipline of the Lord because it is a testimony of His fatherly love and a sure sign that He is changing them incrementally into the man or woman He has designed them to be. Remember, God is working in you to make you like the prime artist, Jesus—not to give you your version of the perfect artistic life. Each day is a chance to decide afresh which outcome you are living for.

Still, the artistic life can be a very difficult one, especially when so few in the Church understand the role of the artist in church and culture. Given this, let me suggest that true artists commit to work against apathy and indifference. They purpose in their lives and their art to lead men and women away from such worthless occupation of the mind and heart. To do so is to love the Church and the watching world in a tangible way.

Since loving well requires thinking well, true artists purpose to be good thinkers. Philippians 4:8 is their text. They meditate on what is lovely and truthful and desire such things in their art. They never stop thinking. They are curious to know how things work. They know the power of ideas and pray to use only those whose consequences produce fruit in keeping with the purposes of God. They

cultivate the ability to distinguish good and evil (Hebrews 5:14). A good life is framed by discernment, and discernment comes through knowledge of the Word and the power of the Spirit. Study and pray. Great art is created in an environment of freedom, but the fuel of freedom is the substance of truth. The artist learns to watch both his life and his doctrine closely.

KNOW MISSION AND DESTINATION

True artists know their mission and destination. They know where they are going and what they are called to do along the way. It's a panoramic vision that keeps them focused on the promise ahead as well as history behind. And when they begin to stumble about the road from fatigue or hunger or loneliness, this same vision keeps them from falling into foolishness at either side of the road.

Years ago William Barclay wrote,

It may be said that there are two great beginnings in the life of every man who has left his mark upon history. There is the day when he is born into the world; and there is the day when he discovers why he was born into the world.

In this Barclay is quite correct, and it's here that Christians have the advantage. We know why we were born into the world. We know the kingdom story and how it's meant to inform our own. We know that we are the Church, the *ecclesia*, the called-out-ones. We are called not to our own purposes but to

I was a one-time wide-eyed boy from California
Who lost his way in a haze of pride
blinded by my pain
Had no use for the Father or the Son
I was spiritual
I answered to no master
but the one named Coltrane
All that changed when God made his play
And I heard the voice of Jesus say

Follow me to the ends of the earth
Come and see how my kingdom works
It's time to bring the world good news
Hear the voice of Jesus calling me, calling you
To be the word and work of God in the world
To be the word and work of God

I've been on this mission
as a musician twenty years or more
I've been hip, I've been hated, loved and berrated
Been hot, cold, young and old
It doesn't matter
I'm not the point of it all
It's only chatter
Evidence of the fall
The only thing that matters
is to live for Christ today
Set aside my own agenda
Hear the voice of Jesus say

CHARLIE PEACOCK. *God in The World,* 2004. Full Circle: A Celebration of Songs and Friends.

God's. The words of John Henry Newman add to this idea even further:

> God has created me to do Him some definite service; He has committed
> some work to me which He has not committed to another. I have my mis-
> sion. Therefore I will trust Him. Whatever, wherever I am, I can never be
> thrown away. If I am in sickness, my sickness may serve Him; in perplex-
> ity, my perplexity may serve him; if I am in sorrow, my sorrow may serve
> Him. My sickness, or perplexity, or sorrow may be necessary causes of
> some great end, which is quite beyond us. He does nothing in vain.

This is the kingdom perspective. It is the perspective that God has called all
artists to take a hold of. The kingdom perspective is a perspective fueled by faith,
freely expressing itself through love in response to the grace of God.

IMITATE JESUS

True artists imitate Jesus in his serving and his storytelling. They pursue great-
ness in craft in order to give the Lord the best fruit of the talent he has given them,
not to build themselves up. They understand that true greatness is found in the
heart of the servant.

After Jesus had washed the feet of his disciples he told them:

> I have set an example that you should do as I have done for you. I tell you
> the truth, no servant is greater than his master, nor is a messenger greater
> than the one who sent him. Now that you know these things you will be
> blessed if you do them (John 13:15–17).

True artists purpose to love the Church despite indifference or opposition to
their work. Though indifference is their enemy, they separate it from the brother
or sister who is seduced by it. They are eager to find their place in the Body and
do not consider themselves exempt from fellowship and church stewardship
responsibilities. They love the Church and do all they can to build it up, for how
can you love Christ and hate his Church?

In Genesis 1:31 we find our subject matter for art-making defined: "God saw
all that He had made, and it was very good." The whole of creation can and
should be the subject matter and the inspiration for the arts. To imagine good
things for the arts is a part of what it means to care for creation. In addition to
subject matter, Genesis 2:18 instructs us in the need for community. We all need
relationship for "It is not good for the man to be alone." You are made for relation-
ship in all its variety. It is impossible for Lone Rangers to produce fruit of a com-
prehensive nature—they're too selfish. In addition to caring for the artistic needs
of his or her community, a good artist will make other significant contributions

as well, e.g., serving through prayer for others. In a natural way, prayer for others is a spiritual discipline that gives birth to good art.

Other-centered living (after the model of Jesus) is at the very heart of good art-making. The arts have the ability to serve people in a number of healthy ways, from worship to our need for beauty. Let me encourage you to care for others through your talent and be imaginative about what caring and serving might look like. The possibilities are wide, high, and long.

I believe that Christian art should be what Eugene Peterson called the "observable evidence of what happens when a person of faith goes about the business of believing and loving and following God"—not "a rulebook defining the action" but instead "a snapshot of the players, playing the game." Good Christian artists make snapshots of all of us playing the game.

In his book, *Rainbows For A Fallen World,* Calvin Seerveld has this to say:

> . . . Christians of the historic Reformation will be wise if they understand art to be like clothes: a gift of the Lord to cover our nakedness, to dress our human life with joy, to strengthen and enrich our labors of praising God, serving the neighbor and caring for the world.

Praising, serving and caring—these concepts should be as much a part of the artist's life as oils and brushes, guitars and word processors.

TELLING A GOOD STORY WITH YOUR LIFE

In making art that is glorifying to God, the Christian artist must imitate his Lord in story telling. Edward Knippers speaks to the centrality of the biblical narrative in his essay. And central it is. Story is our doctrine! God has spoken in history, giving his people a narrative which not only frames our view of the truth, the Church and the kingdom, but reminds us that God acts in history on behalf of His people, and that these acts are stories worthy of being told again and again. He is still acting on behalf of His people today, and we should be telling today's stories (which is why all God's actions in history represent good and worthy subjects for art-making).

Scripture teaches us that Christians " . . . must learn to devote themselves to doing what is good, in order that they may provide for daily necessities and not live unproductive lives" (Titus 3:14).Or as Eugene Peterson puts it in *The Message,*

> Our people have to learn to be diligent in their work so that all necessities are met (especially among the needy) and they don't end up with nothing to show for their lives.

Or no story to tell. As my son Sam once said, "The way I see it, if you're old and don't have any stories—then something must have gone wrong." Wrong indeed.

The unproductive life is one in which you end up with nothing to show and nothing to tell. One sure-fire way to reach such an unproductive end is to give little credence to the life of the mind, the imagination, or holy, kingdom-perspective living. Live to tell the story as only you can tell it. Don't miss your cue.

Remember, the storyteller of good imagination seeks to leave the world and its inhabitants tangibly better than they were before the storyteller arrived on earth. Make this your goal.

The good story is never about the wisdom of the world. The kingdom is absent when the whole of your work remains within the range of human competence—especially so when it bets on it alone.

Telling a good story with your life is about faith that gives birth to action. It is about the object of your faith inspiring you to love responses or love actions. According to Dallas Willard in his book *The Divine Conspiracy*, telling a good story with one's life involves living "a life in which the good laws of God eventually become naturally fulfilled."

Some part of a good story is about imitation. It's doing the Father's business. As Jesus said,

> But love your enemies, do good to them, and lend to them without expecting to get anything back. Then your reward will be great, and you will be

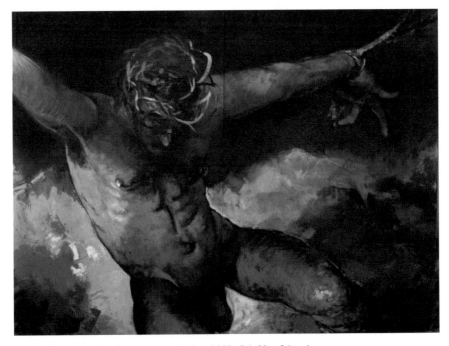

EDWARD KNIPPERS. *The Resurrection Breakfast*, 2000. Oil. 22 × 34 inches.

sons of the Most High, because he is kind to the ungrateful and wicked. Be merciful, just as your Father is merciful (Luke 6:35-36).

In addition, heed Paul's advice and "take note of those who live according to the pattern laid out by the apostles" (Philippians 3:17).

Live your life in the context of what God is doing and you will live a life that tells a good story, an eternal story. Rise every morning to talk with God about what He's doing on that day. Have what Willard calls an "intelligent conversation about matters of mutual concern." Ask God where the kingdom is being advanced, where the invisible is being made visible, where the battles are being fought, and ask Him to let you be a part of what He's doing in kingdom history. Ask this with great confidence "for we are God's workmanship, created in Christ Jesus to do good works, which God prepared in advance for us to do" (Ephesians 2:10).

What does each day require of you? The goal of life on a daily basis should be to live up to what you have presently grasped, understood, and lived through in the disciple's life. Paul understood this (Philippians 3:12-16). It is—in fact—all any of us can do.

Let the measure of success in the artistic life be how well you have loved. "Dear friends, since God so loved us, we also ought to love one another. No one has ever seen God; but if we love one another, God lives in us and his love is made complete in us" (1 John 4:11-12). "The only thing that counts is faith expressing itself through love" (Galatians 5:6).

Here's what I've figured out for myself. My life and my art are going to tell a story whether I try to or not. They will tell a story that says: "This is what a follower of Jesus is. This is what he is about. This is what he believes. This is what he thinks is important." Because this is going to happen and can't be stopped, I had better make sure I know my role and my job description: *a Christian is a living explanation*. As I go about living I will either make the teaching about God the Savior attractive or I won't. I make it attractive by living out what it is. It's attractive without me. My life and artistic work is to represent it accurately and not do violence to its attractiveness. That doesn't mean that the answer is to simply do every specific thing that Jesus did. That would be far from simple for someone not God. I'll be doing well if I can become the kind of person He's teaching me to be. That's some big work right there. Big work indeed. But work is beautiful. It's what we do. Gratefully, there is immeasurable freedom in Christ as we work and play. I am free to be who and what I am—a prepared and active participant in God's universe. My freedom serves to remind me that an heir does not live like an orphan; a subject in the kingdom does not live as if there is no authority higher than himself; an object of affection does not live as if she is not deeply loved. These things are true, as true as shadow and light or melody and rhythm.

Be who and what you are. There is no truer starting place for making good and true art.

Art, Faith and
the Stewardship
of Culture

Has there ever been a time when the public has been more alienated from the world of contemporary art—the art being produced in their own day and age? It's hard to imagine. That alienation from visual arts and classical music is obvious, but it exists even to some extent from the serious literature of our time. The reasons for this estrangement are numerous, and go beyond our era's love affair with pop culture and the general dumbing-down of our society. There are more complex factors at work here, factors that include everything from the emergence of modern art forms a century ago to the changing roles of technology, media, and the economics of making and "consuming" art.

I would like to focus on, however, the more specific issue of the uneasy relationship between Christians and contemporary culture. Having spent the last decade founding and editing a journal of religion and the arts, I have spent a great deal of time reflecting on the role of art and the imagination in the contemporary church. While there are many hopeful signs in the Church and in our culture as a whole, there are also some disturbing trends. It is my conviction that the Christian community, despite its many laudable efforts to preserve traditional morality and the social fabric, has abdicated its stewardship of culture and, more importantly, has frequently chosen ideology rather than imagination when approaching the challenges of the present.

If this approach remains the dominant one, then the community of believers will be squandering a remarkable opportunity. There are innumerable signs in our society that, on the eve of the new millennium, people are hungering for a deeper spiritual life. Baby Boomers are aging and feeling guilty about their youthful abandonment of religion. There may be more genuine openness to religious

faith—in the sense of curiosity and yearning—than at almost any time in a century. One of the powerful ways that believers can speak to that yearning is through the arts—and through faith that is leavened by the human imagination. Whether the Church will respond or not will determine its willingness to be a steward of culture.

FINDING THE BALANCE

There is no doubt that we live in a fragmented and secularized society—the polar opposite of the unified Christian culture that writers like Dante, Chaucer, and Milton took for granted when they penned their religious poems, or that Fra Angelico and Michelangelo assumed when they painted church walls and ceilings. The twentieth century witnessed art that frequently mocked religious faith, indulged in nihilism and despair, and engaged in political propaganda. Many artists have created works that are so difficult to apprehend that the disjuncture between the 'elitist' art world and the 'populist' world of art-consumption has widened into a dark chasm. The estrangement between the creators of art and their public is one of the facts we all take for granted.

Within the Christian community there have been many different approaches to modern culture. Some of the mainline denominations have followed a liberal ethos that welcomes new trends in secular culture. Evangelicals and fundamentalists have moved in the opposite direction, retreating into a fortress mentality and distrusting the 'worldly' products of mainstream culture—so much so that they have created an alternative subculture. To simplify somewhat, you might say that whereas liberals lack Christian discernment about culture, conservatives have just withdrawn from culture.

Among Christians who care about the arts, there are many who cling to the works of a few figures, such as J.R.R. Tolkien, T.S. Eliot, and Flannery O'Connor, who have forged a compelling religious vision in the midst of a secular age. But the danger in celebrating these Christian artists is that we isolate them from their cultural context, from the influences that shaped their art. There is a large body of believers who have essentially given up on contemporary culture; they may admire a few writers here or there, but they do not really believe that Western culture can produce anything that might inform and deepen their own faith. One might almost say that these individuals have given in to despair about our time. For me, the most depressing trend of all is the extent to which Christians have belittled or ignored the imagination and succumbed to politicized and ideological thinking.

THE DARK SIDE OF THE CULTURE WARS

Perhaps the best way to get a purchase on this situation is by looking into the phrase that has come to describe the present social and political climate—the

phenomenon known as the 'culture wars.' In his book on the subject the sociologist James Davison Hunter describes the two warring factions as the progressives and the traditionalists (terms that are synonyms for liberals and conservatives). The progressives are, by and large, secularists who believe that the old Judeo-Christian moral codes are far too restrictive; they actively campaign for new definitions of sexuality, the family, and the traditional ideas about birth and death—the 'life' issues. Traditionalists, clinging to what they see as the perennial truths of their religious and cultural heritage, wage a rear-guard action against the innovations wrought by the

SANDRA BOWDEN. *Annunciation after Fra Angelico (1387–1455)*, 1997. Mixed media drawing with 22-carat gold leaf. 21 × 16 inches.

progressives. Issues such as abortion and euthanasia, homosexuality and the family, school prayer and other church and state conflicts lie at the heart of the culture wars. The stakes are extremely high and the struggle is fierce and bloody—and likely to become even more intense.

I do not wish to quarrel with this description of our cultural politics, nor do I want to suggest that these issues are not crucial to the survival of our social fabric. But I confess that I am astonished by the lack of attention most religious believers have shown to what I call the 'dark side' of the culture wars. The dominance of the culture wars over our public discourse is a striking example of how politicized we have become. It was once a universally accepted notion that politics grows out of culture—that the profound insights of art, religion, scholarship, and local custom ultimately shape the terms of political debate. Somewhere in our history we passed a divide where politics began to be more highly valued than culture.

It is not difficult to find evidence for this assertion. Take, for example, the rise of single-issue politics and the plethora of political pressure groups and the lengths to which politicians go to court such groups. Above all, there is the shrillness and one-dimensionality of most political rhetoric. The quality of public discourse has degenerated into shouting matches between bands of professional crusaders. As James Davison Hunter has put it, the culture wars consist of "competing utopian politics that will not rest until there is complete victory" The result, Hunter concludes, is that "the only thing left to order public life is power. This is why we invest so much into politics."

Even in the circles where I have felt most at home—including the conservative intellectual movement and the many Christian organizations dedicated to defending religious orthodoxy—I have come to see a dangerous narrowing of perspective, an increasingly brittle and extreme frame of mind. Coverage of the arts in conservative and Christian journals is almost non-existent. Again and again I have seen the emphasis in these circles shift to having the correct opinions and winning political victories rather than on cultivating a reflective vision and seeking to win the 'hearts and minds' of our neighbors.

The very metaphor of war ought to make us pause. The phrase 'culture wars' is an oxymoron: culture is about nourishment, cultivation, whereas war inevitably involves destruction and the abandonment of the creative impulse. We are now at the point in the culture wars where we are sending women and children into battle, and neglecting to sow the crops in the spring. Clearly we cannot sustain such a total war. In the end, there will be nothing left to fight over.

IMAGINATION AND CULTURAL RENEWAL

Here is where the realm of literature and art comes into the discussion, in two important ways. First, the changing attitudes towards art provide another case

study in the narrowing effects of the culture wars. Second, it is my contention that the imagination itself is the key to the cultural and spiritual renewal we so desperately need.

As in any other arena, progressives and conservatives have very different attitudes toward literature and art. Modern progressives have been far more interested in the art of their own time than conservatives, who have seen it as a subversive force, capable of undermining traditional values and making 'alternative lifestyles' more acceptable. The progressives, in their approach, have touched on one of art's most important functions: to force people to look at the status quo in a new way and challenge them to change it for the better. From the satires of Euripides and Swift to the novels of Dickens and Flaubert and beyond, great art has engaged in the paradoxical activity of constructive subversion.

Unfortunately, the progressives have preferred art that is subversive without a corresponding vision of the deeper wellsprings of human and divine order. Being members of an elite that is alienated from the traditional social order, they have become associated with art that is frequently nihilistic, or simply amoral. With less and less substance in their works, the artists supported by the progressives have resorted to irony, political propaganda, and sensationalism to elicit a response from their audience. Hence, the passing celebrity of figures like Bret Easton Ellis, Karen Finley, Andres Serrano, and Robert Mapplethorpe.

On the other hand, conservatives have been deeply estranged from the art of this century. While they have celebrated artists who have shared their views, including such writers as Yeats, Eliot, Evelyn Waugh, and Walker Percy, conservatives have frequently condemned 'modern art' as if it were a monolithic entity. The idea has been that modern art is somehow tainted by a predilection for nihilism, disorder, perverted sexuality, even an indulgence in the occult. Conservatives frequently mock abstract art, experimental fiction, the theater of the absurd, and functionalist architecture. They prefer art that provides uplift and lofty sentiment. Unlike the progressives, conservatives tend toward the populist attitude encapsulated in the phrase: "I don't know much about art, but I know what I like …."

A corollary of this conservative alienation from modernity is the tacit assumption that Western culture is already dead. The stark truth is that despair haunts many on the Right. When conservatives turn to art and literature they generally look to the classics, safely tucked away in museums or behind marbleized covers. Ironically, many conservatives don't seem to have noticed that they no longer have anything to conserve—they have lost the thread of cultural continuity. They have forgotten that the Judeo-Christian concept of stewardship applies not only to the environment and to institutions but also to culture. To abdicate this responsibility is somewhat like a farmer refusing to till a field because it has stones and heavy clay in it. The wise farmer knows that with the proper cultivation that soil will become fertile.

The tradition of Christian humanism always held that the secular forms and innovations of a particular time can be assimilated into the larger vision of faith. That is why T.S. Eliot could adapt Modernist poetics to his Christian convictions, or Flannery O'Connor could take the nihilistic style of the novelist Nathanael West and bring it into the service of a redemptive worldview. Only a living faith that is in touch with the world around it can exercise this vital mission of cultural transformation.

Because progressives and conservatives are so thoroughly politicized, their approach to art is essentially instrumentalist—as a means to an end, the subject of an op-ed column or a fundraising campaign. Of course, there is a deep strain of pragmatism in the American experience, and it does not take much to call it to the surface. In the context of American Christianity, the Puritan strain has shown a similar tendency toward pragmatism: art becomes useful insofar as it conveys the Christian message.

In a politicized age, constricted by the narrowness of ideology, few people really believe that art provides the necessary contemplative space that pulls us back from the realm of action in order to send us back wiser and more fully human. For Christians, the idea that contemplation and prayer ought to precede action should be second nature. How many of us have become unwitting disciples of Marx, who said that "up till now it has been enough to understand the world; it is for us to change it"? Marx's preference for revolutionary action over the classical-Christian belief in the primacy of contemplative understanding of transcendent order lies at the heart of modern ideology.

ART AND TRANSCENDENCE

Art, like religious faith in general and prayer in particular, has the power to help us transcend the fragmented society we inhabit. We live in a Babel of antagonistic tribes—tribes that speak only the languages of race, class, rights, and ideology. That is why the intuitive language of the imagination is so vital. Reaching deep into our collective thoughts and memories, great art sneaks past our shallow prejudices and brittle opinions to remind us of the complexity and mystery of human existence. The imagination calls us to leave our personalities behind and to temporarily inhabit another's experience, looking at the world with new eyes. Art invites us to meet the Other—whether that be our neighbor or the infinite otherness of God—and to achieve a new wholeness of spirit.

The passion to find reconciliation and redemption is one of the inherently theological aspects of art. Before the modern era, this passion often took the form known as theodicy—the attempt to justify God's ways to man. There are, to be sure, few full-blown theodicies to be found in bookstores and art galleries today, but the same redemptive impulse has been diffracted into dozens of smaller and more intimate stories. We may not have towering figures of intellectual orthodoxy

like Eliot, O'Connor, or Walker Percy living among us, but there are dozens of writers, painters, sculptors, dancers, filmmakers, and architects who struggle with our Judeo-Christian tradition and help to make it new. The renaissance of fiction and poetry with religious themes and experiences is in full swing, from older figures like J.F. Powers, Richard Wilbur, and John Updike to such gifted writers as Annie Dillard, Kathleen Norris, Anne Lamott, Ron Hansen, Louise Erdrich, Elie Wiesel, Larry Woiwode, Doris Betts, Reynolds Price, Chaim Potok, Frederick Buechner, Mark Helprin, Anne Tyler, John Irving, Tobias Wolff, and poets like Scott Cairns, Edward Hirsch, Paul Mariani, Geoffrey Hill, and Donald Hall.

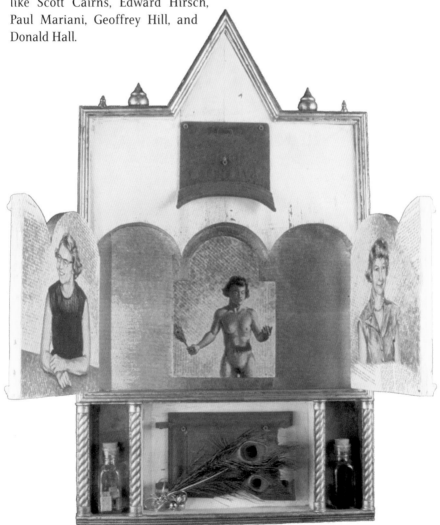

TYRUS CLUTTER. *Altarpiece & Reliquary of St. Flan*, 2003. Mixed media with oil on book pages, 35 1/2 x 26 inches (open).

But it is not only in literature that contemporary artists are returning to the perennial matters of faith. Take classical music, for instance. The three best-selling composers in classical music today are Arvo Pärt, John Tavener, and Henryk Gorecki. All of these composers were profoundly affected by the modern musical style known as minimalism. Yet they felt minimalism lacked a spiritual dimension—a sense of longing for the divine. So they returned to the ancient traditions of Gregorian chant and developed music that combines ancient and modern techniques, and which has brought back to contemporary ears the spirit of humility and penitence.

It is true that some of the artists that I've mentioned may not be strictly orthodox on all aspects of doctrine, and many of them remain outside of the institutional church. But many of these figures are faithful Christians and observant Jews. All of the artists I've listed treat religion as one of the defining components of our lives. I think it is fair to say that if this body of art was absorbed and pondered by the majority of Christians, the quality of Christian witness and compassion in our society would be immeasurably strengthened.

Above all, these artists and writers are neither baptizing contemporary culture nor withdrawing from it. In the tradition of Christian humanism, they are reaching out to contemporary culture and using their discernment to find ways to see it in the light of the Gospel. Just as Christ established contact with the humanity of the publicans, prostitutes, and sinners he encountered before he revealed the message of salvation to them, so Christian artists must depict the human condition in all its fullness before they can find ways to express the grace of God. In other words, Christian artists must be confident enough in their faith to be able to explore what it means to be human. At the heart of Christian humanism is the effort to achieve a new synthesis between the condition of the world around us and the unique ways in which grace can speak to that condition. That is how art created by Christians will touch the lives of those who encounter it.

CHRISTIAN HUMANISM AND THE INCARNATION

Behind this vision of Christian humanism stands the doctrine of the Incarnation: the complete union of Christ's divine and human natures. The Incarnation is the touchstone against which we can test the rightness of our efforts. That is because we must remember to keep the divine and human perspectives in a healthy balance. Emphasize the human over the divine, and you fall into the progressive error; stress the divine over the human, and you commit the traditionalist sin. To take just one specific manifestation of this, consider the need to balance God's justice with His mercy. If all the emphasis is on justice, you end up with a harsh, abstract, and legalistic view of the world. But if mercy is all you care about, compassion will become vague and unable to cope with the complex realities of a fallen world.

All great Christian art is incarnational because art itself is the act of uniting form and content, drama and idea, the medium and the message. If art is dominated by a moralistic desire to preach at the audience, it will become lifeless and didactic. We can easily spot didacticism when its message is different from what we believe, but no one who cares about art should confuse it with politics or theology. Art does not work through propositions, but through the indirect, 'between the lines' means used by the imagination. We need look no further than the Gospels to be reminded of this fact. Christ's parables are marvels of compressed literary art: they employ irony, humor, satire, and paradox to startle us into a new understanding of our relationship to God. If we are too quick to boil these unsettling stories down to one-dimensional morals, they will no longer detonate in our hearts with the power that Jesus poured into them.

Many believers fear the imagination because it cannot be pinned down. But the imagination is no more untrustworthy than, say, reason. Like any other human faculty, it can be used for good or ill. Imagination, because it draws on intuition, can help us to see when reason has become too abstract, too divorced from reality. In a work of art the artist's imagination calls out to the audience, inviting the reader or viewer or listener to collaborate in the act of discovering meaning. Jesus' parables only find their fulfillment when we puzzle out their meaning, interpreting their ironies and paradoxes.

It is precisely this fear of the imagination that has led many Christians in America to create a subculture with Christian publishers, Christian record labels, and Christian art galleries. The underlying message conveyed by these products is that they are safe; they have the Christian seal of approval. But this is a devil's bargain: in exchange for safety, these products have given up their imaginative power. And this is just where the strangest irony of all emerges. This subculture has rushed to produce Christian versions of almost every secular trend: from Christian heavy metal bands to Christian romance novels to Christian self-help books. But because these products lack the transforming power of the imagination, they are little better than the pop culture trends they imitate.

A STEWARD OF MYSTERY AND CULTURE

What is an example of a contemporary work of Christian imagination that truly synthesizes the realities of the culture in which we live with the timeless reality of God's grace? Almost anything by the writers and composers I've listed above would make for a brilliant case study. I could also draw on the work of visual artists, choreographers, singer-songwriters, and many other art forms I haven't yet mentioned. But I will stick to what I know best—literature.

Ron Hansen's *Mariette in Ecstasy,* published in 1992, is a haunting, enigmatic novel that is almost impossible to categorize. What makes *Mariette* especially fascinating is that it deals with a subject that must appear bizarre and esoteric to

today's reading public. Set in a Benedictine convent in upstate New York around 1906, it is the story of a young girl who experiences the stigmata, the five wounds of Christ, in her own flesh.

Given the remoteness and "abnormality" of this world, the expectations and preconceptions of the reader undoubtedly play an important role in how the story is perceived. There is, of course, a long and undistinguished tradition of lurid, melodramatic tales of masochism and smoldering sexuality in the monastic enclosure. The genre, which probably began with Boccaccio's *Decameron,* moves on to nineteenth-century anti-Catholic novels such as *The White Cowl* to contemporary psychological fables such as the film *Agnes of God.*

But if Hansen works with some of the same materials, he has fashioned an altogether more serious and profound exploration of suffering and religious passion. The novel's protagonist, Mariette Baptiste, is the daughter of a possessive, hyper-masculine father; her mother died when she was young. Mariette is an intelligent and strikingly beautiful seventeen year-old when she enters the convent. She is the type of woman who would cause jealousy, envy, and adoration anywhere she went, including the monastic enclosure.

Rather than using her intelligence and beauty in the more conventional modes of academic achievement and marriage, Mariette withdraws into an intense inner life. She becomes a spiritual prodigy. All of her sensual energy and vivid imagination is channeled into her courtship with her divine lover, Jesus.

RON HANSEN. *Mariette in Ecstasy*, 1991.
Cover illustration by Honi Werner.

Within her first year in the convent, Mariette experiences the trauma of seeing her sister, who is also a nun, killed by cancer at the age of 37. She undergoes a spiritual crisis in which she loses any sense of Christ's presence. Then, in the midst of this agitation, the stigmata appear on her body; she bleeds from hands, feet, and torso.

When questioned, Mariette claims that the stigmata were given to her by Christ Himself. It becomes clear that, far from being proud and ostentatious about these wounds, Mariette is embarrassed and troubled. The convent is thrown into a turmoil of conflicting opinions and emotional responses.

Here is a subject that is perfectly suited for Freudian analysis. If there was ever a paradigm of repressed sexuality, the apparently masochistic mysticism of the female *religieuse* would seem to be it. And yet Ron Hansen's novel makes no attempt to *explain* Mariette's experiences; there is no sense in which the author stands above and outside his protagonist's life, ready to share a knowing look with his reader about this sadly deluded girl. The story is open-ended, allowing the reader to interpret Mariette's experience in any number of ways. That is exactly what happens in the convent, where almost every possible reaction, from adoration to loathing and fear are evoked by Mariette's stigmata.

The open-endedness of the narrative is not a cop-out, but a sign of Hansen's respect for mystery, that dimension of the Christian imagination championed by Flannery O'Connor. For the writer who acknowledges mystery, O'Connor held, "the meaning of a story does not begin except at a depth where adequate motivation and adequate psychology and the various determinations have been exhausted. Such a writer will be interested in what we don't understand rather than in what we do He will be interested in characters who are forced out to meet evil and grace and who act on a trust beyond themselves—whether they know very clearly what it is they act upon or not."

O'Connor's words describe not only Hansen's vision but also his protagonist's significance. Mariette's psychology is more than adequate. The modern reader, consciously or unconsciously schooled by Freud, will note the eroticism of Mariette's spirituality and be tempted to think that in 1906 repressed sexuality led to religious hallucinations. But Hansen's narrative also takes into account the tradition, from the *Song of Songs* through Carmelite mysticism, of Eros as a metaphor for the soul's relation to the heavenly bridegroom.

The final level of ambiguity in the novel concerns the perceptions of those who must interpret Mariette's ecstasies. These perceptions are colored by the characters' deepest hopes, fears, and needs. Mariette's stigmata, like any intense and miraculous religious experience, act as a touchstone, revealing the inner lives of those around her. Though such revelations include jealousy, credulity, and anger, Hansen's compassion is broad enough to forgive nearly all of them.

Hansen seems to leave the reader free to embrace almost any explanation of Mariette's stigmata. But he is doing more than that. In leaving the narrative open-ended, the author is asking us to make our own judgments, and thus to confront and question our deepest beliefs and emotions. Despite the strong evidence for the truth of her experience, why is it so hard to let go of our suspicion that Mariette may be nothing more than a brilliant fraud? Is there something in us that refuses to accept such signs of God's grace irrupting into our world?

At the end of the novel, Mother Saint Raphael says to Mariette, "God gives us just enough to seek Him, and never enough to fully find Him. To do more would inhibit our freedom, and our freedom is very dear to God." Taken out of context,

this might sound like a relativist's creed, but the prioress is talking, in simple and direct language, about the nature of faith itself.

Hansen draws on modern Freudian notions of human motivation only to suggest that there is a far more profound and satisfying answer to the mystery—Christian faith. Here is a work that truly synthesizes elements of the culture we inhabit with the perennial wisdom of the Christian imagination.

Ron Hansen is a true steward of Christian culture, as are the Christians who read and ponder his vision. His art is neither safe nor predictable; it requires, and rewards, a deep engagement of our imaginative faculties. Such an engagement requires us to invest our own time and passion. Which brings me back to my central theme: how committed are we as Christians to nourish our faith and renew our society by becoming stewards of culture? Unless we contribute to the renewal of culture by participating in the life of art in our own time, we will find that the barbarians have entered by gates that we ourselves have torn down.

SINGING
in unison

Art is at once exhaustively personal and inescapably social.
—Conductor Robert Shaw[1]

It has been said that silence is the canvas on which all music is inevitably rendered. While this may be so, art does not exist in a vacuum. Color and shape have no acuity in darkness; neither can melody or harmony be discerned when silence is absolute. For art is perception. It presumes a recipient: a distinctly human one. Art is art because it is observed by someone who can recognize and assess its meaning. It encapsulates a part of the human experience and elicits a response. We, the perceivers, are moved and in some way changed. Art is marrow and sinew of the human soul and a mark of the Divine image on created man. It has value only to those who bear that image, we of the uniquely human community.

We don't generally think of ourselves as a community of living beings separate from other things in the created order. Our understanding of a community comes from a distinction we make between groups of people that are linked geographically, or that are kindred in tastes or interests. We seek out others who share similar experiences and align ourselves with them. It is in our nature to belong, so we form communities—groups of people with whom we have something in common. As we operate within those groups we develop friendships, enrich our lives, and find a source of personal satisfaction.

Every human community can be considered an artistic community. Art is so infused with the human spirit that our lives themselves are a work of art—a living drama carried out over time. Paul describes a Christian community as

"a letter from Christ, written. . . not on tablets of stone but on tablets of human hearts."[2] Sometimes, a group of people join together to create a specific work of art. Such a community brings a work to life and then shares in appreciating it and evaluating its substance. These are the performers, the craftsmen, composers, screenwriters, technicians, actors—the architects of sound and light over time. Their acts of purpose and their collective spirit generate works of power and impact. The whole becomes greater than the sum of its parts. People assemble and embrace the creative process to pursue a mutual goal.

Living within a community (the church) and pursuing the artistic process (worship) are no less than a paradigm of the godly life and a dwelling place for the Holy Spirit. God inhabits the praise of his people.[3] Two events in the life of the Hebrew nation bring this to light: Moses building and dedicating the tabernacle in Exodus 35, and the dedication of the Temple by Solomon in I Kings and II Chronicles. More than ten chapters of the Bible are devoted to describing the artistry and detail of these events. On the day of dedication, God Himself descended on the nation to dwell with His people. Martin Selman, remarks on the dedication of the Temple in his work *Second Chronicles, A Commentary:*

> Priests and Levites were indicating through their unity, commitment, and praise their desire to worship God, and the Chronicler clearly intends this to be seen as an example to be followed. When God's people set themselves apart for him to express heartfelt worship and praise, God will surely respond with some sign of his presence.[4]

Both the Old and New Testaments are filled with references to the community of God's people. God's purpose for His people is to bring each of us into fellowship with Himself and with one another. We recall passages that urge us to "love one another, teach and admonish one another, edify one another, build up one another," or to "pray for one another."

> Speak to one another (*corporately*) with psalms, hymns and spiritual songs. Sing and make music (*together*) in your heart to the Lord, always giving thanks to God the Father for everything...[5] (*italicized words implied*)

More than one-seventh of the Bible—the book of Psalms—is poetry intended as texts for cooperative worship.

So we conclude that God's purpose for his people is not only to call everyone to a relationship with the Almighty and with each other in community, but in addition, we are summoned to embrace an artistic medium as the means of expressing our living relationship with the One who loves us. "But wait a minute," someone says, "I'm no artist," but this is only partially true. Each person entering the church brings an artistic perspective with him because he bears the image of God.

While we might agree that worship is both corporate and artistic, we must also recognize that, as the body is made up of many members, some among us are gifted in artistic means. This was true of Oholiab, Beniniah, Asaph, and David—men that we would recognize as artistic. By taking this a step further, we see that not only is a worshipping church a community of artist-participants, but those gifted in the arts are themselves members of smaller communities: musicians, sculptors, writers, dancers, or painters. It is here that we begin to appreciate the scope and breadth of the greater artistic body when we consider those among us who aspire to a particular community. And, when we examine the interaction of those in an artistic community—and here I will be speaking of performing artists—can we discover a design for the Christian life that may have its origins with the divine Creator?

SOLITUDE

One would think, upon seeing a major theatre production, that the life of a performing artist is largely spent in rehearsal and preparation for great musical events. In reality, the opposite is true. The amount of time allotted for complete rehearsal—even for the largest of works—is actually very little. The majority of the artist's life is spent in solitude, as any craftsman will attest. For in these times alone the performer learns his technique and the composer seeks inspiration. Beethoven sought the quiet surroundings of the Vienna woods to gather strength. Mahler rebuilt a "shed" for himself in a remote part of Austria where he could compose in silence.[6] Josef Haydn would schedule a specific time of day to compose alone in his studio, and if he didn't receive any ideas on a particular day, he would pray for them. A 1996 study of young musicians has stated that "up to the age of 21, a talented pupil will have spent about 10,000 hours of purposeful practice."[7]

One of the first characteristics of the artist and community is a balancing of time spent with others and times spent in solitude. A performer knows what it means to practice: taking at times only incremental steps on a path that will eventually lead to true artistry. But he also knows that he can't do it alone. He is equally committed to the discipline of practice and an inner drive to be heard by others. Practice leads to performance, and performance is almost never alone. The performer finds himself in an unending search for collaborators—singers need pianists, guitarists need a band, and all are vitally linked to their communities. Once the performance is finshed, on to more practice . . . and so it goes. Each gives strength and purpose to the other, and both are held in a kind of rhythm in the life of the performing artist.

For the Christian, quiet times alone with God are preparatory to the times when we are bringing His message to a lost world. In these times of communion with Him our faith is honed and our strength restored. But His spirit convinces us that we can't live our lives cloistered from those Jesus died to save. In the quiet hours when we are "still and know" that God is God, we are empowered to act. And in the heat of the struggle for men's souls, our energies are depleted and we

need to return alone to the source of all power. Jesus' ministry is nothing more than the perfect balance between times spent feeding the masses, and hours alone with His heavenly Father.

ARTISTRY AND UNITY

Unison singing has a symbolic significance. The singing of only one melodic line signifies unanimity of spirit and is the symbol of ultimate fellowship.
—German conductor Wilhelm Ehmann[8]

Arguably the most significant concert of the twentieth century occurred at the Schauspielhaus in Berlin, Germany on December 25, 1989. To celebrate the collapse of the Berlin Wall and the reestablishment of a united Germany, musical artists from around the world met to perform Beethoven's Ninth Symphony

SANDRA BOWDEN. *Sonata*, 1988. Collagraph, 20 x 20 inches.

conducted by an American conductor of Jewish descent—Leonard Bernstein. The event included orchestral musicians from the countries allied against Germany in the Second World War, along with a large chorus of German singers who came from both sides of the fallen Wall. Peoples who were at one time enemies in the greatest conflict in human history were united in the music of one of Germany's greatest musicians. This extraordinary project was achieved with the collaboration of the Bavarian Radio Chorus, Dresden Philharmonic Children's Chorus, the Berlin Radio Chorus, the Dresden Staatskapelle Orchestra, the Orchestra of the Kirov Theater in Leningrad, the London Symphony Orchestra, the New York Philharmonic, the Orchestre de Paris, and Deutsche Grammophone Recordings.

Reviews of the concert and the subsequent recording seemed to agree that the emotion of the event produced a less-than-pristine reading of Beethoven's crowning work. But for this discussion, imagine the number of communities represented by those entering the concert hall to perform such a masterpiece as this. This "community of communities" is a familiar occurrence in the performing arts. Look at the credits at the end of a major motion picture, or read the names of the participants in the program of a theatrical production. Each individual participating in a larger undertaking brings artistry and humanity to the project that is critical to its fulfillment. In a symphony orchestra we find accomplished musicians who are not only performers, but prominent members of their individual fields, including the guilds and intelligentsia of each orchestral instrument. A chorus may involve professional vocalists, teachers, students and some whose professions are outside of music altogether. A dramatic production requires technical expertise—lighting and sound technicians as well as backstage assistance, costuming, and makeup. Each participant arrives at a different stage in his own artistic development, but all have something specific to contribute. In a very real sense, the work becomes a functioning organism, with activity from the smallest atom to the expressive whole.

UNITY AND SUBMISSION

At the beginning of a live performance, the hush that falls after the lights are dimmed is usually broken when we see a single person enter the room and assume the podium: the conductor. His task is to bring all the musical and expressive forces together. Under his direction, the next hours will be spent bringing a specific work to life with order and meaning. He is a guide in the purest sense, navigating through a musical score using wisdom and elegance. He knows that this work is no different from every other in the performing arts: it must be recreated in time for it to exist at all. His musicians are unified in purpose and desire, yet they also submit their own interpretative ideas to those of the leader. He channels the common spirit and energy to bring to the audience a unified ideal.

Unity in any aspect of serious music making is a difficult and frustrating pursuit, yet almost every aural model is connected to unity in some way. Unison, ensemble,

rhythm, octaves, timbre—these and many other terms are intertwined with unified musical expression. I would mention here one of the musician's favorite nemeses: intonation, or performing in tune with another instrument. Intonation may well be the determinant between music and noise. From the simplest solo line to the most complex harmonic structures, every pitch from each performer must have a center, and it must align with the pitches of those around it both melodically and harmonically. This is no small undertaking; it is a way of life. A performer literally never stops critically listening and making adjustments for the sake of intonation. And, it should be noted, that the closer an ensemble gets to achieving artistic unisons, the less discernible the timbre of the individual contributing to the overall sound.

As community is significant to a sovereign God, so also is unity. Both the Old and New Testaments present this as a distinctive of God's people. "How good and how pleasant it is for brothers to dwell together in unity" (Psalm 133). Paul wrote to the Philippians: "then make my joy complete by being like-minded, having the same love, being one in spirit and purpose" (2:2). Jesus' final prayer with the disciples in the upper room reads:

> I have given them the glory that you gave me, that they may be one as we are one: I in them and you in me. May they be brought to complete unity to let the world know that you sent me and have loved them even as you have loved me.[9]

Complete unity. Perfect unison. When we consider this for a moment, we approach the very presence of God at perfect oneness within the Trinity. In Deuteronomy 6, the Hebrew *Shema,* begins, "Hear, O Israel! The Lord is our God! The Lord is one!" In the New Testament, "there is one God and one mediator between God and men, the man Christ Jesus" (I Tim. 2). After Pentecost, the Spirit, (paraclete) is one with the Father and the Son. Jesus' prayer is that those who bear His image would know a "perfect unity" that will be not only the impetus for bringing His message to a lost world, but also proof that He came to earth at all.

Unity, then, operates in the Christian life on two levels. God desires that we be bonded with Him in the unity of the Holy Spirit—the conductor ("that they may be one just as we are one"). Secondly, God desires that we be bonded together in community—the worshiping artist. Taking this a little further, we notice a Biblical distinction between unity and oneness. Oneness refers to a state of being in the character of God or of His people. "That they may be one just as *we are* one." the Lord *is* our God. The Lord *is* one." "The one who joins himself to the Lord *is* one spirit with him"[10] (*italics added*). Unity among believers, on the other hand, is one-ness played out in time—a purposeful act of pursuit. The brothers "*dwell* together in unity," and Paul entreats the Ephesians to be "diligent *to preserve* the unity of the Spirit in the bond of peace" (4:3). We become one with God in who we are, but we are unified with others in what we do.

This call for submission to unity does not mean that our personal identites are sacrificed to achieve unity. For example, when the Spirit was poured out on the day of Pentecost, the disciples did not preach the Gospel in Aramaic, but rather each person heard the disciples speak in their own native tongue. We find perfect unison in the Trinity, but we also find three distinct persons. So also in the church, koinonia is not monophony but *polyphony*. Polyphony is a term for music with two or more independent melodic parts sounded together.

When we hear two notes sung or played simultaneously, they don't occupy discrete places in a box. Each fills the whole of our heard space, yet we hear them as distinct. Notes neither exclude nor hide the other. Of course, they can do that … but they don't have to; they can sound *in and through* each other. Moreover, when one string sets off another on a piano, it is not a case of 'the more of one the less of the other', but 'the more of one, the *more* of the other'. God *frees* us to be fully ourselves. The *more* God is involved, the *more* free we are: that is the pattern of Christian freedom.[11]

Our lives spent in this polyphonic community with other Christians should be marked by the same kind of unrelenting passion and selfless devotion to unity that the artist brings to the performance of a great masterpiece.

THE SPIRIT FOR THE COMMON GOOD

There are different kinds of gifts, but the same Spirit. There are different kinds of service, but the same Lord. There are different kinds of working, but the same God works all of them in all men. Now to each one the manifestation of the Spirit is given for the common good. —I Corinthians 12

As stated earlier, art is inescapably linked to the human spirit. In the performing arts we can actually watch a living laboratory of communities functioning under a "leader" for the realization of a common ideal. In the performing venue we know that many function together to create something greater than any individual can achieve alone. Performers are dependent on this. They bring their craft to a level of artistry over a lifetime of balancing community interaction with the solitude of training. And they are willing to subjugate their artistry to another of their community, the conductor, striving for a unity that is necessary for the art to exist as an integrated whole.

Human nature being what it is, we would like to think that we are capable of achieving great artistic and expressive heights on our own. But let's not kid ourselves. Anything that is so unmistakably joined to the human spirit draws its life from nothing less than the Holy Spirit. Here we must give credit where it is due

and recognize that a unified functioning body works at all because the Spirit gives it life. So before we go any further, we must consider how the Holy Spirit plays a role in the community and the artistic process.

At this point, we leave our discussion on community to briefly look at three attributes of the Spirit: His regenerative work, His redemptive work, and what the Bible calls the "gifts of the Spirit."

HIS SPIRIT AT WORK

First, we must reaffirm that the Holy Spirit is a person, and that He is God. He is everywhere, and in Him all things coexist. The apostle Paul, in speaking to the Athenians stated, "For in Him we live and move and have our being."[12] R. C. Sproul has written, "In the sense of creation, everybody participates in the Holy Spirit. Since the Holy Spirit is the source and power supply of life itself, no one can live completely apart from the Holy Spirit."[13] He is present as a creative force today, and continues to be as active as when the earth was first created. Sinclair Ferguson notes in his book *The Holy Spirit,* "From the beginning, the ministry of the Spirit had in view the conforming of all things to God's will and ultimately to his own character and glory."[14] In the Holy Spirit, we encounter the administrator whose role is to "order and complete what has been planned in the mind of God."[15] This is an ongoing, creative work.

Second, we must realize that since Pentecost, part of the Spirit's ministry is to call all people to redemption. It is the Spirit that moves in men's hearts to bring them to the knowledge of Christ and His atonement. In his book, *The Mystery of the Holy Spirit,* R. C. Sproul writes, "Just as nothing can live biologically apart from the power of the Holy Spirit, so no man can come alive to God apart from the Spirit's work."[16] This is the function of God's Spirit in this age—with Pentecost as the "beginning." As Ferguson puts it,

> The inaugural outpouring of the Spirit creates ripples throughout the world as the Spirit continues to come in power. Pentecost is the epicenter, but the earthquake gives forth further aftershocks. Those rumbles continue through the ages.[17]

Further, we must agree with theologians who contend that these two aspects of the Spirit are essentially the same. The redemptive work is at once a regenerative work. In his conversation with Nicodemus, Jesus explains the meaning of being born again, "That which is born of the flesh is flesh, and that which is born of the Spirit is spirit" (John 3:6). We know that our spiritual life is dependent on the Holy Spirit for the renewal of a proper relationship with God. The Spirit convicts and leads us to confession, forgiveness, and restoration. In David's petition of Psalm 51, he cries out; "Create in me a clean heart, O God" (a creative act), "and renew a right spirit within me" (regenerative). Later he writes, "Restore to me the

joy of my salvation (redemptive) and uphold me by your free spirit."

In addition to His regenerative and restorative work, we briefly examine the activity of the Spirit in the giving of spiritual gifts. This is an issue of intense dialogue in the Christian community and an arena in which the arts flourish. Nowhere is diversity of human gifts more universally celebrated and significant to a populace than the artistic community. Ferguson comments:

> In pursuing his purposes among his called-out people, God's Spirit also granted gifts of design and its execution to men like Bezalal and Oholiab. The beauty and symmetry of the work accomplished by these men in the construction of the tabernacle not only gave aesthetic pleasure, but a physical pattern in the heart of the camp which served to re-establish concrete expressions of the order and glory of the Creator and his intentions for his creation.[18]

God's Holy Spirit is alive and working in both the creative process and in the community of artists. He is both the giver of gifts, and the impetus for causing them to resonate. On one hand, diversity of gifts is a perfectly acceptable doctrine to a performer—not only acceptable, but embraced! Recognition of the Giver of the gifts, however, is an entirely different matter. In a context where artists are so dependent on their talent, many are unaware of their ultimate dependence on the Spirit of God.

MAN'S CREATIVE SPIRIT

While performing artists for centuries have been eager to applaud the human spirit, in most cases, they have been unaware of or disinterested in the Holy Spirit. The great composers surely brought artistic expression to new heights with their innate creative gifts. They were true visionaries. But, like the Russian cosmonaut who launched into orbit around the earth to exclaim, "I didn't see God," so also is the performer who might give his audience a glimpse of heaven, but has not known God.

J. S. Bach's music spills over with a devotion to the Redeemer whom Bach knew and loved. The story is told of conductor Robert Shaw rehearsing his choir for J. S. Bach's *Mass in B Minor.* In this towering work we find one of the great expressions of the human soul to a personal, relational God. Julius Herford, Shaw's friend and mentor, was present at the rehearsal. At a particularly climactic moment of the piece, Shaw, turned to Herford after the cutoff and asked, "Well, how was that?" Herford's reply: "It was perfect, Bob, just perfect. But you missed the whole point."[19]

Often the artistic community has been missing the point. We have been willing to recognize the creative gift, but not the Creator. We have applauded the epic musical event, but have not recognized the Spirit that infuses life. While the greatest minds have shown genius when called to orchestrate the collective voice of humanity, they have not been able to evoke the presence of God. Art cannot redeem, only God can.

WORSHIP IN COMMUNITY

"If you sing in a choir, the question is not just if you're on your note; it's why you are singing at all."—Jim Cymbala, Pastor, The Brooklyn Tabernacle[20]

Our extended family of twenty has traditionally spent our vacation at the beach, but we avoided July 4 because of concerns for crowds and traffic. One year, though, we found ourselves on vacation at the busiest time of the tourist season. We stayed in the small town where we normally stayed. It had become a second "home" for us noted for its lovely beach—no real boardwalk or large resort—and immediately we realized that there was parade that day. What a commemorative day it was! Almost every house on every street was decorated and visitors were cheerfully welcomed. Some of the tourists even marched in the parade along with the townspeople. The patriotism was contagious. Walking back from the parade we remarked at how we had felt a kinship with people throughout the country who were doing the same thing that day. Later in the evening as we sat on the beach, we could see fireworks from three different cities. It was a vivid acknowledgement that we were part of a truly national celebration.

When Christians enter the church sanctuary on a Sunday morning, we are similarly part of something bigger than ourselves: a global celebration. We don't generally think of the community outside of our own congregation, although we might allow denominational differences or forms of worship to cross our minds. But the global community has set apart the day for gathering and worshipping God corporately, and the sounds of praising God are continuous each Sunday. We are part of this. We are mankind representing every tribe of every nation, every language, all involved in an artistic process for the purpose of glorifying God. We are the earthly counterpart of the vision of Isaiah where cherubim surround the throne continuously saying "Holy, Holy, Holy is the Lord of hosts. Heaven and earth are full of His glory," (6:3). Like the July 4 fireworks, the songs of God's children are lifted on the same day, hour after hour, as an affirmation that we are part of a universal chorus of praise.

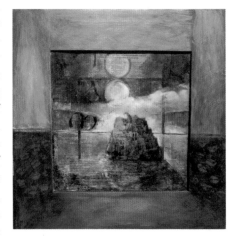

CAROL BOMER. *Babel Purified Lips.* 2004. Mixed media, 30 x 30 inches (includes frame).

But there is another dimension to our acts of worship as the congregation of God's people. The Spirit that unifies all Christians today is the same Spirit that has been at work through the ages. We are part of a spiritual heritage, and our

worship is filled with the artistic works of those who have gone before us. In our "songs, hymns, and spiritual songs" (Col. 3:16) we connect with Christ's life-giving work in our spiritual forefathers. Jesus' redemptive work is as relevant today as when the words of "Amazing Grace" were penned. As we raise our voices together in praise, we actually get a glimpse of the greatness of our God.

Could it be true that our worship is connected in some way with God's people throughout the world, and with the Spirit of the ages? Is the praise of men in some way a microcosm of the angelic praise that eternally surrounds the Almighty? Before we allow our thoughts to carry us away, we need to be reminded of Paul's words in I Corinthians 13: "If I speak with the tongues of men and angels but have not love, I have become a noisy gong or a clanging cymbal." Lofty as we imagine our praise to be, God is not interested in our Herculean efforts. God looks at the heart. Man asks what we are doing, God asks why. If we think for an instant that our praise is acceptable to God in and of itself, we are no better than the Pharisees. God looks down in compassion on the one who beats his chest and cries out "Lord, be merciful to me, a sinner." The Spirit visits those who humbly pray and seek Him, knowing that they deserve His judgment. And to those who gather together, and are united in purpose, He comes in power and revival. Our worship, our art, is a process of preparation, refinement, and then an emptying of self to be used by the Spirit that gives all things life.

So let us return for a moment to the two significant musical events previously examined: the Beethoven concert in Berlin and the dedication of the Temple in Jerusalem. At the performance at the Schauspielhaus in 1989, an international collaboration of artists met at an historic moment to present a living work of art in the name of one of the great themes of humanity: freedom. Israel's dedication of the Temple under Solomon's rule was no less an historic event. Similar in size, with multiple choirs of Levites and 120 priests blowing trumpets, the entire nation of Israel met to express gratitude to the God of Abraham for his mercy and kindness. Both events were recorded for future generations. The Berlin recording by a renowned recording company captured the significance of the event to the German nation and the outpouring of human expression. The music was glorious. By contrast, in the Biblical record of II Chronicles 5–6, the Spirit of God descended on the Temple and stopped the music. God Himself was glorious.

Spirit-filled worship, as with Spirit-filled art, can live in us only when we are willing to submit talent, practice, and purpose to the One who gives these gifts in the first place. Also, we must also be willing to submit each time we pick up our instrument, or inhale to utter speech. The nation of Israel is our model. When we do this—with united hearts and minds, and for the glory of God alone—we can experience His presence and know that the words of our mouths and the meditation of our hearts are acceptable in His sight. "For just as we have many members in one body and all the same members do not have the same function, so we, who are many, are one body in Christ, and individually members one of another."[21]

DEVOTION TO MAKING

Where there is charity and love, God is there.
The love of Christ has gathered us together.
Let us rejoice and be glad in it.
Let us revere and love the living God
And from a sincere heart let us love one another.

Likewise, therefore, when we come together
let us be united as one;
Let us be careful lest we be divided in intention.
Let us cease all quarrels and strife.
And let Christ dwell in the midst of us.
—From a 10th century Plainsong

Having said all this, can we honestly admit that we are aware of such lofty ideals when we are in the midst of the creative process? Are we really in communion with men and angels when we join in worship to our Lord Christ on Sunday morning? Does our facility with movement or use of light show real inspiration and unique perspective? I suppose it is rare indeed that we think of these things during a worship service or performance simply because we are up to our elbows in the creative process. Our thoughts don't deny the existence of a Godly presence, it's just that we are intent on the act of doing. We are so focused on performing that we become like the Mickey Mouse cartoon in which a tornado interrupts an outdoor band concert. The music, audience, instruments, gazebo, fences and trees are all swept away, but the musicians never miss a beat. As the tornado goes on its way and the music comes to an end, the musicians are frazzled but suddenly aware that something else had happened during the course of the concert. In artistic expression, something else is happening. Zoltan Kodaly, the Hungarian composer and pedagogue wrote: "While singing in itself is good, the real reward comes to those who sing, and feel, and think with others. This is what harmony means." Aristotle said:

> Good and effective ensemble is when its members have a commendable
> knack of subordinating themselves to the benefit of the whole.[22]

So before we leave the discussion of the artist/community experience, we must consider the difficulties of community work, compound it with the difficulties of artistic process, and place both in the church environment.

It should not be surprising to us that (in a spiritual sense) when the house lights are dimmed and the spotlights come up on the artists, we are brought face-to-face with sinful man. Christian art is a battleground. Those who are gifted to interpret praise, joy, mourning, and other aspects of human experience, find it difficult to con-

trol their own emotions. The passion necessary to bring a great idea to life is also the stuff of criticism, quarrels, and strong opinions. The church choir can be a place of nurturing or of constant bickering and jealousy. Artists are also intensely competitive, and they often crave attention. They are prone to create for personal gratification or to satisfy an inner need to be applauded. Their work is done at risk: risk of criticism, or of poor performance, or of being misunderstood. It is no wonder that the mix of artistic "temperaments" and the unending issues of leadership are an ideal setting for the work of the deceiver. The task of the artist/leader to bring the diversity of gifts to unity is difficult enough, particularly when these gifts are attached to intense wills and opinions. At the center, it seems, is the question of control.[23]

For the musician, each musical phrase, each dynamic and tone, must be controlled. For the dancer, each movement must be brought under discipline. The representational artist controls color and light, even hammer and chisel. The words on the page, the volume of the instruments, the worship in song and prayer all play a part. And each participant has an idea of how it should be done. Who ultimately decides how or what is accomplished? After a time, it seems useless to attempt to do anything in love or unity of spirit. When we are ready as artists to throw up our hands at the church and take our gifts elsewhere, we are confronted with the disciples and their experience on the day of Pentecost.

ART SINCE PENTECOST

Acts 2:42 tells us that after the Holy Spirit was poured out on the disciples, "They devoted themselves to the apostles' teaching, and to fellowship, to the breaking of the bread and to prayer." Four new disciplines characterized the new "community," the Church. First, the apostles' teaching in God's Word implies accountability and mutual growth. Second, fellowship signifies the rich koinonia or "common life" modeled by Jesus and his disciples. Third, the breaking of bread represents the sacrament of communion. And fourth, prayer was not a shallow recitation of requests, but a deep intercessory prayer life, focussed on adoration and thanksgiving and immersed in the needs and knowledge of others. Even more convincing to us today is that the disciples devoted themselves to this new community way of life. The Bible makes no mention of these men's individual gifts, although they certainly had them. They were learning to sing in unison. In their devotion to each other they fulfilled His purpose for the new church—a community so compelling that it would bear witness to the world that Jesus had come as the Redeemer of mankind. In addition, by devoting themselves to God's purpose, they placed their talents and gifts under subjection to the One from whom all gifts were given.

These are such penetrating words to us today as Christians and particularly as artists. Isn't it obvious in the postmodern age that the arts need to be brought into the church community and that Christ needs to be brought into the artistic community? Charlie Peacock reminds us in his essay that artists that are followers

of Christ should "not consider themselves exempt from fellowship and church stewardship responsibilities. [Instead they should] love the church and do all they can to build it up . . ."

So tomorrow—today—if we check our agendas at the door and devote ourselves to the community of others in love and unity for the glory of God, submitted to His purpose, He promises to send His Spirit to indwell us and give meaning to the work of our hands.

Endnotes

1 Robert Shaw's comment seems to have been his adaptation of a statement made by Leonard P. Barnett in an influential book *The Church Youth Club* in which Barnett wrote, "Religion is at once intensely personal and inescapably social." Leonard P. Barnett (1951): *The Church Youth Club,* (London: Methodist Association of Youth Clubs) 52.

2 2 Corinthians 3:2-3.

3 Psalms 22:3.

4 Martin J. Selman, *Second Chronicles: A Commentary* (Leicester: Inter-Varsity Press, 1994), 320.

5 Ephesians 5:18-20.

6 Mahler's *Komponierhäuschen* was built just outside of Salzburg and was a shed hardly big enough to fit his grand piano. The surrounding lakefront view is absolutely spectacular.

7 In a 1993 study by Ericsson and his colleagues, the practice habits of a population of violin students were categorized into three groups—those who were considered the "best" "good" and "teachers." They found that in all cases, by the time a student reached the age of 20 the number of practice hours ranged between 5,000 and 10,000. K. A. Ericsson, and A. C. Lehmann, "Expert and exceptional performance: Evidence of maximal adaptation to task constraints" *Annual Review of Psychology* 47, (1996): 273–305.

8 Wilhelm Ehmann, *Choral Directing* (Minneapolis: Augsburg, 1968), p 152. Ehmann devotes an entire chapter in his book to "Artistic Unison Singing."

9 John 17:22–23.

10 I Corinthians 7:17.

11 Jeremy Begbie "Prima Donna or Koinonia?" Lecture given to CIVA conference in Dallas TX.

12 Acts 17:28.

13 R.C. Sproul (1990): *The Mystery of the Holy Spirit* (Wheaton, Tyndale House), 88.

14 Sinclair Ferguson (1996): *The Holy Spirit* (Downers Grove, Intervarsity Press), 22.

15 Ferguson, 21.

16 Sproul, 93.

17 Ferguson, 91.

18 Ferguson, 22.

19 Shaw was a firmly established conductor when he met Herford and began to study conducting with the German maestro in 1944. The two became musical compatriots and lifelong companions. This exchange came during a rehearsal of the Bach work for a 1946 performance with Shaw conducting his "Collegiate Chorale" in New York.

20 Jim Cymbala (1997), *Fresh Wind, Fresh Fire:* Grand Rapids, Zondervan p 69.

21 Romans 12:4-5.

22 Eph Ehly, *Hogey's Journey, A Memoir,* (Dayton, Lorenz, 2005), 38.

23 Rory Noland, *The Heart of the Artist* (Grand Rapids, Zondervan, 1998). Nolan presents a thorough discussion of "artistic temperaments" and the issues of bringing them under the Lordship of Christ for service in the church.

THERE AM I
in the midst of them

"For where two or three come together in my name, there am I with them."
 —Matthew 18:20

It's Saturday morning. The sky is a breath-taking cerulean, you have a large cup of fair-trade coffee in your hand and you even treated yourself to one of those yummy pastries they had on display by the cash register. For the next six hours you have nothing to do but to be in your studio, working on your craft. Ah, the bliss! You arrive, open the door, climb the stairs two at a time (without spilling a drop of your coffee), take a bite out of that decadent delicacy in your other hand and set up your easel. The blank canvas is lifted into place, your paint is prepared and in your mind you have now added a new definition to the word "happiness."
 Suddenly, you realize you are not alone.
 Into your sanctuary of artmaking has trespassed a filthy barbarian. And then it all comes rushing back into your head. This writer-dancer-painter-musician-sculptor-who-cares-what-he-is is here to work with you. He thinks he is going to be Franz Snyders to your Pieter Paul Rubens, painting the eagle in your *Prometheus Bound*. But you are sure *he* is the eagle and the next six hours will be a process of having your skin clawed and your liver torn from your side—he's going to run all your best ideas up a pole, shoot them down, and then lecture you about your ego problem. Instantly you realize that Dante was wrong. Purgatory has eight terraces, not seven, and that on the level you presently inhabit, *collaboration* is your perverse torture to endure.
 In general, collaboration does not engender much regard among artists. Many who do collaborate burn out and desert community-based arts organizations.

Community theaters continually experience turnover. Those artists in constant collaborative roles—such as teachers and performers —incessantly complain of a shortage of time to do their own work. Films, with now hundreds of people listed in credits, are still thought of as the work of a single director. Plays may be advertised solely by their headliner stars or prize-winning playwrights. Visual artists are really 'making it' when they begin doing solo shows. Clearly, collaboration does not hold much weight in the larger culture.

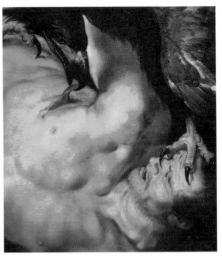

PIETER PAUL RUBENS. *Prometheus Bound* (detail), 1618. Oil on canvas, 95.5 x 82.5 inches.

So why, as Christians and artists, should we participate in collaborative projects and value them as we do our solo work? Solo success is certainly not wrong, or "selling out," but it can cause the artist to depend on himself, lose his focus on God as the true creative power, and separate himself from the community at large for whom he makes his art. Collaboration is often very difficult because it causes artists to depend on one another and on God for the skill to remain humble while working to merge two or more artistic visions. Jesus Christ tells us what is most important in a Christian's life:

> "Love the Lord your God with all your heart and with all your soul and with all your mind." This is the first and greatest commandment. And the second is like it: "Love your neighbor as yourself." All the Law and the Prophets hang on these two commandments." Matthew 22:37–40

All art gives artists the opportunity to love God with all their heart and soul and mind, but collaboration gives artists the unique opportunity to embody the second commandment, to love your neighbor as yourself.[1]

So what does collaboration look like?

IT'S NOT ABOUT YOU

Thanks to the celebrity machine called Hollywood, the creative discipline of acting probably inspires the greatest epidemic of God-sized egos. The stereotypically self-absorbed performer, buttressed by Botox, implants, Grecian Formula and bottle tan may represent the greatest cliché in American culture. Ironically, however, the actor's profession is one of the most collaborative art forms. Nothing a solitary actor does can exist without a playwright, director, producer, costumer,

DEBORAH GILMOUR SMYTH and ROBERT SMYTH.
Private Lives (top) and *The Boys Next Door,*
(bottom), 2003. Lamb's Players Theatre.

lighting designer, stage set designer, stylist, make-up artist, carpenter, publicist—and the rest of the laundry list that always forces the Oscars' telecast into overtime.

San Diego's Lamb's Players is an ensemble theater of extremely talented resident "co-dependents," (in the best sense of the word), dedicated to God, one another, the delectable enterprise of theater, and their audience. Since 1978, cast members gradually grow into roles as playwrights, traveling show producers, and directors in the process, leading Lamb's Players to a coveted status as one of southern California's most popular performing groups, totally supported by season subscriptions. Simply put, this resident company of actors, directors, publicists, promoters, and designers has a mission to tell good stories well. According to longstanding director Robert Smyth, carrying out this mission requires the actors to replace the normal model of selfish solo success with a model that involves humbly bringing the ego into submission as the actor does whatever is necessary to give the best overall performance. Smyth explains:

Many places nowadays actually *teach* young actors that they need to be self-centered—to be concerned with what they look like and where they are going, rather than what is best for the show . . .

But we encourage those in our company to sublimate their egos and become *servant* actors. Ego is a high calorie sweet—it tastes good, but in the long term it is not healthy. We talk about this idea a lot throughout the year at our monthly company meetings. We also use those times to hold the concerns of the company and the staff in prayer. To work as an ensemble and uphold one another and celebrate one another's gifts is a joyful experience. When it is not about you, you can step back and look at what

you have accomplished as a group and appreciate it in a much deeper way. It is actually richer.[2]

Because acting often pushes the actor in the lead role to the forefront, it is easy for actors at any level of experience to forget the real collaborative nature of acting and instead believe their own press and become ensnared by arrogance and pride. They forget that God is the source of their creative gift and that they are commanded to love their neighbor *as they do themselves.* However, when the actor truly understands his place as one small part of a team that includes other actors, production staff, stage crew, management and publicity staff, he is given the chance to show true humility and grow professionally, personally and spiritually.

Honest humility is a difficult virtue to embody. It supposes that we first know ourselves well enough to understand our true strengths and weaknesses. Once we have an accurate picture of our talents, humility calls us to act truthfully, using our strengths to support others while taking care not to feed our own pride or to make others feel smaller. Humble actors also work together without the fear that others will expose their weaknesses because those weaknesses have already been shared. This helps to create a safe environment and increases the trust between actors that can lead to great performances.

Lamb's Players not only supports the individual actor by reminding him of his place in the larger picture, it also allows actors to see many aspects of the theatrical process by asking actors to adopt other non-acting roles that are necessary but often lack the recognition afforded the acting roles. Remaining within our comfort area as those producing art often causes us to forget everyone working behind the scenes. Actors who push themselves (or who are pushed) into positions of responsibility that do not include the actual process of acting (such as publicity, fundraising, etc.) are given a chance to sublimate their ego and artistic vision in order to serve the vision and artistic goals of other actors. These courageous actors who go beyond the art of acting also must learn to seek out help to perform their tasks with excellence even though their training and strengths might lie in other areas. Working outside of their comfort zone, these actors learn to appreciate other aspects of humanity and relationships which in turn can make them better actors.

A BLANKET OF GRACE

Another natural artistic collaboration exists in the art of dance. Dancers work with each other, their choreographer, lighting designer, costumer, publicity staff, etc. in much the same way that actors do. However, the artform is unique in its emphasis on career-long training and constant practice in order to maintain skill. Where acting can appear in actors as a gift that needs gentle guidance and training, dancers, no matter how talented they are, must constantly be in the studio

practicing just to maintain the muscle tone and skill to perform. In a dance production, small differences in skill levels often are distinctly visible, and talented, hard-working dancers are quickly noticed and praised.

When putting on any production, it is beneficial for each dancer to understand his own skill as well as the skills of the dancers around him. This often leads to pride or resentment of less able dancers. However, it does not need to be that way. Dancing gives colleagues the opportunity to learn to love each other enough to help less able dancers grow into a role (rather than trying to take the role), or to cover their weaknesses with kind and gracious words or by working out the choreography to better suit their strengths. Just as dancers learn to cover each others weaknesses, Christian dancers have the amazing image of Jesus Christ covering our sins, our weaknesses with His own blood.

The Great Dance produced in Oxford, England, during a C.S. Lewis Foundation conference titled "Muses Unbound: Transfiguring the Imagination" in 1991, is a picture of how covering grace can lead not only to a positive working environment but also to great success in the face of multiple challenges. Conference organizers commissioned a balletic premiere based on *Perelandra* from C.S. Lewis's Space Trilogy, scheduled to occur during a two-week summer institute at Oxford's Apollo Theatre. In February 1991, only the composer and sponsor existed. By March, a French choreographer with a professional background at the Paris Opera Ballet agreed to participate. Soon eleven dancers of all sizes, shapes and training had joined the enterprise, willing to work hard for no pay at all. Better yet, Greg Mitchell, renowned Broadway dancer and Julliard graduate, agreed to dance in the production. Mitchell, who performed with the likes of Barishnykov, New York's Feld Ballet, Al Pacino (in a memorable tango from *Scarface*) and Bernadette Peters, agreed to assume the part of Malacandra, the evil planet that puts the entire universe out of whack. He reasoned that since he had excelled in playing bad guys, playing the "archetypal bad planet who starts

KAREN MULDER. *Warnie's Typewriter,* 1998. Silver gelatin print, 8 x 10 inches. From *THE KILNS SERIES: At Home with C.S. Lewis in Oxfordshire, England.* Jack Lewis' brother Warnie typed more than 20,000 letters on this machine, since Jack never learned how to type.

the whole evil thing" in Lewis's Space Trilogy suited him.

The composer who started it all, a British musician and writer with advertising connections in Hollywood, met the French choreographer and international dance group, as well as a few stage crew members picked up along the way, with merely eleven days to spare until the premiere. No one but the choreographer knew the steps. Phalanges (A Phalanx) of conference organizers, staff, and participants prayed furiously that *The Great Dance* would actually occur without embarrassing anyone. Just for spice, the choreographer's family in Los Angeles endured an earthquake in the midst of this frantic rehearsal. Everyone sacrificed to participate in an event that held no guarantee of success.

And yet, from its opening measures, as the laser program began flickering and images of the cosmos flashed across the scrim while the sound system boomed magnificently with the composer's score, the audience seemed spellbound. The entire production was nothing short of miraculous. As choreographer Patrick Franz explained in retrospect, each day was soaked in prayer, and that, according to him, provided the saving grace. One person's weaknesses were covered by another's strengths, and everyone's weaknesses were covered by the grace of God. This demonstration of grace would not have occurred if the group had lost courage and canceled the premiere. If they had not been humbled before their situation and invited God to intervene they would not have had the opportunity to share in this uplifting production that ultimately was such a success.[3]

C.S. Lewis once wrote that "Only the Greatest of all can make Himself small enough to enter Hell. For the higher a thing is, the lower it can descend . . ."[4] It is appropriate then that this was a Lewis-based production. The test that will determine the true strength of any group is not how far it will go to be successful, but to what extent the members of that group will trust each other and God in the midst of that work.

The process of arranging this production could have been more easily accomplished had the organizers chosen to focus exclusively on talent. The producers of *The Great Dance* could have decided to finance a group of paid dancers and they probably would have been able to organize that group more quickly. The dancers participating in a paid role might have been more talented and better trained. However, the production was a great success without the safety net of paying a uniformly trained set of dancers. The careful communication and humble assistance of the better trained dancers in the mixed group allowed the other dancers the freedom and safety to trust each other. This greater trust strengthened their ability to move as a unit and improved the final production.

Rather than depend on a paid dancing group, they decided to trust that God is good, and to rely on prayer. Anyone can depend on his own strength in order to succeed. A man of strong character will recognize his own weaknesses, depend on God and work graciously with others despite their limitations. In *The Great*

Dance, everyone involved graciously worked together to cover over each other's weaknesses to produce an excellent performance.

Christ taught that when we learn to "do nothing out of selfish ambition or vain conceit but ... [to] consider others better than ourselves, looking not only to our [own] interests but to theirs as well,"[5] we become greater. God covered us in grace when we had not the strength to lift our eyes to heaven. He considered our sorry state more than His glorious power. Jesus Christ,

> Who being in very nature God, did not consider equality with God some-
> thing to be grasped, but made himself nothing, taking the very nature of a
> servant, being made in human likeness. And being found in appearance
> as a man, he humbled himself and became obedient to death . . .
> Philippians 2:6–8

In such a way we should cover each other and demonstrate true neighbor-love. No artist can experience the physical metaphor of covering grace without working in collaboration. Collaboration, therefore, is not only beneficial to the art-making process, it also provides sacramental metaphors that will work in the life of the artist to bring him closer to God.

CHRIST ACROSS CULTURES

We live in a time when the larger world wants to recognize a variety of cultures and ways of living. Even within the church, there are a variety of cultures, past and present, that differ widely in their worship, theology, local practices and religious ceremonies. So how do we treat differing points of view with integrity and respectful discrimination? Collaboration offers a tool that can make cross-cultural dialogue not only easier, but bountiful. It creates a safe place where differences can meet and commingle, and it is in these meeting places that the Cross itself can often be held up as a unifying force within a multifaceted Christian faith. Such a safe place was created by Canadian folk culture historian and anthropological religionist David Goa.

Goa organized an ethnographic exhibit on the person of Christ to be held at the Provincial Museum of Alberta in Edmonton where he has been a curator since 1972. Goa's wide-ranging studies in the ethnicity of religion has been influenced by encounters with Paul Tillich and Mircea Eliade at the University of Chicago, as well as pilgrimages to isolated monastic communities like Mount Athos. His study has given him a particular overview of the varying ways that Christian communities choose to depict and worship Jesus Christ in their different cultures.

Goa's organizational scheme for the exhibit began percolating around Jaroslav Pelikan's eighteen categories of Christ's activities in the book, *Jesus Through the Centuries.* The categories included Rabbi, Liberator, Savior, Wise Counselor, and Creator of All. Pelikan, a highly respected theologian at Yale

University, approved Goa's idea, and agreed to deliver the keynote address at the 2000 opening.

While it was discouraging that his colleagues at the museum dismissed his goals as a sentimental nod to a reactionary Old World notion and openly scoffed at his idea for a uniquely ethnographic millennial celebration of Christ, Goa was committed to realizing his dream and he campaigned to move the idea forward. He located funding sources that included the notoriously secularist Canadian government, and began assembling a show from 58 different collections in as many countries, ranging from a third-century coin to a 1999 Don Forsythe assemblage featuring a Hubble Space Telescope image. His refusal to be cowed by colleagues who dismissed Christ as a valid subject of curatorial study resulted in the Museum's most popular event in its 25-year history, and an attendance that rivaled other millennial exhibits on Jesus Christ, such as London's *Seeing Salvation,* at Britain's National Gallery.

Working with a core group that included himself, two part-time editors, a film producer, and a museum designer, Goa coordinated two profusely illustrated catalogs, a tri-lingual website, a striking fifteen-minute film which juxtaposed the Beatitudes with current international news items, billboard-sized posters, collateral advertising and package deals for hotels and flights, at least five major architectural exhibit sets with accompanying musical soundscapes, ten listening posts of speeches that accompanied various

KAREN MULDER. *Anno Domini,* 2000.

artworks, an extended program of related lectures, live music, and drama that ran from October 2000 to January 2001, scripts for over one hundred volunteer docents, and, of course, the museum exhibit, *Anno Domini*—all accomplished within eighteen months.

Goa's personal beliefs filled him with hope that the *Anno Domini* experience would, in fact, bring the human community that much closer to the glory of the Lord, and he was ultimately rewarded with a deep sense of satisfaction for persevering and bringing this vision to fruition in a setting that affected thousands of individuals. His collaboration, while not specifically artistic in practice, required Goa to work with artists, collection owners, museum management, and many others to tell a story of art through the ages, giving each culture an opportunity to share its unique view of God with those who might otherwise never directly interact with anything from that specific culture.

Not only were many people able to view the art of different cultures, they became part of the story. The question confronting each viewer as they entered the exhibit, in huge lettering on a curved wall, asked "Who Do You Say That I AM?" Unsolicited letters inspired by the exhibit from some of the 150,000+ visitors answered this question with expressions of profound sensations of edification and connectedness. They also were able to see how powerful and honest each point of view was within its own context. While these letters were not part of the exhibit, they did become part of the collaboration as they continued to show the community of believers and how they experience, worship and display God in their lives.[6]

Transforming Relationships

Cultural differences can be "ethnic" or "religious," but can also stem from any deep differences in how individuals live. Driven by a desire to be painfully honest in a culture that's driven by comfort rather than community, artist Dan Callis patiently traveled a loving path that led to an unusual collaboration. Callis, who has taught art for years at Biola University, initially helped to support his family (while completing a grueling M.F.A. at Claremont) by working as a recreational director for severely disabled individuals. His ability to see the people behind the restraints, institution paraphernalia, and systems that sucked the individuality out of his charges led him to develop deep relationships over a decade, based on trust and appreciation. Learning their stories, Callis's artwork gradually morphed into assemblages made with used crutches, wheelchairs, and straightjackets. His work boldly confronted the viewing public with the sordid plights of institutionalized disabled people, who existed in an unnecessary and unfair prison beyond the one that kept them anchored to their dysfunctional bodies.

Eventually, Callis's assemblages focused on two long-term institution residents, Mary Bane and Terry Colbert, both severely disabled by cerebral palsy but

motivated by a desire to write poetry. Callis found that Mary and Terry were deeply interested in collaborating with him. They met weekly over a year's time, conversing about their experiences in state institutions. Callis responded with drawings, photographs, video, and edited transcripts from previous sessions, inspiring more conversation, more poetry, and ultimately more refined artworks. At the first show, after Terry observed the whole exhibition, he remarked, "My words are up there, that's me up there. When I see that I feel . . . normal." Terry inspired, in fact, the title *"My Words/Your Words"* for the collaborative installation.

Mary had expressed a fierce antagonism for anything religious, but after two years with Mary, Callis felt compelled to explain his faith to her. He initially hesitated, but pressed on and six months later she dedicated her life to Christ. Not long after this, both Terry and Mary's poetry became recognized with invitations to a cultural event in Washington, D.C. Inspired by Mary's transformation—certainly a miracle of grace if ever there was one—Callis envisioned an artwork that required a full body plaster cast of Mary. He was, however, concerned about endangering Mary's life since cerebral palsy causes severe, involuntary contractions. Mary could be mired in, and possibly suffocated by, drying plaster. "As we began our casting session she noticed I was nervous, so I explained, 'I don't know of any other artist in history who has done a casting

DAN CALLIS. *Rumors of Glory: Inheriting the Waters*, 1995. Mixed media. Lifesized.

of a disabled person' and she said, 'Well, great, we'll be famous.' I said, 'Yeah—but I also don't know of any artist in history who killed his model doing a body cast!' She said, 'Yeah, well either way we'll be in the books.'"

Mary was unharmed. Callis successfully got the cast and positioned Mary's slumped figure into a wheelchair, attaching a third wheel to the back of the chair to suggest a large halo. He inserted a television monitor into her chest that played an amplified loop tape of crystal clear running water, which Callis shot at the Idyllwild retreat in the San Gorgonio mountains—a place he often took institutionalized kids on nature walks. The finished assemblage, *Rumors of Glory: Inheriting the Waters*, celebrated Mary's newfound identity as a child of Christ, grounded on the certainty that her broken being will be fully restored and perfected, and even today, provides a vessel for God's cleansing waters. On another level, the assemblage provided a metaphor for today's church-at-large—an entity that simultaneously models extreme brokenness and weakness, as well as the strength and incalculable glory of its future restoration as Christ's bride. Callis savors the juxtaposition:

> Her head is dropped to the side and her eyes are closed. She becomes the worshipper and you are in her presence. She's ministering to you, instead of you feeling you have to minister to her. This gives flesh to the biblical text of weakness as strength, and of brokenness as wholeness.[7]

We are often victims of circumstance, and the same is true when we find ourselves in the midst of collaboration. While Goa had to push forward to organize his exhibit, Callis found himself in relationships of trust and friendship and together they were able to depend on one another for artistic expression and support. The collaboration was first and foremost the friendship; just by loving each other they spurred each other on to greater artistic achievement.

They were also changed by the experience of collaboration. Because good collaboration rests so much on trust, it is important to really understand each other and learn about each person in the collaboration. When Callis shared his faith with Mary, he gave her a more full picture of who he was and in so doing gave a better understanding of his art and his person. She was involved in the collaboration not only as a passive observer, she was changed by God through the collaboration, through the friendship with Callis and the collaboration itself became a means of direct change in her life.

Interestingly, no matter how grand the project is, the same principles apply: patience, perseverance, and love between all collaborators provide the mortar and masonry for the finished work. In the late 1990s, the Archdiocese of Los Angeles began designing the first American Roman Catholic cathedral in over a quarter of a century. Deemed to be the third largest cathedral in the world, at a tremendous cost that exceeded 62 million dollars and a height that surpasses ten

stories, Our Lady of the Angels opened in 2002. Art historian Richard Stephen Vosko, a priest from the Diocese of Albany, New York, served as the liturgical and public art consultant, creating a master plan for all cathedral art, and directing a competition that resulted in major commissions for eleven Californian artists.

This collaboration sought to give the faithful a beautiful cathedral designed to facilitate worship in a way that even a rather pretty church can't. They wanted to listen to their community and build something that they would appreciate not as a distraction, but as a means of worship. One major change that arose because of this commitment to the community is that while Cardinal Mahony and Vosko initially envisioned a monumental crucifix hanging from the wooden vault, Father Vosko's team realized that the largely Hispanic congregation preferred to physically kiss and caress the feet of Jesus on the cross, and commissioned a standing bronze crucifix by Simon Toparovsky. Not long after its installation, the feet of Christ glowed gold with the burnishing effect of hundreds of devout hands and lips.

Vosko later explained, "Cardinal Roger Mahony wanted it to be a 'familiar place'...an opportunity to balance traditions with a new vision," and a model for "all other churches."[8] Given all these superior motives, Vosko expected the artists,

RICHARD S. VOSKO. *The Baptismal Font, Cathedral of Our Lady of the Angels, Los Angeles, CA*, 2002. Carnelian granite font, Rosa Laguna marble border, powder coated brass gates. Octagon approximately 144 inches in diameter. Fabricator: Carnevale & Lohr, Inc. Los Angeles, CA. Photo by Julius Schulman and David Glomb.

"to let go of their egos and their pride … in order for something new to be created for the people who would engage with the worship."

> Thus, the artists were called to be humble servants commissioned to design and craft something wholly other and yet something of themselves. Once each artist understood the nature of the programmatic requirement for the work of art he or she was let go—to create anew and be created anew. I am always amazed to see the kinds of transformations that occur in authentic artists as they make art. Something seems to stir in them that both energizes and enervates them. It is as if something is released from them leaving them totally exhausted. On the other hand the production of a work also leaves an imprint on the artist. Thus, there is an exchange. The artist is different and the material used in the making of the art is different. Then the one who appreciates the work is also drawn into the transformation. Thus the artist, the art and the viewer (or listener) engage in some sort of mystical dance whereby each moves the other in a way that is entirely new and unexpected.[9]

STRUGGLING TOGETHER

It is important to remember that not all collaboration leaves the people surrounding the collaboration with a perfectly happy, content, successful feeling. Successful, collaborative experiences may not be perfectly fluid and free of controversy. In the collaboration to present the exhibit of Christ through the ages, Goa's colleagues, who should have been the first to collaborate on such a multifaceted exhibit, never saw the value of the plan and did not assist Goa in his goals. In some circumstances, collaboration is brought about by one man's dream and leadership, as it was in Goa's case, in spite of other's disapproval. Sometimes struggle and conflict occur when two opposing visions are forced to compromise in order to complete a collaborative effort.

The biblical metaphor of building—one of the most complicated collaborations around—is a rich one. Architectural endeavors inevitably draw the talents of many different people from inside and outside the faith together to actualize a unified vision. During construction of the Tabernacle, Moses implored the Israelites to stop heaping their precious metals and gems on the building site, according to Exodus— doubtless, a situation of untrammeled collaboration that modern church-building campaigns never experience. Ultimately, the architecture, artworks, musical provisions, vestments, lights, landscaping, flooring, engineering, and infrastructural elements all work together, contributing to the worship and glory of God.

Yet building collaboration is about much more than its materials. Calvin College and Yale philosopher and aesthetician Nicholas Wolterstorff tells an engrossing story about his experience as a member of the building committee for Church of the

Servant in Grand Rapids, Michigan. Fortunately or unfortunately, the church was able to commission Gunnar Birkerts, a world-renowned, Pritzker prize-winning architect. At times, in the name of aesthetic perfection, Birkerts willfully counter-manded or adjusted the church's desires for processional routes and a large central-ized column near the altar space that would unmistakably symbolize a tree. While the congregation either disparaged or pressed for 'industrial chic' materials, such as polished concrete flooring and affordable plywood paneling, clashing ideas of tradi-tional versus nouveau church furnishings turned the project into an endless series of debates. As Wolterstorff admitted, however, in the end, the church remained true to its initial vision. Those involved learned how to compromise or stand firm when egos got in the way, and discovered exactly how much patience and perseverance artistic collaboration requires—all of which contributed to the recent construction of an addition. The formative experience truly constituted a labor of love, because while the process became extremely contentious and uncomfortable at times, the commit-tee and architect had to move on to finish the work. Without this layer of spiritual work, the completed church—one of the most original and intelligent ecclesiastic architectural expressions in late twentieth-century architecture—could never have been built.[10] Perhaps collaboration is an opportunity to let iron sharpen iron.

COMMUNICATE/COLLABORATE

Collaboration forces us to communicate. There are no safe hiding places in our studios or our heads; we must speak, write, paint, act, for the collaboration to come into being. But it is not just accurate expression that communication asks of us; it also requests an intense listening, as we receive what our partners speak, write, paint, or act back. A cycle begins, a back-and-forth, where the work of one feeds into the work of another, and boundaries are given up for the creation of a whole. We model the Trinity; we are distinct individuals with distinct ideas about art, but through our work, we speak as one.

Steve Scott, a poet and cultural commentator in Sacramento, and Gaylen Stewart, a painter and house builder in Ohio, met at the Cornerstone Festival in Illinois, where both were leading seminars in the Artrageous tent. When they decided to col-laborate, after a series of lively conversations, they naturally modeled their project on the act of dialogue. Their exchanges became a multi-media traveling exhibit titled "Crossing the Boundaries," which located interconnections between symbols, objects, images, text, and sound, all aimed towards illustrating the conceptual segues between the spiritual and the natural realms. They wanted nothing less than to criss-cross artistic and intellectual boundaries, all the while celebrating diversity in God's creation. Scott and Stewart avidly chronicled the processes and patterns that emerged from the overlap of their interests, concerns, and working methods.

Throughout the collaboration, rapid-fire exchanges of inspiration rocketed between California and Ohio as ideas for poems, random word-groupings and

sketches for imagery flew back and forth through the U. S. mail. Scott transformed his poetic semaphores into chance poems, open verse, and digital textual rearrangements. In response, Stewart manipulated, projected, printed, painted, reworked and layered naturalistic imagery over Scott's word. Then, Scott's poems responded to Stewart's personal photographs and photocopies, which often incorporated transparencies of Scott's typed manuscript pages. Stewart adhered botanical images, diagrams, gum prints, and bird illustrations to painted canvases, printed fabrics, metal

pieces and pieces of photographs. Scott, accompanied by his daughters, recorded bird songs that were eventually slowed, staccatoed, patterned and merged onto a loop tape with original instrumentation, then overlaid with words that Stewart incorporated into his three-dimensional compositions. Scott made the final comment on Stewart's images with a new round of poems, sound loops, and instrumentation, until both artists knew that the exhibit was complete and ready to travel. Even in the most basic gallery spaces, the installation produced a richly mysterious and resonant weave of sound and sensation. Both artists concluded that the combination of all these found objects, including sound and word concepts, connected the artwork to

GAYLEN STEWART. *Bury the Tender Word*, 1998. Acrylic, ink, prints, photos, fabric, metal, xerox, fossil, light, recording. 30 x 24 inches.

the reality of nature—bringing nature 'inside,' to some extent—and simultaneously addressed the value of discarded things in the larger scheme of creation. Metaphorically, they hoped that viewers would make an aesthetic leap of logic to the notion that even though we, as people, may seem or feel discarded, there is always redemption ahead if we choose to see and receive it.

Additionally, both friends received something beyond artistic satisfaction for their efforts. Stewart explains,

I tried to understand the reference point from which Steve was creating his text. Through our communications, I strove to create images that complemented the meaning of the poetry, yet redefined and enlarged it at the same time. It was very satisfying to work with Steve in this way. I think we became closer in our vision and personal relationship with each other. We began to think somewhat more alike (outside of ourselves), which brought

unity to the project and a deeper friendship between us as collaborators.[11]

Scott, who has participated in arts and counseling ministries out of Sacramento's Warehouse Ministries for decades, concluded that

> . . . working with Gaylen on an installation that explored and celebrated nature at work in objects, processes and systems, I learned not only about nature, but also the nature of art, and perhaps deepened my understanding of aspects of the nature of Grace. I don't believe these insights would have occurred outside of this collaboration.[11]

NOT JUST FOR ARTISTS

Whatever we may think about collaboration, or whatever our previous experiences might be, collaboration benefits the community at large. People who have not had the opportunity to experience the joy of making art can share in that joy through collaboration with a professional (and patient) artist. Through collaboration, the artist's audience is not limited to a role of passive participant; sometimes the audience can be involved as non-professional art-makers. Art exists within man as a creative power irrespective of professional discipline. Collaboration allows many people to touch excellent art-making no matter what their skill and training. Catherine Kapikan works with congregations to produce giant needlepoint tapestries. She coined the term "participatory aesthetics"[12] to describe these collaborations: "In these situations, artist and community join together to make and design what neither could achieve by themselves." In her career, she has found only benefits to such processes:

> Communities who engage in and live alongside an art-making process prosper. When a community creates a work designed by an artist, its members all work collaboratively to create a work through which they experience evocation instead of description, insight instead of illustration. Community blossoms. Community, energized and agitated by the complexity of the challenge, engages rather than shrinks. Lurking [behind the challenge of making art] is the knowledge that creative undertakings expand our world.[13]

Collaboration calls us out of ourselves and into community. The artist is no longer a specially gifted loner, making art in a large white room, free of distraction. Instead, art-making is shared by the artist and the community, giving the community the tools to share in the artist's experience and showing the artist that it doesn't take a Fine Arts degree to share in the process of making art.

Many people might think that collaboration limits and binds us to someone else's goals. While at times collaboration is hampered by the limitations and expectations

of the collaborators, sometimes collaboration can itself be a source of freedom and experimentation. In a very unique form of collaboration, families can be a vehicle to achieve free musical experimentation. An example of this kind of collaboration is found in the Music Together® program. Music Together is designed to support the natural musical development of very young children in a family setting through classes of songs and music games. This exposure helps to normalize musical development that has severely slowed in this country.

It may sound strange to describe pre-school children and their families as collaborators. Very small children do not have the ability to make fully *conscious* technical musical choices. They may be very musical, sing in tune, and understand rhythmic and harmonic structure intuitively, but they do not have the language to discuss the technical aspects of musical collaboration as a group of adults would. So rather than being concerned with performance or precision for the sake of an audience, the goal of this program is that children learn to enjoy the gift of music as competent participants throughout their life. Freed from the pressure to manufacture mini Mozarts, these children are then able to collaborate musically with the people in their lives who love them, and experience the joy of making music in community.

The freedom and flexibility of these classes is a good visual for the Christian life. Christ paid the price of our sin and we should no longer live in fear. As those children are unconcerned with musical performance, so should we act with confidence free from the pressure of moral performance or precision in law keeping. Trusting that God will protect us from evil we can take risks to discover how to infuse real good into every situation. Rather than be swept away by a situation, we can exercise our will to enact good in accordance with our understanding of Scripture and sanctifying work of the Spirit. While He walked among us, Jesus acted with radical goodness—confronting corrupt leaders and showing kindness to the weak and the outcasts. He was tempted as we are and he chose to act rightly. Unlike Christ, we will fail from time to time. Sin is inevitable in our lives, but by taking risks and trusting that God will guide our steps and protect us from evil, we can learn more and more how to do good in the most difficult situations.

LOVE YOUR NEIGHBOR

From informal classes of songs and rhythmic movements where young children are free to experiment, we turn now to the discipline of classical music and its demands for collaboration on a grand scale. Before a performance, musicians must be gathered together, given time to learn the music independently and then meet to rehearse. Each group of instruments (violins, flutes, trumpets, etc.) must collaborate to produce a uniform sound and the orchestra as a whole must listen carefully to each other to accurately and emotionally convey the music as written. While the orchestral symphony is easily the most popular genre in classical music, it also happens to be the most expensive, impractical, and difficult to

produce, as conductor and composer Patrick Kavanaugh explains in his listening guides.[14] For years, Kavanaugh maintained a standing date to produce Handel's quintessential Christmas oratorio, Messiah, at the prestigious Kennedy Performing Arts Center in Washington, D.C. To pull this off, he assembled at least eighty believers with excellent musical credentials from fifty different denominations and various national symphony orchestras. In addition, he also gathered a choir, technical staff, and troupe of classical ballet dancers all willing to give up a portion of their Christmas vacation to stage this production.

During the early 1990s, as Executive Director of CPAF (Christian Performing Arts Fellowship), Kavanaugh transported a huge group to Russia, performing at the Bolshoi and other select venues. During a similar Russian exchange called "Sacred Fire" in 1992, the St. Petersburg chamber orchestra was treated to several Messiah segments, with classically trained American musicians and a Met tenor. This presentation provided one part of an ambitious tour that also involved art exhibits with an international panel of artists, including Bruce Herman and Ed Knippers, mimes, theatre acts and dance as well as rock and classical music, all provided by Christian professionals. According to organizer Colin Harbinson, the Russian musicians expressed incredulity at the work's sublime beauty and power; the citizens of the former atheism-touting Soviet Union had never heard Messiah before. When they were told that Handel's masterwork included twenty additional movements, they apparently looked as if they had died and gone to heaven. And as a result, perhaps some will. What is Messiah, after all, but the recitation of Old and New Testament excerpts

EDWARD KNIPPERS. *Jacob's Ladder*, 2006. Oil on panel. 96 x 144 inches.

concerning the ultimate Redeemer? Eventually, with coaching from their new friends, the St. Petersburg Chamber Orchestra learned the entire piece.

It is important to share the love of God with those around us. We are commanded in Matthew 22 to love our neighbor as ourselves. The musicians, artists, actors and everyone involved in this production shared the gift of one of the greatest musical works ever written with a people suddenly free of the censorship of Communism. CPAF went to great lengths to share with the Russian people the great art of the past in a uniquely Christian way. Handel himself was a Christian and *Messiah* is entirely excerpts of the Old and New Testaments and portions of the Book of Common Prayer. Collaboration does not have to be merely a means to open the minds and hearts of artists to produce good art, it can also itself be part of the artistic statement. By collaborating with Christians to produce a distinctly Christian musical work of art, the Gospel is theoretically and literally displayed within the collaboration. The people singing the words of Messiah not only understand their meaning, but know their truth. This is not to say that non-Christians can't fully embody the musical brilliance and weight of the text. However, there is something a little different when trained musicians perform *Messiah* with the skill to execute the technical aspects of the work as well as the confidence in the truth of the text.

Messiah was originally written for a concert in Dublin to support three local charities; it was literally a labor of love. Handel was the good Samaritan (or German) who went out of his way to give all he could to show love and kindness to those who needed it most (the Irish). He continued to give *Messiah* to charities to help them raise money throughout his life. He loved those who were unloved by his adopted country of England and in the process wrote one of the most profoundly loving pieces of music highlighting the birth, death and resurrection of Jesus Christ and the resurrection of the dead to new life and glory. When *Messiah* is performed in a manner that embodies that mission, that collaborative effort, again, is part of the artistic story. CPAF showed love to the Russian people and furthered Handel's mission of loving those who are in need.

In Other Words

Collaboration is not an intruder into the arts. Without collaboration, artists might not have the opportunity to experience some of the most empowering accomplishments in their careers. Whether a community of dancers, visual artists, musicians, actors, or any other group of artists coming together to ply their craft, real artistic growth awaits the courageous artist willing to face the challenges associated with collaboration. It is true that other artists can be difficult to work with; each has his own vision and life experiences that often find voice in his art. When collaborating with another artist we have to learn to compromise, to be humble and to graciously cover each other's weaknesses. We can use collaboration to bridge and appreciate our differences, to strengthen our relationships, and to transform our lives and the

lives of our audience. Some collaborative experiences are difficult, and the reward of the collaboration is sometimes not easily identified. However, when collaboration works it can enrich our lives and share with us tangible pictures of the mystery of the Trinity and what it truly means to love your neighbor. The art world is so often the realm of "artsy" people. Without collaboration, it is easy to leave behind those who did not chose art as a profession, but with collaboration we, as artists, have the opportunity to learn from those outside the professional art-making world and to look at our art with new eyes. Beyond the good collaboration can do for the artist, it is simply part of art-making and can itself communicate more effectively than art produced without the benefit of collaboration. It is by no means easy to cooperate as a flawed individual with other flawed individuals, but great art is always pushing forward down difficult paths, and to be great artists, we must try to do the same.[15]

Endnotes

1 Commenting on the Second Great Commandment, an Under Secretary from the Lowerarchy of Hell once wrote:

> "[God] wants to bring the man to a state of mind in which he could design the best cathedral in the world, and know it to be the best, and rejoice in the fact, without being any more (or less) or otherwise glad at having done it than he would be if it had been done by another.... He wants to kill their animal self-love as soon as possible; but it is His long-term policy, I fear, to restore to them a new kind of self-love—a charity and gratitude for all selves, including their own; when they have really learned to love their neighbours as themselves, they will be allowed to love themselves as their neighbours."

 —C.S. Lewis, *The Screwtape Letters* (Old Tappan, N.J.: Lord and King Associates, Inc., 1976) 74–75.

2 Robert Smyth, phone interview, July 2006.

3 Based on excerpts and interviews used in *The Chronicles of the C.S. Lewis Foundation* (Redlands, Calif., Fall 1991): 1, 2, 7.

4 C.S. Lewis, *The Great Divorce* (New York: Macmillan, 1946) 123.

5 Philippians 2:3–4.

6 Information on *Anno Domini* came from Karen L. Mulder, "Specifying Sacred Space: The Anno Domini Experience," in *Religious Studies and Theology* (vol. 21:1, 2002) 27–49.

7 This section on the work of Daniel Callis was excerpted from "Spitting with Intent: An Exploration of the Restorative Artist," *Inklings* (vol. 1:4, Winter 1995) 4, 24.

8 Richard S. Vosko, "Foreword," *John Nava: Tapestries from Proposal for Installation from Art in the Cathedral*, exhibit catalog (Pasadena: Judson Studios, 2002) 2.

9 Comments come from email exchange between Richard Vosko and Ned Bustard (June 2006).

10 Nicholas Wolterstorff shared this experience at a Christians in the Visual Arts conference held at the Pacific School of Religion in Berkeley, California (1995).

11 Comments come from email exchanges between Steve Scott, Gaylen Stewart and Ned Bustard (June 2006).

12 Catherine Kapikian, "Participatory Aesthetics," *Seen: The Journal of CIVA* (vol. 4:2, 2006) 11.

13 Kapikian 13.

14 Patrick Kavanaugh, *The Spiritual Lives of Great Composers* (Nashville: Sparrow Books, 1992); *A Taste for the Classics* (Grand Rapids: Zondervan, 1993); and several listening guides widely available on the internet.

15 This chapter itself is an example of collaboration. The effort involved at least seven individuals, including Ned Bustard, Karen Mulder, and Kristine Harmon.

THAT FINAL
Dance

Joel Sheesley, a painter, begins his lecture called *Content: the Substance of Things Hoped For* by stating his conviction that

> the important questions about content in art do not revolve around issues of abstraction or recognizable subject matter, but rather around the possibility that human beings can sustain belief in their own existence as responsible individuals.[1]

His comments become my starting point because any discussion of content must rely on an existential presupposition of God. Sheesley is correct in connecting belief with content. Existence of content requires faith. We are not Platonic shadows, but in us, *imago dei,* remains a trace of the solid 'Substance.' Without the Source of content, or the Content of all contents, there is no point in talking about content at all.

With modernity, with the advent of photography, the central theme for artists became not "How do I depict a flower?" but "What is a flower?" Then postmodernity asked "Is there a flower at all?" Postmodernity, highlighted with Duchamp's "ready made" urinals, challenges us in its question, "Is there content?" The knowledge of existence requires faith in existence. Postmodernity is skeptical of such faith. It is agnostic by nature (as opposed to the modernist's often atheistic stance), and thus it is also agnostic in its stance towards our own existence. Thus, as Professor Sheesley correctly points out, discussion of content is a discussion of "our own existence as responsible individuals."[2]

JOEL SHEESLEY. *Night Climbing*, 2005. Oil on canvas. 44 x 101 inches (triptych).

A discussion of form/content in a fragmented postmodern reality requires we take off the agnosticism 'hat' and consider "the substance of things hoped for." In Christ, God became flesh, and his historical presence points to a world where hope is assured to be substance. With this gospel of incarnation, then, and only then, it is possible to speak of fusing spirit and body, content and form. Christ's incarnation resolves the most difficult dichotomy that exists for an artist; that is the dichotomy of form and content.

THE MERCY SEAT

The Japanese poet Kinotsurayuki wrote in the tenth century of this dichotomy in his poem, "Ka-jitus-so-ken" which can be literally translated "flower-form-mir-roring-jointing." He meant by this that we must strive to fuse form and content together so well that the form (words) becomes the content (flower). Ben Shahn brought this concept home to the twentieth century when he stated, "I think that it can be said with certainty that the form which does emerge cannot be greater than the content which went into it. For form is only the manifestation, the shape of content."[3] Francis Schaeffer echoed this aesthetic perspective when he said, "For those art works which are truly great, there is a correlation between the style and the content."[4]

Christ's uniqueness lies in not just the content (divinity) but also in the form (humanity). He was the form of all forms, the content of all contents. This unique-ness gives an artist fundamental motivation and reason to pursue the daunting task of bringing form and content together. The first commandment tells the artist there is only one source, one content from which all other contents derive. And the "manifestation, the shape of content" is Christ Himself. All art owes the unique figure of Christ a tribute; without Him, we simply do not have any model to fully meet the challenge posed by aestheticians of the ages past.

Form and content may be hard to separate in some cases where form may be

MAKOTO FUJIMURA. *Mercy Seat,* 1999. Mineral pigment and gold leaf on paper. 102 x 80 inches.

the content and content may be the form itself. Christ's presence even frees us from the artificial separation between form and content. My approach to form/content dichotomy flows out of His being. This approach is particularly highlighted in the series of my works called *The Mercy Seat.*

The Mercy Seat series uses the exact dimension of the Mercy Seat of the Ark of the Covenant as described in Exodus. "Have them make a chest of acacia wood—two and a half cubits long, a cubit and a half wide, and a cubit and a half high" (Exodus 25:10). In today's measurements, it is about 3 3/4 feet long and 2 1/4 feet wide and high. I used this dimension not to replicate the Ark of the Covenant, but as a departure point for a visual dialogue. I have repeatedly made works of these dimensions in the past. From December 24, 1999 through February 13, 2000 I had some of my work on display in the St. Boniface Chapel at The Cathedral at St. John the Divine.

When I first made the wooden panels, I realized that the proportions produced a very dynamic visual movement on their own; the dimensions of the piece alone proved to be inspirational. Its size also communicates a physical presence: it does not dominate nor recede, it is neither 'big' nor 'small,' it is both imposing and intimate. In mere dimensions and proportions, the mercy seats anticipate the person of Christ—Christ was both imposing (God) and intimate (Man) at the same time.

In fact, the material used to create the ark itself was symbolic. Kevin J. Conner writes, "The ark was made of acacia wood overlaid with gold within and without. Wood speaks of His incorruptible humanity, and gold His Divinity. Two materials, yet one ark; two natures yet one person, the God-Man."[5] The materials symbolically point to Christ. I use gold (divinity) on paper (humanity) to allude to Christ in all of my works.

A question may be raised here: "Are you trying to depict God (content) through your works (form)?" And the answer is "No." I cannot depict God and I do not need to. Christ is the ultimate and only true fusing of content and form. But because of Christ, we are free to create works on the foundation of Christ. We are free to be his creatures, living under the sovereign rule and power of the Creator. We are free to see natural forms and human experiences as an extension of

Christ's rule and reality. When we create, we can create without trying to fuse content and form but to base our works on the notion that the fusing has already occurred—that this ultimate fusion can power our art.

THE ESSENCE OF ABSTRACTION

Such a Christocentric perspective on the arts can also release our creativity from being enslaved to a particular form, or style of art. For example, while I was in Japan to study *Nihonga* (Japanese style painting), I remember telling a friend of mine, who also used Nihonga materials and techniques, about Jesus' statement regarding the Sabbath. He said (in Mark 2:27), "The Sabbath was made for man, not man for the Sabbath," warning against the Pharisaic, legalistic view of the day of rest. I told him that "Nihonga (or any type of art-form) was made for the artist, not the artist for Nihonga." In Japan, where traditional forms, *'kata,'* are seen as sacred, my comments must have sounded disrespectful. But a Christocentric perspective honors our humanity in Christ; and any form must follow the content of our expression, not the other way around.

This perspective leads me to my particular art-form, and that is abstraction. Yet what does abstraction really mean? The word *abstract* is defined in the *Merriam-Webster Dictionary* as "having only intrinsic form with little or no pictorial representation [painting]" when it is used as an adjective and as "summary, epitome," when it is used as a noun. I see the word "abstract" more as the noun definition than the adjective definition: not strictly in the sense of giving an abstract, but in the sense of giving a summary and describing the epitome of experience, both internal and external. But in the end, I find defining Abstraction too problematic so I have come to replace the word with *essentiation*. Through my painting I seek after the *essence* of reality, experience and objects. I want my work to be a stripping off the unnecessary while it accentuates the physicality of Creation's textures, colors and materials. I suspect that it is this essentiation that Japanese poets and painters of the past viewed as so central to their depiction of nature and life.

I am interested in essentiation as a mode of experiencing reality, and not necessarily as a philosophical term: as a student, I was told by an art professor that the way I approached drawing an object was different from others. I had more of an eastern approach, of capturing the inner essence of an object, rather than drawing the outline of its form. My interest in abstraction grew out of my interest in Japanese medieval works, and also in the twentieth century American abstract expressionists' works.

Tohaku Hasegawa, who has been called the Michelangelo of Japan, painted the "Shorinzu" byobu (a folding screen piece) in the sixteenth century, a work which many consider to be one of the greatest paintings of Japanese history. The painting, done in sumi ink on thin rice paper stretched over a byobu screen,

depicts pine forests, but in essence he evokes the fog and the breeze which move the trees in simple, calligraphic lines. If there ever was a painting which captured the "sound of silence," this would be it. Hasegawa forged new ground, moving beyond his formal education in Chinese paintings with its harsh representationality, and he moved into the arena of ambiguity and transcendence. (If you don't think that Chinese paintings are highly representational, you haven't seen

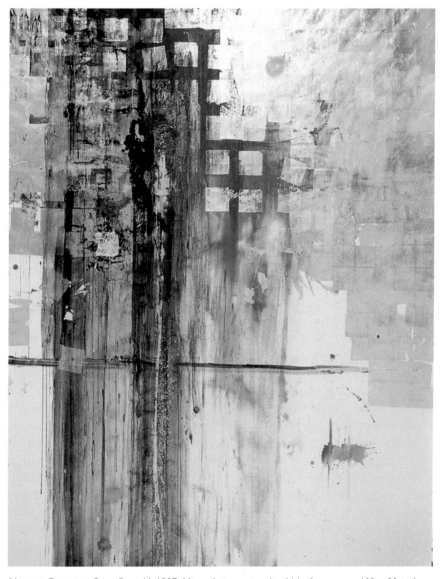

MAKOTO FUJIMURA. *Grace Foretold,* 1997. Mineral pigment and gold leaf on paper. 102 x 80 inches.

Chinese landscapes. Believe me, they are more representational than Giotto.) Less was indeed more. He did not merely want to capture a pine forest, he wanted to get to the essentiation, the core of being and seeing.

I remember going to the Arshile Gorky retrospective in the early eighties at the Guggenheim, and having the paintings speak to me in ways the Shorinzu byobu speaks to me today. In fact, I believe that experience convinced me that I should seek to pursue art. Gorky's works probed the depth of essentiation. Gorky's later works spoke in a language I could not comprehend but yet yearned for. His exquisite lines opened space and closed them at the same time. His colors, both delectable with their focused intensity like that of the stamen of a lily, remained in my memory and affect my vision today. And this is not to speak of the influence of Rothko and Diebenkorn. The language of abstraction both eastern and western came to me early, and stayed with me.

Many, seeing my paintings today, would call my works abstract, or semi-abstract. Labels not withstanding, I am still conscious of Gorky and Hasegawa. Even with my new angle, I see their attempt to reach transcendence as noble and bold. In the works of many abstract expressionists I see not only abstract paintings but a yearning and groping for the heavenly language. They were convinced that earth and history did not contain the language to capture the fear and power of the age.

They were right. I see abstraction as a potential language to speak to today's world about the hope of things to come. And for the follower of Christ who is making art to the glory of God, isn't this potential exciting? I believe that in many ways, spiritual qualities and ideas can be more readily accessible in abstraction than they would be in representational art, where renderings of familiar things often carry with them conceptual baggage. This baggage can mislead or even prohibit the viewer from moving further up and further in to the spiritual to which the artwork points.

My works exegete both classical Japanese works and contemporary American paintings. I interpret them in a way that I hope will increase the viewer's passion for seeing the physical reality and heavenly reality. To me the weakness of abstraction does not lie in its denial of the spiritual: the weakness of abstraction lies in its Platonic, Gnostic denial of the physical. I want to affirm and celebrate the physical. As the writer Paul Mariani stated, we need to affirm "the splendid grittiness of the physical as well as the splendor and consolation of the spiritual. In a word, a sacramental language."[6] This sacramental language must address reality and confront what we see, but must transcend it to grasp what we can't see yet. Therefore I use precious minerals, gold, and silver on delicate handmade Japanese paper to affirm and celebrate the physical with the "sacramental language."

NEW HEAVENS AND THE NEW EARTH

I believe that true, Christ-filled expression results in more diversity than what Christ-suppressing expression would allow. The more we center ourselves in Christ, the freer we are to explore new arenas of expression. When Christ gave his disciples the commission to "therefore go and make disciples of all nations," he was literally empowering them with his authority. Here, the Author entitles authorship to his creatures, to be authors (with a small "a") of spreading God's Kingdom. This sovereign authority encompasses all the earth, and therefore, with Abraham Kuyper we are able to say, "There is not a single inch of the whole terrain of our human existence over which Christ ... does not exclaim, 'Mine!'"[7] The centrifugal, outward movement of the gospel hence moves beyond culture and geography. Therefore, in this sense, the gospel is always cross-cultural. The resulting diversity mimics and transcends the extravagant diversity of creation, breaking-in of the New Kingdom. This diversity is also a glimpse of the world to come.

Christ-suppressing expression, on the other hand, leads to disintegration of expression and identity. "Truth," as Calvin Seerveld noted, "is the way God does things." And the unbelieving world will always wrestle against the whole fabric of creation by suppression, however unconscious, of God. "The wrath of God," Romans 1:18 states, "is being revealed from heaven against all the godlessness and wickedness of men who suppress the truth by their wickedness." Paul notes that the result produces idols as we exchange "the glory of the immortal God for images made to look like mortal man and birds and animals and reptiles" (vs. 23). Forms, here, counterfeit Content as the "Real Thing." Christ-suppressing expression pretends to be truthful but reduces God to a concept. Such expression may even be "Christian," but often with a false notion of beauty and order that is more Platonic than biblical.

Art reaches to both heaven and earth, fusing them together. If we attempt to do this in our wisdom, the result will be a greater schism between heaven and earth. Christ is the ultimate example of this fusing—the incarnation of Christ, the divine becoming man—and is therefore the greatest example in which all artists can find inspiration. Christ's unique significance for the artist goes even deeper than mere inspiration. I believe that He is the only true source of inspiration available to us to learn from.

WORK AND PRAY

In order for this fusing to occur, our thoughts and creativity must be driven by prayer. "To look is to pray," Sister Wendy quotes St. Benedict—substituting "look" for "work." For a redeemed mind and heart, our new nature prompts the believer to direct praise and intercession to God always. We seek "God's Kingdom and His righteousness," and thereby ask God to limit evil, and help us to bring the news of His Kingdom advancing into our broken world. And it is to seek the fulfillment of

the Great Commission, "to make disciples of all nations" (Matthew 28:19). Prayer is to our lives as glue is to pigments. Prayer, in the Spirit, mediates (and is a true "medium"), and God uses prayer as a powerful binding agent in the world.

Prayer is central to the making of art. When I work on large paintings of gold surface, the rhythm of laying on gold leaves (about three inches square) prompts me to pray. I usually go through the Lord's prayer, letting each section of the prayer direct my thoughts. I often wonder if the artisans Bezelel, Oholiab and others in the Exodus passages prayed as they put gold on the tabernacle. The prayer for the Kingdom to advance, and for God's will to be done, naturally go together with laying of gold, which for most cultural settings symbolizes divinity.

Prayer requires us to move in the world and her cities. Cities are the greatest expressive forms of our culture. Paul intentionally sought after influential cities first to spread the good news of Christ's death and resurrection. The Bible begins at the garden and ends in a city. And by moving into cities (metaphorically and literally) we have to face the reality of evil and depravity as well as glory and splendor. Often times, being "in" the world and not "of," requires a peculiar grace of what I call "praying with our 'Eyes Wide Shut'." (I chose not the see the movie so-named, but the title captures the idea.) That is, I must face evil and depravity, but to look beneath and beyond the surface, to wrestle with the underlying tension of culture at large. We need to approach culture with the intensity of what Simone Weil called "orientation of all the attention."[8] According to Weil, prayer is paying attention to God and God's world. Such holy attention, given her gaze to the world, unravels the true horrors of the darkness, and yet does so with a redemptive vigor.

In our prayer life, content (The Holy Spirit) must drive how we view form (a lifestyle of prayer), and not the other way around. We must examine carefully, as Paul has done in Athens, cultural "voices" of the city and her poets from the content of gospel freedom. We cannot be afraid to send our children into such cities, because we would be the first to suffer from (and we are the first to complain about) such neglect of our cultural mission field. We need to ask God to create genuine biblical communities within the cities of the world; because such a City of God will far outshine any earthly ones. There is something wrong if people find more connectedness and grace in the gay communities than in Christian communities, and yet this is an example of what we find today. The world's cities have become the greatest mission opportunities available. It is time we send talented young people to prosper and express their creativity, to move, with Jeremiah, into our cities and "settle down and build houses," to seek the peace and prosperity of the city into which "I have carried you into exile." Christ's Bride, His Church, is meant to be the ultimate fusing of form and content, representing a new paradigm that Christ instituted when he "breathed on" his disciples after the resurrection.

Conversely, this unique perspective creates an opportunity for us to depict

and exegete evil in the light of grace and the light of Christ. Evil needs to be portrayed in a way that is true about evil. It takes artistic vision and grace-oriented imagination to depict hell. Eric Fischl stated

> Artists connected to the church were asked to imagine four things: what heaven was like, what hell was like, and what the garden was like before and after the Fall. Those are four profound archetypes and they're part of many cultures. What has happened over the centuries is that artists in the West have become specialized. You still can find heaven painters, hell painters, and Garden painters, but you rarely find them in the same person.[9]

Who can better depict a hell, heaven, or garden vision than Christians who are cognizant of Christ's grace? It is time that Christians took seriously this calling that the world beckons for, to provide new archetypes that communicate clearly and convincingly the reality of hell, heaven, and that garden.

Instead of an honest and truthful visual presentation of heaven, hell and the garden, the suppression of the truth continues. Rather than giving specific examples here, I would venture to say that all form of expression is tainted with suppression of God. As Christians, we need to constantly seek the "joy of repentance," but when the issue relates to the unbelieving world, Christians must realize, with Cornelius Van Til, that such suppression of truth is the "point of contact."[10] Therefore, when we see Duchamp's urinal, we need to speak to the Duchamps of the world to say, "we are all 'ready made' in the eyes of Modernity; but is your experience as a human being consistent with reality?" And when we encounter Serrano's *Piss Christ,* we need to say, as a friend of mine had the opportunity to say, "Andres, did you know that that is exactly what we have done to our Lord? We have put him in the refuse of our lives!" Forms of suppression can become an important bridge to lead people to the Content of Christ.

-ING AND THE SPIRIT

"God in His wisdom," Nigel Goodwin states, "did not give all His gifts to Christians." And I often find myself learning from non-believers about the realities of our condition and the ache for Heaven. I often see in "secular" artists redemptive seeds and valuable insights. At those moments, I see that prayer given by God is also used by God to fuse Heaven and Earth together. As I believe Christ is the only source of true inspiration to learn from, and the only true content, I will accentuate this principle for the Great Commission. It is true that "art needs no justification," as Hans Rookmaaker once pointed out, and we do not need to be superficially driven to paint "Christian" images. In fact, a sentimental, superficial depiction of Christ will only impede the true message of the gospel to be communicated. The best way possible to advance the Kingdom is to attain a state of

T.S. Eliot's "unconscious" Christianity. But part of this unconsciousness assumes our passion for Christ. We cannot separate art from the context of such a missiological vision, any more than you can separate breathing from a living being, or an engine from an automobile.

MAKOTO FUJIMURA. *Countenance Gold*, 2005. Japanese vermillion, gold on Kumohada paper.
In situ digital file, Ryann Cooley photograph of Fujimura painting in process.

Samuel Escobar stated, "the Incarnation is the greatest translation ever, and poetry is a little incarnation."[11] Just as Christ entered our world, translating heavenly existence to the earthly, the arts enter one human heart from another, sharing the experiential reality. Christ's incarnation is the greatest example, the greatest of translations. All art forms attempt to translate what is unseen into what is seen. Art, especially as we engage with a redeemed vision, becomes an activity of faith, translating the "substance of things hoped for" with words, paint and other materials into both the content and form of art. Content meets form in translation, and the art process mirrors this.

If we are to see the Incarnation as the greatest of translations, then we also need to see that the person best suited for the task of translation is God himself. In other words, the reality of Christ precedes and supersedes the act of incarnation. There remains what an artist friend of mine has expressed as the "ing" factor for both content and form. Content, in some way, is always *content-ing*, and form always *form-ing*. Christ remains at the center of all creative activities, and He is the "ing." He causes each little translation to take place, and in order for art to become a "little incarnation," we also must allow Christ to be at the center of our activities.

The bridge between form and content, the essential power that allows form to be *form-ing* and content to become *content-ing*, is the Holy Spirit's work in our lives. He is the Medium. The word Medium has been twisted to mean media of mass communication, but originally, in medieval times, it meant the Holy Ghost. Without the intervention of the Spirit, neither the form nor the content can connect, or be integrated. In any form of communication, we need the medium: in the essentiating work that follows the incarnational translation of Christ, the Medium constantly intervenes, facilitating all of us, including those in the public sphere, to relate to one another. The Spirit negotiates, in other words, to peacemake within a conflicted, divided world, and the arts can be "possessed" by the Holy Spirit to do this irreplaceable work. Art can be a leading force in reconciliation, in other words to lead us to God, the Church and ourselves.

As Ted Prescott notes, we exist in the "co-inherence" state of having two identities: one of Christ having entered our hearts through faith, and the other of our independent identities as individuals. We do not cease to be ourselves when we enter into a relationship with God; rather, we find our true selves by Christ's redeeming blood and the Holy Spirit changing us within. We become more and more like Christ (2 Corinthians 3:18), but, conversely, we become more and more like ourselves made by and for our Creator. Our *content-ing* and *form-ing* both may have much to do with the source of our identity—Christ, and our identities being transformed. As Ted articulates, our identities must be lived out in order to have any meaning. Mysteriously, both the form and content must interdependently grow into fullness. Both, though, are utterly dependent upon the work and

the person of Christ, who said "apart from me you can do nothing" (John 15:5). In an artist's life, the Spirit administers the diligent work of reconciling, or fulfilling, the potential of our dual identities. And this on-going work is a greater reconciliation in process: God's reconciliation for the restoration of Heaven and Earth. The guidance of the Holy Spirit is a "deposit" in us of essential power for this life-long journey of reconciliation.

I have written elsewhere[12] that my approach to art resembles the paradigm set by a woman in the gospel who broke her jar of nard upon Christ's feet. Christians must take on this disintegration of today's culture with a bolder vision flowing directly from the very aroma of Christ—an aroma that spreads, like the nard, from Christ's feet to the world. In other words, fusing content and form is one thing, seeing form and content dance together is another. Christ provides for that final dance, and the Holy Spirit is the music, and our joy is to be reflected in our works. To the degree that we, artists cognizant of God's grace, can express this dance, to that degree the language of art will find freedom and renewal. This fruit feeds not only Christians but also culture at large.

Togyu Okamura, a great Nihonga painter, once commented, "What matters is not how finished the work looks, but how unfinished it remains." Such understanding gives the "completed" form space to breathe and live. Ultimately, a type of faith is required to release forms to be driven by content. This faith, a shadow of the faith God gives, allows the artist to trust another to complete the vision. This transaction is not unlike the Christian's journey to lose his or her life in Christ: "For whoever wants to save his life will lose it, but whoever loses his life for me and for the gospel will save it." The *form* of a Christian is Christ himself; the only way to attain this *form* is by dying to His calling. Christ gives all artists a vision of the transistion from death to life, by the Spirit that turns our "wailing into dancing" (Psalm 30).

Endnotes

1 Joel Sheesley, *Content: the Substance of Things Hoped For*. A lecture given at an IAM conference in New York City, March 13, 1999.
2 ibid.
3 Ben Shahn.
4 Francis Schaeffer.
5 Kevin J. Conner.
6 Paul Mariani.
7 Abraham Kuyper.
8 Simone Weil, *Waiting for God*, (New York: Harper Perennial Classics, 2001), 105.
9 Eric Fischl, in an *Art in America* interview.
10 Cornelius Van Til.
11 Samuel Escobar.
12 *Image: A Journal of Arts and Religion* #22.

WHO DO YOU
say I am?

One of the truisms of our culture is that art somehow reveals the artist. The roots of this belief go back to the Renaissance. At that time artists began to promote and be celebrated for the idea that "art" came from the soul, imagination, and poetic invention of creative geniuses. These rare individuals, whose art is distinct from the mere skilled work of craftsmen, are to be cherished for their unique gifts. The idea that art is an expression of the sensitive genius got a tremendous boost from the Romantic movement of the nineteenth-century. The Romantic artist was typecast as an outsider who suffers estrangement and privation for the sake of personal expression.

I encounter these beliefs about art and artists in discussions with my students. When we are talking about what visual art does, I often hear ideas like, "you can see the feelings of the artist," "art is an expression of the artist," or "art allows people to be themselves." There is much that could be explored in these ideas, both in terms of what they say about art, and how we think about human uniqueness and individuality in our society. But my purpose is different. Ideas about the inherent relationship between the character of the artist and the content and quality of his or her work suggest that the *identity* of the artist is a critical component in the way we think about the arts. And the concept of identity is no less important for Christians as they think about their life before God. Indeed, identity is simply central to being and doing. Our concept of our identity answers questions about who we are, and what characterizes our life and work.

In my experience there is usually a substantial gap between the way our culture thinks about the identity of the artist, and the way the Church thinks about

a Christian's identity. Thus artists who are Christians find they have membership in two subcultures, and participate in two institutions that have markedly different views of how to order one's life and determine what counts for the good, the true, and the beautiful.

I believe that the actual gap between the two subcultures is narrowing, with changes taking place in both. Today there are many more Christians active in the visual arts than twenty years ago, and it is no longer unusual to find churches that have started to use the arts for worship, outreach, or simple enjoyment. In the art world, postmodernism's critique of the monolithic and totalizing claims of modernity has sometimes had the effect of allowing religiously grounded belief a place at the table. And for about a decade the art world has had an interest in spirituality, which obviously has resonance with Christian belief and practice.

It is encouraging to see a narrowing of the gap. Nevertheless, the division is still substantial; particularly as each subculture defines and celebrates the characteristics of its important members. So I find that some artists of faith experience degrees of dissonance as they live and act in both worlds. At its extreme, the dissonance causes people to feel as though they can't be artists and Christians, and thus they opt for one group or the other. More often artists who are Christians tend to accommodate the ethos of the subculture they are in, or colonize one in the name of the other.

The colonizing impulse can be seen in some aspects of the "Christian Arts" movement. Colonizing occurs when the norms and standards of one area of life are used to shape and determine another area, without respect for the inherent character of that area. Thus "Christian Arts" movements can be narrowly prescriptive about content, moral tone, and audience impact when art is made by Christians. It applies standards developed by the Church for the place of art in churches, even though the arts have a distinct presence in culture outside of the Church. Christian colonizing dresses up the arts in acceptable Sunday clothing, and is akin to the early settlers "Christianizing" Native Americans by having them dress as Europeans. It ignores the legitimacy and

CATHERINE PRESCOTT. *The Artist as a Young Man: Portrait of Peter*, 2002. Oil on canvas. 28 x 22 inches.

integrity of art that does not have a Christian message, or is deemed uplifting in its effect.

What follows, then, is an attempt to shed light on complex questions about identity, as we live out our lives in two spheres—art and faith. I begin with a brief discussion of what constitutes identity, then move to a consideration of how both the arts community and the Christian community think about identity in light of their beliefs, and finish by offering some reflections on a scriptural understanding of identity. My goal is to help artists who are Christians find a way to fully utilize their gifts and be fully Christian, which is both our calling and our "reasonable service."

THE CONCEPT OF IDENTITY

Discussions about identity have figured prominently in American culture, particularly in the political realm, where questions of origin, ability, and orientation are being debated and legally proscribed. Thus, one way to think about identity is in terms of the socially and legally defined groups we belong to, such as Hispanic, single, dyslexic, and the like. Categories relating to identity can be enumerated endlessly, and in one sense the more categorically complete a description we have, the more we should know someone's identity. But this is misleading, because categories defined by one's inclusion in a group are always about *group* characteristics. Even fairly specific groups, such as "Greek Orthodox Christians with M.F.A.s who specialize in large-scale sculpture" are limited tools for understanding an individual.

Here it is useful to point out how general the terms "Christian" and "artist" are. They definitely mean something, but the shared beliefs and experiences may be less than the differences between an Anglo-Catholic artist who paints like Giotto and a Pentecostal commercial photographer. So it's important to acknowledge the limitations of identity as defined by membership in groups.

Another way to think about identity is in terms of the personal characteristics of an individual. These may include physical characteristics like left-handedness, personal experiences like serving in the Peace Corps, gifts such as the ability to conceive space three-dimensionally, and dispositions such as an optimistic outlook or a tendency towards anger. It is the interaction between our personal characteristics and our membership in socially defined groups that begin to create the depth and complexity of our identity.

But it's important to point out that neither our identities as members of a larger group nor our personal characteristics—which may roughly correspond to the way we are seen by others and the way we know ourselves—is the full picture. Our identity is grounded in and conditioned by the fact that we are created by God, bear His image, and are known by Him. That is to say, our identity is circumscribed by our creatureliness, and charged by the capacity we have to know and interact with God.

Nothing I've said about group identities or personal characteristics is controversial. But the fact that we are made by God is of a different nature. It is beyond the realm of incontrovertible proof, and certainly not a place of easy consensus in our culture. Even people who entertain the idea may find the reality of God an abstraction, with little bearing on the subject of one's identity. Yet I would argue that this fact is of enormous practical importance. For Christians live in relationship to God, and have a rich and deep point of reference regarding their own identity. Knowing that we are made by God and known by God can give us courage to resist the tyranny of groups, and to act as corrective lenses for the myopia of our strictly personal viewpoint.

Another facet of identity that is raised by this possibility of communication, whether with God or fellow humans, is that much of our identity is *relationally conditioned*. This may occur in several ways, such as when someone is a wife, a mother, a teacher, and a friend. Different aspects of the same person are called forth by each relationship, which expands and enriches her identity. But that person's identity—and to a degree her being—changes depending upon which relationship she is involved in.

The relational aspect of identity extends beyond relationships with persons. Our doing is relational too. By way of example, Degas' failing eyesight is an important aspect of his identity in relationship to his late paintings and pastels. It helps explain the reduction of detail, blurred edges of forms, and emphasis on color found in his late work. Degas' eyesight is sometimes mentioned by art historians when they are discussing that work. But assume that Degas also taught a Sunday school class. (As far as I know, he didn't.) His failing eyesight would likely not affect the conduct of his teaching greatly, and thus not be an important element for understanding what he did in Sunday school.

It should be clear that our identities are complex, multifaceted, developing, subject to some change, and related to our circumstances and roles. But this is not quite the same as what is often asserted in academic and art circles, which is that our roles, characteristics, and beliefs are "socially constructed." One usually hears this phrase applied to questions of gender and sexual orientation. The concept "socially constructed" suggests that we are like silly putty, and receive our identities and characteristics from the ideas and images that are dominant in our environment. It also suggests that since our identity is the result of external forces, rather than internal predispositions, we may change our identity without too much cost. Much of our culture's imagery and commerce is also built on an idea of malleability and change. As one ad put it, you should "make yourself over." Would that it were so easy.

Our culture recognizes certain kinds of limitations, particularly physical and social ones. But it tends to project the idea that we have the power to invent ourselves, or at least radically change our circumstances, if we are not obviously

handicapped. The idea of changing one's circumstances, and by extension oneself, is deeply imbedded in the American story. It is part of what it means to be free in the American sense. In the archetype of the American western, people move out West to start over again, "make something of themselves," or find a new identity. So there are powerful narratives, both in the art world and the larger culture, which promote the idea of ready change, or a tinker toy self made from various bits and pieces of those handy cultural conventions that are just lying around.

In my judgment, these ideas disastrously overstate the case for human malleability. I believe identity is developed as one's innate abilities and temperament interact with personal and social experience. So I would suggest that there is a core person who, though capable of growth, change, flexibility, and deceit, is bound by innate physical, personal, and cultural limits. My goal is not to limit any human's potential, but to suggest that human potential has limits. Thus there is a fixity we carry around, which can be expanded or contracted, concealed or revealed, but not jettisoned when something more desirable appears. Indeed, we do not make ourselves; though we are responsible for what we do with the gifts and abilities we are given. And although I have not quoted chapter and verse, I believe this play between fixity and change, limitation and possibility, reflects a biblical understanding of the human condition.

In summary then, when we think about identity, it is important to make distinctions. Since a person's identity is multifaceted, we need to recognize its different aspects and be aware of how temperamental inclinations affect innate aptitudes. Some aspects are critical for our vocation, our faith, or our friendship, others are not. We also must be aware that our sense of how free we are to construct our identity has a great deal to do with what we hear and see in our own culture. While there is the possibility for real growth and change in one's identity, it is neither easy nor inevitable. And though will and effort are extremely important human resources, they will never adequately compensate for the capacities we lack—such as the ability to always do the right thing.

IDENTITY WITHIN SUBCULTURES

By definition, subcultures are a piece of a larger picture. When people participate in one, such as playing a role in historical reenactments, they return to a more fully orbed life. Ordinarily people do not make totalizing claims about the philosophy and benefits of belonging to historical reenactment groups, even though some people spend a great deal of time as reenactors, and may find substantive affirmation and satisfaction through participation.

However, some subcultures are more totalizing in their views and their claims. Clearly, Christianity is not a typical subculture in its claims and its scope. It tells us about the character of God, answers questions about why there is death, and

explains how we may find peace and joy in this life. The Christian faith presents a complete world and life view, and in this sense is distinct from an ordinary subculture. Yet when we participate in the institutions of Christianity, which is typically the Church, we are located within one particular expression of the faith—with its own history, theology, and cultural presence. We experience this as a subculture, because it is a localized and temporal manifestation of the faith. If we change denominations, we find a different, sometimes very different, expression of the faith. So even though Christianity's claims are total, its expression is local. This is particularly true in post-Reformation, post-Enlightenment Western cultures, where the Church supports and interacts with much less of the total culture than did its predecessors.

The visual arts may seem more clearly like a subculture than the Christian faith. Artists do not have creeds or confessions, and they have no communal rituals equivalent to baptism or the celebration of the sacraments. Indeed, individualism and free thinking are cherished. Also, many visual artists would not articulate a clear overarching world and life view founded on art. But as the visual arts have developed in the last two centuries, they have progressively assumed a religious role for art's most devoted followers. This tendency towards religiosity has been observed and discussed by artists, historians, and critics—sometimes appreciatively, and sometimes with caution and concern.

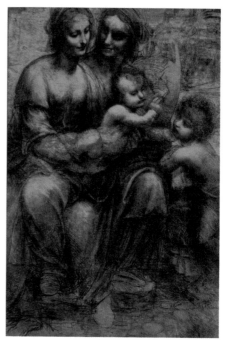

I believe the most challenging and thorough study of art's religious pretensions is Jacques Barzun's *The Use and Abuse of Art,* a compilation of the Mellon Lectures he gave at the National Gallery of Art in 1973. The wittiest analysis of art as religion I've read is *The Worship of Art: Notes on the New God,* by Tom Wolfe, which was first presented as part of the T. S. Eliot Lectures at the University of Kent,

LEONARDO DA VINCI. Cartoon for *The Virgin and Child with St. Anne and the Infant St. John.* Charcoal with white on brown paper. Approx. 54 x 39 inches.

England, and published in the October 1984 issue of *Harpers.* In it Wolfe asserted that art today fulfills two "objective functions" of religion, identified by the great sociologist Max Weber. While art is not an adequate religion, the fact that some

people see it that way means that the art world is not quite like the subculture of golf, corporate finance, or historical reenactment. Some of its members have devoted their lives to art, and make totalizing claims about art's role for the initiated.

Thus, when we look at the characteristics that each subculture esteems, the things considered important and essential to the successful practice of art or the life of faith, we encounter values that give direction and shape to life. To the degree that the ideas are internalized and acted upon, they become part of our identity, and an explanation of who we are and what we are about. In what follows I describe two important and commonly assumed values from each subculture, which make it difficult to fully participate in the other group. I begin with the arts.

THE IDENTITY OF THE ARTIST

At the beginning of this essay I spoke of our culture's penchant to think of a work of art in terms of its maker, the artist. While a work of art may represent many things, our culture has a pronounced tendency to see it as somehow representative of the artist: "An artist expresses herself." Thus for many people the use of art, and its obvious goal, is *self- expression*. In this view, there is a kind of seamlessness between the artist's work and the artist's life. The artist does not make art as one would work at a job, with set hours every day, and an entrance into and exit from a work world and a work consciousness. Everything in the artist's life may be part of the artistic process, or subject matter for the art.

Examples like this are not hard to find. One that caught my attention was in the April 18, 1999 edition of the *New York Times* "Styles" section, titled "The Artist is a Glamour Puss." The artists discussed were young feminists who were breaking free of the "Jackson Pollock image" of the artist, and moving towards a sophisticated fashion consciousness. One of the artists interviewed was Tracey Emin, who created quite a stir when she exhibited a tent which had the names of all of the people she had slept with on it. A lot of the publicity centered around the fact that one of the names on the tent revealed an incestuous relationship. Emin told the interviewer for the article, "If I was in denial about my sexuality, I'd be in denial about aspects of my work, which deals with *personal revelations*" (italics added). My point in relating this is that for Emin, her personal history constitutes the source and content of her art. As she defines it, her art is personal in the sense that it is about her. Keeping her life private would evidently impede her development as an artist.

Art historians have studied the lives of artists for some time now as a way of understanding more about the artist's work. Freud wrote a famous piece on Leonardo in 1910, which was a psychobiography based on an analysis of Leonardo's iconography and working methods. In it he drew conclusions about Leonardo's Oedipus complex, which was suggested to him by the two mothers in Leonardo's famous painting of "The Virgin and Child with St. Anne." Today it is

commonplace to hear or read that Van Gogh's nervous, edgy color and energetic strokes express his emotional turmoil, or that Picasso's distortions of women express his sexual anxiety or misogyny. People just tend to assume that both the process and the content of art *reveal* the artist.

I once heard the wonderful illustrator (*The Shrinking of Treehorn*) and occasional writer of children's books (*Amphigorey Too*), Edward Gorey, repudiate that idea. The characters in Gorey's books are often creating trouble for, or are in trouble with, the rules of behavior composed by adults. An interviewer said to Gorey, "Well, you must have been a difficult child to raise," or something to that effect. Gorey responded with a polite demurral, by pointing out that he was creating stories, not writing about himself.

Of course art does reveal something about the artist. One cannot make something without exposing his or her interests, tastes, and skills in some way. But, as Gorey's response indicates, artists also make conscious choices, and have the capacity to create fiction. They may choose to conceal, exaggerate, distort, or fabricate. So I believe it is a risky proposition to think that you learn a lot about artists by simply looking at their art.

It is embarrassing to compare Leonardo and Emin, but also instructive. Whether or not Leonardo's "Virgin and St. Anne" actually reveals an oedipal conflict is open to question, but it seems beyond dispute that Leonardo did not consciously choose that subject to reveal conflicts about his mother. His considerable intellectual and artistic prowess was directed elsewhere. Tracey Emin, on the other hand, has chosen herself as the subject of her work, and in that she is hardly a voice crying in the wilderness. She and many others are simply following the logic of the idea that art expresses the self.

The only systematic study I know of about the beliefs of artists was conducted by the sociologist James Davison Hunter, with the assistance of two graduate students, James Nolan and Beth Eck. Hunter is interested in the role that beliefs play in our culture, particularly the beliefs of opinion makers and elites. In the late 1980s they conducted extensive interviews with twelve prominent artists, artists whose work would be considered progressive or avant-garde. Since anonymity was a condition for the interviews, we don't know who the artists are. But as described in the study, their accomplishments are impressive.

All have received a notable level of prominence in their respective areas—some internationally and almost all on a national level. Collectively they have been the recipients of numerous awards. Majorities have received National Endowment for the Arts (NEA) grants, several have sat on NEA panels, and one was, in fact, a Policy Panel Chair for Visual Arts for the Endowment. Several have published books and still others have been

associated with well-known galleries. Their works have been featured in scores of publications both within and outside of the art world. For example, in the mainstream media, discussions of these artists' works have appeared in such places as the *New York Times, The Washington Post, the Wall Street Journal, U.S. News and World Report,* and the *Philadelphia Inquirer* to cite only a few instances.

For the authors, the interviews revealed a "remarkable consistency of attitude" whose "world view seems to be woven naturally from the fabric of their participation in a community of like-minded artists; a community whose cultural identity is shaped, in large part, by its particular social location." The study suggested that there are a cluster of related beliefs held by these artists. For my purposes here, what is significant in the study is what the authors found about the relationship between art and self expression.

The authors concluded that for the artists expression "is a measure of our being—existence. To express oneself is to participate in the creation of reality: a process co-terminus with life itself. Conversely, not to express oneself is "not to exist." The study is peppered with quotations from artists. One said, "Art is merely a way of getting out stuff within yourself." Another declared that art "is an expression of someone's soul." And a third artist believed that "the value of the work is higher, the more personal it gets."

In the study the authors sought to determine what the point or end of self-expression might be. They concluded that there was no point, no end, no ideal, no *telos* that directed the artists' efforts. Hunter and his colleagues observed that "... change itself is sacred. Transformation is its own end. The canvas, as it were, remains blank freedom; expression, choice, and change exist in their own right and need no compelling justification." They also pointed out how at variance these views are with those articulated by traditional religious belief.

If I have established that self-expression is widely seen as justifying art, it in turn raises a question which leads to the second value or characteristic that shapes artistic identity today. If self-expression is so valued, how do artists, critics, and the art public determine what counts, or is worth engaging? Put another way, why are some selves accorded more status and significance than others? What standard and criteria is at work in the recognition and ranking of artists?

The circumstances and mechanisms of recognition have changed in Western societies. In pre-industrial and pre-Enlightenment cultures, the artists with the best imaginative and technical skills were afforded the most recognition. The recognition came from patrons the artists served and the communities they lived in. Artists might achieve international fame, like some cathedral builders, or Albrecht Durer, but their reputations were communally and commercially determined, starting locally and spreading.

With the social changes wrought by the spread of democracy and the industrial revolution, critical success became less dependent on broad public recognition, or the financial support of patrons. It was at this time that the distinction between the fine arts and the practical arts became significant. "Artists" were fine artists, attending to beauty, or the sublime, while practical artists were tradesmen, selling a product. So artists and critics (who first emerged with a distinct voice in the nineteenth-century) began to determine which artists were worth looking at or buying. The critic Hilton Kramer believes that today artists' reputations are first made among other artists, and then with critics, and then with the larger art public. Given this, it no longer follows that financial success or popular appeal lead to a critical reputation.

A few years ago, the painter George Wingate sent me a copy of a letter that a friend of his had received. George's friend is a painter and printmaker. He had gotten the letter from a curator who was interested in helping him with his career. The artist, Don Journey, is a realist influenced by the Dutch and American landscape tradition. His work has a self-evident mastery of technique and love of subject which places it outside of the main currents of "advanced" art. He is very successful financially. A number of years before, George and I had visited an exhibition of Journey's in New York. The entire show was sold out. But while he sells well, Journey has no critical reputation to speak of, and that's what the curator wanted to address.

The curator's letter was full of good, sound advice about placing works in collections and having the right collectors. But he made it clear to the artist that one thing was lacking. Though Journey is a very good painter, he isn't *interesting* enough to command critical attention. Here are the curator's comments regarding critical reputations:

> The system is not corrupt but it is stupid. It froths enthusiasm—so transitory critical reputations are not difficult to create. More lasting reputations are made by critical consensus. Critical consensus is a general agreement of dealers, curators, academics, critics, and collectors. Nothing that makes critical sense is likely to make economic sense.

A bit further on he continued:

> Critical consensus favors innovation and inaccessibility. It favors sensation: craftsmanship detracts. It is not so good to take your critic work too seriously. Humor in the art bespeaks a self-detached irony. Add Martians, George Bush in drag, pubescent nudes, and an overlay of chemical equations and you are on your way. But understand that you will be "misunderstood" and not sell. The making of reputations is a parallel but separate process from the making of art and is a form of art-making in itself.

At a later point in the letter, he actually suggests, tongue firmly planted in cheek, that the artist invent a fictitious personality. The purpose was to create *interest* for the circle of dealers, curators, and critics who would see, write about, and promote his work. My point is that being *interesting* is an important value within the art world. I believe that, like the concept "artists express themselves," the idea that artists are interesting people, lead interesting lives, and make interesting things is part of the popular identity of the contemporary artist.

The great French painter Georges Rouault must have been thinking of something similar to this when he announced in a statement in 1937, "I am a believer and a conformist." He is quoted in the book *Artists on Art* as going on to say:

Anyone can revolt; it is more difficult silently to obey your own interior promptings, and to spend our lives finding sincere and fitting means of expression for our temperaments and our gifts—if we have any. I do not say "neither God, nor Master," only in the end to substitute myself for the God I have excommunicated. Is it not better to be a Chardin, or even much less, than a pale and unhappy reflection of the great Florentine?

It's logical that artists would want their art, and certainly themselves, to be interesting. Who wants to make boring art (though I must say I can think of some artists who seem to have been trying), or worse yet, be labeled a bore? But the interesting is not merely defined by a lack of boredom. In our culture "interest" has built into it the idea of arousing curiosity, standing apart from the ordinary, and having or doing something that attracts attention. In our media-saturated culture, where so many voices compete for our attention, arousing interest is the first step towards getting publicity. So to set out to make interesting art is to move in a very different direction than to pursue beauty, faithfully limn the visual world, seek to expose the soul's traces on the structure and expression of the human face, make art that exposes frailty and corruption, or any of the other myriad goals artists may set their hearts toward.

In the last chapter of *The Use and Abuse of Art*, entitled "Art in the Vacuum of Belief," Jacques Barzun describes "the interesting" as an inversion of the ordinary, the commonsensical, and the normal. In the search for the new angle, the interesting tends towards oddity, and the exploration of the anti-conventional. The interesting is the residue left after the "*avant garde*" has ceased to be a meaningful cultural distinction, but still functions as part of the apparatus of difference and promotion.

For Barzun, one mark of the interesting is found in audience response. He believes that to declare a painting or sculpture interesting reveals a superficial engagement on the part of the viewer. It's as if viewers are saying, "this has caught my attention and diverted my thoughts for a few moments. How interesting.

What's next?" There is no passion, either of embrace and surrender, or disgust and rejection. Barzun notes that

As late as the Sacre du Printemps the audience howled when it was hurt, stomped out when it was bored. By the time, 50 years later, when Mr. Cage and his pupils performed the audience had become *uniformly interested.*

In the 25 years since Barzun wrote those words, it seems as if interesting art, with its low voltage shocks and fleeting gestures towards significance, has become more firmly embedded in our art institutions. The art critic Deborah Solomon, who could hardly be described as reactionary in her tastes, wrote a piece for the *New York Times Magazine* on graduate education in the visual arts. The schools she visited were all in California, and have booming enrollments. In fact, M.F.A. program enrollments are at an all-time high nationally.

Solomon's article explores the tremendous irony that "cutting edge art (has) become a lesson you learn at school." This betrays the *avant garde's* insistence that art is not learned in the academy, and stands outside of mainstream social institutions. According to Solomon, advanced art, at least as it's taught in California, is based on theory and intellectual strategy, and looks a lot like home-work. Towards the end of the article Solomon remarks that

At the moment there is no shortage of interesting new art, but that is not the same thing as important art, art that promises to last. One wonders whether the new–genre art favored in the 90's, will ever be able to compete with the epic achievements of this century.

It's a pointed observation that underscores Barzun's insights about the rise of the interesting as a value in art. However, I believe the issue is not what kind of media or genre the artist chooses—after all, there are plenty of "interesting" oil paintings around. Rather, the question is, who does the artist want to be and what does she want to do in her work?

I have sought to make a case that "self-expression" and "interest" are two important concepts of our culture's—our art culture and our broader society's— image of the artist. I have argued that these can shape the identity of the artist as they are perceived by others or as artists think about their own work. My argu-ment is not that all artists embrace these values. Many do not. But to the degree that they are culturally active, they are the kinds of things young artists must grapple with as they make choices about what they want to do and who they would like to become.

It is my contention that if an artist embraces these as goals for her work, the relationship of the Christian faith *to her art* will likely become more difficult. This is not because Scripture or the Church teaches that selves are negligible, or that

they are best kept in check by hairshirts and constant denial. Instead, it is a question of ends. The biblical concept of self, and of vocation, is found *in relationship* to God and other selves. So it is not that we should not be expressive, but instead a question of what our expressions arise from and what they ultimately serve. Self-expression as an end is solipsistic, and finally locked within the sparsely populated universe of the utterly personal.

In a similar fashion, it is not that we should shun what we find interesting. Rather it is that when the interesting becomes the *raison d'etre* for art, the development of an artist's gifts, including the necessary maturing of skills and vision, are stunted by continued efforts to be different. It is unlikely, then, that one's work will develop the kinds of passion, depth, and knowledge that art can offer, both to the artist and to his audience. If this is true, there is a delightful irony in the fact that artists may find their own voices and develop the gifts that are uniquely theirs without setting out to be self-expressive and novel, which are the signifiers of the personal for so much of our culture today.

Clearly, more could be said about how these values affect the practice of the Christian faith. But instead I want to turn to ideas that are prominent within Christian circles that may hinder artists of faith as they work in the world of art. My observations are drawn from my experiences as an artist, my discussions with other artists and with my students, and from reading and listening as Christians seek to articulate a Christian understanding of art. My church affiliations have been with the Evangelical Protestant wing of the Church, and a great deal of what I've read and listened to is grounded in a Reformed view of culture. So I am aware of the parochial nature of my remarks. While they may not directly correspond to the experiences of Catholic, Orthodox, or old-line Protestant readers, I believe they will be broad enough to stimulate reflection about the assumptions of other theological traditions regarding the artist.

THE IDENTITY OF THE CHRISTIAN ARTIST

In American Protestantism the visual arts have historically had a peripheral role in the articulation and practice of the faith. There are a number of reasons for this. Much of American Protestantism, particularly its "free-church" adherents, has been populist and pragmatic in nature. Also, the lingering Reformational doubt about the use of images within the church has meant that many Protestants have not encountered the visual arts within the church. And, with few exceptions, it has been only in the last twenty-five to thirty years that evangelical theologians, literary critics, and philosophers have sought to develop a Christian view of culture.

Since the 1970's there has been a growing stream of books, usually aimed at popular audiences, dealing with Christianity and the arts. The general purpose of these books is to introduce interested Christians to the arts, argue for the place

and validity of art in the Christian life, and give the reader a sense of the kinds of critical distinctions one needs to make to think Christianly about the arts. Some books are more historically oriented than others, and discuss styles, periods and movements. The late Dutch art historian H. R. Rookmaaker's *Modern Art and the Death of a Culture* is the earliest book I encountered on art from a Christian perspective. It was first published in 1970.

These books have been useful in stimulating discussion and helping evangelical Christians sort through issues concerning the arts. One of the recurring themes in these books is the distinction between the secular arts of our culture as it exists, and the values and characteristics of a culture animated by Christian belief, which largely doesn't exist. Embedded within this separation between secular and Christian is the idea of *Christian art*.

Some artists I know who are Christians are fairly leery of being categorized as Christian artists. This may be for reasons of modesty, or because to be so labeled has not been much of a career booster outside of Christian circles, or because "Christian" seems too small to describe the artist's body of work, or because the concept "Christian art" is the intellectual equivalent of a briar patch. "Christian art" can variously mean: 1) work with obvious Christian subject matter like biblical narratives; 2) work whose worldview or spirit is Christian; or 3) work that is made for a Christian audience, to be used in some Christian way—usually liturgically. If these possibilities aren't confusing enough, sometimes people simply mean that Christian art is art made by Christians.

Regardless of where the authors may come out in their discussion of Christian art, the structure of the discussion indicates a belief that the visual arts have a capacity to express, communicate, or reflect a Christian viewpoint. This is a particularization of a tendency among Protestants that Nicholas Wolterstorff has noticed. Wolterstorff says in *Art in Action* that Protestants tend to think that "... a work of art is always *an expression* of its composer's religion." He says that this is because Protestants tend to believe that humans are irreducibly religious in orientation and have an "in-created" tendency to substitute and elevate something else in the place of God if they do not acknowledge and worship Him. Wolterstorff does not think that all art is religiously expressive, because he does not believe that all people are irreducibly religious. He distinguishes nonbelief from misplaced belief.

But, if you believe that all art is an expression of a religious view, then it is natural to assume that *the Christian artist's art should somehow express a Christian view.* You can hear this in a passage from Leland Ryken's book *Culture in a Christian Perspective.* He affirms that "artists are free to portray the subjects they are best at portraying." But he almost immediately qualifies this by saying,

Sooner or later, writers or composers or painters will say something about the things that matter most to them. If this is true, it is inevitable that the Christian vision in art will be characterized by the presence rather than the absence of such realities as God, sin, redemption, and God's revelation of himself in both Word and Son.

Others would be less specific about what constitutes a Christian view. For instance, Rookmaaker says in *Modern Art and the Death of a Culture*, "what is Christian in art does not lie in its theme, but in the spirit of it, in the wisdom and reality it reflects." So I believe that one of the assumptions within Evangelical Protestantism is that *art by Christians will, or ought to, somehow communicate a Christian worldview*. It is important to notice that I have changed the earlier italicized "express" to "communicate." This is because many people view expression as a communicative act. It is also useful to see that Christians share with the larger culture an expressive view of art. It's what is being expressed that is different, though Christian expression might be conceived of as a form of self-expression.

PROBLEMS WITH "CHRISTIAN EXPRESSION"

Now many artists I know fervently desire that their faith be a constitutive element in their art. Some want to express their faith through their art; others want their faith to be the foundation for, or worldview behind, the work. But other Christians are content to let their work develop without much reference to their religious beliefs, or perhaps they have explicitly a-religious ends in mind, such as that the work should enliven architectural spaces, or decorate visually impoverished places.

I want to note three problems with the idea that Christian artists will, or should, express/communicate Christianness in their art. The first is that this ignores two diversities. One is the diversity of purposes to which art may be directed. Certainly art can be used as a means of communication, but it is not only that. One of the most common uses of visual art throughout human history is frankly decorative. We recognize this when we speak of the *decorative* arts. And even though there are libraries full of dense critical books trying to prove otherwise, one of the primary uses of modern abstraction has been decorative. Indeed, as the arts have unfolded in human history, we have tended to qualify them according to their designated ends. The communication arts, which are a distinct discipline and practice, have communication as their central preoccupation. "Art" by itself signifies no end, though we are quick to associate it with exhibitions in museums and galleries, with their characteristic uses of appreciation and study.

In a similar fashion, to stress expression/communication also ignores the diversity of gifts that God has poured out on humanity. Some artists have the gift to express faith, or a world view, others don't. I have watched some believing

artists struggle to do something "Christian" because they feel that this is their duty. But it was obvious to me that these artists have no real gift for that, and the results were forced, awkward, and self-conscious. Other artists, laboring to be Christian, will attach a Christian "reading" to work that doesn't naturally carry it.

While it is understandable that Christians would want to privilege Christian expression, particularly in light of the poverty of a Christian presence in the visual arts over the last two hundred and fifty years, this bias is not without cost. It may even prolong what we all wish would go away, the overabundance of bad art in the service of faith. I believe it is better to recognize and encourage a diversity of artistic gifts that are fitted to diverse artistic ends than it is to suggest that the test of one's Christian conviction is found in the ability to artistically express the faith.

A second problem with the emphasis on expression/ communication can be found in a possible objection to what I've argued above, which is that some artists will express their faith in their work, but others will not. Some might argue that it is inevitable that what a Christian does will be tinged with a Christian view or expression. You can hear this when Leland Ryken responds to W. H. Auden's quip that "there can no more be a 'Christian art' than there can be a Christian diet." Ryken responds in *Culture in Christian Perspective*, "For one thing, there is such a thing as a Christian diet: it consists of eating meals that are healthful, moderate, modest in cost, and delicious." What Ryken has done is to exercise a form of the "all truth is God's truth, hence anything true is Christian" argument. Of course we live in God's created order, and in one sense a good diet is Christian.

But is a diet expressive of a world view? Many Buddhists and New Agers whose diets fit Ryken's description would not be able to discern anything Christian about their eating habits. They might agree that their diet is godly, but not specifically Christian. There is nothing that necessarily leads to the Christian faith in the kind of diet described. The ability to recognize and choose a good diet

THEODORE PRESCOTT.
Book of Light, 2003–04.
Patinaed bronze and statuario marble. 86 × 19 3/4 × 3 1/2 inches.

is given to all people, and to the degree a good diet may be expressive, it is capable of congruence with differing convictions. Of course there are diets that are chosen for religious reasons, but those are prescribed and are beyond commonly recognized virtues like moderation and healthfulness.

A little later on in the same passage, Ryken says:

> Since art not only presents experience but also interprets it—since it has
> ideational content and embodies a world view or ethical outlook–it will
> always be open to classification as true or false, Christian or humanist, or
> Marxist or what not. In the long run, every artist's work shows a moral and
> intellectual bias. It is this bias that can be compared to Christian belief.

I disagree. I believe there are many areas in life where one's choices and actions do
not express or communicate the religious convictions that generate them—even in
the long run. When called upon, we may articulate the convictions and try to
explain how they lead to our actions, but other explanations may be plausible too.
This is particularly true in a culture that is as open, diverse, and pluralistic as ours.

For example, I know of many landscape painters who are painterly realists.
Their work is united by the plein-air tradition of quick response to the complex
and shifting sense experiences provided by vista, atmosphere, and light. Some are
indebted to the American painter Fairfield Porter. While these artists do not con-
stitute a school, they do have a common language and shared concerns, includ-
ing a love of and respect for the sensory experiences provided by the creation.
Some of these artists are Christians, and know that a Creator made and sustains
the creation. But others do not. Apart from talking to the artists about their reli-
gious convictions, I do not see a real way to discern them. It would be a tortured
act of critical exegesis to try to make the Christian's work express a Christian view,
especially to distinguish them from the religious views other painterly realists
might hold and potentially express. Would it not be more honest and accurate to
say that Christian and non-Christian alike can respond to and affirm the beauty
and goodness of creation? This is not to argue that landscape painting cannot
express religious views (one need only look to the American luminists, or to
Dutch seventeenth-century painters), but rather to assert that not all art by
Christians will express or communicate their faith in a discernable way.

The third problem with the expressive/communicative view is that it tends to
make the Christianness of art reside in content that can be verbally apprehended.
Now I think there is a great deal that can be said about visual art, but at its heart
it is irreducibly visual, and words necessarily fail us. At their best words can open
avenues to visual experience that we might otherwise miss. If the Christianness
of an image resides in content that can be articulated, dissected, analyzed, and
"proofed" in some way, we may have the illustration of an idea on our hands.

I once heard a purportedly intelligent pastor argue before a group of artists
that Lucas Cranach the Elder was one of the greatest Christian artists to have
ever lived because his work was so full of Lutheran theology. The artists were
incredulous. Certainly Cranach is an important artist, with his gossamer pubes-

cent Venuses and Eves, and his many pristine portraits of the doughty Luther. But who would seriously compare him to Grunewald, Michelangelo, or Caravaggio? Only a person who is happy when he can see words.

In discussing how Christian authors have thought about the arts, I pointed out that they have generally made a distinction between the secular and the Christian. One way to distinguish the Christian from the secular is through the expressive/ communicative assumption I've been discussing. But there is another way that Christians often draw a line between the secular and the Christian. That distinction revolves around the moral vision or moral effects of art. This idea is sometimes expressed as *the Christian artist's work should embrace what is good.* Sometimes this will be taken a further step, to include the effect of the work on the audience. This idea might then be formulated as *the Christian should make work that morally uplifts the audience.* These views make the ethical content of a work of art an important consideration in determining its Christianness, as we heard in the last quotation from Ryken.

It is probably foolhardy to critique this assumption. Our culture is awash in degeneracy, both in popular and "high" art. I have no desire to argue on behalf of immorality. Nor do I want to suggest that thoughtful Christians have not grappled with the issue, and made no distinctions between work that may be disturbing and difficult, and work that is morally pernicious. Some of the authors I've mentioned have addressed this complex subject, and do not advocate a world-denying, neutered, stained-glass kind of art. But of course, there is a concern that Christians should be morally distinct from the sinking morass around them.

I believe most of the pressure to be morally uplifting as an artist comes from the Church, and the results are manifested in much Christian popular art. One can see those results in many Christian bookstores. Their art, music, and literature exemplify the problems with the notion of "Christian art" as it is popularly conceived.

My point in calling attention to the idea that the Christianness of a work can be discerned by assessing its ethical content is not to challenge it. Clearly art can communicate ethical views, and some Christians will want ethical dimensions in their work. Nor is my intent to fix a line between what is acceptable or unacceptable for Christians who are artists.

My purpose in calling attention to the ethical content in art a Christian makes is the same as my purpose in discussing the idea that the Christian's art will express a Christian view. What makes these assumptions problematic is not even that they are only sometimes true, and ignore the complexity and diversity of possible things a Christian may do. Rather, what really makes them problematic for the artist who is a Christian is that *neither assumption acknowledges the way art is actually made, nor how art works in our cultural landscape.*

THE ARTISTIC PROCESS

I have three observations about the way art is made and its uses in the larger culture. These are based on what I've *observed,* both in my own life, and in the life and work of artists I've known. First, the idea that artists who are Christians will make something Christian can lead the artist to view Christian content as an element to be manipulated during the creative process. So while the intention is admirable, the goal can become an impediment to art because Christianity is incidental to so many of the particularities of the creative process. This is especially true for people that are not working with overt Christian subject matter.

The artistic process, even for highly theoretical artists, is characterized by stops and starts, intuitive gropings, the retracing of steps, the coaxing of recalcitrant details into a coherent whole, and the search for a sense of substance. Except through the resources of prayer, one's faith may have little to say to the moment-by-moment choices the artist makes in the give and take of creation. And if artists try to assess the Christianness of their work as they proceed, they are treating the faith as material that can be added or adjusted, as one might put a bit more magenta into a color mix. Christian expression, when it exists, suffuses the whole work, and comes from the insight and vision of the artist far more than it does from conscious decisions made in the process of creation. I am not saying that conscious decisions cannot be made about the content and direction of one's work. But I am saying that in the deepest levels of the creative process *what* an artist expresses cannot be managed the way one struggles with *how* it is expressed. Christian content is not a craft to be learned.

In our battle-weary culture, concerns about ethical standards can create special problems for Christians who are artists. Pressures from an imagined audience can be troubling. I believe that artists are responsible for what they make, but they are not responsible for what their audience perceives. It is useful here to recall Upton Sinclair's remark after the success of his famous novel *The Jungle,* published in 1906, which exposed the sordid conditions in Chicago's meatpacking industry. Sinclair hoped to outrage his readers with his descriptions of the low pay, danger, exploitation, and social injustices workers endured. He said, "I aimed for their heart, but I hit them in the stomach." What outraged readers was not the plight of the workers, but the disgusting and unsanitary ways meat was processed. Their revulsion helped stimulate reforms in the industry.

This anecdote is relevant to questions of morality in art. Christians who are artists may offend the moral sensibilities of their local church, or a particular audience, even though in their own minds they have worked within the bounds of morality. This is especially true if audiences are looking for a certain position as an indication of the Christian commitment of the artist. There is no easy way out of this dilemma. To the degree that the artist tries to guess an audience's

response and adjusts the work to appease sensitive sensibilities, the likelihood increases that artistic power and expression will be diminished. So while artists must care for their audience, they cannot be controlled by it. In the final analysis, no one can aim art so well as to be assured of audience response. This is true even for advertisers, who spend billions of dollars trying to manipulate audience reactions.

Finally, I think the assumptions that Christians will somehow express something Christian and support Christian morality flow from a desire to create a Christian culture that is distinct from a secular culture. The desire seems to be based on two things: the belief that at one time Western culture was predominantly Christian in its arts with Christian concepts of the good, the true, and the beautiful; and on a longing for the arts to be redemptive in contemporary culture. So, Christians may want to recover a former position in the arts, and may also see the arts as a possible way to change our culture. But we need to attend to what area of the past we look to, and understand how our art affects people's minds and hearts.

In my judgment, the past that we should be looking to for guidance is not the glory periods of Western art, but that of the early Church. This is because the contemporary Church's position relative to its larger culture seems more like that of the early church than like the Church in the later, more thoroughly Christianized

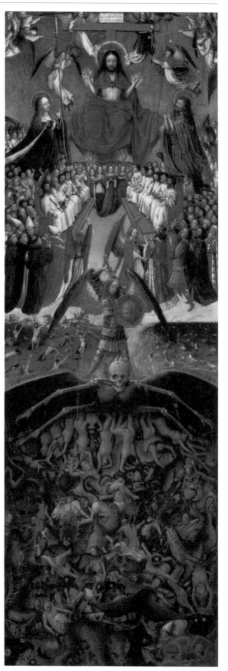

JAN VAN EYCK. *The Last Judgment,* c. 1420–25.
Tempera and oil on canvas transferred from
wood, 22 1/4 x 7 3/4 inches.

West. This means that the Christian who is an artist works in a culture that is oblivious to, indifferent to, amused by, afraid of, or perhaps somewhat curious about the religious dimensions of his work. But usually the audience is not informed about the faith or disposed to embrace a work because of faith's presence. So the recognition and critical reception that Christian artists receive will not be due to their giving form to faith, unless the artists specifically address a Christian audience. And the Church—at least the Church I know—while beginning to use the arts again, simply does not have the theological imagination, artistic sophistication, or financial resources to call forth an aesthetically significant and emotionally charged Christian expression that will engage the hearts and minds in our art's culture. Thus the individual Christian artist who tries to create a Christian art *distinct from* the artistic concerns and idioms of our culture is shouldering a very, very heavy burden.

While it is understandable that Christians think a Christian expression may act redemptively in culture, this idea founders on our culture's actual uses of art. For many years, when I've visited the Metropolitan Museum of Art, I've stopped to look at Van Eyck's exquisite and terrifying depiction of the *Last Judgment*. I always watch other visitors, trying to fathom what they are experiencing. Does the painting move them religiously in any way? Does it predispose them to wonder who this Christ is, or make them meditate on the possibility that one day they will be judged? I'll never know, but I suspect that's usually not the case.

It may be that since Van Eyck painted in the fifteenth century, the contemporary viewer may see the Christian subject and content as something from the past and not relevant today. After all, it was once in a church, and now is in a museum. However, we can ask the same question about a twentieth-century artist like Rouault, or a contemporary painter like Tanja Butler. The fact is that many people see, appreciate, and experience their work without being religiously stirred. Art as we know it is bound to the aesthetic, the expressive, and the personal. People moved by Rouault's pictures of Christ will likely see them as Rouault's personal expression of belief, and not as an image whose purpose is to communicate religious truth. So while viewers may sense the depth and authenticity of Rouault's belief that is part of the *aesthetic* experience of his work. It is an uncommon viewer who will be moved by Rouault's belief to examine her own religious convictions.

The art historian Bruce Cole has noted that somewhere in the thirteenth century, Western paintings and sculptures began to lose their iconic power (the capacity to communicate and shape religious belief) and made the first steps towards our idea of "art" (*Italian Renaissance Art 1250-1550*, p. 17). I suspect that many Christians long for art to regain some of that earlier iconicity. But as long as we participate in our culture's institutions of art, that iconic power will always be tantalizingly beyond our reach. Our culture's arts are very effective at mediating experiences of beauty, passion, mystery, intellectual engagement, or cultural

challenge. But they are not capable of cultural redemption, unless society as a whole shares in the Christian longing for signs of the kingdom.

I have spent a longer time discussing Christian assumptions about who the Christian artist should be than I did discussing the art world's assumptions about the character and identity of the artist. This is because I assume that Christian expectations will be more normative for the readers of this book than the art world's assumptions, not because I believe the Christian subculture is more detrimental to art than the art world is to faith. My concern in both instances is to show how the values and expectations of each subculture may affect our thinking about our identity as artists. I believe that if we sort through and understand the pressures to *be* a certain way, we can more thoroughly develop our gifts, and determine our calling.

What remains is the question of whether we can live within both worlds, be true to our vocation and sense of God's call, and develop identities that allow for the integrity and flourishing of both our art and our faith. I will close by considering identity in the scriptural narratives, and suggest that we need to look at our identity in light of its engagement with Christ.

IDENTITY IN SCRIPTURE; IDENTITY WITH CHRIST

One of the central acts of the Christian faith is the confession of Christ's identity. He is the Son of God, the Savior, the Redeemer, the Mediator between God and man, and the author and finisher of our faith. Christ's identity is revealed in Scripture, and enshrined in the creeds and confessions of the Church. Our identities as Christians are dependent on recognizing who Jesus of Nazareth is, and for most Christians the distinction between Christian orthodoxy and its various deformations rests on correctly identifying the character, role, and work of Jesus, the Christ. It's hard to exaggerate the importance of His identity.

The effects of continually confessing Christ's identity may be misleading. We may reduce the character of Christ to a few codified phrases, or we may make the recognition of Jesus seem easier than it actually is. Clearly the scriptures paint a vivid picture of the difficulty people have in grasping Jesus's identity. It's possible to dismiss that difficulty as a result of His audience's hardness of heart, because they belonged to a "wicked" and "faithless" generation. But there is value in trying to imagine what it would be like to hear and see Jesus through all of the mixed, confused, and competing cultural assumptions that clamored for attention in a Middle-Eastern outpost of the Roman Empire during the first-century. Recognizing Jesus is no sure thing—and He doesn't seem too concerned about making it easy. He speaks in parables, disappears at strategic times, aggravates powerful people, and in general, doesn't act like someone who's working at developing a large following.

In the sixteenth chapter of Matthew there is an exchange between Jesus and His disciples that may shed light on the way we think about identities. In the thirteenth

TANJA BUTLER. *Abraham's Sacrifice*, 1989. Oil on canvas, 12 x 12 inches.

verse, Jesus asks the disciples, "Who do people say the Son of man is?" The disciples' response, "Some say John the Baptist, others say Elijah, and still others say Jeremiah or one of the prophets," indicates multiple perceptions about Jesus's identity, all cast in light of earlier great Jewish figures. Then Jesus turns to the disciples. "But what about you, who do you say I am?" Peter, always quick to speak, says, "You are the Christ, the Son of the living God." Jesus affirms Peter's answer, but tells him that he wouldn't have understood this, unless God had revealed it to him. A bit later on, Jesus warns His disciples "not to tell anyone that He was the Christ."

Peter must have been feeling pretty proud about his perceptual powers. So when Jesus went on to explain that He must suffer many things, be killed, and raised from the dead, Peter was sure that those experiences were entirely inconsistent with the role and identity of the Christ. He took Jesus aside and began to rebuke Him. We all know Jesus's response, "Get thee behind me Satan!" Poor Peter, so right and so wrong.

What an intriguing story. Peter had confessed the "true" identity of Jesus. Yet he didn't have any understanding of what that meant. For Peter, and for Jesus's audience, "Son of God" was incompatible with suffering and death. That category simply precluded those experiences.

Then there is the question about Jesus' self-disclosure. Why did He not want people to know He was the Christ? Certainly a great deal of His reticence can be explained by sheer disbelief. "You are who? The Messiah? Yeah, sure!" But as Peter's attempts to dissuade Jesus from talking about pain and death show, what Jesus knew awaited Him was unthinkable to his followers. In his little book *On the Incarnation*, St. Athanasius explains, "He did not offer the sacrifice all immediately He came, for if He had surrendered His body to death and then raised it at once He would have ceased to be an object to our senses." So Jesus' work as the Christ had to be slowly unfolded as He set his mind and heart towards what lay ahead. It could not be simply announced, but had to be lived out through space and time to make it comprehensible to people.

In a similar fashion, our lives *as* artists, *as* parents, or *as* followers of Christ have to be lived out for our identities to have any meaning. And our concepts about identity are always in dialogue with our moment-by-moment experiences. Concepts are necessary to order and understand experiences, but they also are modified and reconfigured to the degree that there is dissonance between what we think we know, and what we actually experience. Peter thought he knew the person who was the "Son of God". But his experience of Christ radically reconfigured his ideas about God's nature. Over time he came to see that God's power over pain and death was not exercised remotely, or without cost.

Thinking about our own identities is particularly difficult for us, because we possess such clouded self-knowledge. As Walker Percy points out at the beginning of *Lost in the Cosmos*, "it is possible to learn more in ten minutes about the Crab Nebula in Taurus, which is 6,000 light years away, than you presently know about yourself, even though you've been stuck with yourself all your life." Scripture is full of people who don't understand who they are or who are unable to do what they know they should or who are fearful of the consequences of some aspect of their identities.

Peter's denial of Christ is one of the most clear and wrenching examples of someone unable to understand himself and unable to bear the consequences of his identity. We can only wonder about the change in consciousness at the critical moment when Peter was caught between his desire to be faithful to Jesus and to stay out of trouble. While the stakes are rarely so high for us, we play out this drama over and over again, as we adjust or suppress one aspect of our identity to make present circumstances more "comfortable."

Scripture shows that our identities are unfolded in the acts of living, and that there will be degrees of dissonance and brokenness between how we know and

identify ourselves, and what we actually do. That dissonance, whatever its nature, is a particularized instance of the original rupture that separates us from ourselves, from others, and from God. So just knowing what the pressures are to be a certain way will not by itself give us the freedom and courage to act consistently. Contrary to what is offered by a lot of religious purveyors today, the Christian faith never promises a personality transplant.

The Christian faith's uniqueness lies in the way God relates to individuals. We are not subsumed by God, but co-joined. Our identity is not erased, as desirable as that might seem at times, but instead is involved in a deep and complex exchange with Christ's. Christians seem most clear about this exchange at the point of the atonement. But this is only one aspect of a relationship that extends into all areas of our lives.

The English author Charles Williams has called this state of being "co-inherence"—the opposite of incoherence. He sees it permeating both the natural and supernatural worlds, as when a child is conceived and carried in its mother, and godparents stand in for a baby about to be baptized. Christians "partake" of the life, death, and resurrection of Christ in that they share in the *identity* of Christ. The exchange between the believer and Christ is at the heart of the Christian life, and the believer's motives, thoughts, and acts can be renewed and transformed in "being with" Christ.

CATHERINE PRESCOTT. *You See Me: Portrait of Ted* (detail), 2005. Graphite on paper. 22 × 16 3/4 inches.

The action of Christ's identity in us, with us, and through us is neither automatic nor easy. It can be thwarted or displaced, and must not be confused with the cultivation of the Christian "personality" that is the preoccupation of many churches. *That* personality may or may not reflect the character of Christ. But to the degree that we live in the knowledge of and communion with Christ, we have the potential to resist and transform pressures to conform to someone else's idea of who the artist is or what kind of art the Christian should make. All kinds of ideas and experiences affect our identities, but they cannot overshadow the foundational identity we have of being with the living Christ.

For a large part of this essay I have argued that our culture's ideas about

the institutions of art will shape what is possible regarding a Christian expression in the arts. I have argued this because I've found that Christians tend to have expectations about what art can do, and what it will look like when Christians do it, that ignore the real terrain of art. But I have not argued and would not want to suggest that the contours of art today are permanent and immutable. It is possible that the way we think about and do art, and how we experience it, can change. It may be that thoughtful and dedicated Christians will have a hand in that, and help create a world where the words Christian and art coincide more easily, more naturally, and more fully.

MAKING ART
that shouts

It was only a few decades ago when Christians involved in the arts would swoon with delight over the most modest of gains. At the time, for example, it seemed like a huge cultural concession to find Flannery O'Connor quoted on the front page of the *New York Times Book Review.* The 1984 feature article—impishly titled, "And Now, A Word from Our Creator"—coyly celebrated the re-emergence of God as a character in novels. O'Connor asserted, with an eye to the world-at-large as well as fellow believers who were not at all on the same page:

> When you can assume your audience holds the same beliefs you do, you can relax a little and use a more normal means of talking to it; when you have to assume it does not, then you have to make your vision apparent by shock—to the hard of hearing you shout, and for the almost-blind you draw large and startling figures.[1]

Within the avenues of Christian authority, shouting and startling seemed the very antithesis of the way Christians were supposed to behave. But as Christians we have a responsibility to speak into a world that rejects God, and by association, the possibility of redemption. And to carry out that call artists back then came off like the loud, embarrassing, drunken wedding guests at the banquet. Many artists of good faith (and good intentions) received their own stripes through the tongue-lashings of their elders, and some left the fold but not necessarily the camp. And many kept doing the work as faithful messengers of God.

As Charlie Peacock wrote in the song *Message Boy,* on his 1986 eponymous Island Records release:

I am the message boy
Moving down the street
I'll be moving in and out of traffic
I've got a business man's deadline to meet
I might bring you good news
A message boy does that
I might bring you bad news
A message boy does that
The words they might be beautiful
Then again they might annoy
All I ask is remember I'm only the message boy

Underscoring his lyrics with "big '80s" horns, Peacock described our responsibility of bringing the annunciation of God's offer for reconcilliation and hope in the face of fragmentation and despair. The message boy cannot orchestrate or manipulate the reception of the news—*The words they might be beautiful/Then again they might annoy.* The message boy just keeps moving down the street, trusting that though the Spirit blows wherever it pleases, the Spirit *will* blow and the messengers do not labor in vain.

PAUL MARTIN. *Annunciation/The Messenger,* c.1989. Oil without linseed oil on canvas.

ANNUNCIATION:
to make known
officially or publicly;
to bring news of; to declare;
to intimate; to proclaim

The initial text describing how Mary learns that she will be the mother of Christ occurs in Luke 1:26–38,[2] vastly embellished over the years by several apocryphal texts and an infusion of inventive, symbolically loaded visual associations in late medieval and Netherlandish painting, from the fourteenth century upwards. The actual feast day first occurred in 336, established once the date of the Christ Mass was determined, falling on the date that all retailers currently aspire to, known as December 25. While the Annunciation theme may first appear in art during the fourth century, as a provisional looking fresco in the Roman catacombs of Priscilla, its earliest known

formal depiction glows out of the gold-lined mosaics at Santa Maria Maggiore in Rome, *circa* 432. Since then the theme has been as irresistible to artists as catnip is to cats, so it has received a goodly amount of conceptual energy.

At its core, the Annunciation depicts a tender, life-changing moment in space and time with cosmic implications that hinges on communication between God and a human being. In a singular moment of this historical conversation, God projects a plan for salvation through the archangel Gabriel, who foretells the virgin birth of Jesus through Mary, the greatest ambassador of humankind.

Humble teenaged Mary, entering the exchange as an ordinary human agent in God's redemptive plan, is transformed by her obedience and generosity into the extraordinary *Theotokos*, the Bringer of God, the 'most favored' among all women, as Gabriel promises. We can easily imagine how perplexed and afraid this portent strikes Mary at first. Much has been made in drama of her initial reluctance to take on the smudgy role of unwed mother in the kind of environment where women perceived as adulterers might well be stoned by their elders. She must have presciently realized that Jehovah's covering grace would preserve her from this fate, as well as Joseph's possible rejection. We can certainly empathize with her hesitation. But ultimately, it is her self-surrender that initiates a major shift in humanity's relationship to God. Humility becomes the foil for the greatest mercy that humans have *ever* received.

Our modest annunciations as Christians surely entail *enunciating* God's desire for creation to rejoin its Source, in a peaceable eternal realm of complete restitution and balance, far beyond the limits of human imagination. What is annunciation, if not the continuing assertion of a hope and a future in the midst of despair and fragmentation?

For centuries, innumerable artists have endlessly re-envisioned ways to convey the simplicity, power and majesty of this momentary transaction in the space-time continuum, leading to delightful collaborations and appropriations between artists from completely different periods of history. For example, in the 1970s, sculptor Ted Prescott began massaging the conceptual and material hinges between historic and contemporary approaches to biblical narratives, resulting in stunningly simple and eloquent Annunciation and Descent installations. The archangel Gabriel solemnly glows in an energetic blood-red neon outline, which reads like an action drawing. Gabriel's light enfleshes the white cast of

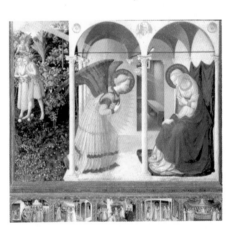

FRA ANGELICO. *Annunciation*, c. 1430–32.
Tempera on wood panel. 61 × 76 inches.

Mary's plaster skin with warm tones. The lines that circumscribe this heavenly being are, appropriately, illuminated by electrified gas, yet clearly correspond with the gently urgent postures of traditional Annunciation angels in iconic fifteenth century Annunciation paintings by Fra Angelico (c. 1432), for example, or Robert Campin (c. 1425). Casting the angel in an ethereal substance composed of non-solid gas and electrical impulse constitutes such a unique and delightful stroke of inspiration, one has to wonder why it hasn't spawned an industry.

The ethereality of this neon angel contrasts with the basic substance of Mary, a human counterpart weighted by gravity and solid flesh. Prescott deliberately quoted George Segal, whose plaster figures had reached a critical peak of popularity and acclaim by the 1970s.[3] This appropriation amounted to Prescott's rebuttal, at the time, against the old saw that religious imagery was too irrelevant to be reinterpreted in contemporary artforms and materials. Conversely, Prescott's obvious evocations of traditional compositions underscored the conviction that the 'old themes' were just as powerful as anything that contemporary artists could cook up—and this at a time when the work of master artists (even Rembrandt or Rouault) that portrayed Scriptural content sold for far less money than 'secular' imagery. Additionally, Segal's idiom intentionally framed 'real' moments from everyday life with 'real' (vs. model) people—butchers, bus drivers, or benchwarmers, quietly going about their unspectacular lives in this deliberately spectacular art format. In essence, Segal dignified quotidian, boring moments in time by creating meticulous, ostensibly beautiful compositions for exhibition in the pantheons of high art. Similarly, Prescott's *Annunciation* acknowledges the timeless reality and

THEODORE PRESCOTT. *Annunciation,* 1978–79. Mixed media including cast hydrocal, wood, neon, and found objects. 48 x 144 inches.

humanity of the event, reiterating its scriptural, historical, and contemporary relevance at a time when critics generally dismissed biblical content as a regurgitation of mythological glosses. It presumes that the greatest atheist or agnostic will recognize the plot, which is, after all, an iconic fixture in Western culture. In the process, Prescott also shows the ordinary being transformed to the extraordinary, with extraordinary potential for life, by God's message.

Prescott's very 'real' Mary—who appears to be a simple housewife bedecked in vintage '70s gear—Scholl's sandals and a bandana—responds with an Amish sort of

reserve, hand modestly raised to her heart, face frozen by any number of possible emotions. A cheap magazine reproduction of a white lily framed in acrylic contemporizes Mary's traditional attribute, preserving the allusion to her purity of heart. Adding his own mark to the genre, Prescott includes a completely original metaphor: Mary, somewhat proprietarily, hovers over two pans containing loaves of bread, simulated by polished wood—Prescott's allusion to Virgin Mother as the Maker of the Bread of Life—one of Christ's self-qualifiers, unceasingly celebrated as a worldwide, communal event in the Eucharistic rite, regardless of denominational aches and pains.

Michael Schrauzer. *The Annunciation*, 1994.
Oil on panel, maple. 11 x 12 inches.

THE BIG STORY

Does the fallen world listen to such earnest annunciations? Is anyone—apart from kind friends, family and fellow worshippers—actually tuning in?

The lines that used to sever art tinged by Christian truth from art-in-general began blurring by the 1980s. Neither universal acclaim nor universal rejection accurately characterize our present interactions as artists of faith. How much this has changed since the 1970s, when dozens of arts ministries cropped up around the world to provide safe havens of fellowship for harried artists of faith. We gave thanks for very small gains back then. The gains are far richer, more varied, and farther reaching now, plainly evident in the success of art departments at Christian colleges, the profusion of illustrated books and journals on art, the availability of experiences through efforts like CIVA, MOBiA, NY-CAMS, I AM, and a plethora of spiritually-themed exhibit opportunities.

Nevertheless, the opportunity for annunciation remains the greatest challenge

of all in a stiff-necked world. As we continue the dialogue with "large and startling figures," will our art be compelling, or will it look like a 72 dpi jpeg blown up 300 percent and plastered on a billboard? *It Was Good* addresses questions that confront followers of Jesus who seek to make art that glorifies God and speaks with a clear and relevant voice to a fallen world. Above all, *It Was Good* asserts that we have the Big Story. We have God's covenant of redemption to share with the world. We also have the nuances and refinements that spin off of the Big Story, not just the Big Statements; few artists in the world can make Big Statements these days, in such a fragmented, transient, and fractious culture—the condition that cultural critic Neil Postman described in *Amusing Ourselves to Death*.

What would be a Big Story, suitable for shouting at the hard of hearing? God's faithfulness throughout history as we know it, culminating in the decisive victory of the cross. What would be the nuances of that story? Our ongoing spiritual battle as we move towards the paradox of God's intended end, which is actually an eternal beginning. Big Story with "large and startling" implications: the Cross of Christ. Nuance: every facet of life, expressed in every means possible, from social commentary to still life to abstract walkthrough sculpture to madrigal to balletic *pas de deux* to soliloquy. Our Big Story ultimately expresses itself through the Body of Christ. And this Body has many parts; this Temple is composed of many discrete stones; this Royal Priesthood requires diverse skills and aptitudes. Each part creates a whole that is greater than the sum of the parts, and that is the Big Story.

STATIC WINDMILLS

A few decades ago, artists of faith were often so confused by acceptable spiritual clichés and pressure to portray only the Big Story, in totality, that the nuances were temporarily lost. A few decades ago, young believers with an artistic streak used to tantalize themselves with the question, "*Can I be* a Christian and an artist?" Nothing more

LINDA LOWE OREN. *Servant's Basket,* c. 1988.
A bowl of pure new gold nestled on soft woven felt, within a brittle clay basket. *Originally 12 inches high, until a viewer tried to pick it up, knocking it off its pedestal. The shattered clay vessel and scattered felt surrounded the intact gold bowl—a fitting conclusion, the artist explained in retrospect, to her theme.*

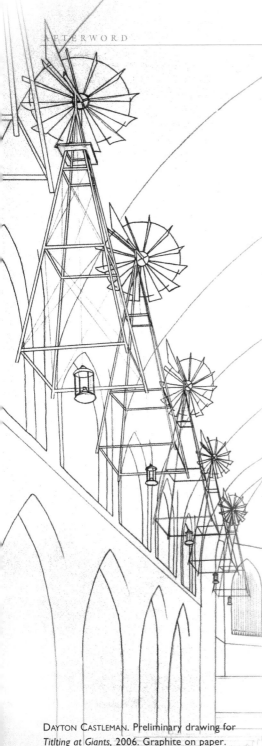

adeptly captures the shift in sensibility in this arena than the new question, which runs more along the lines of, "*Who am I* as a Christian and an artist?"[4] The torch is passing to a new generation that never experienced the weighted and fraught meditations of their predecessors, at least not to such a harsh degree. Such forerunners were frequently advised in the 1960s and 1970s that the arts had gone to the Devil and that we as Christians should have nothing to do with them. What broke the hearts of young dancers, painters, sculptors, actors, architects, designers, and musicians has been broken by so many triumphs in the field, for all to see. Of course, contemporary artists have other pressing concerns, particularly as the world teeters more and more determinedly on a razor's edge, and every category of meaning has received a thrashing or upending at the hands of modernism, from which intellectual endeavor is still recoiling.

Out of many possible examples, Dayton Castleman represents a willing messenger who faithfully dialogues with contemporary society on a daily basis. A few years ago, he entered the operating arena for radical brain surgery—a gifted figural realist painter threatened by a life-changing procedure. Unaccountably, by the time he recuperated, he was only interested in three-dimensional, multi-media conceptual art—particularly art that spoke powerfully to the fears of life after 9/11, having weathered his own journey with mortality. Serving as a lay minister to artists with the Coalition

DAYTON CASTLEMAN. Preliminary drawing for *Tilting at Giants*, 2006. Graphite on paper. 17 x 24 inches.

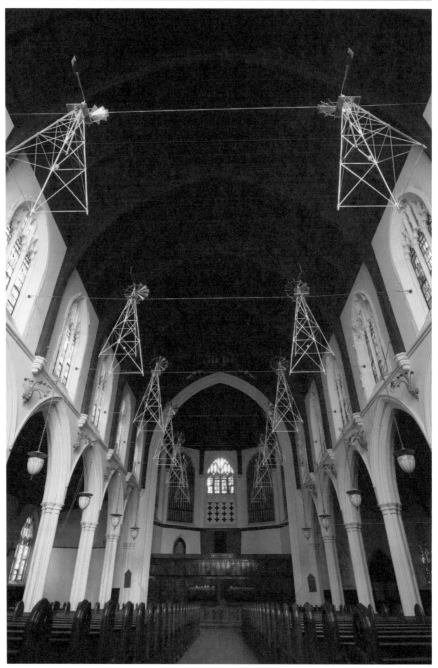

DAYTON CASTLEMAN. *Titlting at Giants,* 2006. Mixed media including aluminum farm windmills, votive candles and holders, steel cable, mono-filament line, steel rings, steel brackets, concrete anchors, turnbuckles, steel wire clips. Dimensions variable, approx 35 x 25 x 100 feet.

for Christian Outreach (CCO) with his wife Karen, a professional dancer recently with MOMIX, Castleman discovered opportunity in the form of an empty Sunday school annex at an historic Philadelphian church. This led him and other artists of faith to inaugurate The Church Studios, with the generous blessings of the church's home congregation and CCO. The facility's historic nineteenth century plan provides low-cost studio space to thirteen accomplished artists of faith. The artists form the core of a daily community, each committed to public art that operates in various sectors of the Philadelphia art scene. The Church Studios oversees a lecture series called DIAlogue, with art historians, critics and accomplished artsists. Surely, Castleman's experience and familiarity with the issues that currently press artists of faith enhances his contributions as a board member to CIVA (Christians in the Visual Arts). Having artists like Castleman literally 'on board' an internationally respected endeavor like CIVA provides almost a tactile sense of a torch being passed to the next generation of CIVA leaders, providing an encouraging example for uncounted artists in subsequent decades. Surely, there will be more exciting synchronicities to come as Castleman interacts within a competitive masters' program at The Art Institute of Chicago.

In 2006, Dayton took advantage of an opportunity "to make known officially or publicly" the coming of the Spirit through his installation, *Tilting at Giants*. Not usually inclined to make direct allusions to biblical texts, he nevertheless became entranced by the Spirit's dramatic appearance during Pentecost, described in Acts 2 as "the blowing of a violent wind [that] came from heaven and filled the whole house." The pastor and arts committee at Philadelphia's Broad Street Ministry offered Castleman the entire sanctuary as an exhibit space, hoping to make a place for contemporary art in their ecumenical church. This motivated Dayton to realize a prior vision of regimented windmills, operating as tropes for the pneumatic presence of God (*pneuma:* Greek; referent to wind, breath and spirit or Spirit). The project followed his first large-scale installation (highlighted in Garza's essay) in which a bright red, heavy-gauge steel gas pipe appears to wend its way rather impishly through the massive corridors and thick masonry walls of the nation's first 'modern' prison (c. 1826). In his post-brain surgery mind, windmills without wind equated to bodies without breath, resulting in a condition that he describes as an 'existential ache' and loss of purpose. Even the title, *Tilting at Giants*, provokes thoughts on failed intentions by evoking Cervante's flawed hero Don Quixote, who heroically took on battle with windmills in the countryside, because he feverishly imagined that they were enemies of all that was good and right.

For Castleman, the rickety delicacy of the windmills also resonated with God's prophecy to Ezekiel about the valley of dry bones. Ezekiel receives an edifying vision from God, after 36 churlish chapters that spew out God's anger about 'faithless brides' and 'rebellious people' and the like. While God agrees to enflesh a valley's worth of dry bones into a mighty army by divine fiat, Ezekiel is

commanded to pray an animating breath into each one (Hebrew: *ruach*, also synonymous with spirit or winds). "Come from the four winds, O breath, and breathe into these slain, that they may live," the prophet prays. Ezekiel's obedience gives life to an entire army.

Centuries after the miracle in the valley of dry bones, Castleman felt somewhat daunted by the prospect of hanging 10-foot high, 30-pound sculptures from the rafters of a neo-Gothic nave. In fact, he assembled a hardware store's-worth of brackets, steel cable, concrete anchors, steel plating, wire rope clips, and turnbuckles to engineer the illusion of delicate weightlessness, waiting on a breeze. This waiting, which conveys a sense of suspended animation, alludes to our reliance on God—our utter dependence on the breath of Life. Similarly dependent, the windmills float in air, but must be supported. While they burn with votive candles that evoke a Pentecostal flicker, they cannot generate the fire. While they were built to work, the blades cannot turn unless they receive that animating *pneuma/ruach*/Spirit of God. Twelve windmills not only suited the architecture, but neatly denoted the Twelve Apostles chosen by Jesus to construct the New Testament church out of the living stones of new believers. "Judas Iscariot" happened to locate itself over the pulpit in the nave. "I see this serving as a warning to preachers to be cautious," Castleman says, fantasizing that if anything said from the pulpit betrays the Word, Jesus Christ, the Judas windmill might just brain the speaker of its own volition.[5]

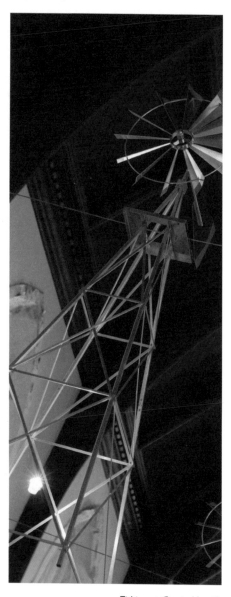

Titlting at Giants (detail)

The sense of truncated purpose that the project embodied immediately began to work on the hearts and minds of a wide variety of individuals. For example, as he grappled with the supporting elements, Castleman witnessed his assistant's dawning conversion to Christian faith. Installation artist Albert Pedulla appreciatively commented that the windmills "seem perfectly content to be anchored in the sky staring straight ahead, unblinking, waiting. It is a bit uncomfortable gazing at this regiment that, like the Palace Guard, cannot be provoked into acknowledging your presence." A local art critic writing on the *Philadelphia Artblog* admitted that she was blown away by both the high-tech slickness and the "stunningly inert" attitude projected by the unmachinated machines. It dawned on her that the windmills, in their unmotivated state, "suddenly become metaphors for people, unable to catch the wind, unable to work efficiently in a universe where atmosphere is a condition of existence." As one theologian within the artist's circle concluded, "Yes, the wind blows where it will, the Spirit moves and it is always a surprise. When the Spirit comes, the windmills will bear evidence of God's presence."

Awaiting this inspiration has been one of the artist's main job descriptions for centuries. Shortly after World War II, as much of Europe still lay in ruins and wrangled with the brutal injustice of the Holocaust, a few French Dominican priests involved in the Resistance chose to 'update' the Catholic church's public face by enlisting the genius of Europe's main artists—Matisse, Braque, Lipschitz, Rouault, Léger, Chagall, and Le Corbusier among them. These priests understood a thing or two about 'large startling figures' when they accepted Germaine Richier's tortured, expressionistic Christ on the cross, prepared for Our Lady of Grace in the French Alps. In fact, local clerics sequestered the cross for almost half a century, scandalized that Richier's avowed atheism should be present in any form in any Catholic sanctuary, even in an artwork with obvious religious meaning. As a 1950 editorial in *Sacred Art* frankly admitted,

> the life of independent art was, on the whole, not very Christian either in its customary themes or in its inspiration What could be expected of it that might be truly sacred?[6]

Yet to paraphrase the writer's conclusion, after long years of observation, artmaking, and commissioning art,

> artists are spiritually intuitive by nature and temperament, so why not expect them to occasionally specify the source of this spiritedness, and to be inspired by the coming of the Spirit himself, who blows, after all, where he will?

Today, Richier's empathetically suffering Christ on the Cross reigns over the altar within its little Alpine chapel. Decades later, *Tilting at Giants* offers yet

another indication that our endeavors must await the breathy inspiration of the Spirit. With great delight, Dayton Castleman observed his critics' gradual realization that his concept depicted the human condition as one of stuckness or stasis. Whereas we anxiously await the creak of a blade moved by the hint of a breeze, only the Spirit of God knows when that motivating purpose might be restarted. Annunciating God's plans for human restoration through the creative act, and fueling creative dialogue comprise important facets of his practice as an artist, but primarily, Castleman sees his task as an artist as one of hoping, watching and waiting for connections that transcend his own control or conceptual agenda. "That's when the exchange is made," he writes with a palpable sense of excitement—"when the viewer somehow connects to the artist in way that is mediated by the artwork."

MARY MCCLEARY. *Greg Looking into the Mirror to See if the Image of God is Still There,* 2006.
Mixed media collage on paper, 18.5 x 18 inches.

Can denizens of the fallen world who refute the option of a redeemed and resolved future receive such holy exhalations, or hear amid the winds and cross-currents the goodness, beauty and truth that animate the Big Story? Will they welcome this exchange of vital information? Who can say? The narration has often come at a steep price, headed by the self-negation of Christ on the Cross. The major prophets, like Ezekiel and Jeremiah, carried out extremely unpopular prophetic messages and bizarre performance art at God's request, but escaped the fury of the mob only to end up exiled from the Chosen Land with the very crowd who criticized their prophesies, all strangers in the strange land of Babylon. Mary must have weathered a life of stigma and shame, since the world perceived her as the mother of an illegitimate child with enigmatic habits, such as preaching to the temple priests at the age of twelve. Nearly all of the Twelve who felt the Spirit blow upon them and the warmth of Pentecostal flames died brutally for their calling in God's service. Where was the glory in these lives? Else*where.*

Being a messenger entrusted with the annunciation of God's message is not a posh job, guaranteed to deliver benefits or security or social acceptance during this lifetime. It will not win friends or influence enemies. Yet as glorious, broken image bearers of God, we will shout and draw startling figures, attempting to translate our Story for the blinded, deafened and bent. Through the grace of God, we will astound with beauty, compel with goodness, convict with truth, and question the absence of these qualities today. But most of all we will *make*—since that is what God did. And God said that it was good.

Amen.

Endnotes

1	Flannery O'Connor, "The Fiction Writer and His Country" in *Mystery and Manners,* edited by Sally and Robert Fitzgerald (Farrar, Straus and Giroux, 1962) 34.

2	Moreover, even the lowly shepherds receive an annunciation in Luke 2:8–20. This provision on God's part was quite odd considering that shepherds smelled funny and were considered too untrustworthy to testify as witnesses in court, along with prostitutes and tax collectors. Hence, the stress on Jesus as the Good Shepherd is a radical distinction. Shepherds came by their bad reputation by 'inadvertently' losing the masters' sheep and blaming the loss on lion attacks or indigestion (usually their own, after a nice lamb stew). Jesus insisted on pursuing the one lost sheep out of one hundred to the ends of the earth.

A highly useful visual source for images of Annunciation, as well as Crucifixion and Descent, has been issued by Phaidon Press Limited of London (2000), under those titles. Sources explaining this historical background include Diane Apostolos-Cappadonna, *Dictionary of Christian Art* (New York: Continuum, 1995) 28–30, and *The Oxford Companion to Christian Art and Architecture* (Oxford University Press, 1996) 23–24. Amazingly, Peter and Linda Murray's Oxford compilation, very late in its release compared to other Oxford reference sources, is subtitled, "The Key to Western Art's Most Potent Symbolism." And this from the institution that would not promote C.S. Lewis for his Christian apologetic sideline on BBC radio.

3	Douglas Adams, *Transcendence with the Human Body in Art: Segal, De Staebler, Johns and Christo* (New York: Crossroad, 1991) 13–44.

4	See, for example, chapters on impact by Nicholas Wolterstorff, Karen Mulder and Alva Steffler in *Faith and Vision: Twenty-Five Years of Christians in the Visual Arts* (Square Halo Books, 2005).

5	All comments about *Tilting at Giants* are excerpted from an email dated 24 March 2006 from Dayton Castleman to Ned Bustard, as well as conversation between the artist and Karen Mulder in March 2006.

6	Marie-Alain Couturier, O.P., "The Lesson from Assy (1950)" in *Sacred Art* (University of Texas Press and Menil Foundation, 1989) 52. For a marvelous and contemporary account of the Vatican's objection to using modern artists with atheistic, agnostic, Jewish or Communist leanings in church art, see Wiliam Rubin's *Modern Sacred Art and the Church of Assy* (Columbia University Press, 1961).

RESOURCES
and bios

In the back of Calvin Seerveld's book *A Christian Critique of Art and Literature* there is a booklist section entitled, "Kindred Readings Behind, Around, and Beyond the Text." This appendix works in a similar way. Following is a list of books distilled from a huge list of recommendations provided by the contributors to this project.

Barzun, Jacques, *The Use and Abuse of Art* (the A.W. Mellon lectures in the fine arts) Princeton University Press, 1974

Jeremy S. Begbie, *Voicing Creation's Praise: Towards a Theology of the Arts* (Edinburgh: T & T Clark, 1991).

Bowden, Sandra and Anderson, Cameron, editors. *Faith and Vision: Twenty-Five Years of Christians in the Visual Arts* (Baltimore: Square Halo Books, 2005).

Hilary Brand and Adrienne Chaplin, *Art and Soul: Signposts for Christians in the Arts* (Carlisle, UK, 1999).

William Edgar, *Taking Note of Music* (London: S.P.C.K., 1986).

Image: A Journal of the Arts and Religion (Seattle, WA).

Madeleine L'Engle, *Walking on Water* (Harold Shaw Publishers, 1980).

Jacques Maritain, *Art and Scholasticism* (Notre Dame, IN: University of Notre Dame Press, 1974).

Ken Myers, *Mars Hill Audio Journal.*

H. Richard Niebuhr, *Christ and Culture* (New York: HarperCollins, 1986).

Flannery O'Connor, *Mystery and Manners* (New York: Farrar, Straus & Giroux, 1962).

Charlie Peacock, *At the Crossroads: An Insider's Look at the Past, Present, and Future of Contemporary Christian Music* (Nashville: Broadman & Holman, 1999).

Prescott, Theodore, editor. *A Broken Beauty* (Grand Rapids, Eerdmans, 2005).

James Romaine, editor. *Objects of Grace: Conversations on Creativity and Faith.* (Baltimore: Square Halo Books).

Marleen Hengelaar Rookmaaker, *The Complete Works of Hans Rookmaaker, vols. 1–6.* (Cumbria, UK: Piquant Editions).

Hans R. Rookmaaker, *Modern Art and the Death of a Culture.* (Wheaton: Crossway Books).

Philip Graham Ryken, *Art for God's Sake: A Call to Recover the Arts.* (Phillipsburg: P & R Publishing, 2006).

Francis Schaeffer, *Art & the Bible* (InterVarsity Press, 1973).

Calvin Seerveld, *Rainbows for the Fallen World* (Toronto: I.R.S.S., 1980).

Gregory Wolfe, ed, *The New Religious Humanists: A Reader* (New York: The Free Press, 1997).

Nicholas Wolterstorff, *Art in Action* (Grand Rapids: Eerdmans, 1980).

DAYTON CASTLEMAN. *The End of the Tunnel—North Wall,* 2005. Steel pipe, industrial acrylic enamel, pressure treated lumber, hardware. 36 x 6 x 3 feet.

CONTRIBUTORS

Suzannah Bauer earned a BA in Music with a Performance emphasis at Eastern University and is currently teaching at the Peabody Preparatory. She is a registered Music Together® center director and teacher at the Abbott Center for the Arts in the Kodaly method. She instructs pre-K–8 general music in the public and private school systems, gives private voice lessons, and teaches music at a summer camp for disadvantaged youth. Suzannah also is the Senior Editor at Square Halo Books.

Sandra Bowden is a painter and printmaker living in Chatham, MA. Reading and seeing, image and text have provided a rich well of materials from which she draws her inspiration. In 2005 Square Halo published *The Art of Sandra Bowden*. With over 100 one person shows, her work is in many collections including the Vatican Museum of Contemporary Religious Art, the Museum of Biblical Art, and the Haifa Museum. She is also a passionate collector of religious art dating from the early 15th century to the present. *Miserere and Guerre by George Rouault* was shown from her collection at MOBIA (www.mobia.org) in NYC in 2006. Sandra is president of Christians in the Visual Arts (www.civa.org). She studied at Massachusetts College of Art and received her BA from the State University of New York. She has studied biblical archaeology, geology and biblical and modern Hebrew. For more on her art go to *www.sandrabowden.com*

Ned Bustard is the owner of an illustration and graphic design firm called World's End Images. He received his B.A. in art from Millersville University of Pennsylvania. He has done work for various clients ranging from the Publication Society of the Reformed Episcopal Church, White Horse Inn, and Young Life, to ICI Americas, Macy's West and Armstrong World Industries. He was the art director for the late, great, alternative Christian music publication, *Notebored Magazine*. Much of his current work is for Veritas Press, for whom he has also written a number of books including *Legends & Leagues or Mr Tardy Goes From Here to There, The Sailing Saint, Ella Sings Jazz,* and a historic novel *Squalls Before War: His Majesty's Schooner Sultana*. In his spare time, he is the creative director for Square Halo Books. He currently is living in Lancaster, Pennsylvania with his wife, Leslie, and three daughters, Carey, Maggie and Ellie. *www.worldsendimages.com*

Adrienne Dengerink Chaplin received her doctorate in philosophy from the Free University of Amsterdam and studied violin at the Sweelinck Conservatory. She worked for Universities and Colleges Christian Fellowship (the British wing of Inter-Varsity Fellowship) in the UK and was a board member of the London-based Arts Centre Group. After moving to Canada in 1999 she taught philosophical aesthetics at the Institute for Christian Studies in Toronto and served as Anglophone president of the Canadian Society for Aesthetics and as delegate member of the International

Association for Aesthetics. She contributed a chapter on Sartre and Merleau-Ponty to the *Routledge Companion to Aesthetics* and has written several articles on faith and art, art and embodiment, phenomenology and theology. She is co-author of *Art and Soul: Signposts for Christians in the Arts* (IVP, 2001) and currently works as a freelance writer and speaker in Cambridge, UK. She is married to political theorist Jonathan Chaplin, and they have a teenage daughter and college-age son.

William Edgar is currently Professor of Apologetics at Westminster Theological Seminary. He studied musicology at Harvard and Columbia. He holds the Docteur en Theologie from the University of Geneva (Switzerland). He has taught at the Reformed Theological seminary in Aix-en-Provence. His books include *Taking Note of Music* (SPCK), *La Carte Protestante* (Labor et Fides), and *Reasons of the Heart* (Baker). He has written numerous articles on such subjects as cultural apologetics, the City of Geneva, and African-American music. His favorite avocation is jazz piano. He plays part-time with a professional jazz band. His wife Barbara is Administrative Secretary for the Huguenot Fellowship. They have two children, Keyes, a lawyer in New York, and Deborah, a campus chaplain at Harvard.

Roger Feldman is currently Chair and Professor of Design and Sculpture at Seattle Pacific University. His undergraduate degree is from the University of Washington and his MFA is from Claremont Graduate University. He received an Individual Artist Grant from the NEA in Sculpture in 1986, and has created site-specific installations throughout the United States, as well as in Austria and England. He also creates drawings, giclee prints, and maquettes. He has participated in artist residencies at places like Yaddo, and has been invited to speak about his work in numerous settings. His work is in a number of public and private collections including the Washington State Arts Commission. His work has been featured in Image Journal, and has been reviewed in the Los Angeles Times, Seattle Times, and other publications. He received the Prescott Award for Sculpture in 2005 from CIVA. He and his wife, Astrid, live and work in Seattle. They have two highly creative children. *www.rogerfeldman.com*

Makoto Fujimura was born in Boston. He graduated from Bucknell University (B.A.) and Tokyo National University of Fine Arts and Music (M.F.A.) where he spent six and a half years studying the tradition of Nihonga (Japanese-style painting) as a Japanese Governmental Scholar. He has had over twenty solo exhibits both in Tokyo and New York. Public collections of his works include The Saint Louis Art Museum, The Contemporary Tokyo Museum, and the Yamaguchi Prefecture Museum. His work was recently selected by two museums in Tokyo as one of 70 outstanding works of Nihonga of the Twentieth Century. He was also chosen to produce works to commemorate the Millenium Christmas at The Cathedral Church of St. John the

Divine, New York City.

He is the founder of the International Arts Movement (www.iamny.org) whose mission is to "stand in the gap between the arts community and the Church, and be a catalyst for cultural renewal." He and his wife and three children live in New York City. *www.makotofujimura.com*

Kimberly Garza is a graphic designer and educator. She works as an art director for Jolly Design in Austin, Texas, and teaches part-time at several area schools. For seven years, she partnered with not-for-profit organizations through her design firm, Above: The Studio. She studied design at Anderson University (B.A.) and North Carolina State University (M.G.D.). Her work moves across print, interactive, and motion mediums. She is currently making a series of short films in collaboration with her husband, Todd, a singer-songwriter. Kimberly would like to extend a special thanks to all of the artists who shared their time and art for the essay and to Kate Van Dyke for her writing assistance. *www.abovethestudio.com*

David Giardiniere is a native Pennsylvanian who has been a teacher, conductor, vocalist, dramatist, clinician, adjudicator and composer. He has served in churches and Christian schools since 1978, and his choral and instrumental groups have performed throughout the eastern US, Canada and in Vienna, Austria. A graduate of West Chester University, Northwestern University, and New York University, he has also received a diploma for studies done in Siena, Italy. In 1998, he was chosen to appear in *Who's Who Among American Teachers,* and was guest conductor for the Christian Youth Honors Choir at Carnegie Hall in New York. A growing list of his published choral works may be found in the catalogs of five major publishing houses. Living outside of Philadelphia with his wife and three children, he is currently the Director of Music at Faith Presbyterian Church in Wilmington, DE, and head of Product Evaluation for J.W. Pepper & Son, overseeing a team of musicians who survey more than 18,000 new publications a year.

Tim Keller is the founding pastor of Manhattan's Redeemer Presbyterian Church (www.redeemer.com). Since its beginning in 1989, many arts and business professionals have found spiritual life at Redeemer. Before coming to New York, Dr. Keller was an associate professor of practical theology at Westminster Theological Seminary in Philadelphia, where he continues as adjunct faculty. Dr. Keller has written *Resources for Deacons* and *Ministries of Mercy* (P & R). He is currently engaged in developing curriculum for leadership training at Redeemer and helping to found the Urban Church Development Center and the City Seminary of New York (CISNY). His wife Kathy is the Director of Communication at Redeemer. They have three grown sons: David (at the College of William and Mary), Michael (at Vanderbilt University) and Jonathan (at The Stony Brook School.)

Edward Knippers (MFA, University of Tennessee) has studied at the Pennsylvania Academy of the Fine Arts, Philadelphia, and under Zao Wou-ki (painting), Otto Eglau (printmaking), and was a fellow at S. W. Hayter's Atelier 17 in Paris.

His exhibits include the Los Angeles County Museum of Art; the Virginia Museum of Fine Arts, Richmond; the Southeastern Center for Contemporary Art (SECCA); the Tennessee Fine Arts Center at Cheekwood, Nashville; the Roanoke Museum of Fine Arts, Virginia; the J. B. Speed Museum, Louisville; the Billy Graham Center Museum, Illinois; the Biblical Arts Center, Dallas; and the Universities of Kentucky, Oklahoma, and Tennessee. He has also exhibited in England, Canada, Italy and Greece.

His work has been featured in *Life Magazine, The Washington Post, the New Art Examiner, The Washington Times, The Richmond Times-Dispatch, The Richmond News Leader, the Fort Worth Star-Telegraph, The Baltimore Sun, the Los Angeles Times, the L.A. Weekly, Artweek, Art Voices, Faith and Forum, Christianity Today, Christianity and the Arts, Eternity, The Critic, Image, Washington Review, Clarity, Rutherford, Poet Lore*, and *New American Paintings*, a juried exhibition. *www.edknippers.com*

Mary McCleary is Regent's Professor of Art Emeritus at Stephen F. Austin State University, where she taught from 1975 to 2005. She received her B.F.A., cum laude in printmaking/drawing at Texas Christian University and her M.F.A. in graphics from the University of Oklahoma. Since 1970 she has participated in over 250 one-person and group exhibits in museums and galleries in 24 states, Mexico, and Russia. These venues include the National Museum of Women in the Arts in Washington, D.C., MOBIA in New York City, the Boston Museum of Art, the Dallas Museum of Art, the Contemporary Art Museum in Houston, the San Antonio Museum of Art, and the Nelson-Atkins Museum in Kansas City. She is also a recipient of a Mid-America Arts Alliance/National Endowment of the Arts Fellowship. Her work has been regularly reviewed or featured in Texas newspapers, as well as in national publications: *Art in America, Art News, Image, Art Papers, The New York Times, The Washington Post, Art Week, Artspace, Texas Homes, New American Paintings*, and *Contemporanea International Arts Magazine. www.marymccleary.com.*

Karen L. Mulder teaches art and architectural history, which she studied at Boston University, Radcliffe College, Yale University's Institute of Sacred Music and the Arts (MAR), and the University of Virginia (Ph.D), specializing in European and American modern architecture, contemporary art by Christians, and the effect Germany's post-war reconstruction on ecclesiastic art. She has lectured extensively and internationally on the arts since co-founding Christians in the Arts Networking, Inc. in 1981, contributing to a variety of publications, including *American Arts Quarterly, Material Religions, Christianity Today, Shaping Christian Higher Education* (Broadman Holman), and several *excellent* Square Halo books. She has also served the boards of

the C.S. Lewis Foundation, Christians in the Visual Arts, and the Newington Cropsey Cultural Studies Foundation. *www.mulderartefacts.org*

Charlie Peacock is a singer, songwriter, and record producer with a twenty-four year career in the music industry, including sixteen years in contemporary Christian music. In addition to recording his own albums (most recently, *Love Press Ex-Curio*), he has produced and written for numerous artists ranging from Amy Grant to Switchfoot. He is the founder of a study center called The Art House and of Re:think Records. His first book is *At the Crossroads: An Insiders Look at the Past, Present, and Future of Contemporary Christian Music.* His main avocation is fishing. His wife, Andi, is a master gardener and a writer. They live in Nashville in a remodeled turn-of-the-century country church and have two grown children, Molly and Sam. *www.charliepeacock.com* and *www.charliepeacockjazz.com*

Theodore Prescott is a sculptor and professor at Messiah College. He majored in art at the Colorado College and received his M.F.A. from the Rinehart School of Sculpture, the Maryland Institute College of Art. He has exhibited widely in the United States, and completed several public commissions, including a recent collaborative commission in Golden, Colorado for the Colorado School of Mines. His work is in several private collections, The Vatican Museum of Contemporary Religious Art, and the Armand Hammer Museum of Art, UCLA. He edited the quarterly publication CIVA for six years, serves on the editorial advisory board of *Image*, and has published several articles on the visual arts. He and his wife Catherine, a painter, have begun the renovation of an old farmhouse and barn near Harrisburg, Pennsylvania. They have two daughters, Flora and Grace. Prescott enjoys reading, hiking, and working in the landscape.

James Romaine is a New York based art historian. With the loving support of his wife and son, he is a PhD candidate at the Graduate Center of the City University of New York, writing his dissertation on the art of Tim Rollins and K.O.S. Co-founder the New York Center for Arts and Media Studies, a program of Bethel University (NYCAMS.Bethel.edu), he is a frequent lecturer on faith and the visual arts and has authored numerous articles, in the *Art Journal of the College Art Association, American Arts Quarterly, Christian History & Biography, Re:Generation Quarterly, The Princeton Theological Review, Image: A Journal of the Arts and Religion,* and *Faith and Vision: Twenty-Five Years of Christians in the Visual Arts.* His books include *Objects of Grace: Conversations on Creativity and Faith* and *The Art of Sandra Bowden,* both published by Square Halo Books.

Krystyna Sanderson has exhibited her photographs at, among other galleries, the Photo Center Gallery of New York University, Soho Triad Gallery and the Narthex

Gallery at St. Peter's Church, all in New York City, and at the Barrington Center for the Arts at Gordon College in Wenham, Massachusetts and the Dadian Gallery in Washington, D.C. Her photographic series *Masks* was published in book form by Texas Tech Press. In 2003 Square Halo published *Light at Ground Zero: St. Paul's Chapel After 9/11*. She curated the online ECVA (The Episcopal Church and Visual Arts) exhibits: "Out of Darkness Into Light," "Since September 11," "Art and Faith: A Spiritual Journey" and the online CIVA exhibit "The Faces of Christ."

Krystyna holds an M.F.A. in painting and photography from Texas Tech University. She taught photography at The New School and at St. John's University in New York, was a staff photographer for the New York City Police Department, and currently works as a fine art and commercial photographer. She is a founding member of the board of directors of ECVA (www.ecva.org) and a CIVA member. She worships at Grace Episcopal Church in New York. *www.krystynaphotography.com*

Dale Savidge was instrumental in founding Christians in Theatre Arts (www.cita.org) in the mid 1980s, and was elected its first President; he held the presidency until his appointment as Executive Director in 1994. Dale Savidge earned two Masters degrees in theatre and a PhD in English and Theatre from the University of South Carolina. After teaching collegiate theatre at the undergraduate and graduate levels for fifteen years, in 1996 Dale launched Associates and Savidge, an arts management organization for professional Christian actors. He resides in Greenville, SC with his wife Tammy, a registered nurse, and their three children: Timothy, Patricia and Olivia. *www.savidge.com*

Steve Scott is a writer, lecturer, performer and mixed-media artist. Since moving to America in the mid 1970s, he has published a number of articles on postmodern art, multiculturalism, and the Christian opportunity afforded by these developments in various magazines. His two books are: *Crying for a Vision* (Stride Books, UK, 1991) and *Like A House on Fire* (Cornerstone Press 1997, Wipf and Stock 2003). Transcripts of his Cornerstone lectures were included in *Artrageous: Volume One* (Cornerstone Press, 1992). In addition to this he has published several small press books of experimental poetry both here and in the UK. He has released nine albums that range from rock music to ethno-electronica and spoken word, and worked with painter Gaylen Stewart on a mixed-media collaboration called *Crossing the Boundaries*. He has performed and lectured from Belgium to Bali and is the director for Christian Artists' Networking Association (www.canagroup.org), a predominantly majority-world arts and ministry organization.

Gaylen Stewart is a professional artist and lecturer. He was Associate Professor at Grand Canyon University and instructed at Ohio University (where he received an MFA in painting, 1986), and University of Rio Grande.

He has been awarded several fellowships and grants including Individual Artist's Fellowships from the Ohio Arts Council, and a grant awarded by Robert Rauschenberg and James Rosenquist. His writing and art have been published in several books and magazines including *Dialogue: Arts in the Midwest* and *New American Paintings*, (*Open Studios*). He has exhibited in over one hundred shows (thirty-three solo) including: Alexandria Museum of Art; Bellevue Art Museum; The Butler Institute of American Art; Cleveland Center for Contemporary Art; Huntington Museum of Art; and Mesa Contemporary Arts Center.

In addition to making art, he enjoys traveling and spending time with his wife, Vicki. As a fifteen-year cancer survivor, he says, "I'm thankful for God's miraculous power and I document my healing through art." *www.gaylen.com*.

Gregory Wolfe is Writer in Residence at Seattle Pacific University and the founder and editor of *Image* (www.imagejournal.org), one of America's leading literary quarterlies. He also directs the Master of Fine Arts in Creative Writing at SPU. In 2005 he served as a judge in nonfiction for the National Book Awards. Wolfe has published essays, reviews, and articles in numerous journals, including *Commonweal* and *First Things*. His essays have been anthologized in collections such as *The Best Christian Writing* and *The Best Catholic Writing*. Among his books are *Intruding Upon the Timeless: Meditations on Art, Faith, and Mystery* (Square Halo, 2003), *Malcolm Muggeridge: A Biography* (Eerdmans, 1997) and *Sacred Passion: The Art of William Schickel* (Notre Dame, 1998). Wolfe is also the editor of *The New Religious Humanists: A Reader* (Free Press, 1997). A collection of his essays, *Beauty Will Save the World*, will be published by ISI Books in 2007. *www.gregorywolfe.com*

ACKNOWLEDGMENTS

It Was Good was and is a collaborative effort. Thanks must be extended to the many hands that worked on this project. First, to the writers from the first edition for their initial labors and for reworking their essays. Next, to the new writers for their contributions. And for this full-color edition, thanks is extended to all of the artists who generously donated their work for reproduction. Buckets of thanks go to Karen Mulder who expended a great deal of time, energy and expertise in helping to reorganize this book and offering vision and depth to the editorial process. Also to Alan Bauer who volunteered to read gallies and offer editorial insights to improve this second edition. Thanks to Ellen Vest and Kim Garza who gave of their eyes and experience in tweaking the design. Byron Borger, Tom Becker, Peter Mollenkof and Matthew Clark for reading miscellaneous drafts and giving a critique or adding a well-crafted phrase where needed. Jennifer Schmidt for proofing the entire book. Leslie Bustard for sacrificing time and money for the greater good of this work and joining in with prayer and encouragement to see *It Was Good* develop into an acceptable service.

MORE GOOD BOOKS
from Square Halo

MARY MCCLEARY: AFTER PARADISE
"The collages in *After Paradise* are McCleary's most challenging to date. They convict and console like an Old Testament prophet shunted up in a tree stump but strangling out a message nevertheless." —*Harold Fickett*

THE ART OF SANDRA BOWDEN
A beautiful visual record of an amazing personal and spiritual journey of more than forty years, through the veiled mysteries that lead us to belief. "This book is immensely important to bring Bowden's works into a proper context, and attention that they deserve."—*Makoto Fujimura*

THE BEGINNING: A SECOND LOOK AT THE FIRST SIN
"Bauer's work demonstrates a strong commitment to the authority of Scripture as well as a creative approach to the theology of the fall into sin. His efforts will stimulate much helpful discussion about the nature of good and evil on very practical levels." —*Richard Pratt*

THE END: A READERS' GUIDE TO REVELATION
"Bauer spares us much of the speculative application that tends to show up in popular commentaries on John's Apocalypse. His goal is much more modest, that to equip us to read and study the book for ourselves. In this, he has succeeded handsomely." —*Report Magazine*

FAITH AND VISION: TWENTY-FIVE YEARS OF CHRISTIANS IN THE VISUAL ARTS
This amazing book features more than 200 images that showcase the work of most accomplished artists in Christians in the Visual Arts (CIVA). "CIVA is a wonderful association and this book shows off the God-blessed glory of their members' work in extraordinary fashion."—*Hearts & Minds Books*

INTRUDING UPON THE TIMELESS: MEDITATIONS ON ART, FAITH AND MYSTERY
A compendium of the editorial statements from *Image: A Journal of the Arts & Religion*. "... not since O'Connor's *Mystery and Manners* has there been such bracing insight on the pile-up where art and faith collide. This book will rev your engines and propel you down the same road." —*Annie Dillard*

LIGHT AT GROUND ZERO: SAINT PAUL'S CHAPEL AFTER 9/11
A picture essay accented with fragments of prayers and Scripture, that tells of the relief work carried on at St. Paul's Chapel, an 18th-century Episcopal church that stands less than one hundred yards from the World Trade Center site.

OBJECTS OF GRACE: CONVERSATIONS ON CREATIVITY AND FAITH
"[A] colorful and concise collection of interviews and art from some of America's most intriguing Christian artists. Romaine interviews ten artists, presenting color reproductions of the artists' work along with the text of the interviews."—*Image: A Journal of the Arts & Religion*

*www.*SQUARE HALO BOOKS.*com*